Flow TV

If Raymond Williams' concept of flow challenges the idea of the discrete television text, then convergence destabilizes the notion of television as a discrete object. From viral videos on YouTube to mobile television on smart phones and beyond, TV has overflowed its boundaries.

Flow TV examines television in an age of technological, economic, and cultural convergence. Seeking to frame a new set of concerns for television studies in the 21st century, this collection of all new essays establishes television's continued importance in a shifting media culture. In order to make sense of television and new media not just as technical devices, but as social technologies, the essays in this anthology insist we must turn our attention to the social, political, and cultural practices that surround and inform those devices' use. The collection examines television through a range of critical approaches from formal and industrial analysis to critical technology studies, reception studies, political economy, and critiques of television's transnational flows. This volume grows out of the critical community formed around the popular online journal *Flow: A Critical Forum on Television and Media Culture* (flowtv.org).

Michael Kackman is Assistant Professor of Media Studies in the Department of Radio-Television-Film at the University of Texas at Austin. He is author of *Citizen Spy: Television, Espionage, and Cold War Culture*.

Marnie Binfield is a doctoral student in Radio-Television-Film at the University of Texas at Austin.

Matthew Thomas Payne is a Media Studies doctoral student in the Department of Radio-Television-Film at the University of Texas at Austin. He is coeditor (with Nina B. Huntemann) of *Joystick Soldiers: The Politics of Play in Military Video Games*, also published by Routledge.

Allison Perlman is an Assistant Professor in the Federated Department of History at the New Jersey Institute of Technology and Rutgers University-Newark.

Bryan Sebok is Assistant Professor of Media Studies at Lewis and Clark College.

Flow TV

Television in the age of media convergence

Edited by Michael Kackman,
Marnie Binfield,
Matthew Thomas Payne,
Allison Perlman, and
Bryan Sebok

Routledge
Taylor & Francis Group

NEW YORK AND LONDON

First published 2011
by Routledge
270 Madison Avenue, New York, NY 10016

Simultaneously published in the UK
by Routledge
2 Park Square, Milton Park, Abingdon, Oxon OX14 4RN

Routledge is an imprint of the Taylor & Francis Group, an informa business

Typeset in Perpetua by Wearset Ltd, Boldon, Tyne and Wear
Printed and bound in the United States of America on acid-
free paper by Edwards Brothers, Inc

Library of Congress Cataloging in Publication Data
Flow TV : television in the age of media convergence / edited
by Michael Kackman ... [et al.].
p. cm.
Stems from the online journal, Flow: a critical forum on
television and media fulture (www.flowtv.org).
Includes bibliographical references and index.
1. Television broadcasting–Social aspects. 2. Television–
Technological innovations. I. Kackman, Michael. II. Title:
FlowTV.
PN1992.6.F575 2010
302.23'45–dc22

2009037292

ISBN13: 978-0-415-99222-0 (hbk)
ISBN13: 978-0-415-99223-7 (pbk)
ISBN13: 978-0-203-87963-4 (ebk)

Contents

Acknowledgments

From the outset, *Flow* – the online journal, conferences, and this anthology – has been a collaborative endeavor that has drawn on the commitment, enthusiasm, and intellect of a wonderful and vibrant community. This project began in 2004 with the launch of the first issue of *Flow*, an online television and new media journal hosted and run by the Radio-Television-Film Department at the University of Texas at Austin. *Flow* provides a forum for multiple communities with a shared interest in media to discuss current and past developments in programming, industrial trends, policy, and audience behaviors. The continued commitment, intellectual interest, and labor of a tremendous group of graduate students has enabled *Flow* to become an important space for discussion, inquiry and collaboration. We would like to thank all of the incredible graduate editors who have worked on *Flow*, and especially the journal's past and present coordinating editors – Peter Alilunas, Alexis Carreiro, Alex Cho, William Moner, Annie Petersen, Jacqueline Vickery, and founding editors Chris Lucas and Avi Santo – who along with Marnie, Matt, and Bryan, have made *Flow* run for all these years. We'd also like to acknowledge the crucial support of the faculty of the RTF Department, especially Mary Celeste Kearney, Shanti Kumar, Tom Schatz, Sharon Strover, and Janet Staiger. *Flow* as an experiment never would have succeeded without the brilliance and enthusiasm of our many contributors and conference panelists, of whom there are too many to mention by name, but to whom we are very grateful. Each of the contributors to this volume is a *Flow* alum, and we thank them for their continued interest and involvement in the *Flow* project. We also extend our gratitude to Roderick Hart, Dean of the College of Communication at the University of Texas, as well as to the College staff who have helped to get the *Flow* journal online and keep it up to date. In addition, we'd like to thank Joshua Green, Joanna Jefferson, and Aaron Maxwell for their provocative conversations and moral support. Thanks finally go to Matt Byrnie at Routledge for his enthusiasm, support, and especially patience as we have put this collection together.

Introduction

"Flow" and "convergence" are both terms central to the study of television, though their pairing may seem paradoxical. Raymond Williams had deemed television's flow – the abutting and collision of programs, advertisements, promos, film trailers – as the central experience of watching television; television programming, in other words, was not a series of discrete texts, but this "planned flow."[1] Williams coined the term in 1974, when in the United States the three-network oligopoly was still intact, video cassette recorders were an emerging technology, cable had not yet penetrated many television households, and the Internet was unheard of outside of university and military research labs. Flow can thus seem like a relic of television's past, a descriptor that no longer captures the messiness and complexity of what television has become. Convergence, a term that came into usage in the 1990s, has described television's present and pointed to expectations of its future. Convergence is an umbrella term that refers to the new textual practices, branding and marketing strategies, industrial arrangements, technological synergies, and audience behaviors enabled and propelled by the emergence of digital media. If flow challenges the idea of the discrete television text, then convergence destabilizes the notion of television as a discrete object. Television texts overflow onto interactive websites, television content is available on myriad platforms, and television networks are part of multi-media conglomerates.

Yet Williams' concept of flow always has been about more than just television programming. To understand television, according to Williams, was to place it firmly within its historical context and read it – its texts, its uses, its forms – alongside the needs and values of the culture in which it operates. Flow does not inhere to the medium of television, but rather reflects a particular "institutionalization of culture."[2] As Williams wrote, "a technology is always, in a full sense, social. It is necessarily in complex and variable connection with other social relations and institutions."[3] While scholars working in a range of humanities traditions could draw upon ample skills of textual and

institutional criticism to make sense of particular programs, those techniques couldn't entirely account for the essentially social, and porous, act of "watching television." Some of Williams' initial observations were formed out of the vertigo he felt as a Brit watching American television; as we all do when we travel and tune in to local programming, his first reaction wasn't in response to a particular program, but rather the overwhelming sensation of being inside a different culture. His sense of alienation likely made plain that television represented nothing short of a distinctly American culture in which citizenship, entertainment, and consumerism comingled. For Williams, to talk solely about an individual program or network is to miss the forest for the trees; television as a social technology is an instantiation of cultural values, rooted in time and place. Its forms, structures, and meanings neither inhere to the medium itself nor are ever fixed or immutable.

It is this sensibility that guides the discussion of television and convergence in this collection. Though it has acquired the patina of a well-worn theory, flow remains more of a critical provocation than a coherent analytical method. The concept seems particularly problematic in light of the development of interactive viewing technologies. The remote control and the video cassette recorder certainly confounded some of the power of planned flow to shape our immediate viewing experiences, while online video and the digital video recorders developed by TiVo and other companies have further complicated the idea that television can be explained by a metaphor derived from centralized broadcasting. But, while contemporary viewing practices complicate the original theorization of flow, the concept remains a powerful heuristic device. What we take from Williams is an insistence that we not consider media texts in isolation as textual wholes, but rather consider the ways in which texts brush up against other texts, institutions, technologies, and practices. Television sprawls; it is our job to explain why, how, and to what effect. The scholars in this volume, writ large, reflect this binding logic as they explore the intersections between technologies, institutions, and cultural forms and practices, despite the methodological and conceptual differences that inform their work. While some of the chapters center on media texts, and others foreground other sites of analysis, they collectively illustrate the necessity to consider and question which contexts matter, and why, as we grapple with the meanings of the media. This has led some scholars in this collection to look at the social experience of viewing, while others focus on the role of "paratexts" (extra-textual elements like promotional posters, DVD special features, or websites) in structuring uses and interpretations of media texts themselves, and still others explore the degree to which online video challenges older models of textual production and reception. In order to make sense of television and new media not just as technical devices, but as social technologies,

the chapters in this anthology insist we must turn our attention to the social, political, and cultural practices that surround and inform those devices' use.

In this sense, convergence (whether technological, industrial, or cultural) offers not a bitter challenge to the legitimacy of the flow metaphor, but a series of complications to understanding its operation. Meditations on "convergence" date back at least to Ithiel do Sola Pool's 1983 *Technologies of Freedom*, where he described an imminent convergence of communications forms – then common carriers (telephones, telegraph), print, and electronic (radio, television) media – and argued for a regulatory paradigm that would maximize the free speech protections of communicants in this interconnected communications environment. The term convergence, however, would catch fire alongside the popularization of the Internet in the mid-1990s, capturing the imaginations of technologists and academics alike. In a series of *Wired* magazine essays that culminated in the 1995 book *Being Digital*, Nicholas Negroponte described it simply as what happens when bits of data comingle; devices would become steadily less important than the data that flowed seamlessly across them.[4] The metaphor of free mobility was seductive. Many initial discussions of convergence, especially by technological utopianists in the trade press, framed it a positive, exciting, and revolutionary phenomenon that not only bridged devices, but inherently promised to erode encrusted social barriers. Others were less sanguine, and imagined that the customization and personalization that accompanied digital technologies could instead shatter the social binding function of the media, leading to the proliferation of narrow lifestyle enclaves that would no longer interact in a shared public sphere.[5]

More recent work has questioned both the presumed newness of media convergence and the possibility that current instantiations of media formats, audience behaviors, and technological apparatuses might reinscribe – rather than challenge – existent power relations. Scholars, for example, have examined the resilience of "old" media conglomerates to shape and dominate media production, even as they redefine their own marketing strategies and business models. Others have investigated how longstanding discourses on identity (race, gender, class, sexuality) and on taste continue to inform how media is understood, structured, and consumed. What binds much of contemporary scholarship on convergence is a shared belief that technology is not neutral, and that our current media environments – as much as those of the past – are not *determined* by the rise of new technologies, but are shaped by institutional, cultural, and political factors and by the continual engagements between emergent and residual media forms.[6]

This volume continues in this vein, and questions the celebratory assumption that convergence has uniform, or uniformly positive, cultural and political effects. One of the emerging themes of this collection is that, while the

narrowly technological and economic issues of media convergence (those that seem the most obvious evidence of transformation) are likely more evolutionary than revolutionary, the more compelling issues surrounding convergence are often those regarding cultural boundaries and practices. Overall, we hope to question just *what* is new, and what is not, in order to engage a critical dialogue about convergence that doesn't reinforce hegemonic discourses of technological utopianism.

Television has likely always been a convergent medium, though it's only relatively recently that the term "media convergence" has captured the imaginations of academics, technology journalists, users, and the industry itself. Emerging from the institutional and technological foundations of radio, the new technology borrowed not only from its immediate broadcasting forebear, but from other media forms as well. Like radio, television borrowed heavily from the motion picture industry. In the United States, the major studios had attempted to develop subscription and theatrical television, and by the mid-1950s, the commercial broadcast networks quickly found that the "vault of Hollywood" was a promising source of narrative content for a fledgling medium. Programs like the *Lux Video Theater* (CBS, 1950–1959), offspring of the long-running *Lux Radio Theater* (NBC and CBS, 1934–1955), brought the glamour of Hollywood to broadcasting in a popular series of abridged adaptations of popular films. Furthermore, by the end of the decade Hollywood studios alone generated 40 percent of network programming, and studios both large and small quickly adapted their production models to create new episodic serials specifically for television.[7]

At the same time, television has long been a particularly effective means of extending the reach of popular stars, texts, and brands. Children's media helped lead the way; for cowboy stars like Gene Autry, Roy Rogers, and William Boyd, television was but one piece of transmedia franchises that included films, comics, radio, musical recordings, books, magazines, and toys. Today we might call it "repurposed content," but from the 1950s to the present, transmediation has often been standard industry practice. From Bing Crosby's *Fireside Theater* and *The Sonny and Cher Comedy Hour* to *Batman* and *Transformers*, the boundaries between seemingly disparate media forms have long been quite porous. If mobility of forms across multiple media industries and technologies is a key criterion for understanding "convergence," then early television certainly qualifies. Television has always borrowed from, exploited, and contributed to other media.

This is not to say, of course, that there is nothing new in our current media environment. New digital technologies, and new appropriations of existing technologies, have made transmedia exploitation by producers and distributors virtually instantaneous. Furthermore, digital technologies have opened up new

opportunities for media users and consumers, prompting scholars like Henry Jenkins to understand convergence not just as intertextual, economic, and technological linkages at the site of production, but as the shifting cultural relations and reception practices that emerge around and exploit those linkages. Convergence culture, for Jenkins, is a highly interactive participatory climate in which the mobility of texts and discourses across media forms blurs distinctions between producer and consumer, and helps generate "collective intelligence" communities that can contest or alter the meanings and reach of commercial media texts.[8]

The implications of convergence culture are unclear. Whether these new modes of participation represent the comprehensive commodification of everyday life or new opportunities for grassroots agency is an open question. One premise of this collection is that the question itself can't be answered in generalities; instead, our intention is to provide a range of smaller case studies that explore the texture and complexity of television as it is experienced today. While these chapters explore television's connections to a wide range of electronic devices, from cell-phone cameras to home digital video recorders, they do not adopt what technology historian Carolyn Marvin has called an "artifactual approach."[9] Rather than focus narrowly on technical innovation and the industrial exploitation that follows it, we approach technology as something more than hardware and software; recalling Williams, if we treat technology as an embodiment of cultural values, we must look outside the box to figure out what the flickering images on it mean.

Part I of this collection, "The Convergent Experience: Viewing Practices Across Media Forms," blends textual analysis, political economy, and material culture studies to begin to map out the kinds of transmedia encounters characteristic of convergence culture, with particular attention to televisual experiences outside of traditional, bounded practices of watching content on television. These chapters explore myriad aspects of audience experiences, including the various pleasures available to the contemporary media consumer. Thematically, the chapters consider how these experiences have changed notions of identity, genre, space, access, and television itself.

Part I begins with Daniel Chamberlain's chapter, which situates television's new mobility as part of a broader reorganization of the built environment. Bringing together research into television technologies and contemporary urban planning, Chamberlain argues that the intersection of media interfaces and pervasive networks is reconfiguring the private/public dialectic in favor of a new paradigm of spatiality for the network society – the media space. Media interfaces, he suggests, auger epistemological shifts in our understanding of both our built spaces and the cultural constructions that make them possible. These shifts hint at increased democratic potential even as they are predicated

upon social and economic privileges that tend to reinforce familiar divides. Focusing on one of those new spaces, Jason Mittell's "TiVoing Childhood" presents a personal reflection on how digital video recorders (DVRs) change family behaviors around, and children's understanding of, contemporary television. As Mittell shows, TiVo challenges many fundamental assumptions about television as a medium in an era in which there are multiple coexisting paradigms for what television is and how it is used.

In his contribution to this volume, David Gurney offers a nuanced snapshot of the current state of transmediated participatory culture. Focusing on the Sammy Stephen's flea market commercial, the author explores two important recurring traits of the viral comedy clip that function in close proximity to one another. He explores the shifting notion of the "amateur" in regards to unmitigated access to the means of production and distribution. In addition, Gurney maps the opportunities for "reconfiguration" that stem from the wide accessibility and manipulability of these clips and the countless tributes, remixes, and re-enactments that closely follow them. These manipulations are not bred from years of engagement with textual elements, nor do they rely upon pre-existing like-minded communities for their dissemination.

The next two chapters in this section explore how reality television complicates our understandings of convergence as both industrial practice and narrative form. In "Affective Convergence in Reality Television: A Case Study in Divergence Culture," Jack Bratich suggests that reality television programs complicate the optimistic discourse on convergence media culture. He proposes that an important contemporary trend is that of "affective convergence," a process by which individual subjects are formed by their ability to act, and be acted upon by others. The chapter in particular examines reality television programs as producers of a divergence culture, one governed by systems of conflict, separation, hierarchy, judgment, and exclusion. In "Industry Convergence Shows: Reality TV and the Leisure Franchise," Misha Kavka investigates the interrelationships between television and other cultural industries, including music, food, and fashion. She analyzes how – and whether – television programs can effectively serve the needs of these outside industries and how the tension between the imperatives of television and other cultural industries are negotiated, mediated, or resolved within the format and narrative of reality television shows.

Part II of this book, "Creating Authors/Creating Audiences," explores how the concept of authorship has transferred from other media into the televisual landscape. "Authors" are numerous here: they are writers, directors, critics, fans, and creators of websites for fans. Interaction among a variety of "authors" and the definition and performance of authorship in a convergent media landscape are the central concerns of these chapters. This section similarly broad-

ens and complicates the relationship between author, text, and audience. Audiencehood, like authorship, is revealed to be an unstable category; audiences are multiple and do not behave in uniform ways. This section explores not only how audiences are courted, but also how perceptions of audiences – and authors – influence the production of the textual world, from programs themselves to the materials that promote them to the critical works that surround them.

In "More 'Moments of Television': Online Cult Television Authorship," Derek Kompare describes the extensive online presence of the television "author" as a performance of authorship. Kompare focuses on blogs, podcasts, and audio commentary tracks, and points to the ways that the use of these technologies facilitates communication and insures that discourses of authorship circulate in new media venues. Kompare argues that these discourses reveal ongoing anxieties about television's cultural status and have introduced new codes and layers of meaning between producers, texts, and viewers, and may point to a more collaborative future for television creation. Next, Jonathan Gray explores the ways in which critics help audiences to make sense of televisual texts. His chapter, "The Reviews Are In: TV Critics and the (Pre) Creation of Meaning" challenges Stuart Hall's assumptions about the chronology of interpretation and grapples with questions of where the preferred meaning comes from and who prefers it. Through close readings of multiple reviews for a variety of television programs, Gray shows how television critics serve as intermediaries between television's marketing wing and audiences. He argues for the importance of hype, synergy, and reviews to the process by which a television show becomes a text and an artifact of popular culture.

The next three chapters in this section are centrally concerned with the various strategies by which niche-oriented television attempts to speak to audiences. In "Word of Mouth on Steroids': Hailing the Millennial Fan," Louisa Ellen Stein considers the attempts by niche cable networks to develop online material that will engage audience members and build fan investment. She looks specifically at ABC Family's *Kyle XY* and its accompanying website, arguing that the site hails audience members by mirroring fan-authored texts in an effort to construct a perception of an active fan community. In "*Masters of Horror*: TV Auteurism and the Progressive Potential of a Disreputable Genre," Heather Hendershot argues that Showtime's *Masters of Horror* series can best be understood by examining its auteurist discourse and the political and economic context in which it is produced and marketed. She points out that, although "Showtime forges a profitable little niche for itself with this series," as a horror program it is not likely to achieve critical success. Nonetheless, the series and its various authors deserve to be taken seriously as they raise a number of interesting issues. Finally, John Corner's chapter, "*49 Up*: Television, 'Life-Time,'

and the Mediated Self," examines how the latest installment of Michael Apted's *Up* series contrasts to concomitant "articulations of 'ordinary' selfhood" in an era of convergent media. As Corner notes, the proliferation of reality television shows and social networking websites has transformed how the mediated self is presented to society, and he illustrates how *49 Up* diverges from contemporaneous texts in its mode of address, narrative structure, and aesthetic choices. Corner additionally investigates how and why audiences have become invested in the programs, questioning the ways that viewers are implicated in the ethics of a series in which individuals become subjects with whom audiences are asked to identify, but whose lives are routinely (every seven years) held up for scrutiny and judgment.

Although new media and television technologies are commonly lauded for offering us ever-increasing avenues for civic participation, these same representational and communication tools often obscure the institutional forces and prevailing discourses that drive their very usage and popularity. The chapters in Part III, "Technologies of Citizenship: Politics, Nationality, and Contemporary Television," investigate how nationality, politics, and national security come to bear on how we participate in public dialogues about the body politic, and question how civic participation is itself represented through these emergent technologies and channels. The section begins with a reflexive look at the development of television studies as an academic discipline. In "Television/ Televisión," Hector Amaya argues that the discipline's marginalization of Spanish-language television reproduces a dominant and conservative definition of the US nation, which imagines itself principally through Anglo-Saxon ethnic and cultural markers. This systematic discursive media segregation not only paints an incomplete picture of the television landscape as an object of business and as an object of study and commentary, but it also undermines the cultural franchise and contributions of Latinas/os in America.

The remaining chapters in this section explore how citizenship is constructed, commodified, and deployed through convergent television. Eric Freedman, in "The Limits of the Cellular Imaginary," considers how the witnessing, recording, and sharing of violence and trauma via cell phones – often dubbed as a form of citizen journalism – engender a communication milieu whereby the "person on the street" contributes to a growing visual lexicon of terror. Connecting trauma theory to visual culture studies, Freedman explores the tenets of post-traumatic integration in the digital age, the movement of personal images from localized spaces to less geographically fixed arenas (such as YouTube), and how this image migration affects contemporary discourses of media broadcasting.

James Hay and Chuck Tryon address more overtly political uses of television. Hay explores the political and technological convergences at work with

the US-backed Iraqi Media Network and its first TV channel, Al Iraqiya, in "Extreme Makeover: Iraq Edition – 'TV Freedom' and Other Experiments for 'Advancing' Liberal Government in Iraq." In particular, Hay's chapter examines the paradoxes of the US political rationality that conceived of Al Iraqiya as a solution to the problem of bringing freedom and democracy to Iraq, and how this televisual "answer" emerged from a primarily neo-conservative discourse of liberalizing and democratizing the Middle East "problem." Tryon turns to US electoral politics; in "Representing the Presidency: Viral Videos, Intertextuality, and Political Participation," he analyzes several emerging genres of viral videos produced by presidential candidates and activists during the 2008 presidential campaign. Contrary to Manichaean evaluations of these videos by political pundits as being either "good" or "bad" for a politician's candidacy, Tryon interprets them through the lens of convergence culture, arguing that these popular videos shape and are shaped by discourses of political and participatory culture.

The collection closes with L.S. Kim's account of the rise of NASCAR as not only a symptom of converging media, but also as a study of whiteness, class, and fandom. "NASCAR Nation and Television: Race-ing Whiteness" explores the relationship NASCAR loyalists have to their cultural history and identity in the midst of a changing (and admittedly newly recruited) fan base. For the author, televised racing represents a generic convergence: it is simultaneously live sports, reality television, narrowcasting on cable (the Speed Channel, ESPN) and broadcasting networks (Fox, ABC). Racing represents convergent forms, convergent cultures, and is a prime example of television as a convergent medium.

This anthology grew out of the critical community that has formed around flowtv.org since its inception in 2004. Created by graduate students at the University of Texas at Austin, and housed by its Radio–Television–Film Department, Flow intended to provide a forum for multiple communities with a shared investment in television and new media. Flow, in other words, continually has experimented with its own forms of convergence. The online journal, which has published short interactive articles on a bi-weekly basis, has brought together emerging and established scholars across multiple disciplines, undergraduate students, media professionals, media activists, and media audiences. Two Flow conferences, held in 2006 and 2008, extended the virtual space of the journal to the physical spaces of roundtable sessions where participants engaged in conversations on myriad topics, including feminism and the blogosphere, fandom and online communities, and media reform and policy. Flow was founded to create a space within which scholars could engage the medium at the speed at which it moves, while establishing relationships and conversations that would lead to further scholarly work.

In the spirit of participation and interactivity that has guided the Flow project since it formed, this collection features online materials to extend and enhance readers' engagement with each of the articles. Readers are invited to visit http://flowtv.org/anthology, which features accompanying video clips, hyperlinks, and discussion questions that build upon the chapters in this volume. The flowtv.org website is also a forum in which all readers – students, scholars, fans, citizens, authors, and audiences – are invited to participate in an ongoing conversation over the shifting contours of television and new media, where flows and convergences will continue to challenge and inform how we understand the media we produce and consume.

This collection, and its accompanying online material, offers multiple approaches to think through our contemporary media landscape. Television, as it is conceived here, is not a uniform object understood through a singular methodology, but rather a nodal point around which we can chart the movements of a shifting media culture. Together, the chapters argue that even as the boundaries of both the cultural form and the scholarly field that emerged around it grow more porous, television remains a vital site of critical analysis.

Notes

1. Raymond Williams, *Television: Technology and Cultural Forum*, 2nd edition (New York: Routledge, 2003), pp. 90–96.
2. Roger Silverstone, "Preface," in Raymond Williams, *Television: Technology and Cultural Forum*, 2nd edition (New York: Routledge, 2003), p. x.
3. Raymond Williams, *Contact: Human Communication and History* (London: Thames and Hudson, 1981), p. 227.
4. Nicholas Negroponte, *Being Digital* (New York: Vintage Books, 1996).
5. See Cass Sunstein, *Republic.Com* (Princeton: Princeton University Press, 2001).
6. See especially Lynn Spigel and Jan Olsson's collection, *Television After TV: Essays on a Medium in Transition* (Durham: Duke University Press, 2004); John Caldwell and Anna Everett's anthology, *New Media: Theories and Practices of Digitextuality* (New York: Routledge, 2003); and Dan Harries' collection, *The New Media Book* (London: British Film Institute, 2002). See also the April 2007 issue of *New Review of Film and Television Studies*, dedicated to a discussion of TVIII, edited by Glen Creeber and Matt Hills.
7. Michele Hilmes, *Hollywood & Broadcasting: From Radio to Cable* (Urbana: University of Illinois Press, 1999), p. 166.
8. Henry Jenkins, *Convergence Culture: Where Old and New Media Collide* (New York: New York University Press, 2006).
9. Carolyn Marvin, *When Old Technologies Were New: Thinking About Electronic Communication in the Late Nineteenth Century* (New York: Oxford University Press, 1990).

Part I

The convergent experience

Viewing practices across media forms

Convergent media offer scholars a wide range of material as objects of study, including inter-industrial partnerships and consortia building, technological shifts and studies of digitization and diffusion, changing modes of production, exhibition, and distribution, and transmediated narrative forms. The chapters in this section interrogate how convergent media affect the lived experiences of media users and consumers. Digital media not only have restructured media industries, distribution platforms, and textual practices, but have altered our relationships with technologies, the built environment, and one another. Platforms like YouTube, as one chapter illustrates, not only enable the formation of communities around viral videos, but also expose ruptures in viewers' interpretive practices concerning a singular media text. New media interfaces and digital video recorders (DVRs), as two chapters argue, encourage customization of our media consumption choices and of our built environment. The final two chapters examine how reality television programs present their own forms of convergence, yet simultaneously expose forms of divergence (separations, ruptures, conflicts) within their narratives and for their viewers. In sum, the chapters in this section ask us to consider how the new technologies, screens, textual practices, and consumption habits ushered in by convergent media influence common aspects of our everyday lives.

The chapters in this section also illustrate the degree to which community and cultural expression remain at the heart of contemporary media studies. Each author returns, either explicitly or implicitly, to questions surrounding how media technologies transform the construction and maintenance of community. If broadcast television had cohered a national community around a simultaneous engagement with shared texts, then what kind of communities form in response to the multiple screens, interfaces, and media platforms of our contemporary mediascape(s)? How do sites like YouTube reconfigure how communities form and how individuals enact their membership within them? In what ways do DVRs transform television's place within the domestic

sphere, and the ways that families engage – individually and collectively – with the digital televisual apparatus? How does reality television, itself a relatively new social technology, influence how audiences form relationships with each other and with the persons, objects, and industries presented on screen? Do they propel us toward convergent (sharing, empathizing, and collaborating) practices or divergent (judging, separating, and criticizing) ones? In posing these questions, this section foregrounds the impact of new technologies and media forms on communal relationships and on the private meanings we attach to and derive from the media.

The chapters in this section also posit that examinations of convergence (or divergence) culture be tied to specific contexts of media consumption. They ask questions about storytelling and genre, urban planning and architectural design, the ubiquity of digital interfaces, and fandom within specific communities in particular historical moments. Together, they remind us that we need to remain curious about just what constitutes the "cultural surround" of a reception culture. Convergence, they show, is not just a narrow technological matter of transmediated texts circulated by digital media. Instead, media convergence is part of a cultural landscape that extends from the menu design of a digital cable box to our built environment – one that poses both challenges and opportunities for our relationships with the physical spaces around us, the media texts in front of us, and the people (literally or figuratively) sitting beside us.

Media interfaces, networked media spaces, and the mass customization of everyday space

Daniel Chamberlain

In a recent commercial for the Acura TL, a young man sits in an upstairs den maneuvering his mouse around his computer screen. His surroundings suggest an easy sophistication – spare white walls, mid-century modern furnishings, an Apple iMac resting on a glass table, and an entire wall of windows looking out on a well-manicured private yard. Glancing out the window, he contemplates the car in his driveway. Registering the dichotomy between the interactive, customizable, and engaged experience he has with his computer and the seemingly static relationship with his car, the man uses his wireless mouse to drag the cursor off of his computer screen. With the all-powerful pointing device now liberated, he begins to drag and drop icons representing his digital lifestyle off of physical objects, through the upstairs window, and onto the car below. He first selects the icon for a mobile phone, magically upgrading his car to include a "bluetooth hands-free link." Next he chooses an iPod, so that his car might possess "mp3 connectivity." Rounding out "the luxuries of the modern world" are a surround-sound system and, incongruously, a golf bag. The vehicle, somehow primed for networked customization, takes on the attributes of the devices and systems selected with the mouse. The commercial ends with a voice-over suggesting the benefits of leading a mobile lifestyle in a configurable automobile as the newly modern car eases through a sylvan scene. This advertisement is clearly attempting to generate interest in its product by associating something familiar – a high-end sedan – with something new and exciting; the association with Apple computers in general and the iPod in particular is a strategy followed by the advertising and feature appointment of many car-makers in recent years.

More notable in this advertisement is the suggestion of an affinity between the configurable experience offered by emergent media technologies and the broader world of daily engagements with the objects of everyday life. The implicit argument in this spot is two-fold. First, that regular individuals – who, presumably, can afford a two-level home in a leafy suburb and a car

outfitted with the latest in media technologies – are accustomed to engaging with a host of entertainment and communications media technologies that allow for regular and compelling interaction and customization. Although this particular spot foregrounds the familiar user interface of the computer and mouse, it also references the personalization offered by the iPod and mobile phone. Beyond mere familiarity with and appreciation of the modes of inter-action offered by contemporary media technologies, the advertisement suggests that individuals accustomed to configurable media experiences expect a greater degree of responsiveness in other aspects of their lives. Crucially, the spot is not simply about the mediation of automobiles, but the idea that the material world should be more easily subject to our desires. The product on offer in this spot happens to be a car, but one could imagine an extension of this approach to a range of objects, spaces, and even other people. The man upstairs now wants point-and-click control over his entire world.

This advertisement is representative of both the cultural salience of config-urable media experiences and an associated spatial logic that extends the ideal of personalization beyond digital devices and into those parts of the material

Figure 1.1 Media interfaces on screens large and small. A customized YouTube interface on Apple's iPhone (above) and the AppleTV interface (below) (screen capture by the author).

world not strictly associated with media. This chapter will take up these themes, connecting the spatial implications of emergent media technologies to their fundamental conceptual underpinnings. My argument is not simply that new gadgets drive new uses of space. Although many determinist examples could be offered, from iPods on the subway to mobile phones on the jet-way, I instead argue that we are engaging in a more fundamental shift in which the intersections of media interfaces and pervasive communications networks are reconfiguring the private/public dialectic in favor of a new paradigm of spatiality for the network society – the networked media space. Most any space, at most any scale, has the potential to become a configurable, contingent environment produced through physical, social, and networked engagements.

In addition to highlighting the connections between emergent media technologies and networked media spaces, this chapter argues that the regular and repeated articulation of networks, interfaces, and spaces yields both material changes to everyday environments and shifting expectations as to how spaces should respond to our technologically inflected desires. Configurable media experiences have developed alongside responsive socio-spatial developments, such as flexible work environments, modular layouts of retail and residential space, and changing expectations toward ratios of living, working, and consuming. Moreover, media interfaces have analogues in spatial interfaces. These metaphorical, ideological, yet material approaches to place-making – such as neo-traditional neighborhood design, loft-style urban revitalization, and gated community proliferation – build upon the logics of control and personalization emphasized in media interfaces. Just as media interfaces enable the filtering of entertainment and communication experiences, spatial interfaces work to order other lived experiences and screen out undesirable possibilities. Ultimately, such affinities between emergent media technologies and complex spatial formations work within and help support a shift toward an economic and cultural moment based on principles of mass customization.

Variations on a theme: new media, emergent media, and convergence

In order to understand the relationship between contemporary media technologies and space, we must first be clear on terminology. As the issues at stake in the 2007 Writers Guild of America strike reminded us, the contemporary media landscape is populated by destabilizing technologies of production and reception, and battles over semantics have material consequences. Even as the guild re-capitulated in its negotiations over DVD and home video revenues, it steadfastly maintained demands for a financial stake in content produced for or distributed through "New Media." As used in these high-profile industry

negotiations, this term primarily referred to the distribution of made-for-broadcast television programs and theatrically released films through the Internet or on mobile phones, but was intentionally left vague and future-looking in order to account for permutations of platforms, technology, and programming. In industry argot, new media refers to television-like content that is not "free television, basic cable, pay TV, video disc/video cassette and radio, even if digital."[1] Lawyerly industry terminology notwithstanding, deployment of the term "new media" tends to stop critical discussions before they can get going, in no small part because, as Carolyn Marvin so memorably noted, all old media were once new.[2]

Building off Raymond Williams' description of the processes of culture, I find it more useful to think about changes in the contemporary media ecology using the terms "emergent," "dominant," and "residual."[3] Such a formulation recognizes that the experience of media has not necessarily been radically altered for all viewers in recent decades, as residual modes of viewing television exclusively via over-the-air broadcasts still apply to approximately 14 percent of US television households.[4] This approach also foregrounds the conditionality and indeterminacy of emergent modes of media engagement, which need not be celebrated simply for being new or automatically praised as liberating advancements. If the dominant mode of television consumption refers to the constellation of cable, digital cable, and digital satellite that feeds the majority of television households, I take the emergent mode to characterize both time-shifted consumption associated with watching television on digital video recorders and digital video discs as well as off-television consumption through the Internet or on mobile phones. More specifically, I use the term "emergent media technologies" to refer to those devices and services that rely on interactive engagements with microprocessors and networks. Users programming their digital video recorders, multi-touching their iPhones, or watching YouTube videos are effectively engaging information networks, media interfaces, and the programming and protocological code that describes both networks and interfaces. These fundamental conceptual properties are simultaneously functional and ideological, delineating both the apparatus and impact of emergent media.

Another popular tack for describing the current moment recognizes that the cultural importance of configurable media experiences is popularly linked with specific devices, such as Apple's iPod or the TiVo digital video recorders, and with a shift toward a media ecology operating within a broader rubric of convergence. Understood this way, specific technological gadgets bring the processing power of computers to bear on digitized media in a manner that allows users to store, organize, and access media content using customized filters, agents, and layouts. This technologically determinist approach, popular

with *Wired* magazine and countless techno-centric online venues, roughly equates digital devices with convergence and increased user control. Such an approach buys into the "black-box fallacy" critiqued by Henry Jenkins in *Convergence Culture*.[5] Whereas Jenkins forcefully argues in favor of understanding convergence as a series of discourses representing the interests of conglomerates, professional cultural producers, and engaged media users, it is worth unpacking the black boxes a bit further in order to understand how their participation in a convergent media ecology may be more symptomatic than determinative of greater economic and cultural shifts.

Recognizing that specific devices will come and go, the black boxes in question are certainly emergent media devices that can be described in terms of networks, interfaces, and code. Framed by their conceptual underpinnings rather than as branded gadgets, such devices can be productively critiqued rather than simply discarded. Such a critique begins by bringing together theorists of each concept. Manuel Castells, for example, has argued that the network usefully describes most forms of contemporary social organization, has an unevenly distributed materiality, and implies a binary logic of inclusion/exclusion that has the power to disenfranchise the disconnected.[6] Alexander Galloway has drilled further into the architectures and code needed to make the network function, suggesting that the distributed nature of networks has engendered and enabled protocol as a system of control that is material, textual, and political.[7] And William Uricchio has argued that media interfaces serve to give users a sense of control even as they actually advance a "radical displacement of control" in favor of filters and adaptive agents.[8] By engaging both the material nature and conceptual power of these elements – network, interface, and code – these critiques retain an interest in the technological functioning of emergent media technologies but insist on a more complex understanding of their social impact. For Castells and Galloway in particular, it is not simply that technological networks or computer codes cause change, but that material networks and existing protocols are instead manifestations of complex changes in social relations. Castells understands the network as a primarily social form that has instantiations of materiality. Galloway sees protocol is a mode of power, arguing "protocol is how technological control exists after decentralization."[9] The power of each rubric is precisely that the technological mode is but a moment of the changing social formation.

Accordingly, these massive shifts in technological function must be situated within and alongside significant changes in the global economic order. Beyond the vague but unmistakable interplay between technological change and the forces of globalization exists a more distinct relationship to the various business strategies that have been collectively referred to as "post-Fordist." The now-familiar and pervasive move to flatten hierarchies, outsource contract

work, employ part-time or short-term labor rather than career employees, and relocate the sites of labor has been productively characterized as operating in a regime of flexible accumulation.[10] Associated with such changes in business structure have been alterations in modes of marketing and production known as "mass customization." As opposed to mass production and distribution, companies emphasizing mass customization attempt to slightly alter their products to meet the desires of niches of individuals, or directly incorporate consumer interest and feedback to truly customize products to personal tastes. The mode of mass customization is emergent in the sense that it does not simply replace previous modes of production, but generally exists alongside more traditional methods. Flexible employment and production practices are prevalent in nearly every industry in which this mass customization takes hold, but this approach takes on new valences in digital media economies, where consumer labor is commodified right into the service being offered. Mark Andrejevic has noted that "one of the cannier strategies of mass customization is its claim that surveillance works to the advantage of consumers by allowing producers to more closely meet their wants and needs" and that this effect is heightened by the surveillant capabilities of emergent media technologies.[11] Like networks and protocol, mass customization is an integral characteristic of contemporary media industries and a phenomenon with broader social salience. Mass customization is also a productive way to think about the rise of the media interface.

Media interfaces: personalization and mass customization

The media interface is an artifact of the digital creep of all entertainment media. In the case of television, recent decades have seen printed program grids give way first to onscreen channels, then to electronic versions viewed on the Web, and now as interactive programming guides which populate locally generated screens with networked data. Such guides accompanied the introduction of smart cable and satellite boxes, the development of the stored-access features of digital video recorders and personal portable video players, and the surge in viewing programs on DVD in the past half-decade – developments which are marked by an attendant increase in the importance of intermediaries between viewers and content. These interfaces consist of both functional screens and material means of manipulating those screens – the iPod's famous form factor and haptic navigation system, for example, or a TiVo box and remote. Not everything about television is changing as a result of its technological engagement with the digital, the microprocessor, and the network over the past decade, but it is particularly striking that we increasingly find ourselves not simply watching

Figure 1.2 Media interfaces can be found on many different devices, guiding access to a variety of media. A DirecTV QuickTune interface (above) and Microsoft's Media Center (below) suggest the central role of media interfaces in the playback of television and other video content across devices (screen capture by the author).

programs, but first navigating menus, customizing layouts, and programming agents – myriad means of finding our way through the explosion of programming choices and platforms while managing the look, feel, and content of our engagement with entertainment media.

Although the purview of these media interfaces is limited to those with the means to acquire and manipulate the requisite technology and service plans, their diffusion is proceeding rapidly and decisively. While much of the published work on devices and technologies such as TiVos, iPods, and the conversion to digital broadcasting in the US emphasizes the early-adopter nature – and the attendant classed and gendered characteristics – of their enthusiasts, we are moving rapidly toward a time in which media interfaces are dominant.[12] Both Microsoft and Apple have bundled television and video management –

and attendant interfaces – directly into their most recent operating systems. Apple claims that the iTunes Store has sold more than 50 million television episodes and two million movies, and a significant portion of the 60 million iPods sold since the launch of the fifth-generation iPod have been video-capable.[13] As digital video recorders have moved from oddities to commodities provided by most major cable and satellite providers, their interface-intensive reach is now over 20 percent of US homes. Companies like Google, YouTube, Hulu, Revver, and Joost provide Web-based platforms – and distinct interfaces – for both corporate and non-corporate television distribution. As a result of these pressures and opportunities, broadcasters and other content providers have experimented with Web-based program distribution. The advent of recent technologies underscores the plural and mutable nature of the media ecology, yet media interfaces order engagements with content delivered though digital cable, satellite, over the Web, on personal media players, through DVDs, and ultimately through digital broadcast. At the same time, the broad distribution of media interfaces brings with it the establishment of new televisual and media divides based on access and competency, which become particularly compelling when mapped against strategies of flexible microcasting that are already resulting in distinct and differentiated articulations of platform and content.[14]

Effectively naturalized as part of the evolution of entertainment media, these interfaces present themselves as neutral information providers and finding aids designed to assist users confronted with an expanding array of programming choices. As a result, to the extent that they are discussed at all, they are evaluated in functional terms – on the basis of their usability or simplicity, with occasional nods toward color schemes, font choices, or sound design.[15] Instead of this type of functional and aesthetic criticism, media interfaces should be understood as privileged sites for the analysis of changing media ecologies. Through a critical lens, it is clear that these interfaces introduce new aesthetics, alter individuals' relationships to entertainment media, and bear the traces of corporate and industrial struggles. Beyond even these concerns, media interfaces foreground new ontologies of user customization, personalization, and control, challenging long-held critical conceptions of viewer engagement and spatial practice.

As our television-viewing devices become complex, digital, and networked, the promise and practice of user customization, personalization, and control are exercised at the interface, displacing liveness and flow as the primary ontologies and ideologies of contemporary entertainment. Emergent modes of television viewing are predicated less on explicit temporal sequencing and simultaneous spectatorship than on asynchronous viewer choices of what, when, and, increasingly, where to watch. As I have noted previously, this

functioning of control is both empowering and surveillant.[16] As we take advantage of the flexibility, portability, and customizability of new television technologies, we both experience the sensation of control over technology and subject ourselves to technological networks of control. This double logic holds for most any engagement with emergent media technologies, like when we record things on our digital video recorders, purchase limited-use television programming from Apple, stream video (or simply make calls) using mobile phones, or take advantage of unsecured wireless hotspots in airports, coffee shops, and city streets. As Mark Andrejevic notes of the use of interactive emergent media technologies, "entry into the digital enclosure carries with it, in most cases, the condition of surveillance."[17] In each of these examples, we decide that the value of the service or the empowerment provided by our experience at the interface is worth the tradeoff of having our actions and behaviors constantly tracked, even as our engagements with media interfaces are precisely where we make our actions trackable.

Even as such issues of control are meaningful for each individual user, sys-temically they describe an emergent television industry based on principles of mass customization. Beyond even the niche programming and narrow demo-graphics of the cable era, the emergent mode of on-demand and user-selected programming curated through media interfaces allows for configurable media experiences that are unique to each viewer at any particular moment in time. Such unique user experiences can perhaps be seen most clearly in the interface offered by Google's YouTube service, which highlights "videos being watched right now," rotating featured videos, and frequently updated "most viewed," "most discussed," and "related video" lists. And, of course, online videos can be started, stopped, and clicked away from at any point. All of these naviga-tional aids tend to increase user exposure to the most popular videos, yet they allow for responsive viewing experiences that vary from user to user. Each click gives the service more data to work with, allowing for further personali-zation. Extended across a range of media experiences – programming a digital video recorder, watching an entire season of a television program on DVD in a commercial-free marathon session, recalling favorite online videos on a port-able device – the emergent practice of engaging media interfaces to customize media experiences represents both a shift in control over programming to individual viewers and an extension of the decades-old media industry effort to further target and commodify ever-narrower consumer segments.

Networked media spaces

As the multiple, mobile, and customizable nature of media interfaces is pro-jected along the vectors of contemporary communications networks, hybrid

media spaces are created in places that were once thought of as public or private. In the history of media studies, particularly of television studies, the space most often considered with regard to questions of privacy is that of the home. Although the most panicked accounts of media and domesticity decry a loss of privacy, more nuanced historical explorations of the social and cultural impacts of media technologies have carefully emphasized the transition of the private space of the home into a blurred space that increasingly displayed characteristics both public and private. In her account of the introduction of electricity and the telephone into the space of the home, for example, Carolyn Marvin notes that new communication technologies "lessened the family's control over what was admitted within its walls" and "introduced a permeable boundary at the vital center of class and family."[18] In a similar vein, Lynn Spigel explores the introduction of the television into the post-war US suburbs. Beginning with a cultural history of home-based amusements from "Victorian America" through the early broadcast era, her account emphasizes the developing challenges to "ideological division between public and private spheres."[19] As first commercial amusements drew bourgeois Americans out of their homes and then broadcasting invited them to return, Spigel traces the manner in which "this interest in bringing the world into the home can be seen as part of a larger historical process in which the home was designed to incorporate social space."[20] From these accounts it is apparent that the actual incorporation of media technologies did not simply reduce individuals' privacy, but more substantially raised questions about the existing ideological conceptions of what it meant to think in terms of private and public space. While this may have initially meant a perceived loss of control over the policing of such boundaries, it soon meant the carefully managed opening up of certain spaces of the home in both the designs of homebuilders and the practices of residents.

In considering contemporary networked media spaces, however, we need to push our understanding of privacy questions beyond the home. Such a project involves careful negotiation between an emphasis on the material histories of portable media technologies and an engagement with the techno-social practices associated with the networks and interfaces of emergent media technologies. Lynn Spigel has moved in this direction in her accounts of the portable televisions and "privatized mobility" of the 1960s as well as the "conspicuous production" of the information age, noting patterns of mobility which nonetheless remain inscribed by familiar "logics of sexual difference and divisions of public and private space."[21] In a slightly different direction, Anna McCarthy has documented the cultural and spatial implications of televisions used in non-domestic contexts.[22] For the most part, however, these accounts do not directly consider the technological specificity of emergent media technologies, particularly how the practice of mobile media engagements are

restructured through the intersections of media interfaces and networks. Accounting for the multiplicity and ubiquity of contemporary networks and technologies means, on one hand, turning to questions of globalization and the network society, and on the other, more directly considering how contemporary media spaces exceed domestic boundaries.

A first step in developing notions of emergent media and space is to hold media historians' emphasis on blurred domestic environments in tension with the power-full communications networks described by many network theorists. Steven Graham and Simon Marvin, for example, demonstrate that the provision and maintenance of networks are subject to state, social, and systemic controls that are not generally negotiable.[23] In their accounting, communication networks are explicitly material forms that increasingly take on the qualities of civic infrastructure. In a quite different direction, Eric Alliez and Michael Feher argue, within their broader critique of crisis as a productive force for capital's hegemony, that dramatic changes in the social use of space are predicated on extensions of media into domestic environments. In making this point, they suggest that the colonization of domestic space by productive technologies is paralleled by a change in subjectivity, with laborers now blind to the erosion of privacy.[24] Instead of thinking solely about individual engagements initiated by autonomous actors leading mediated lifestyles, these critiques suggest that we must also consider the limitations which structure the networks that underwrite the freedom to choose in the first place. Crucially, we must also recast our understanding of places as not simply private or public, but as primarily mediated.

As mediated space brings together questions both familiar to and distant from media studies, it is a concept that is best engaged through a critical analysis that also considers questions of urban planning, architecture, political economy, and media infrastructures. Nick Couldry and Anna McCarthy have offered up MediaSpace, in the introduction to an edited volume of the same name, as a term that literally, in their concatenation of words, and conceptually bridges the gap between the "allied phenomenon" of Media and Space. In a chapter within the Couldry and McCarthy volume, Fiona Allon specifically addresses the possible meanings of "media space" in a study of the impact of media technologies on Bill Gates' millennial smart home. Allon productively juxtaposes both the shaping impacts of global economic changes and the more pointed interventions of networked media technologies:

> Within this regime of flexible production and flexible accumulation there are new ways of working (home-work) and new ways of living (connectivity) characterized by the dissolution of rigid boundaries, between public and private spaces, for example, but also between markets and economies,

and by an emphasis on the productive potential of speed and mobility (of information, finance capital, labor etc.) and by decentralization and movement (see Harvey 1989; Castells 1997).[25] Enabling a range of interactions between the near and the far, frequently in shared time and without dependency on spatial proximity, digital media technologies are not only playing a primary role in reconfiguring the spatial orders of social life, but are also affecting how we directly experience place and territory.... Media and communication networks effectively constitute a new matrix of spatio-temporal relations which complicates, and overlaps with, existing domains of spatial experience.[26]

Ultimately, as these networked media intersect with domestic architectural and social space, Allon concludes that "we see the rise of new modes of living organized almost entirely by the reconstitution of 'private space' as 'media space.'"[27] Although derived from an analysis of a celebrated house of the future, Allon's concept can be usefully extended to most any space that brings together communications networks and media interfaces – we might call this "networked media space."

A networked media space can be described as possessing a kind of telescoping spatiality, articulating together proximate experience, local connections, and networked global flows. The boundaries of domestic media spaces can no longer be characterized by the simple binary of private and public, because the networked nature of contemporary technologies simultaneously extends boundaries and introduces the inherent qualities of surveillance and control associated with media interfaces. It is not that private space has been obliterated, but that its boundaries are now subject to the networked vectors of the media space, ever-changing and uncertain. Networked media spaces are flexible techno-social-spatial relations that can take on different characteristics depending on which social relations and which technologies are being articulated. Different registers of private-ness and public-ness are engaged through such factors as physical propinquity, the mode of communication (broadcast, narrowcast, interpersonal communication, etc.), the variety and types of networks present, and the social practices being performed. In the domestic context, this means that a house does not have to be sentient in order to be smart. Any house subject to network flows – and a substantial number, in the US as well as globally, are subject to some form of satellite and broadcast flows, even if it is not redundantly connected through wired and wireless networks – is inscribed in networked media space.

More importantly, the concept of networked media space can be extended beyond explicitly domestic boundaries. Just as domestic and other private space becomes media space when networked, emergent portable media tech-

nologies can allow for instances of media space to be carved out of networked public spaces. Ultimately, the full assemblage of emergent entertainment and communications media technologies has the potential to articulate the private and public aspects of most any space into a networked media space, becoming instantiated whenever personalized media technologies are used to engage with a relevant network. As Anne Friedberg and Kazys Varnelis point out, our daily activities take place in a number of separate media spaces:

> We inhabit physical and virtual space in specific ways, to specific ends, employing different forms of audio, textual, and visual virtual co-presence based on the situation we find ourselves in: if I am sitting on the bus, please text me on my phone, if I am in a boring meeting at work, send me an instant message through AIM, if I am in the car, try calling me on wireless. We turn to the Internet for information when necessary or turning it off as need be.[28]

Whereas questions of privacy and public-ness have generally been considered at the level of global flows or domestic space, it is crucial that we also think at other levels to account for the specificities of regional, corporate, and community deployments of and interaction with communications infrastructures. Taking account of the multi-spatiality of networked media spaces also better addresses the real and imagined mobilities engendered by the ubiquity of network provision. Different networks allow for different levels of access and discrimination, parameters managed at scales ranging from the individual to the household to the community and beyond.

Even as networked media technologies extend and reconfigure both domestic and non-domestic spaces, media interfaces work to bridge these spaces. In these destabilized and destabilizing spaces, and across devices which offer different form factors and varying degrees of functionality and engagement, media interfaces act as a touchstone working to orient viewers by providing a familiar and often customized means of organizing and engaging entertainment media. This can be as simple as using an iPod or a laptop computer across a variety of spaces, relying on personalized access and networked content regardless of the inherent limitations of the environment. Rather than turning on the TV in a hotel room after a long flight, only to struggle to determine the available channels, navigate time-zone induced changes in schedules, or just simply figure out how to use an unfamiliar and overloaded remote, the privileged traveler can simply turn to his or her familiar interface to access a personalized database of media. It can mean watching a "webisode" on a mobile phone rather than the CNN airport channel while waiting for a delayed flight, substituting a personalized media flow for an ambient one. For participants in a

study conducted by the Entertainment Technology Center at the University of Southern California, this meant huddling with friends around small screens showing movies at the beach, or killing time in line at Disneyland by catching up on TV shows.

While certainly these emergent technologies are a product of television's various historical trajectories, these personalized viewing possibilities are more than just an update on the portable television of the 1960s, and go beyond the extension of ambient television into non-domestic spaces. Whereas McCarthy has described how the physical spaces around television sets in non-domestic contexts are often arranged or customized to highlight public screens, the demands of engaging the screens of emergent media technologies tends to divide space into semi-private bubbles.[29] Individuals using such devices effectively customize their spatial environments along with their media experiences.

The mass customization of everyday space

Ultimately, as networked media interfaces extend the logics of personalization and control into fields of media spaces, they threaten to alter viewers' expectations of and engagements with the physical nature of their surroundings, while simultaneously laying the foundation for new spatial imaginaries, including new conceptions of the relationships between space and identity. Such shifts are enabled by the ideological imperatives that attend emergent entertainment media technologies. We expect new degrees of flexibility and malleability from most of our experiences, from our automobiles to the physical nature of our surroundings.

With regard to networked media spaces, we now clearly favor environments that provide constant connectivity, in both the construction of our domestic environments and our use of shared spaces. We now expect that our mobile phones will work anywhere, and are beginning to demand the same for wireless connections to the Internet. Coffee shops, business districts, and urban developments all prominently tout the networked media spaces they offer. Corporations and municipalities have worked to meet demands for connectivity over the past decade, as they installed Internet-enabled computers in libraries, schools, and public spaces. More recent developments have found cities like San Francisco and Portland, Oregon, partnering with companies like Google and Microsoft to deploy wireless networks accessible by anyone with the means to obtain connectible devices. Of course, the uneven build-out of such ever-changing networked environments inherently exacerbates access-based digital divides and introduces troubling new geographic divides.

Beyond such basic expectations for ubiquitous connectivity, we are further learning to value customization and personalization in our physical environ-

ments. We do not simply choose where and how to live based on a determined relationship to technology, but our exposure to technological ways of thinking impacts our imagination of what manner of living is possible. If postwar suburbia can be understood as a spatial logic correlating to a broadcast media environment, then identity-affirming residential enclaves could be considered a correlate to a media system that privileges customization and microcasting. Instead of a dominant mode of spatial arrangement – like mass-produced suburbia – we now appreciate the mass customization of environments as spatially and philosophically distinct as neo-traditional communities, ex-urban developments, immigrant enclaves, and gentrified downtowns. The image of mass customized residential environments can be seen in new developments all across the country. My own research focuses on examples currently being developed in Los Angeles, a region with a long history of mediated urban spaces. In Playa Vista, for example, a new urbanist live/work/consume community being constructed near Marina del Rey, the housing options are far from cookie-cutter. Instead of the near-identical two bedroom post-war bungalows that surround the development, Playa Vista offers technologically customized houses and condominiums in a variety of architectural styles: classic craftsman, elegant 1940s West LA, French chateau, Frank Lloyd Wright-inspired, contemporary-modern, 1920s California Mediterranean, 1920s Spanish-Colonial revival, Italianate Villa, South of France-inspired loft-style, and, most noticeably, the Dramatic Art Deco-stylings of the gigantic Metro complex. In downtown Los Angeles, a decentralized network of developers has offered "soft lofts" in dozens of physically and technologically renovated buildings. This development strategy allows potential residents to select units in similar yet distinct buildings and then customize their own floor-plans and design. The developers of such projects clearly appreciate the power of the cultural imaginary surrounding digital lifestyles, as they market their projects with both the direct promise of emergent media infrastructures and the implicit promise of customizable spaces. Future research might productively interrogate both the degree to which these promises attract residents and how such technologies and spaces are ultimately put into practice.

In conclusion, I do not mean to naively suggest that our previous conceptions of domestic, private, or public spaces are necessarily annihilated by emergent media technologies, but instead that our well-considered explorations into the relationships between media and social space must be updated to account for the complexities introduced by the new mobilities and personalization afforded by communication networks and emergent technologies, and for the familiarities and changing epistemologies accompanying the diffusion of the media interface. While we might begin by specifying the technological

imperatives and spatial scales at which networked media spaces are being created, we will quickly recognize that such changes are framing a host of questions around the production and monitoring of media audiences and communities. Who has the means to engage in networked media spaces? What are the boundaries to networked media spaces and how are they marked? What happens to direct social engagement when individuals have different experiences of a space? Who ultimately has authority over networked media spaces and how is this authority exercised? Will content be filtered by network, interface, or space? Will different individuals be treated equally within a networked media space, or will networked technologies allow for new forms of discrimination and self-discrimination? The answers to these questions, and others like them, will guide our understanding of configurable media experiences and the spaces that support them. As the underlying logic in these techno-spatial changes is rooted in the individuation and implicit surveillance underwritten by the logic of mass customization, we must remain especially attentive to the manners in which their emergence is predicated upon social and economic privileges that reinforce familiar divides.

Notes

1. Writers Guild of America, *Sideletter on Literary Material Written for Programs Made for New Media*, February 12, 2008, www.wga.org/contract_07/NewMediaSideletter.pdf.
2. Carolyn Marvin, *When Old Technologies Were New: Thinking About Electric Communication in the Late Nineteenth Century* (Oxford: Oxford University Press, 1988).
3. Raymond Williams, "Base and Superstructure in Marxist Cultural Theory," *New Left Review* 82 (1973), 3–16.
4. Federal Communications Commission, *Third Periodic Review of the Commission's Rules and Policies Affecting the Conversion to Digital Television*, MB Docket No. 07–91, December 31, 2007: 16.
5. Henry Jenkins, *Convergence Culture* (New York: New York University Press, 2006), 13–16.
6. Manuel Castells, *The Rise of the Network Society* (Oxford: Blackwell Publishers, 2000).
7. Alexander Galloway, *Protocol: How Control Exists After Decentralization* (Cambridge, MA: Massachusetts Institute of Technology Press, 2004); Alexander Galloway and Eugene Thacker, *The Exploit: A Theory of Networks* (Minneapolis: University of Minnesota Press, 2007).
8. William Uricchio, "Television's Next Generation: Technology/Interface Culture/Flow," in *Television After TV*, edited by Lynn Spigel and Jan Olsson (Durham and London: Duke University Press, 2004), 175.
9. Alexander Galloway and Eugene Thacker, *The Exploit: A Theory of Networks* (Minneapolis: University of Minnesota Press, 2007), 8.
10. David Harvey, *The Condition of Postmodernity* (Malden: Blackwell, 1990).
11. Marc Andrejevic, "The Kinder, Gentler Gaze of Big Brother: Reality TV in the Era of Digital Capitalism," *New Media & Society* 4:2 (2002), 256.
12. For a discussion of gender and TiVo, see Willam Boddy, *New Media and Popular Imagination* (Oxford: Oxford University Press, 2004), 130–132.
13. Apple, "iTunes Store Tops Two Billion Songs," Apple Press Release Library (January 9, 2007), www.apple.com/pr/library/2007/01/09itunes.html; Apple, "Award-Winning MGM Film Now on the iTunes Store," Apple Press Release Library (April 11, 2007),

www.apple.com/pr/library/2007/04/11itunes.html; Apple, "Apple Reports First Quarter Results," Apple Press Release Library (January 22, 2008), www.apple.com/pr/library/2008/01/22results.html.

14. Lisa Parks, "Flexible Microcasting," in *Television After TV*, edited by Lynn Spigel and Jan Olsson (Durham and London: Duke University Press, 2004). For a discussion of interface competencies, see Max Dawson, "Fingering the 'Digital': Embodying TV Interfaces," paper presented at the Society for Cinema and Media Studies Conference, Chicago, March 8–11, 2007.

15. See, for example: Dave Zatz, "Hands on with the TiVo Series 3!" Engadget, posted September 12, 2006, www.engadget.com/2006/09/12/hands-on-with-the-tivo-series3/; Leander Kahney, "New UI Showdown: Apple vs. TiVo," Wired.com, September 13, 2006, www.wired.com/gadgets/displays/commentary/cultofmac/2006/09/71774; Matt Haughey, "The PVRBlog Interview: Ten Questions with TiVo's Director of User Experience, Margret Schmidt," PVRBlog, December 8, 2004, www.pvrblog.com/pvr/2004/12/the_pvrblog_int.html; Richard Waters, "Don't Just Leave People to Their Own Devices," *Financial Times*, June 28, 2005.

16. Daniel Chamberlain, "Everything is Under Control," *FlowTV* 6:1 (May 18, 2007), http://flowtv.org/?p=413.

17. Mark Andrejevic, *iSpy: Surveillance and Power in the Interactive Era* (Lawrence: University Press of Kansas, 2007), 2.

18. Carolyn Marvin, *When Old Technologies Were New: Thinking About Electric Communication in the Late Nineteenth Century* (Oxford: Oxford University Press, 1988), 76, 108.

19. Lynn Spigel, *Make Room for TV* (Chicago: University of Chicago Press, 1992), 11.

20. Ibid., 106.

21. Lynn Spigel, *Welcome to the Dreamhouse* (Durham: Duke University Press, 2001), 71, 91; Lynn Spigel, "Designing the Smart House," *European Journal of Cultural Studies* 8:4 (2005), 415.

22. Anna McCarthy, *Ambient Television* (Durham: Duke University Press, 2001).

23. Stephen Graham and Simon Marvin, *Splintering Urbanism* (London: Routledge, 2001), 213.

24. Eric Alliez and Michel Feher, "The Luster of Capital," trans. Alyson Waters, *Zone* 1 and 2 (1987), 316.

25. Fiona Allon, "An Ontology of Everyday Control," in *Media/Space: Place, Scale, and Culture in a Media Age*, edited by Nick Couldry and Anna McCarthy (London: Routledge, 2004), 263.

26. Ibid., 256–257.

27. Ibid., 257.

28. Kazys Varnelis and Anne Friedberg, "Place: The Networking of Space," in *Networked Publics*, edited by Kazys Varnelis (Cambridge: MIT Press, 2008), section II.

29. Michael Bull, "To Each Their Own Bubble: Mobile Spaces of Sound in the City," in *Media/Space: Place, Scale, and Culture in a Media Age*, edited by Nick Couldry and Anna McCarthy (London: Routledge, 2004).

Chapter 2

"It's just like a mini-mall"

Textuality and participatory culture on YouTube

David Gurney

For anyone with an active e-mail account, viral video has been all but inescapable since at least the beginning of 2007. Even individuals without regular Internet access are often presented with these video "memes" through reports in newspapers, magazines, and broadcast television – if not on the evening news or daily talk shows, then via commentary on such clip-based review shows as VH1's *Best Week Ever* and E's *The Soup*. Internet streaming video has become nothing if not a fertile plot for the spread and propagation of visual culture, and viral video has become the dominant category or genre description applied to its content. However, the videos that this term has come to describe are a heterogeneous mix in terms of subject, form, and meaning. They include clips that are recontextualizations of pre-existing media texts (e.g. remixed or mashed-up movie trailers, parodies of films and television programs, local television broadcasts allowed to circulate outside their intended market(s), and machinima), original and parodic novelty song videos, repurposed videos made by producers never intending such wide audiences (or any audience at all), and short actualités depicting freak accidents, adorable animals, or various other moments that would mix nicely with the content of old media stalwart *America's Funniest Home Videos*.[1]

Yet, these diverse texts are all described as part of the cultural phenomenon of viral video in that their popularity has resulted not from top-down media distribution but rather through viral circulation: the sharing of URL links, embedding on blogs and other social networking pages, and old-fashioned word-of-mouth. Perhaps the most significant, and closest to unifying, element for these transmediated texts is their reliance on humor as the hook with which to pull in new viewers, to subsequently encourage those viewers to further disseminate the content by sharing links or downloaded files with their family and friends, and sometimes even allowing viewers to take part in the formation of the text by comically modifying it and/or responding to it through direct video re-editing or versioning.

By no means is this situation completely novel, as many nascent media forms have found their beginnings in simple comic scenarios as did early cinema. From early bad boy films like *L'Arroseur arrosé* where a naughty child would play a prank on an unsuspecting elder to racist watermelon films that allowed audiences to revel in the then popularly amusing stereotyped image of blacks eating copious amounts of watermelon, comedy was a major driving force for the early cinema. Humor is almost always built upon novelty of some sort – surprising or upsetting a viewer's (or an onscreen character's) expectations. While, in the very early days, just the situation of seeing a projected moving image provided novelty, very quickly these shorts began to capitalize on more constructed humor as an engine to drive patrons to the theater.[2] Tom Gunning's formulation of early film culture as a "cinema of attractions" foregrounds the importance of such novelty, and his argument offers an interesting parallel to what is going on with viral video right now. These current clips are very much in the realm of the largely comic attractions Gunning outlines as being dominant in early cinema.[3]

The early evolution of television is another period that can help put viral video into relief. Here the work of such scholars as Lynn Spigel, Patricia Mellencamp, and George Lipsitz offers incredible insights into the ways that comedy, specifically situation comedy, in early television allowed for the negotiation of dynamics such as gender and ethnicity. Susan Murray's *Hitch Your Antenna to the Stars* takes a broader view on comedy's role by focusing on the histories of television's biggest early stars – comedians. Murray describes these figures, especially variety stars like Jackie Gleason, as "highly intertextual performer(s)."[4] Based upon her discussions of how these performers circulated transmedially, but also through different roles within a given medium, this description bears out, and though she does not linger on the point, the correlation of the comic persona and performative/commercial intertextuality and malleability is an important one. Comedy, and humor in general, is an intertextual endeavor in a very fundamental sense. Humor can only take place in a space of shared expectation – expectation which can then be subverted in such a way that incongruity arises. Yet this incongruity must still be culturally legible. The comedian thrives on intertextuality which provides a basic legibility even when it is being subverted, whereas the "dramatic" or "earnest" figure is more powerful when the textual persona can be contained. This inherent drive toward intertextuality in comedy makes it a prime vehicle for helping to establish the contours of emergent media. As such, the omnipresence of humor in viral videos should be no surprise; however, in order to ascertain better both the field's parallels and discrepancies with these moments of emergent media history, more focused analysis needs to be conducted on viral video.

Looking to the case of Sammy Stephen's Flea Market Montgomery commercial and its accompanying "Mini-Mall Rap," this chapter will explore several traits of the viral comedy clip and the framework it enters into by being hosted on YouTube. First, the status of the original text and its route of entry to YouTube will be explored. Then, the paratextual framework a clip enters when it is posted on YouTube will be analyzed. Using paratext in the sense defined by Gérard Genette, this means the cluster of accompanying elements that are found on the clip's main page, including various sorts of peripheral information with which the YouTube interface allows, or even demands, its users/viewers to interact through comments and/or video responses.[5] This will foreground the inherent multiplicity of Internet streaming video sites and their "logic of hypermediacy [which] acknowledges multiple acts of representation and makes them visible."[6]

In tracing these multiple acts, the easier access to production in the Internet video medium is important to consider. Although many other early media producers have been novices, never before has the complete amateur had such unmitigated access to the means of production and distribution. This is a bastion of convergence – with a camera phone, a webcam, a digital video recorder, a computer with cheap editing software, or various combinations thereof (and a connection to the Internet, of course), an originative text can quickly expand exponentially. The preponderance of tributes, reenactments, and remixes that closely follow viral clips attest to this and, as hypertexts, constitute a facet of the YouTube paratext.[7] As with the behavior of widely known and dedicated fan communities reworking such television and film franchises as *Star Trek* and *Star Wars*, the presumed audience manipulates the text, but unlike prior fandoms, these manipulations are not born of years of engagement with textual elements, nor do they rely upon the same kind of pre-existing like-minded communities for their dissemination. Considering these characteristics that set the spread of digital comedy apart from antecedent media, this chapter will offer a snapshot and some musings on the current state of transmediated participatory culture, as well as the issues that arise when trying to analyze such phenomena.

Humble beginnings?

A critical quandary in discussing most viral videos, particularly those with embedded levels of transmediation, is where to begin the analysis. Although most clips can be traced to a relatively discrete point of origin, their actual textuality is so radically altered upon entry into the Internet milieu that the clip itself quickly becomes only one component of a still-developing textual field. Of course, as Roland Barthes and other poststructuralists have already

made us abundantly aware, "We know now that a text is not a line of words releasing a single 'theological' meaning (the 'message' of the Author-God) but a multi-dimensional space in which a variety of writings, none of them original, blend and clash."[8] Yet, the space that a clip enters into when positioned on a video hosting site serves to both instantly expand the text and foreground the inherent multi-dimensionality or instability of the text. This condition makes discussion of a singular textual element rather complicated, to say the least. Such a huge component of a viral clip is the dimension of virality – its circulation among users/viewers and the resulting layers of text accumulated in the process. Still, for the sake of illustrating just how the textual seed is planted, tracing this particular clip forward from its germinal moments will illustrate how precarious the stability of its textuality becomes.

Initially, Sammy Stephens' commercial was intended only to be broadcast locally in Montgomery, Alabama, and the immediate vicinity. As the owner of a furniture store called Flea Market Montgomery, Stephens had been using the advertising slogan of "It's just like a mini-mall" for years prior, but in the fall of 2006, he hit upon the idea of working the slogan into a rap jingle. With a repetitive drum machine and synthesized bass line to set the rhythm and an equally repetitive but squawking keyboard accent as the harmonic bed, Stephens himself raps about the exhaustive selection of furniture and related items that can be found in his store: "Living rooms, bedrooms, dinettes, oh yeah!" This list of items is repeated twice, but by far, the most prevalent line (rapped a total of ten times in the two-minute version of the commercial) is "It's just like, it's just like a mini-mall," the very line that Stephens implores the listener to sing along with in the closing section of the song.

The utter simplicity of the song's construction makes it the perfect candidate for a catchy jingle. Rapping the lyrics, rather than singing them, also makes the content much more approachable for those who may not dare sing for fear of being off-key. Furthermore, Stephens' delivery of the rap is very measured and deliberate, much more in line with early or "old school" rap than with the rhythmic complexity often associated with contemporary hip-hop, making the lyrics both legible and reproducible. The sheer repetition of the lyrics is no doubt a major source of the humor involved, and the very act of twice repeating "It's just like" has an insistently playful quality. In addition, the message of the slogan – that the furniture store is just like a mini-mall – has a built-in quality of absurdity. Obviously meant to denote the expansiveness of the selection available, it, perhaps unwittingly, brings to mind the question of what exactly a "mini-mall" is. While some may find the term innocuous or even pleasing, for many the idea of a mini-mall is fraught with negative connotations of suburban sprawl and anti-aesthetic architecture. The presence of "Flea Market" in the name of the store reinforces this as well. In a

way, this speaks to the class demographic being advertised to, as those who turn their noses to mini-malls tend to be those who can afford to shop at higher-priced (and thus upper-middle to upper-class-defined) stores.

The commercial matches the music with shots of Stephens lip-synching the lyrics in various locations in and around his store, and various inserts of merchandise available for sale there. In fact, it is a quick series of shots that pan across particular items (a wraparound couch and a dining table) that opens the visual narrative of the TV version of the commercial. Matched to Stephens' listing of items, these shots are cut together by dissolves, with the second shot quickly dissolving into a long shot of Stephens standing in front of a tan couch in his showroom. The commercial continues with various shots including Stephens in front of a delivery truck with the store's slogan painted on it, in front of other items in the store, and ultimately, in the parking lot of the store itself. In many of the later shots he bobs and dances to the beat, and in the longer version, he even "make(s) it a dance" by ascribing the simple and repeated movement commands of, "To the left, to the right."

There is a long tradition of quirky local business owners using their own extroverted personalities in television advertisements as promotional tools, and it is likely that even the occasional television viewer would be able to name a handful of such merchants who have pitched to their publics in this way since the dawn of television. However, shortly after going into rotation in the Montgomery broadcast market, Ellen Degeneres received a copy of the commercial in response to a request for her viewers to send her their favorite local advertisements. Known for her own uninhibited dancing which has been featured in several nationally televised American Express commercials, Degeneres not only liked the commercial but also saw a kindred spirit in Stephens and invited him to appear on her show in late November 2006. Ellen lauded his work and suggested that he might help her compose a new theme song for her show – an ultimately unrealized collaboration that was proposed in a joking manner. Here we begin to see just how ambiguous the reception of the commercial becomes as the audience expands. Was Ellen making fun of Stephens or having fun with him?

Given Ellen's own penchant for putting her silliness and awkwardness on display for mass audiences, it is more likely that she was celebrating Stephens' willingness to open himself up to potential ridicule by producing a commercial and an accompanying jingle that are not terribly proficient in a technical sense. His old-school style of rapping bears little relation to the polyrhythmic rhyming that contemporary rappers wield. The quality of the visuals are reflective of a low budget, linking it more with locally produced commercials than with slick nationally broadcast ads or music videos. There is little effort to make the project appear more or different than it is, and yet, there is mirthful-

ness to the jingle that makes it stand out. Still, Ellen's partly sarcastic and unrealized suggestion of collaboration indicates a potential double-edge in the reaction of many viewers. The commercial may be intentionally funny, but that does not foreclose on the ability of a viewer to perceive a different, unintended humor, especially as the scope of the audience, and the text itself, broadens.

Entering the fray

Mere days after Stephens' appearance on *The Ellen Degeneres Show*, "Flea Market Montgomery – Long Version" was posted to YouTube, as well as various other video-sharing sites and blogs, such as BoingBoing.[9] The existence of such video-sharing sites had been generating interest in the news media due to both the novelty of laypeople providing media content and the various lawsuits that popped up as artists and corporations began to recognize that their materials were being posted without permission. Due to the user-friendly interface and the ease of posting clips and then embedding them on other webpages using automatically generated HTML markups, YouTube became the first video-sharing site to gain a truly large number of users and, as a result, the most external media attention – both negative and positive. A complaint garnering early coverage came when NBC approached YouTube in March of 2006 asking for clips from its programs, especially *Saturday Night Live*, to be removed. YouTube complied and took down the content, averting a potential lawsuit. Since then, various other interested parties, most prominently Viacom later that same year, have approached YouTube with similar complaints. Yet, in the period just prior to Stephens' commercial being posted, the news for YouTube could not have been better. Internet conglomerate Google, itself a startup only a few years before, purchased the company in exchange for $1.65 billion worth of stock. This mega-deal for a venture only 18 months old made a big splash and gave YouTube a huge boost in publicity and interest. Given this backdrop, the timing of the clip's arrival could not have been better.

While every medium has formal conditions that impact its texts, YouTube has an overtly complex matrix that is still quite approachable, as evidenced by its considerable popularity. Its framework immediately adds layers to a text when a clip is uploaded to it, regardless of the original clip-maker's (or poster's) intent. This multilayered, and largely uncontrollable, network of textuality expands the original clip in various ways. In its name alone, YouTube draws a very direct analogic relationship with television and thus signals its remediative nature, yet the space it creates for its users'/viewers' content is not simply a resketching of the televisual interface but, rather, something quite different, more overtly mediated. In this sense, YouTube, like most Internet

streaming video hosting sites, is a clear example of remediation through hyper-mediacy, as Jay David Bolter and Richard Grusin have described it.[10] Rather than seeking to hide their mediated nature, these sites make it unavoidably visible. Tracing Stephens' commercial through this network will elucidate both the workings of YouTube and the still expanding text of "Flea Market Montgomery – Long Version."

A major point of interest for this clip, or any YouTube clip, is the video window nested on the clip's page. The window is of the standard 4:3 aspect ratio that was initially established by early cinema and then transferred to television (though both these antecedent media now employ various wider formats to distinguish various texts). When one enters the "Flea Market Montgomery – Long Version" page, like any YouTube clip page, the video immediately starts playing. Over the voiceless music track, the camera slowly pans right at

Figure 2.1 YouTube video window (screen capture by the author).

a low angle across Flea Market Montgomery's showroom, past the back of a striped couch in the foreground with a sea of other couches and table lamps in the background. The dropped ceiling – complete with fluorescent lighting – features prominently in the upper region of the shot, and there is a large "Financing Available" sign hanging from it. While it might seem to be the sort of thing that many commercials would avoid, this visual information has definite use value. This type of ceiling signals that this is a lower-priced furniture outlet catering more to the working or lower-middle classes than to those who are looking for designer, antique, or custom items. Like the lyrical content considered above, the sign highlights this class-specific coding by emphasizing that even with the lower prices, there is the option to spread out the payment through financing.

A series of two, faster, right pans at lower angles avoiding any ceiling reveal another sectional couch and a clear glass dining table as the first lyrics, "Living rooms, bedrooms, dinettes, oh yeah," are rapped. The bouncing beat seems to propel the camera along in these shots, attesting to the plenitude of furniture available, but then, the commercial cuts to a static shot, still in the showroom and at a straight-on angle. This is a long shot of Stephens in front of a beige sectional couch, very close in color to his own suit. He dances back and forth with the music while lip-synching to the vocal, making it clear that he is the performer/pitchman. Also in this shot, superimposed text in the bottom left corner identifies that this is "Sammy Stephens Mini Mall Rap."

Upon announcing the name of the store in the lyrics, there is a cut to an exterior shot in the parking lot where Stephens stands next to two delivery trucks, pointing to that name and the store's slogan emblazoned on the side of

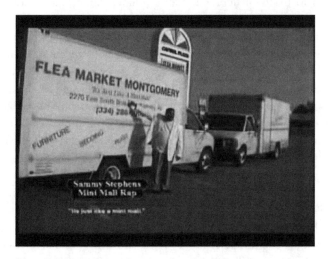

Figure 2.2 Delivery truck in a parking lot (screen capture by the author).

one of the trucks. The intentionally stuttered version of the slogan, "It's just like, it's just like a mini-mall," is rapped by Stephens at this point, subsequently becoming the most frequently repeated phrase in the entire song. Appropriately for the introduction of this sonic motif, the shot is the most dynamic of the commercial, beginning as a canted angle close-up of the truck, quickly zooming out to a much longer straight-on shot that includes Stephens and another truck, zooming in to a medium shot of Stephens during the crucial line, and eventually zooming back out and rotating to a canted angle. This fluid shot matched to the music underlines that Stephens is a fun-loving retailer, a true character in the tradition of many pitchmen throughout television (particularly local television) history.

In total, within this first 15 seconds of the "Long Version," most of the key image and sound components are put into place, including the products available, the target customer demographic, and, most importantly, the owner's quirky, affable, and entertaining personality. From here, the commercial largely repeats these elements, with Stephens taking various other positions within the store to do his lip-synching and dancing, yet repeatedly returning to his original position in front of the beige sectional. In the second half of this "Long Version," he compels users/viewers to dance. This participatory call on his part seems quite apt, especially in consideration of its nesting on YouTube.

Paratext: contested (con)text

Included as a portion of the video window is the control bar that allows a user/viewer to play, pause, restart, choose a starting point, watch the elapsed time in relation to the total duration, adjust volume, mute, and adjust the window size (one button to shrink the video – increasing image fidelity – and another to expand it to full screen – decreasing fidelity). While similar control has been widely possible with VCRs and DVD players in the recent past, these specific controls are novel in that they actually are a part of the image. Here, essentially a tenth of the video window's screen space is devoted to elements that allow the user/viewer to cater the viewing situation to their specifications.[11] Like Stephens' call to join him in a dance, the control bar calls users/ viewers to customize the experience of the clip, acting as a paratextual component that defines the textuality of a YouTube clip as something open to manipulation.

Below this control bar, in the normal view mode, there are various other options for a user/viewer to consider, including a "share" function that allows one to e-mail the URL of the clip to a friend, "favorite" and "add to playlists" functions to mark the clip for easier finding later, and a "flag" function to alert YouTube staff to any potentially inappropriate material. Below these are some

statistics on how many times the clip has been viewed (5,590,367 for "Flea Market Montgomery – Long Version" as of February 12, 2010), its average star rating as determined by users/viewers, the number of comments posted, etc.

The comments form a portion of the paratext as well, with two forms available for inspection and engagement. First, just under the statistics, are the video responses that have been posted. These are a series of thumbnails created using a screenshot from each response video. Clicked on and viewed, these form part of the hypertext that will be further considered later in this chapter. The text comments fall below the video thumbnails, offering users'/viewers' opinions, thoughts, concerns, or anything that they would like. As such, this is an interactive area of the paratext that becomes a terrain for celebration, degradation, and conflict.[12]

Here it is important to recognize the contextual assumptions that impact a video clip posted to YouTube. Given the incredible number of clips (the number approached 75 million as of February 2008) available, there is a wide range of material reflective of myriad tonal registers. However, the majority of the most popular clips are those that have a humorous element. This means that the de facto mode of the interface is comedy, and when someone is made aware of a clip – by being sent a link, hearing or reading a reference to it, etc. – the common expectation is that it is meant to cause laughter – though laughter and humor are polyvalent. As has already been mentioned, the commercial is constructed as comic, but that does not mean that the clip cannot produce laughter for users/viewers through ridicule or degradation.

Even with a seemingly pleasant and innocuous commercial like Stephens', conflict is ever-present. While the overwhelming majority of the 4,283 text comments praise the commercial, as Ellen did, for its free spirit and ingenuity, some deride it for what they perceive to be its simplicity and amateurishness.[13] However, these aesthetic discussions are far from being the most barbed; rather, what repeatedly becomes the focus is race.[14] This manifests in both small and large ways, but mostly negative when initially mentioned with responses to these comments being somewhat reparative.

Stephens is African American, and his chosen form of jingle is derived from the rap genre – one created and evolved largely by African Americans. Some comments, like user/viewer MasterGunz67's "His eyes ... are huge ...," could be meant harmlessly but, intentionally or not, recall the racist coon caricature of the bulging-eyed African American character, either signaling childlike naiveté or exaggerated cowardice in the face of danger. To be certain, Stephens does have bulging eyes, but one would hardly fit his actions into the typical attributes connoted by this feature. However, there are much more pointed comments that do nothing to hide venomous racist intent (e.g.

totse1's "it's just like a mini mall … filled with niggers"). Obviously, such users/viewers are making their own (albeit feeble) form of comedy by incorporating epithets into the largely laudatory comments window. These racist comments typically spur their own responses with other users/viewers chastising the apparent racism, others encouraging it, and some seeming not to understand it. Of course, the extent of such discussion is limited as only the most recent ten comments are typically displayed.[15] While one might choose to look back through the archived comments, the very nature of the truncated text comment window means that only the most current will impact most users'/viewers' experiences of a clip.

Still, the recurring racial debates on the "Flea Market Montgomery – Long Version" YouTube page highlight the radical ambivalence of the clip's ever-expanding textuality. While the racist comments would undoubtedly have been components of some readings for even the television-aired commercial, the ability of those comments to be incorporated into the text/paratext marks a distinct change. The cloak of relative anonymity and the potential for racial masquerading and/or exaggerated performance (i.e. most users/viewers choose screen names and personas that are often only tangentially related or else wholly unrelated to their real-life identities) makes the likelihood of such incendiary comments higher.[16] The communal nature of YouTube manifests in the quick policing of these comments, usually through responses that chastise the offending user(s) and a rapid series of more positive comments, but this recurring site of contestation is always looming on the comment window's cyclical horizon.

On the right side of the video window, there is the information box that reveals which user/viewer has posted the video, some statistics and general information (number of clips posted by the user/viewer, the date the clip was originally added, etc.), as well as a short synopsis of the clip provided by the posting user/viewer. Immediately below that is a collapsed box that, when expanded by clicking on it, shows other clips posted by the same user/viewer. In the case of "Flea Market Montgomery – Long Version," this offers very little potential for expanded viewing, as the poster (screen name "teedadawg") has few other clips posted, and none with anywhere near the same level of interest (as indicated by the number of views). For other clips, especially those posted by their actual producers, this box can be an entry point onto a body of work that is ever-changing, and as such, can be a significant paratextual portal into a matrix of textuality.

Below these poster-specific boxes is a scrolling box of "Related Videos." These are clips that YouTube finds to have search terms associated with them that are similar to the main clip's search terms. Like the "Video Responses" directly below the clip, many of these are in direct dialogue with the clip,

especially in the case of a viral clip such as "Flea Market Montgomery – Long Version." Unlike the "Video Responses," these videos may not have been properly submitted as responses, though some of the clips in the "Video Responses" can appear in this box as well. These listings are composed of screen-capture thumbnails, titles, durations, poster screen names, and the number of views for each related video. Directly beneath these are four "Promoted Videos" links that YouTube arbitrarily places on the page. These need not have any relation to the featured clip, as they are videos that YouTube is being paid to feature on the site. These clips noticeably do not have titles or views counts listed for them. It is likely that many of them are recent posts with few views or little current name recognition to garner them user/viewer interest, but their presence on the page of a clip does figure into the textual fabric.

Hypertextuality: opening a textual network

Clicking on any of the screen-capture thumbnails will take a user/viewer from the clip page to the page of the clip being clicked on. Especially for the "Video Responses" and "Related Videos," these further open the text to the user/viewer, expanding the reading of the initial clip as well as introducing novel textual elements. While there are upwards of 30 videos associated with "Flea Market Montgomery – Long Version," choosing two of them to look at more closely will give a sense of how the textual network springing forth from an initial clip can function.

One clip in the "Related Videos" box is "Flea Market Remix." With a screen-capture image that is a medium close-up of *American Idol* judge Simon Cowell grasping his chin with one hand as if in contemplation, the clip is appropriately enough a reworking of "Mini-Mall Rap" as an audition for *American Idol*. "Flea Market Remix" begins with a shot of *American Idol* judges Simon Cowell and Randy Jackson that has obviously been excised from an episode of the audition rounds of the show. Cowell asks an offscreen contestant what he will sing, and the disembodied voice of Stephens answers "Flea Market," to which Cowell unflinchingly responds, "Okay." The clip then cuts to a shot of Stephens doing an a cappella rendition of the jingle in front of a backdrop similar to one that *American Idol* hopefuls would typically have behind them.[17] After a few lines have been rapped, there is a cut to a close-up reaction shot of Cowell tilting his head and smiling as if on the verge of laughter. After cutting back to Stephens, a similar reaction shot of Jackson is shown with him hiding his face behind a piece of paper, then dropping the paper to reveal pursed lips which also appear to suppress laughter. This pattern repeats with Cowell actually looking more intrigued than amused in the second cycle and Jackson shaking his head as if in disbelief. When Stephens finishes the rap, Cowell

announces, "You don't look like a pop star, but you've got a great voice," which Jackson backs up with, "Yes, it's weird. It's wild. I say 'yes.'" The judges tell him he will be going on to Hollywood – where the next stage of the *American Idol* competition is held, and a reaction shot of Stephens opening his eyes quite wide as if in surprise or excitement is inserted as a reaction.

This parodic "remix" works on many levels. First, it is putting the raw footage of Stephens in a novel context, but one that even many transnational users/viewers will be aware of, given *American Idol*'s origins in the British *Pop Idol* program which has now been made over in at least 20 different formats reaching an even larger number of countries, addressing various degrees and confluences of celebrity and national identity.[18] The clip takes Stephens from the familiar but generally restricted local advertising format to one of the few programs that still retains truly wide and broadcast-worthy appeal. Second, it puts him in a situation where harsh judging is expected, particularly from Cowell, and upsets that expectation. Stephens' own surprised reaction underlines that. This, of course, is the primary joke of the clip. *Idol* has very little interest in rapping skills, even when they are more rhythmically advanced than Stephens', as it is a "singing" competition, but here, an exception is made. On another level, this parodic take on *Idol* emphasizes the democratized distribution that YouTube allows. While Stephens might have been confined to regional celebrity in the past (even with the boost of his appearance on *The Ellen Degeneres Show*), YouTube has given him the platform to go from local to potentially transnational talent. It is as if the egalitarian playing field of Internet streaming video has literally infected *Idol*, breaking down its gate-keeping function.

A second, more recent, clip with a different approach to the original text is "Sammy Music Video with the Smithes – Long Version." Instead of taking pre-existing footage and creating a remixed or reconfigured version of Stephens' rap, Chicago area furniture retailer Walter E. Smithe actually hired Stephens to re-record the jingle to advertise their own chain of furniture stores. Known for making humorous commercials not unlike Stephens', the three Smithe brothers are themselves businessmen with a penchant for buffoonery and clowning in their locally aired television spots. Seizing upon Stephens' Internet celebrity status, they filmed a commercial quite similar in form to the original with the addition of the three brothers appearing next to, behind, and sometimes dancing with Stephens.

With this commercial airing summer 2007 throughout the Chicago area, Stephens charts a course from local pitchman paying to air his own ads to free national exposure via a daytime talk show to viral celebrity by becoming an Internet meme and then coming full circle as a local pitchman – though in this case, paid for his efforts and promoting a store in which he has no personal finan-

cial interest. In fact, there are various other parties (Current TV, website mylivebid.com, and others) who have recruited Stephens for similar services. He has also been profiled on VH1's program devoted to Internet memes and their creators, *Webjunk*. This cycling and expansion of his celebrity is indicative of the potential impact of which YouTube-hosted content is increasingly capable.

"Flea Market Montgomery – Long Version" and its textual network indicate some of the best and the worst of what viral video is. While many clips garner little or no attention, those that do seem to be generating wider and broader interest apart from just their original form. Naturally craving something light and humorous (albeit humor that can cut various ways) in an ever-expanding web of knowledge, viral comedy may well be a necessary pressure release in the digital era. Although YouTube may be the ne plus ultra of media ephemerality in that clips can be removed by posters as quickly as they are uploaded, Stephens' clip has persevered and maintained a level of popularity for now well over a year. The commercial and its mastermind have even found ways to flow back into television (and then again to the Internet) through various collaborations. While YouTube may not last forever, the participatory video culture exemplified by "Flea Market Montgomery – Long Version" is resilient and malleable – open to new forms. The question is not whether viral clips will endure, but rather, how their open and participatory nature will impact their forms in the future.

For scholars interested in such questions, the textual field of the YouTube clip represents a fascinating object of interest that may never be satisfyingly fixed. As you read this, the text of the "Flea Market Montgomery – Long Version" page (including both its paratextual and hypertextual elements) has shifted in some way – expanding or perhaps even disappearing entirely from the site. The openness of the text is both a blessing and a curse. The ability of other users/viewers to add to or critique the initial clip in an inexhaustible number of ways can lead to parodic glory (an *American Idol* seal of approval), derogatory drivel (racist text comments), or many other registers around and between. The inquisitive media scholar must look upon this as an opportunity to reapproach the concept of what being a "text" hosted on the Internet means. Debates around representation and context that were once the exclusive domain of the critic are now functional and adaptable components of the text – a new form of text that offers no easy beginnings or endings.

Notes

1. Some specific examples are the offhanded moments of the serendipitous camera-phone-shot "The Bus Uncle" and the mistake-laden local sportscast "Boom Goes the Dynamite." More premeditated clips include Tay Zonday's "Chocolate Rain" and the remix of the mistranslated "All Your Base Are Belong to Us." "The Bus Uncle" is a 2006 Cantonese video clip of

one bus passenger berating another for a perceived affront, which has been popular both in Hong Kong and outside through subtitling in Mandarin and English. "Boom Goes the Dynamite" is the popular title given to a 2005 clip of then Ball State University freshman Brian Collins fumbling through a sports report on a student-run newscast. Musician Tay Zonday nee Adam Nyerere Bahner composed, performed, and directed the video for his 2007 song, "Chocolate Rain," which he uploaded to YouTube as his primary means of distribution. "All Your Base Are Belong to Us" is a creative video remix of a poorly translated (Japanese to English) video game that began circulating in early 2001. All these clips can be found (as of February 2010) by searching for their titles on YouTube.

2. For more on the evolution of novelty in early cinema, see Charles Musser, *The Emergence of Cinema: The American Screen to 1907* (Berkeley: University of California Press, 1994).

3. Tom Gunning, "The Cinema of Attractions: Early Film, its Spectator and the Avant-Garde," in *Early Cinema: Space, Frame, Narrative*, ed. Thomas Elsaesser and Adam Barker (London: BFI, 1990).

4. Susan Murray, *Hitch Your Antenna to the Stars: Early Television and Broadcast Stardom* (New York: Routledge, 2005), p. x.

5. For a full description of paratext, see Gérard Genette, *Paratexts: Thresholds of Interpretation* (Cambridge and New York: Cambridge University Press, 1997). Genette later delimited his formal typology in Gérard Genette, *Palimpsests: Literature in the Second Degree* (Lincoln: University of Nebraska Press, 1997) and thus refined his usage of "paratext." Both his original formulation and the latter are coherent with the usage in this project.

6. J. David Bolter and Richard A. Grusin, *Remediation: Understanding New Media* (Cambridge, MA: MIT Press, 1999), 33–34.

7. While "hypertext" has now entered colloquial lexicon, more on its original formulation can be found in Theodor Holm Nelson, *Literary Machines: The Report on, and of, Project Xanadu Concerning Word Processing, Electronic Publishing, Hypertext, Thinkertoys, Tomorrow's Intellectual Revolution, and Certain Other Topics Including Knowledge, Education and Freedom*, ed. 90.1. (Sausalito: Mindful Press, 1990). It is important to note that Genette also uses "hypertext" in his formal typology in *Palimpsests* to denote texts that use an originary or target text (or "hypotext") as a model. Many response videos would fit this category, while others would not. As such, it is not my intention to mobilize "hypertext" in the Genettian mold, though its resonance with my usage may be useful in understanding the complexities inherent in the attempt to delimit the term.

8. Roland Barthes, "The Death of the Author," in *Image, Music, Text* (New York: Hill and Wang, 1988), 146.

9. "Flea Market Montgomery – Long Version" is the extended (roughly two minutes long) version of the 30-second broadcast spot. The extended length allows for further development of the jingle and more shots of the store than in the shorter version. Of the two versions, it is the one that has received the most attention on YouTube. As of February 2010, its URL is www.youtube.com/watch?v=FJ3oHpup-pk. All the elements of the page discussed below can be found there.

10. Bolter and Grusin, *Remediation: Understanding New Media*. Their discussion of hypermediacy as one of the two logics available to a given medium (the other being immediacy, which connotes transparency) is helpful in understanding the operative modes of new media.

11. Although the ability to expand the screen does dislocate many of the paratextual elements being discussed, the expanded video screen does display options for other related videos once the initial clip ends. Additionally, in the beginning of 2008, a "warp" view button has been added to the expanded screen. Located next to the play button, it instantly brings up a series of circles with screenshots of related videos positioned erratically around a circular screenshot of the clip that has been expanded. The destabilization of viewing space created by this function deserves further consideration beyond the scope of this chapter.

12. Text comments, as well as video responses, can be controlled by the user/viewer who originally posted the clip, giving them some measure of authorial control over this compon-

ent. In practice, however, this control is rarely exercised, as evidenced by the array of derogatory remarks that remain for this and many other clips.

13. 12,491 was the number of comments as of February 12, 2010.

14. Part of the iterative cyclicality of the text comments is a function of the comment window only showing the ten comments at a time. When a user/viewer goes to a clip, the initial series of comments on display are the most recent ten. This reduces the collective short-term memory of the text comments, where similar comments appear day after day with new users/viewers not aware of the entirety of what has been said before their arrival at the page.

15. Users/viewers do have the ability to toggle the comments window into displaying a larger number of comments, but the most recent ten is the default mode upon initial visit to the page.

16. For more insight into the dynamics of race and ethnicity online, see Lisa Nakamura, *Cyber-types: Race, Ethnicity, and Identity on the Internet* (New York: Routledge, 2002). In particular, chapter 2 deals with identity tourism on the Internet – a pertinent lens through which to consider such comment field exchanges.

17. Shortly after "Flea Market Montgomery – Long Version" was posted on YouTube, *The Montgomery Advertiser*, a local newspaper for the area, hosted an online contest to remix the commercial, posting footage of Stephens rapping a capella against a blue screen for the contestants to use in their efforts.

18. Much critical work is being done on the status of the *Idol* phenomenon as both transnational and nation-specific. Some insightful comments, particularly on the latter aspect, can be found in Sharon Shahaf, "'Israeli Idol' Goes to War: The Globalization of Television Studies," *Flow* 4, 10 (2006).

TiVoing childhood

Time-shifting a generation's concept of television

Jason Mittell

Two transformative additions to my life are oddly linked: the birth of our first child, and the purchase of our first TiVo. Both occurred in the winter of 2001, and while the former was clearly the more meaningful milestone, my understanding of TiVo is bound up with thoughts about parenting and childhood. My relationship with my daughter is clearly emotionally deeper and more robust than my relationship with my TiVo – although I do love them both dearly – but thinking about the intersections of parenting and DVRs yields some connections that might improve our understanding of how media technologies matter.

To explore these connections between TiVo and childhood, this chapter indulges in acts of self-absorption that play into the stereotype of both parents and TiVo-owners – that we can't talk about anything else! Such personal reflections are fairly uncommon in media studies, and certainly I don't assume that my experiences are in any way typical or normative of all television households, TiVo owners, or parents. But by looking in the autoethnographic familial mirror, I can mine a depth of knowledge about the practices of everyday life and the way children experience media over a long period of time that are otherwise inaccessible in other families. Bringing these experiences to the surface can hopefully draw some connections and insights that resonate with other people's experiences and point to the ways technologies matter in the mundane.[1]

Media technologies are shaped by the intersection of technological, institutional, and cultural forces, emerging with unpredictable uses and social impacts. It's hard to imagine a better way of witnessing how new technologies are culturally consumed and shape our perception than watching a child learn how to use them. By examining how these technological shifts are experienced at the micro-level of the individual family, we can reorient discussions of media convergence away from the broad level of industrial strategies, policy battles, and generalized medium environments, focusing on how television technologies are experienced as part of everyday life.

In terms of the micro-management of the mundane, infants and DVRs both encourage you to restructure your time. When a newborn enters your life, one of the first lessons to learn is that your time is no longer your own – you must yield your daily routine to the whims of someone much smaller than you, but with remarkable powers of persuasion. Parenting an infant helps reveal how much of the flexibility of your everyday life you take for granted, and how challenging it is to mold your time to fit external forces that seem arbitrary when compared to the demands of a howling baby. TiVo similarly reveals the underlying assumptions that structure your time, as we children of twentieth-century America have accepted the now-arbitrary notion that a par-ticular program is only available to be watched at a given time. If infants force you to abandon the flexibility of adult living, DVRs allow you to regain some control from the constraints of the network schedulers, a tradeoff that is by no means even, but provides a little solace.

For new parents who are adjusting to life with an infant but hoping to main-tain some routine of television viewing, the power of a DVR is quite apparent – although surprisingly, I haven't seen a marketing campaign targeting TiVo directly to the lucrative niche of young parents. A baby's schedule is far less regimented and predicable than the networks', so most new parents are forced to sacrifice their dedication to their favorite shows for the immediate demands of a newborn. There is still plenty of time to watch television, as late-night nursing sessions and hours of baby-rocking welcome the company of a glowing screen, but being able to consistently choose these times without interruption becomes a rare luxury. Having a time-shifted menu of your favorite shows awaiting your attention is a parental pacifier.

The importance of DVRs grows as children age and become television viewers themselves. We use the TiVo as a self-replenishing library of children's programming, keeping a steady stream of new episodes of *The Backyardigans*, *Thomas the Tank Engine*, and *Blue's Clues* on demand. Now that we have three chil-dren, we have also adopted another TiVo, allowing one to service exclusively the kids' televisual tastes. Television's best uses, both as a child-development tool and parenting aid, shine through when you can control both what they watch and when they watch it, not having to choose between a program or a schedule – while it may be easier to force a pre-schooler to follow the whims of the television schedule than a newborn, it is still far from ideal. My personal buzzwords for children watching television are "moderation" and "age-appropriate," goals well-served by the control offered by a DVR. Add the ability to fast-forward through commercials, and it's hard for me to imagine raising kids without a DVR (assuming you don't fall prey to the "TV-Free" propaganda).[2]

The parallel shifts in family time-management triggered by parenting and technological changes are important intersections of TiVo and childhood, but

the experiences of children growing up in a DVR household suggest some deeper and more central changes in how we study technologies at the broader level of a medium. Most studies of shifting media technologies follow a version of media ecology, viewing a medium as part of a social system that structures relationships, perceptions, and morality.[3] Whether such technologies are seen as wholly deterministic of their social effects, or are more mutually dependent as part of institutional and cultural forces, such studies tend to treat a medium ontologically, possessing certain features and biases that mold social experiences. As Yochai Benkler sums up, "technology creates feasibility spaces for social practice," and thus any significant technological shift is likely to alter what people do with a medium.[4]

Another way of studying a medium is from a more epistemological perspective, exploring how people think about a given technology and how those frameworks shape social practice. Scholars have charted the history of discursive frameworks surrounding a medium's introduction, such as Lynn Spigel's essential work on early television.[5] But we can merge the ontological and epistemological to target our focus on a medium's relevance to the level of individual experience, exploring how our use of technology frames our perspectives on its meanings and uses – not because the technology determines these definitions, but through the social practices of using a medium and its technological apparatuses, both the "feasibility space" and "cognitive framework" fostered by technology and its uses. Childhood is a crucial moment in forging epistemologies of media, as the norms, limits, and possibilities of a medium that children view as typical of a technology have long-term persistence – while my own experiences with television have been varied and vast over the years, at a base level I still consider television's essence as defined by my memories as a child of the 1970s, defined by the network model and its associated norms of advertising, scheduling, flow, and technological tools and limitations.

My own children are growing up in a vastly different television era than I did, and thus a contrast between our childish notions about television highlights how the medium has shifted both ontologically and epistemologically. While I had six available channels to choose from, my children have more than 100. Children's television in the 1970s was segmented and isolated in scheduling blocks on late-afternoons and especially Saturday mornings, creating an entire genre label of Saturday morning cartoons that resonates across a generation. Today, genres are rarely schedule-driven, but tied to channels – my kids know the distinctions between Nick Jr., PBS Kids, and Noggin, but have no clue as to the distinctions between broadcast networks or scheduling blocks.

The interfaces by which we access television have similarly transformed. My formative television had no remote, and channels still needed to be "tuned

in" via antennas and dials, with an important distinction between sharp VHF and fuzzy UHF – none of these concepts or practices mean anything to my kids. For them, the television itself is something you never need to touch directly, with a remote to control all necessary functions. The effect of a little button like Mute is profound – my oldest daughter has known to mute commercials from as young as age three, often wandering into the room to mute ads while I'm distractedly watching sports. For kids who have never known television without remotes, the medium is inherently a more interactive and controllable technology, enabled by the "feasibility spaces" for engagement offered by such devices.

Thus nearly all children growing up with television today have a remarkably different understanding of the medium than my generation did, with the industrial and technological norms setting different possibilities and expectations for what television can and should do. But a DVR transforms the possible practices and default engagement offered by television even further, changing how children conceptualize the basic act of watching television. Virtually all of my children's experiences with television have been via a DVR, and thus their entire frame of reference on the medium is shaped by a technology that is still on the fringes of American media – DVRs are only in approximately 20 percent of television households as of the end of 2007, and some reports suggest that a good portion of DVR households don't even know that they have one embedded within their cable or satellite boxes. But to my kids, watching TV means watching TiVo.

When my children ask, "What shows are on?", they are not referring to the TV schedule – rather they mean what's on the TiVo's menu. For them, the transmission of television via a simultaneous schedule is an entirely foreign concept, even though this has been one of the defining elements of television as a medium for decades. They understand that sometimes certain shows aren't available, but it's not tied to a concept of how these programs get transmitted and recorded onto the TiVo. Navigating the television schedule is a task for Daddy to deal with, fielding the requests for which shows they wish to have on tap for their daily viewing allowances.

When my oldest was younger and we only had one shared television and DVR, she expressed understandable confusion when faced with the "normal" way to watch TV. If I wanted to watch a football or baseball game in conflict with the normal "time for shows!" in our house – between 5:00 and 6:00 pm, giving tired parents a chance to cook dinner and chat in relative peace – she didn't understand why the timeliness of the game granted it precedence over her menu of programs. For children in a TiVo household, all television is part of an ever-changing menu of programming to be accessed at our convenience, not a steady stream of broadcasting to be tapped into at someone else's

convenience. (Of course, they also think of television as something that grown-ups study, teach, and write books about, so they are clearly not representative of most children.)

For the preschoolers in my house, the programs all air without embedded commercials, another shift from a previous generation – while only PBS was a commercial-free option in the 1970s, today Nick Jr., Noggin, and Disney all offer programs without commercial interruption, with ads airing only between shows, if at all. As my oldest started watching shows for an older audience, she has learned how to fast-forward through ads as effectively as a veteran DVR user. When I was a kid, ads were often as much of a draw as the programs themselves, looking for the latest toy or cereal to plead for. For my kids, commercials have always been seen as an obstacle to overcome, enabled by TiVo to be swept away with a push of a button.

They also have little concept of channels – if programming is part of a personal menu, what does it matter if it came from Nickelodeon or Disney? As they've grown, they have become more aware of channel branding, watching the promotions for other shows on the channel that run during closing credits. But this awareness of channels does not extend to how they watch – when they see a promo for a special episode of *Wonder Pets* or the debut of a new show like *Ni Hao, Kai-Lan*, they simply request that I program the TiVo to record it at a future date. "Appointment television" becomes something to add to a To Do List, not something to schedule your day around.

While my children are mostly unaware of channels and schedules, they do care a great deal about episode titles, an aspect of programming I don't think I was even aware of until well into my twenties – since TiVo offers a title and description of each show it records, they regularly preview what a show will be about before watching it, and judge whether it's new or an old favorite. Or sometimes they'll reflect on the vintage of the episode, whether it's a Steve or Joe *Blue's Clues*, a *Dora the Explorer* with or without Diego. Clearly this is a different mode of consumption than my memories of flipping on the TV to see what cartoons were on, if any.

The way my children understand television suggests a cognitive shift in how the medium is conceived. For my generation, television equaled its scheduled flow, complete with ad breaks, programming blocks, and a knowledge that other kids were watching the same cartoons at the same time, ready to discuss around the water fountain at school the next day. If the *flow* metaphor defined television (and television studies) in previous decades, my children experience the medium within the framework of *files*, digital objects to be accessed in menus and manipulated via an interface. My oldest daughter uses the TiVo remote, a computer mouse, and now the Wiimote intuitively, understanding the similarity between the varied user interfaces on their respective screens.

Clicking, scrolling, pointing, and navigating are practices that transfer across platforms, experiencing media convergence at an intuitive level for children in a high-tech household.

The shifting interfaces of television are certainly part of a broader industrial strategy, with the television industry migrating toward a publishing model over the broadcast paradigm.[6] For us children of the broadcast era, these shifts can cause cognitive dissonance – I have friends who use DVRs regularly to avoid ads, but won't rely on Season Passes for a series, as they are tied to watching a show on its designated night. But for children of the DVR era, the whole idea of watching programming based on a particular time or channel seems arbitrary and artificial. If television programs are seen as files that you store on a TiVo, there is no rationale for watching a show any time besides when it fits into your own schedule and taste. DVRs reveal the arbitrariness of the television schedule and flow model, but that system still feels natural for those of us who have accepted it as the default for decades.

Much has been made about the perceived passivity of the act of television viewing. Many critics have condemned television for being a "lie back" medium, fitting the stereotype of couch potatoes allowing the flow of a schedule to wash over them and falling prey to the schemes of network programmers and advertisers. Computers tend to be seen as "lean forward" media, requiring active participation, choices, and interactivity at all times. Migrating a computer interface onto a television screen via TiVo creates some metaphoric challenges – do we lean forward to choose what program we'll lie back with? Or does the potential to always engage the interface make the act of viewing inherently more active?

Based on the behavior of my children, who have never known television as a lie back medium, they regard watching television as an activity always available for interactivity. My oldest daughter, who drives the remote for the children's television, is quick to pause when a screaming toddler or barking dog interrupts a program, willing to rewind to catch any missed moments, and liable to abandon programs midway through if they fail to please their audience. As with most sibling relationships, age structures all hierarchies, as my younger children follow the oldest's lead when it comes to how to watch television and interact with TiVo's interface – as my middle child learns to use the remote, she models her behavior after what the oldest has done for years.

Their expectations are more profound when confronted with televisions without DVRs – at their grandmother's house, they simply refuse to watch live TV without the control to pause and choose via TiVo, choosing DVDs from the library as a pale substitute for the menu of options available on the home TiVo. Interestingly, my DVR-savvy children much prefer the balance between newness and familiarity offered by episodic television, as well as the

ease of use of TiVoed programs, versus the more common preference for movies on DVD that many of their friends embrace.

Likewise, other families from non-DVR households of similar educational backgrounds and cultural values have a distinctly different attitude toward television. In such families within similar *habituses*, the pre-recorded video reigns supreme, with the DVD and VHS shelves serving as a bulwark against common television and its hyper-commercialized imperatives, with many families even claiming that they do not "have television," just a screen for playing videos. But via the DVR, my kids see television as a much richer source of a range of options than the local video shelves or even Netflix – we can choose the shows and movies we want to watch at our convenience without any of the hassle of the material objects to load and acquire, making active decisions to choose programming wisely and avoid commercialism via the fast-forward button.

Occasionally we have family meetings to discuss revamping TiVo's Season Passes for their daily diet of TV. Media literacy proponents talk about making media consumption a conscious and active process – what could be more active than preschoolers discussing whether they'd rather be watching *Bob the Builder* or *Between the Lions*? Even if they're not the offspring of a media scholar, children in a TiVo household are encouraged to think about what they're watching and make active choices about their televisual taste and experiences in a way previous generations did not, when network programmers decided what you might watch when.

The absence of scheduling as a significant structuring element will leave some experiential gaps in my children's televisual growth. As a kid, Saturday morning was an oasis of children-only pleasures, with wall-to-wall cartoons and sugared cereal ads that licensed laziness both for kids and their snoozing parents. Most networks have abandoned this strategy in recent years, but it's hard to imagine children in a TiVo household embracing such a ritual when cartoons lose their scarcity and may be accessed on demand. Likewise, for me a snow day or being sick meant mornings lying on the couch watching a parade of game shows and soap operas, since nothing else worth watching was on. But when the TiVo is full of age-appropriate favorites, game shows and soaps quickly lose their appeal – snow and sick days for my kids means a parade of stored up episodes, or perhaps a movie recorded from HBO or the Disney Channel.

These gaps are clearly no great loss – I'd rather my kids watch things more appropriate to their ages and interests than just what happens to be on. But it's easy when thinking about new technologies to focus on either their industrial impacts and strategies, or utopian potentials as part of a digitally converged future. These are certainly important, but we should also consider technology's impact on the everyday lives of its users, and on the way technologies shape the way we think about those mundane, commonplace practices.

Considering TiVo in terms of how it impacts our assumptions about television as a medium forces us to question what it means to grow up in an era in which there are multiple coexisting paradigms for what television is and how it is used, exploring how kids understand each others' experiences in a DVR versus conventional household. When my daughters have friends over and the topic of television comes up, there is often confusion when we give our guests the choice of dozens of programs to watch, regardless of the time of day – but the confusion is short-lived, as kids quickly accept the concept of files over flow, and later complain to their own parents about the limitations of only watching per an external schedule.

Television is a far more plural medium than it has ever been, not only in choices of channels and genres, but also in the wide range of interfaces available to engage with the medium. If we want to truly understand how television is consumed and understood in today's world, we need to pluralize the medium, considering how it is used on a range of screens, through an array of interfaces, and placed within a diverse set of cultural rubrics. This is clearly happening within the industry, as networks and channels scramble to reconceive their business models and standard practices in the face of the downloadable, streaming, video-on-demand convergent era. Our conceptions of television as a cultural force and form must similarly be rethought, down to the micro-level of our family's practices and choices.

I am writing this chapter during the 2008 TV Turn-Off Week, as blogs and newspapers run features touting the benefits of cutting off our primary medium for a week, and my daughter's second-grade teacher challenged the class to abstain from watching the medium. But what exactly are they advocating turning off? Protectionist, abstinence-only stances against television assume a singular model of the medium – advertising-supported, network-scheduled, passively consumed, indiscriminately used. That is not what our family's television looks like at all, and such assumptions would make no sense to my kids anymore than arguing that we should go a week without reading or listening to music. But I take solace in knowing that even if we did join the crowd by turning off our televisions for a week, at least our TiVos would ensure that we didn't miss anything.

Notes

This chapter is an expansion and reworking of a 2006 column originally published in *Flow* 3:12, "TiVoing Childhood." Thanks to *Flow*'s readers for their productive feedback to help refine these ideas.

1. For another instructive example of familial autoethnography, see Julian Sefton-Green, "Initiation Rites: A Small Boy in a Poké-World," in *Pikachu's Global Adventure: The Rise and Fall of Pokémon* (Durham: Duke University Press, 2004), 141–164. For discussions of autoethnography as a research model, see the special issue of *Journal of Contemporary Ethnography*, 35, 4 (August 1, 2006).

2. For my critique of the TV-Free discourse, see Jason Mittell, "The Cultural Power of an Anti-Television Metaphor: Questioning the 'Plug-In Drug' and a TV-Free America," *Television and New Media*, 1, 2 (2000), 215–238.
3. See the work of Neil Postman and Joshua Meyrowitz, for instance, both of whom follow from Marshall McLuhan's influence.
4. Yochai Benkler, *The Wealth of Networks: How Social Production Transforms Markets and Freedom* (New Haven: Yale University Press, 2006), 31.
5. Lynn Spigel, *Make Room for TV: Television and the Family Ideal in Postwar America* (Chicago: University of Chicago Press, 1992).
6. See Derek Kompare, "Publishing Flow: DVD Box Sets and the Reconception of Television," *Television and New Media*, 7, 4 (2006), 335–360, for a compelling analysis of this shift regarding DVD box sets.

Affective convergence in reality television

A case study in divergence culture

Jack Bratich

In late 2007, the *Dr. Phil* show ran a series of episodes called "House of Judgment." Six guests were taken from the talk show stage and asked to live together in a house. These were "judgmental" people: self-identified bitches, elitists, religious fundamentalists, misogynists, and misanthropists. The programmatic goals were to correct self-selecting communities for their increasing separation (even separatism). Their divergent tendencies were defined as a problem, and the programmatic convergence of the subjects into living arrangements was designed to adjust these drives.

Dr. Phil's microcosmic experiment could be seen as an example of what Pierre Levy calls an "apprenticeship in civility."[1] Television is filled with examples of experiments in collective decision-making and community building. From apocalypse dramas (*Heroes*, *Jericho*) to survival scenarios (*Lost*, *Survivor*), we are witnessing various programmatic attempts at an apprenticeship in being-together, even in building civilization (*Kid Nation*).

This chapter will survey some recent examples, drawn primarily from reality television (RTV), of these experiments in collectivity. I evaluate RTV in light of recent notions of collective intelligence and convergence culture, arguing that RTV is a site for the management of cultural convergence as well as divergence. I analyze how RTV functions as a series of devices or programs that contribute to the shaping of selves, a process I refer to as "affective convergence," or convergence of subjectivities. I argue that a series of dividing practices (e.g. judgments, commands, humorous insults, and volatile chemistry) prevail in these experiments in collectivity. Being-together produces a collectivity of divergences. Finally, I contend that, while US culture is filled with these separations, affectivity cannot ultimately be controlled by the dividing mechanisms, and that these divergences can produce a backfiring in which subjects can separate from the techniques that experiment on them.

Subjectivity in an age of convergence culture

The recent academic and public discourse on convergence and collective intelligence (most well-known in the work of Henry Jenkins) shapes the conceptual focus of this chapter. Jenkins counters the technological determinism of media convergence discussions by highlighting its cultural component. As Jenkins argues, convergence is not just a technological process, but takes place "within the brains of individual consumers and through their social interactions with others."[2] Jenkins draws on Pierre Levy's work on collective intelligence to inform his insights: that recent developments in socio-technical networks have created new modes of problem-solving and new conditions for innovation, and even the rise of a new public sphere.

Borrowing from Lisa Gitelman, Jenkins notes that the convergence of devices is accompanied and shaped by a convergence of their protocols (sociocultural rules and skills). But what comprises these protocols? Interestingly, Jenkins calls it a convergence of brains. Rather than calling it "mind," Jenkins draws on recent work in cognitive studies (especially on intelligence) to highlight brain activity. In other words, key to understanding the cultural protocols of collective intelligence are the processes of subjectivation which constitute social relationships.

Subjectivation here refers to the practices by which selves are made up, or the processes by which individuals come to constitute themselves via a series of techniques, texts, and interactions. What are the types of selves being forged in an age of collective intelligence? According to Pierre Levy, we are in the "apprenticeship phase" of transitioning to a new media paradigm. In this phase "cooperative apprenticeship and reconstruction of the social bond" are central to new political projects and to the species-types needed for this reinvention of civilization.[3] Jenkins echoes this, noting that we learn through pop culture to pick up and hone skills that have broader implications for political processes, social interactions, education, and work.

One way to understand subject-formation is through the recent theoretical work on affect and affectivity. Social theorists have claimed that we are in the midst of an "affective turn."[4] While sharing some characteristics with emotions, affect accentuates the *relational* nature of these states of being. It includes anxiety, insecurity, fear, joy – passions not usually associated with emotions. Affect refers more broadly to a capacity, the power to act (encapsulated in the verb forms *to affect* and *to be affected*). It is also, as Teresa Brennan defines it, a feeling that accompanies an evaluation, the projection or introjection of a judgment.[5] Affective *labor*, according to Michael Hardt, involves the power to produce community and social relationships at the moment commodities are also produced.[6] Affect refers both to subpersonal capacities (stimulations,

impulses, reactions) and to interpersonal capacities (social relations, enhancement or diminution of others' powers). Many affects comprise a subject, while many subjects can produce an affect (e.g. collective bullying tactics or the collective sentiment of panic).[7] In this chapter, affectivity is the crucial material that RTV works on in its experiments in collectivity.

In addition to proposing a different kind of convergence, we can also investigate divergence. When Jenkins speaks of divergence, he relegates it to the pluralism of the "diversification of media channels and delivery mechanisms."[8] He does not extend divergence to the same domains as convergence. What would it mean to talk about divergence in brains and in social interactions? This chapter is designed to grant the same complexity to divergence that Jenkins gives convergence.[9]

As other media theorists note, we need to examine the contexts of repression, exploitation, and control for convergence culture.[10] To this I would add that the cultural production of subjects as *affective convergence* also significantly shapes convergence culture. Reality television provides us with the most salient cultural examples of how affective convergence is composed, controlled, and conducted. This chapter focuses primarily on the programmatic *code*, the protocols within RTV programs, especially insofar as they create convergences and divergences,[11] in other words as experiments in *affectivity*.[12]

Collective apprenticeship: training and labor

Reality television can be seen as a series of experiments that takes the social bond as a target of "engineering."[13] RTV's collective intelligence training, however, is highly selective. First, RTV reflects and encourages activities that mimic contemporary labor forms (or what Italian social theorists call "General Intellect").[14] Emphasis on team-based projects, flexible responses to new challenges, quick turnarounds, and transferable skills can be found in most reality competition programs (*Apprentice, Big Brother, America's Next Top Model, Survivor, Groomer Has It, Shear Genius, Amazing Race, Project Runway, Top Chef, Hell's Kitchen*). The persistent shuffling of teams and partners keeps contestants on their toes, but also develops the skills found in much of the workforce. Programs thus act as cultural extensions of the "social factory," in which the pooling of labor and the spatial concentration of bodies offer a display of experiments in flex labor.[15]

In addition, the *precarity* of labor is embedded into these game architectures. Failure at one assignment can result in being thrown out of the game. Avoiding a return to the real world of the labor pool creates high anxiety for competitors. This fear is tested in a scare-prank show like MTV's *Room 401*, which terrifies young people at their new jobs. What will youth tolerate in these times of difficult employment?

A more playful (and therefore more cynical) experiment in managing one's own precarity could be found in the short-lived *Fire Me Please!* (*FMP*). The premise of the show had contestants compete by posing as newly hired entry-level employees at low-paying retail or industry jobs (at different locations). Their challenge was to get fired by 5 pm of their inaugural workday in order to win $25,000. Contestants slack off on the job, violate the rules, do not listen to suggestions, and generally antagonize their supervisors and co-workers. But rather than just being a head-to-head race to see who gets fired first, the contestants try to get fired as close as possible to 3 pm without going over. If neither gets fired by then, the game becomes a race to be first fired.

By getting their supervisors to utter "you're fired," the *FMP* workers reverse the painful rejection that comes with Donald Trump's *Apprentice* catchphrase by now actively desiring it. From this perspective, we are witnessing yet another instance where subjects stubbornly crave their own subordination as much as they would their freedom. By becoming conscious of the codes of acceptable workplace conduct, laborers learn a self-discipline that needs no master-figure like Trump to enact the Law. The protocols here involve a set of competences to manage interpersonal relations with co-workers and supervisors as well as to finesse the time of their labor-power, knowing when to give it to their bosses (to keep them strung along) and when to subtract it (to get them to utter the phrase). *Fire Me Please*, although a minor blip in RTV, distills the techniques of laboring found in other reality programs and in most any current workplace. It is summed up by Levy, regarding collective intelligence: "open-minded, cognitive subjects capable of initiative, imagination, and rapid response."[16]

The RTV apprenticeship protocols also depend heavily on communication. First, collective intelligence is often organized around commands from boss-figures. At times, these are potential future bosses (e.g. Trump, Gordon Ramsay, Diddy). In other experiments, the boss is more of a celebrity managerial figurehead (Heidi Klum, Tyra Banks, Janice Dickinson).[17] Hosts often serve this communicative function (Jeff Probst, Phil Keoghan, Julie Chen),[18] conveying the imperatives of the program and conducting any necessary negotiations. Regardless of the actual presence of an individual boss-subject, what is key here is the *program's* status as a subject. As I will elaborate later, the program-subject is a command-giver that organizes the collective's ability to form a community.

Second, the communication by the participants warrants attention. A number of scholars note the importance of the confessional to contemporary culture, and RTV is no exception (with its confessional rooms, private one-on-one interviews, clip shows).[19] Furthermore, this "imperative to express oneself" is central to the operations of immaterial labor (even within the most manual-forms).[20] For example, in the first episode of the second season of

Hell's Kitchen, Julia (class-marked by her previous employment at the Waffle House) states that the key to a good kitchen is good communication. Communicating effectively is noted as part of good leadership, either formally (in presentations to *Apprentice* corporate sponsors) or informally (the putative leaders of secret alliances on *Survivor*). We could even say that participants must walk a fine line between being non-communicative (e.g. keeping secrets) and being excessively communicative (gossiping, revealing secrets).

Communication between participants and the outside world highlights the affective quality of convergence and divergence. On the *Real World – Sydney*, the isolated room with the single phone became the site of violent conflagrations, ones in which parents were brought into the fight, either as targets of insult or as tele-soothers. Communication contact with family, friends, and lovers is a reward on some programs (*Kid Nation, Survivor*). Cut off from communications, the chance to reconnect with the outside world becomes a highly valued prize, and furnishes some of the more affectively intense scenes.

In sum, RTV becomes a cultural mechanism whereby convergence is based on conflictual and hierarchical relations. The collective intelligence protocols that accompany convergence culture persistently promote *divergence*, especially around labor relations. Competition, boss vs. worker, temporary alliances, loyalty tests, toying with affective communicative needs – all of these design elements are premised on a divergence that mimics contemporary labor forms. Divergence has a broader scope, however, and it is to these divergent practices that we turn to now in some detail.

RTV: dividing practices

Reality TV can be said to be comprised of a distribution of dividing practices or separation mechanisms.[21] Obviously, many programs are designed around competition. Lest we forget this crucial fact, we occasionally get reminded, as when host Julie Chen declared in the *Big Brother 8* season opener: "This is, above all, a competition, a summer-long power struggle with only one winner." Programs like this one immediately materialize this competition with a quick distribution of scarce space (often via a lack of beds or not enough properly sized ones). Participants compete over a single prize (one job, one contract, one object of affection) and face regular eliminations. The spectacular elimination rituals (in tribal councils, boardrooms, runways, kitchens) dramatize the dividing practices.[22] The cuts take on a somber tone, with accompanying melodramatic music, solemn host-affect, and ceremonial phrases ("You're out," "You're fired," "Your journey ends here," "The tribe has spoken," "Your tour ends here," "Your time is up"). And to these eliminations are added a whole host of episodes dealing with auditions and "making

Figure 4.1 America's Got Talent judges (photo credit: Trae Patton/NBC Photo).

the cut." The most recognizable version of this is *American Idol*'s increasingly long pre-season, but other programs have included this technique (usually condensed into one episode). In the spirit of convergence culture, interactivated audiences have been recruited to assist in the sorting.[23]

These macro dividing practices (winners/losers, in/out, worthy/unworthy) place their subjects in a state of general precarity. Teams, individuals, tribes: all these refer to the major divergences that comprise RTV, culminating in some being present and some absent. However, what makes RTV different from other game shows is the reliance on micro-level interpersonal strategies and social interactions.[24] Alliances and affinity groups within teams create internal hierarchies, resulting in scapegoating, bullying, and turning some players into instruments while others into mini-bosses. None of these positions is permanent or even predictable.

These "flexarchies," as we might call them, are sometimes integrated into the design of the game. On *Kid Nation*, for example, the weekly distribution of teams into a four-tier class system was accompanied by a regular town council (which was modified once by a recall/lack of confidence vote and once by a general election) as well as a midseason remixing of the teams themselves. Flexarchies are ways of managing the bottom-up interactions of contestants who seek to make their own alliances. Programmatic interventions such as remixing teams, merging tribes, and bringing back losers as a new team all affect participants' shifting allegiances, interpersonal strategies, and identifications. Before affinities can settle and persist, they are disrupted and revised. Some dissolve quickly while others persevere, but all must ultimately dissipate to allow a single victor to emerge.

Figure 4.2 Kid Nation (photo credit: Monty Brinton/CBS).

Divergences have a spatial dimension as well. *Surreal Life: Life on the A-List* had weekly punishments involving being condemned to B-list accommodations. *Survivor* created Exile Island, a space of solitude for a member of the losing team. *The Apprentice LA* placed each week's losing team into a resource-deprived outdoor camp. A more nuanced spatial divergence can be found in MTV's *X Factor*, which tests the fidelity and affective investment of ex-couples by separating them from their current partners and housing them in a luxury spa hotel. The new stranger/partners become voyeurs, separated from their current partners but able to monitor them.[25]

Dividing the individual

James Hay and Laurie Ouellette, in *Better Living Through Reality TV*, note that the governmentalization of RTV subjects requires a self that turns on itself. The self problematizes part of itself *to* itself to render it modifiable and amenable to interventions, especially by experts. This internal split of the self is also noted by Mark Andrejevic in his analysis of *Spying on Myself*, where a subject replicates itself (via disguise) to evince the truth from an intimate.[26] The subject-monitoring-itself is, according to Andrejevic, a role model for a post-9/11 US citizen (but whose roots go back at least as far as panoptical architecture).

Dividuals

This split self can be conceptualized as what Gilles Deleuze calls "dividuals."[27] Rather than being a self with solid interiority, subjects are broken down into a variety of capacities, and then recombined with others in permanent fluctuation. Dividuality involves the techniques of self-reflexivity noted above, ones

geared to adapt to the program imperatives. The breakdown of physical, psychological, and social barriers in and around subjects comprise the techniques of transformation required to accomplish programmatic objectives. These processes create subjects who are increasingly interconnected, nomadic, self-reflexive, and flexible. While Levy affirms these subjective processes as inherently subversive of authoritarian mechanisms, Gilles Deleuze is not as sanguine about these developments, finding in them the new subjectivities for what he calls "societies of control."[28]

Beyond its usefulness to labor management and soft control, dividual practices are fundamental to the very actions a subject must take to become successful. Let us examine, for instance, one of the dynamics involved in the courtship-competition programs (*Flavor/Rock/Age of Love*, *Shot at Love*, *That's Amore*, *I Love NY*, *Bachelor/ette*), namely the modulation of access to the central figure. The program offers select forms of access to the libidinal attractor: the one-on-one date, "special time," the limo ride back from a group date. While the program lays out segmented spaces and times, contestants traverse those limits. Contestants who don't get a date (like *I Love NY2*'s Tailor Made or two contestants on *Rock of Love2*) often insinuate themselves into or in front of the star's room to catch him/her after the date for some unofficial alone time.

These tactics comprise the processes of individuation, where the aim is to get attention from the target by rising above the pack. In the cases above, the processes are taken up by individuals despite the official pathways established for them. However, these processes of individuation have to undergo a careful strategizing in order to become successful. One wants to do "whatever it takes" (a common enunciation by contestants) to eliminate competition and stand out in the crowd, while at the same time one cannot alienate the target via these techniques (e.g. appearing as a liar, as too violent or competitive, as a backstabber). Contestants have to determine the *best possible type* of individuation, one that will achieve the objective (getting selected).

In other words, individuation requires self-modulation, one that is aware of its relationship to its environment as well as having to regulate its internal states (give in to impulses vs. waiting for the right time, for instance). The individual, then, is both a manager of dividual capacities (in relation to others and to the prize) as well as the *outcome* of his/her management (the individuated result that gets selected or rejected).[29]

Affectivity and social bonds

As mentioned in my introduction, "affectivity" is a key way of understanding new media culture. To recap, affect refers both to the dividual capacities (desire, anxiety, passions) as well as social, interpersonal relations. The social

bonds that become a target of engineering on RTV are primarily affective. Gender, race, parent/child, boss/employee, and other social relations comprise the variable material that reality programming (trans)forms. The heightened attention to couples and other pair-bonds is relevant here. Some programs began with the dyad as contestant (*Amazing Race*, which has numerous friend and family permutations), while others have added it in later seasons (*Biggest Loser Couples*, *Fear Factor Couples*). Virtually all of RTV operates on affective social bonds, from programs that focus on already-existing ones (*Wife Swap*, *Scott Baio is 46 and Pregnant*, *My Fair Brady: Maybe Baby?*, *Rob & Big*) or on forming them (*Millionaire Matchmaker*, *Survivor*, *Real World*, *Fear/Age/Rock of Love*, *Date My Mom*, *Room Raiders*, *Next*) or some hybrid (*Real World/Road Rules Challenges*, all-star versions of programs, *Celebrity Rehab*, *Parental Control*, *Date My Mom*, *X Factor*).

Recent seasons of *Big Brother* have led the way in experimenting with pair-bonds. In season eight, the program put three couples in the contestant pool who have had problems and enmity in the past. The reunion of estranged couples (lovers, friends, father/daughter) was integrated into the design as a convergence of divergents. The following season, called "Till Death Do You Part," saw a different experiment with coupling. The program made the couples play as couples (the previous season still retained the individualistic bias). Moreover, the program incorporated a matchmaking function into its design, by determining who the romantic couples would be at the outset. A few twists were embedded into the initial conditions. *Big Brother* inserted an already-existing couple into the pool (a fact hidden from the other contestants) but split them up and paired them with other individuals. Another couple was composed of exes (the other's participation on the show was revealed to each when they arrived). Interestingly enough, both of those pairs lost a partner in the first week of the program, neutralizing any potential dynamic from past affections.

Thus, even when two individuals are the players, the game-play is comprised mostly of dividual and collective processes. The couple modulates itself in relation to the pool and the program (should they reveal their secret status? How will this affect their success?). The dyad also must negotiate its internal affects (lingering resentments, new jealousies). The insecurities of couplehood are multiplied and amplified with the insecurities of their game status. Precarity is layered upon precarity, producing an affective intensification (even volatility) that makes the show entertaining.

In sum, RTV combines, connects, accumulates, and programs affects. We can call it an "affective convergence." When Jenkins speaks about a convergence of brains, he already raises this possibility. We are thus not speaking about people but the prepersonal, the relations and microinteractions that, in

their relation to a milieu, *individuate*. They are a series of strategic calculations, but not ones done from a distance in a cool dispassionate manner. Rather, these are immanent evaluations, ones that respond quickly to variations, and have to regulate revelations via timing and targets. This subpersonal dimension involves the participants, the fans, the producers, the viewers – all elements of the program.

Convergence, then, is not a convergence *of* subjectivities, but of processes, especially processes of subjectivation. So what kinds of affective convergence are we witnessing, and with what subjective effects? My argument here is that affective convergence is constituted as much by divergence as by any set of connections and commons. To examine how affective convergence is a type of divergence, we need to explore some more details about reality programming.

Judgment culture: incivility, humor, violence

Teresa Brennan links affect with divergence in her very definition of affect as "a physiological shift accompanying a judgment."[30] Affect is a transmission, and this relation is accompanied by a feeling. Brennan's link between affect and evaluation is key insofar as reality programming relies so heavily on judgment. The talent competition programs come to mind most readily (*American Idol*, *You're the One That I Want*, *Dancing with the Stars*, *America's Next Top Model*, *Last Comic Standing*, *Project Runway*, *Making the Cut*, *Phenomenon*, *America's Got Talent*, *Top Chef*, *Celebrity Fit Club*, *So you Think you can Dance?*, *American Inventor*) as do the seemingly endlessly replicating judge-personality court shows (*Judge Judy*, *Joe Brown*, *Mills Lane*, *Mathis*, *Hatchett*). Whether done by fellow contestants (*Big Brother*, *Survivor*) or the interactivated audience (*American Idol*, *Make Me a Supermodel*) judgments proliferate. In shows hosted by one final evaluator (*Flavor of Love*, *Rock of Love*, *I Love NY*), the central figure often judges episodic talent shows and performance competitions. Sometimes judges are experts (*Project Runway*, *Top Chef*); other times, they are relatives of the libidinal protagonist (*NY*'s mother, the *Bachelor*'s sisters, Bret Michael's veteran superfans), and even strangers are enrolled (four-year-old girls on *Pick Up Artist*).[31] Once again, these are only the formal game design elements. The informal micro-level domain of interpersonal relations also is filled with judgments and evaluations (determining allies and enemies, trash-talking, gossiping, betraying).

Beyond RTV, judgment culture often takes the form of ratings communities. We are confronted with the constant imperative to rank, from restaurant tastes (Yelp and foodie blogs) to who is hot (hotornot.com) to professor ratings (ratemyprofessors.com) to the peer-to-peer ratings of comments in a newsgroup (slashdot.org). More concentrated versions of these ratings

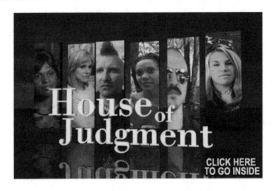

Figure 4.3 House of Judgment (photo credit: Dr. Phil, www.drphil.com/shows/show/998#).

communities can be found on what we can call "beratement panels." These are programs that involve a handful of commentators whose job is to ensure a constant flow of (often humorous) insults and judgments. This mechanism can be found in news programs (*Fox News Morning*, *Red Eye*) and celebrity gossip shows (*Chelsea Handler*, *E!TV*). On reality TV competitions, the panel often includes one figure that embodies this function, namely the scathingly acidic Briton.

Brit-wit, in fact, could be seen as the precursor to the communicative style valorized on these beratement panels and on fan/rating communities, namely *snark* or *snarkasm*. Snark, a hybrid of "snide" and "remark," is a biting, casual verbal attack. Its subtle insult comprises a tone that acts as a weapon to cut its target down to size. As Henry Jenkins notes, snarky recaps signal emotional distance from the program by making fun.[32] Snark is a type of intimacy management via communication. One cannot get too close to the object of desire, but cannot leave it either. It would be naive to say one authentically loves RTV or celebrity antics, but one also cannot break from it. Snarkasm is a type of ironic consumption, but one particularly characterized by fascination, the vexing vacillation between attraction and repulsion.

We are immersed in a society of mutated wit: a democratization of semiotic weaponry, a linguistic aggression of all against all. This peer-to-peer, distributed snark has become a valorized form of communication (in both senses – valued as a skill and a producer of material value).[33] Judgment, a form of divergence with its special linguistic weaponry, is now a cultural norm.

RTV thus might be considered, contra Levy, as an apprenticeship in incivility. Often called "chemistry," social relations are micromanaged via conflict and the introduction of perturbances. From the casting of explosive personalities to the rigors of bodily testing, from the overproximity of living arrangements to sleep and food deprivation, from the pressure-cooker of constant

surveillance to the release valve of alcohol-fueled outings, reality programs design conditions for maximal affective volatility. This incivility, then, becomes RTV's draw (fights, showdowns, individual meltdowns, screaming matches, "drama").

Even programs that are closer to constructing apprenticeships in civility depend on disruptions and divergences. Prank shows such as *Boiling Points*, *Girls Behaving Badly*, *Room 401*, and *Scare Tactics* create perturbations in the normal course of events in order to achieve their objectives. As I have argued elsewhere, *Boiling Points* disrupts the norms of civility, of consumer inter- action, and of personal boundaries to extend subjects' thresholds of toler- ance.[34] Pranked individuals learn that it pays to be patient, as the program learns to fine tune the control of divergences. Etiquette training programs (*From Gs to Gentlemen*, *Charm School*) perhaps best crystallize this ambivalent tendency – relying on volatile relations for entertainment value while formally seeking to tame those very affects.

Here we can pause to consider how the above examples alter the notion of convergence and culture. RTV, as the cultural programming of subjects, is filled with divergence. It involves continuous intervention and modification of social bonds through the management of tension and difference: inserting seg- mentation, competition, judgment, and attachment to commands. Conver- gence, at least in this affective dimension, does not form a synthetic totality or even a kludge, but a volatile compound whose divergences and disturbances are central to how the brains, bodies, and techniques combine in the programs.

RTV can be seen as merely one expression of "divergence culture," also present in the continual subject-sortings embodied in national borders, velvet ropes, VIP access, niche club cards, membership marketing, and the populari- zation of style. Divergence culture can be considered the shadow world of virtual communities and convergence culture. Let us not forget that the origin of Facebook (considered one of the key applications embodying Web 2.0 and social media) was a Harvard dorm-based picture program that ranked photos based on physical attractiveness.

Starker examples of divergent media culture abound. Violent attacks on strangers performed for viral video distribution regularly make broadcast news leads. These brutal divergences are not caused by technology, but media (both news outlets and digital distribution) do augment bullying relationships by conferring wildfire mini-celebrity status to the attackers. We are in the midst of a media-fueled popularization of bullies, a convergence of micro-violences perhaps comprising a cultural will-to-humiliation.[35]

In early 2008, a number of news stories noted the pathological components of social networking, like pro-anorexia groups and online bullying that result

in suicides. The 2007 Finnish school shooter Pekka-Eric Auvinen and Pennsylvania school shooting plotter Dillon Cossey converged in their fandom of the Columbine killers and may have communicated via YouTube.[36] Cho Seung-Hui, the Virginia Tech shooter, did not have a significant online presence, but the multimedia package he sent to NBC, complete with still photos, videos, audio recordings, and writing, resembled a mutant hardcopy version of a social network profile. The point here is not to fuel a moral panic over social media, but to demonstrate that the subjective figure of convergence has no necessary politics, ethics, or affective state. Violence, divergence, separation: are we left with a fragmented world of individuated exile islands? Or have we been examining only *one* type of divergence, one type of affective convergence? The next section begins to sketch out other modes by examining RTV programs in terms of how divergence might mutate into an antagonism.

From divergence to antagonism: subjects in exodus

What I have outlined above regarding RTV and divergence culture appears, from one perspective, to be a thoroughly pessimistic story. In some ways, it is a necessary corrective to all the hype about hyperconnectivity and Web 2.0 communities.

But is divergence culture yet another highly effective mode of control? It would seem to be especially successful because it operates *within* the very processes of subjectivation – e.g. affective convergence. For Pierre Levy, a faith in the collective overrides this dystopia: "The Just promote strength. Conversely, those forces that diminish and eventually destroy humanity will be judged as bad: humiliation, depreciation, separation, isolation."[37] Levy's optimism is not borne out by studying dominant cultural forms like reality programming. Hoping for the best is not enough. Understanding the nuances of divergence culture is not designed to be paralyzing, but intended to ward off any quick and easy appeals to a new public sphere.

How can understanding RTV as part of divergence culture open up new possibilities for analysis and action? Levy gives a clue in the above statement when he says these forces will themselves be *judged*. He uses a mechanism of divergence culture against itself, appropriating and transforming the very techniques of subjectivation that currently vex us. It is akin to Paolo Virno's analytic assessment that antidotes "can be tracked down only in what for the moment appears to be poison."[38] For our purposes, we can say that separation and divergence are not in themselves poisons, but become toxic when fused with relations of hierarchy, humiliation, base affects and dividual disempowerment against peer-to-peer relations.

Due to space constraints, I can only gesture toward what the transformation of divergence into antagonism might look like. By antagonism here I am referring to a social and political divergence, a process by which some subjects deprive others of their ability to act, while relying on the production of those very subjects. Drawn from Antonio Negri's reworking of class struggle, antagonism refers to a production of subjectivity in which dominant forces "disrupt the power which socialization places in the hands of the worker and the producer."[39] These "mechanisms of the production of subjectivity [work] against the socialization of labour and against communication and cooperation."[40] In other words, while RTV programs depend on an expansion of communication and collectivity (both among program participants and between participants and audience), they also seek to regulate and direct the pathways of that collectivity (often via micro-divergences).[41] I will thus end with a sketch of three dimensions of RTV that could be studied: 1. the programs themselves as subjects; 2. evaluating this program-subject as reactive and preventive; 3. the strategies of disaffection and exodus from this program-subject. Specifying these dimensions provides a way of understanding reality programming that would foreground new developments in power relations especially as they involve the production of subjectivity in convergence culture.

1. Clarification of antagonists: the program as subject

The protocols I analyze above are part of what we could call the RTV *code* or *program*. Programs are interventionists, experimenters, and organizers; they establish the ground rules of interaction and shape the pathways those actions ought to take. The program can thus be defined as a designer of experiments, conductor of behavior, organizer of capacities, chemist of affects, and extractor of value. How do programs determine their objectives, how do they emit their commands, what are their formal control mechanisms? Once these rules, protocols, and designs are put into focus, we can think of them not just as subject-creators, but as *subjects themselves*. One could analyze reality programming from the perspective of this code-subject.[42]

2. Evaluation of antagonists: the program as reactive subject

If the first approach asks us to examine the reality program as subject, the second asks us to examine the types of program-subjects. Reality programming seeks to shape the outcomes and pathways that affective convergence takes. On many shows, collaboration is organized around competition, the

threat of elimination governs the range of possible affinities, and there is a pre-determined objective (the prize) that regulates patterns. As affective bonds develop over time, the program will disrupt them (shaking up teams, bringing back old ones, dissolving groups). In other words, the self-organizing character of the collectives is highly contained. RTV usurps and encloses the potential for transformation.

To put it simply, RTV programming does not create subjectivity in any uniform causal manner. The program responds to and feeds off of processes of subjectivation preceding it. Formats combine spaces of confinement (houses, islands, buses), tests of memory and physical capacity, regulation of communication, access to knowledge, contact with the prize, interchangeable membership, and a whole host of other techniques found in "reality" for millennia. The rituals and tests found in RTV also mark initiation phases in archaic cultures. In other words, the techniques of selfhood distributed by reality programming do not belong to that code-subject.

Moreover, the program must ward off certain kinds of affective convergence and selfhood. The first season of US *Big Brother*, with its near-walkout by participants, represents the most extreme version of this tendency. Reality programs incessantly need to redirect affective bonds toward conformist programmatic objectives and away from potential ones that could antagonize the program. As Pierre Levy puts it, "power must continuously thwart the emergence of a collective intelligence that would enable the community to forsake such a power."[43] The reality program is thus *pre-emptive* as well as *reactive*. Analyzing RTV's preventive and anxious strategies begins to foreground its cold, indifferent, even cruel character.[44]

3. Exodus: a new divergence?[45]

Reality TV is filled with minor moments in which contestants break from their programming and exit. On *Celebrity Rehab*, two patients decided to leave the show during recording (and only one of them came back for the reunion). *The Apprentice* is rife with departing contestants, from early-season breakdowns (who were called "quitters") to recent tactics of self-firing in the boardroom immediately before Trump can utter his master phrase. *Survivor* frequently sees exoduses.

These preventive desertions often take place via an appeal to ethical cores and subjective essences (e.g. "This is who I am," "I'm not going to change," "This is not what I signed up for"). Exodus, thus, is not just physical departure from a program. It requires a significant shift in subjective perspective and alignment – a disaffection and disidentification with programmatic imperatives. On RTV, it is often called "checking out" or "doing it for me"; an internally generated deprogramming.[46]

Take, for example, Brad, from season 11 of *The Bachelor* (2007). He refused to pick either of the final two contestants, as well as snubbing the "where are they now?" program. This is a fine example of what Paolo Virno calls "desertion in one's own place."[47] It is recalcitrance in the face of commands to move and to travel down the chosen pathways.

Exodus is thus a matter of re-routing affect around and through the program. It might mean locating moments of empathic peer-to-peer affect that opens up a future not determined by the programmatic objectives (like "showmances").[48] Divergence ultimately is not comprised solely of dividing practices (judgment, rumor mongering, verbal/physical abuse) that separate subjects from each other and themselves. When taking the form of exodus, divergence is a deviation that *creates*.[49] On the one side, divergences emanate from a program-subject (establishing barriers, camps, asymmetries, competitions). On the other side, divergences emanate from an affective convergence that departs from program-subjects. Here, in this meta-divergence, is where antagonism can emerge. Subjects depart from the program-mechanisms that both socialize them as well as try to deprive them of the resultant powers. In this departure, experiments in being-together are made possible.

Conclusion

What these three lines of inquiry indicate is that convergence culture is not simply met with divergence (as a kind of complement or resistance). Convergence is an action that conjoins already fleeing and open-ended affective processes. The self-organizing tendencies, the peer-to-peer affinities, the individual, dividual, and social desires: all of these precede RTV and are in fact the milieu out of which RTV can emerge. Even the techniques of subjectivation (tests, spatial distribution, games) do not belong to the program as creator. Reality programming, as I have argued elsewhere, seeks to capture and direct processes of transformation. The creative capacities, the affective swerves, the processes of transformation: these are the sources of value and innovation in RTV. These processes are organized and routed through programmatic circuits but are irreducible to the control mechanisms. RTV's codes thus are more like selection mechanisms, techniques that draw on and manage affectivity, producing a dynamic system and the occasional struggle. In other words, from the perspective that sees the program as subject we can say that *divergence comes first*. Not the poisonous divergence of RTV's capture of affective convergence, but the desire to flee injurious bonds, to overcome oppressive boundaries, to escape states of domination and rigid power relations.

And here we can understand the complexities of what Levy calls the shift "from democracy (cratein: to command) to *demodynamics* (dunamis: force,

strength)."[50] What is the capacity, the strength of antagonistic exodus-subjects? This question is pertinent to all forms of reality programming, not just the ones in a TV genre.[51] On one hand, this new divergence (exodus) appears as a survival mechanism, in which deprogramming is necessary to avert catastrophe (economic, ecological, social, psychological). Techniques of deconditioning, found in reality programming of all sorts, now circulate in popular culture as a kind of species' last gasp. On the other hand, leaps in species-being take place via such radical swerves and divergences. Reality programs are a type of cultural apocalypse, "collective rituals that imitate destruction in order to repel it."[52] What types of subjects are being forged in these exodus experiments?

The re-pioneers of the 2007 reality program *Kid Nation* give us one such clue. The children are subjects in a collective experiment in refounding the Wild West. They inhabit a ghost town and receive written instructions from its dead fake founding fathers. The fact that this is all highly contrived by the producers demonstrates the absolute ambivalence of our contemporary reality experiments. It dramatizes both the radical quality of exodus/founding and also the deluded cynicism of transforming it into a spectacle (e.g. making specters utter the programmatic commands). *Kid Nation* displays the utter despair (in the program's premise) and hope (in the children's statements) that comprise the affective structure of the program, and of our current era. "A multitude can always veer off somewhere unexpected under the spell of some strange attractor," according to Tiziana Terranova.[53] This exodus could be a founding of a new world or, like so many of our predecessors, a type of species extinction. Perhaps these reality programs, our cultural apocalypse experiments in affective convergence, will turn out to be the haunted communiqués for a people-to-come.

Notes

1. Pierre Levy, *Collective Intelligence: Mankind's Emerging World in Cyberspace*, trans. Robert Bonomo (New York: Basic Books, 1999), 11, 59, 77.
2. Henry Jenkins, *Convergence Culture* (New York: New York University Press, 2006), 3.
3. Levy, 58.
4. Patricia Clough and Jean Halley, eds., *The Affective Turn: Theorizing the Social* (Durham: Duke University Press, 2007); Anu Koivunen, "Preface: The Affective Turn?" in *Conference Proceedings for Affective Encounters: Rethinking Embodiment in Feminist Media Studies*, eds. Anu Koivunen and Susanna Paasonen (Turku: University of Turku, 2000), 7–9, http://media.utu.fi/affective/proceedings.pdf.
5. Teresa Brennan, *The Transmission of Affect* (Ithaca: Cornell University Press, 2004), 24.
6. Michael Hardt, "Affective Labor," *boundary 2* 26:2 (1999), 89–100.
7. Interestingly enough, Levy's concept of collective intelligence has little to do with affective practices or emotional intelligence. The problem-solving raison d'être for knowledge communities highlight a mentalist and rational cognition, one that often seems disembodied. In his later book, *Becoming Virtual*, Levy pays more attention to the corporeal elements of these otherwise "angelic" forms.

8. Jenkins, 284.
9. This is not to say that convergence is either harmonious or static in Jenkins' formulation. Convergence is a "process, not an endpoint" and a "kludge" (16–17). The main cleavage in convergence is between two forces: corporate convergence and grassroots convergence. But this top-down vs. bottom-up divergence of convergences isn't as conflictual as it first appears. As Mark Andrejevic has argued in *iSpy: Surveillance and Power in the Interactive Era* (Lawrence: University Press of Kansas, 2007), expanded participation and expression are not inimical to capitalism. They comprise new modes of value-extraction. Ultimately, Jenkins leaves behind the De Certeauian model of guerrilla warfare consumption he was noted for in his early fan studies in favor of New Public Sphere via popular culture. Even in the chapter on *Survivor*, which foregrounds guerrilla warfare tactics between producers and the spoiler community, Jenkins ignores the warfare model.
10. Andrejevic, *iSpy*; Tiziana Terranova, "What's So Significant About Social Networking? Web 2.0 and its Critical Potential" (keynote panel at the annual meeting for the International Communication Association, San Francisco, June 2007).
11. To do a thorough analysis of these protocols (and a proper critique of Jenkins) one would need to expand the analysis to fans and interactants.
12. Maurizio Lazzarato, "Struggle, Event, Media." Translated by Aileen Derieg. 2005, http://info.interactivist.net/article.pl?sid=04/03/08/1253213&mode=nested&tid=22%0D%0D (accessed June 15, 2008).
13. Levy, 23–29.
14. Over the past three decades labor has increasingly become "intellectualized" in three ways: 1. the contents produced (information, symbols, affect); 2. the technologization of industrial forms (computer skills now required to run many factory lines); and most importantly 3. the collaborative informational networks implemented to produce new and old commodities. For some overviews of this claim about Mass Intellectuality, see Maurizio Lazzarato, "Immaterial Labor," in *Radical Thought in Italy: A Potential Politics*, eds. Paolo Virno and Michael Hardt (Minneapolis: University of Minnesota Press), 133–147; Michael Hardt, "Affective Labor," *boundary 2* 26:2 (1999), 89–100; Tiziana Terranova, *Network Culture: Politics for the Information Age* (London: Pluto, 2004) (especially chapter 3, "Free Labour").
15. See above work on Immaterial Labor, as well as Franco Bifo Berardi, "Info-Labour and Precarisation," *Generation On-Line*, 2003, www.generation-online.org/t/tinfolabour.htm (accessed June 15, 2008); Michael Hardt and Antonio Negri, *Labor of Dionysus: A Critique of the State-Form* (Minneapolis: University of Minnesota Press, 1994).
16. Levy, 1.
17. Trump is the boss-figure of *The Apprentice*, Ramsay of *Hell's Kitchen*, Diddy of *I Want to Work for Diddy*, Klum of *Project Runway*, Banks of *America's Next Top Model*, and Dickinson of *Janice Dickinson's Modeling Agency*.
18. Probst is the host of *Survivor*, Keoghan of *Amazing Race*, Chen of *Big Brother*.
19. Joshua Gamson, *Freaks Talk Back: Tabloid Talk Shows and Sexual Nonconformity* (Chicago: University of Chicago Press, 1998).
20. Lazzarato, "Immaterial Labor," 135.
21. Foucault's work has been largely occupied with dividing practices (mad/sane, sick/healthy, normal/abnormal). He defines them as practices in which "the subject is objectified by a process of division either within himself or from others" (326). Michel Foucault, "The Subject and Power," in *Power: Essential Works of Foucault Volume 3*, ed. J.D. Faubion (New York: The New Press, 2000), 326–348.
22. For more on the ritual functions of RTV, see Nick Couldry, "Teaching Us to Fake It: The Ritualized Norms of Reality Television," in *Reality Television: Remaking Television Culture*, eds. Susan Murray and Laurie Ouellette (New York: New York University Press, 2004), 57–74.
23. The third season of *Flavor of Love* incorporated this feedback mechanism, which backfired

when Flavor Flav eliminated two of the fan-selected three in the first episode, and questioned whether the fans were working in his best interests.

24. Mary Beth Haralovich and Michael W. Trosset, "'Expect the Unexpected': Narrative Pleasure and Uncertainty Due to Chance in *Survivor*," in *Reality Television: Remaking Television Culture*, eds. Susan Murray and Laurie Ouellette (New York: New York University Press, 2004), 75–96.

25. Often the former exes rekindle their relationship. At times this is matched by a vengeance hookup between the voyeurs and their affective proximity.

26. Andrejevic, *iSpy*.

27. Gilles Deleuze, "Postscript on Control Societies," in *Negotiations*, trans. Martin Joughin (New York: Columbia University Press, 1990), 177–182. Elsewhere I have discussed RTV subjects as dividuals in greater detail: Jack Bratich, "Programming Reality: Control Societies, New Subjects, and the Powers of Transformation," in *Makeover Television: Realities Remodeled*, ed. Dana Heller (London: I.B. Tauris, 2007), 6–22.

28. Deleuze, "Postscript on Control Societies." In addition, autonomists like Franco Berardi (Bifo), Paolo Virno, and Maurizio Lazzarato note the depleting and pathological effects of this real subsumption of subjectivity, in which dividuals are "submitted to competitive pressures, to an acceleration of stimuli, to constant attentive stress" (76). Franco Berardi (Bifo), "Schizo-Economy," *SubStance* 36:1 (2007), 76–85.

29. This subpersonal level corresponds to what Jenkins means when he speaks of the convergence of and across brains. His reference here is not necessarily to the organ but to the processes that comprise cognition, ones described in the flourishing studies of the neural and cognitive bases of culture. Popular cognitive studies highlight the affective nature of individual and social beings (e.g. Daniel Goleman, *Emotional Intelligence* (New York: Bantam Books, 1995); Daniel Goleman, *Social Intelligence* (New York: Bantam Books, 2006); Antonio Damasio, *Looking for Spinoza: Joy, Sorrow, and the Feeling Brain* (Orlando: Harcourt Press, 2003)).

30. Brennan, 5.

31. Of course, as the disclaimers inform us, the decisions on these programs are made in consultation with producers. This makes evaluation less individual-based, and more programmatic (what impersonal values underpin the decisions?).

32. Jenkins, 31.

33. For an analysis of snark as labor, see Mark Andrejevic, *iSpy*, 142–151.

34. Bratich, "Programming Reality."

35. This is a proliferation of molecular authoritarians that updates the authoritarian personality studied by the Frankfurt School. For a reassessment of the Frankfurt School contribution for new times, see Brian Holmes, "The Flexible Personality: For a New Cultural Critique," in *Data Browser 01: Economising Culture*, eds. Geoff Cox, Joasia Krysa, and Anya Lewin (Brooklyn: Autonomedia, 2004), 23–54.

36. David Schoetz and Russell Goldman, "Teens 'Idolized' Columbine Killers: Finnish, U.S. Teens Discuss Columbine, Shooting Fantasies Online". *ABC News.com*. November 13, 2007, http://abcnews.go.com/Politics/Story?id=3848474&page=1(accessed June 15, 2008).

37. Levy, 28.

38. Paolo Virno, *A Grammar of the Multitude* (Los Angeles: Semiotext(e), 2004), 84.

39. Antonio Negri, *The Politics of Subversion* (Cambridge: Polity, 2005), 132.

40. Ibid., 133.

41. Ibid., 132–133.

42. Tiziana Terranova referring to information and network culture more broadly, names these processes a "code," which attempts "to capture the increasing randomness and volatility of culture." Terranova, *Network Culture*, 34.

43. Levy, 82.

44. This cruelty, it must be said, does not reside in the techniques themselves, but in the program that deploys them. Some of the most extreme measures such as material

deprivation, isolation, even "torture" are techniques that, in other settings (e.g. shamanic journeys, retreats), do not deserve immediate condemnation. Cruelty emanates from the program's cynical indifference to the development and well-being of the subjects. Transformation is exploited directly for value extraction.

45. For autonomist Marxists, exodus results from an historic separation of capital from labor, in which capital "partially relinquishes its claim to act as the mediator and co-ordinator of production." Nicholas Dyer-Witheford, *Cyber-Marx* (Urbana: University of Illinois Press, 1999), 224. Labor power can directly produce its own value (auto-valorization) and subtract itself from the capitalist system of value. Exodus, exit, and desertion are names given to this subjective potential (whose threat has haunted capital from its inception but is now reaching a peak in the cycles of struggles). For more on these processes, see Harry Cleaver, *Reading Capital Politically* (Austin: University of Texas Press, 1979), 3–66; Paolo Virno, "Between Disobedience and Exodus: Flavia Costa Interviews Paolo Virno," *Interactivist*, 2004, http://info.interactivist.net/article.pl?sid=04/10/05/2334256&mode=nested&tid=9 (accessed June 15 2008); Sandro Mezzadra, "The Right to Escape," *Ephemera: Theory & Politics in Organization* 4:3 (August 2004), www.ephemeraweb.org/journal/4–3/4–3index.htm (accessed June 15, 2008); Paolo Virno, "Virtuosity and Revolution: The Political Theory of Exodus," in *Radical Thought in Italy: A Potential Politics*, eds. Paolo Virno and Michael Hardt (Minneapolis: University of Minnesota Press), 189–212, http://slash.autonomedia.org/article.pl?sid=02/11/14/134217 (accessed June 15, 2008); Eric Alliez and Antonio Negri, "Peace and War," *Theory Culture Society* 20 (2003), 109–118.

46. "Becoming an EX," the subjective (often abrupt) departure from pre-defined roles, has been the object of sociological and psychological study. See Helen Rose Fuchs Ebaugh, *Becoming an EX: The Process of Role Exit* (Chicago: University of Chicago Press, 1988).

47. Paolo Virno, "Between Disobedience and Exodus," *Interactivist* (2004), info.interactivist.net/node/3589 (accessed November 20, 2007).

48. Is the "showmance" (a romantic relationship forged on a program) a cynical strategy (e.g. *BB All Stars*) or are there authentic bondings possible (*BB8*)? For RTV a showmance can become new fodder for more programming (Ron and Amber, Flav and Brigitte, Adrian Curry and Peter Brady). VH1 even had a top 25 program on showmances, indicating that these affects were a direct result of RTV's matchmaking efforts. Love, however, exists despite the program, not because of it.

49. Paolo Virno, "Virtuosity and Revolution: The Political Theory of Exodus," in *Radical Thought in Italy: A Potential Politics*, eds. Paolo Virno and Michael Hardt (Minneapolis: University of Minnesota Press, 1996), 189–212; Paolo Virno, *Multitude: Between Innovation and Negation* (New York: Semiotext(e), 2008), 24. Terranova calls this kind of creative deviation a *clinamen*, *Network Culture*, 106–108.

50. Levy, 88.

51. Reality programming is a term that can be applied to any organized set of techniques to modify reality, especially at the subjective level. It is a synonym for what Erik Davis calls "experience design," and could cover such things as shamanic techniques of transformation, experimental living and affective arrangements, mind/body/spirit training, submission to makeovers and matchmaking services, tests of skill and endurance, artist convergences and retreats, and virtually any mechanism in which people submit themselves with the goal of self-transformation.

52. Virno, *Multitude*, 52.

53. Terranova, 105.

Industry convergence shows
Reality TV and the leisure franchise

Misha Kavka

In his discussion of reality television as "the first killer application of media convergence," Henry Jenkins points out that "*American Idol* [FOX, 2002] was from the start not simply a television program but a transmedia franchise."[1] Seeking to detail the "flow of content across multiple media platforms,"[2] Jenkins notes that *American Idol* producers extended the show with music sales, books, finalists' concert tours, and even the feature film *From Justin to Kelly* (2003), thus converging the medium of television with music, print, theater and film – not to mention *the de rigueur* official website. But it should be clear that not all of the media in this powerful franchise – especially not the poorly received spin-off film – have had the same impact on the cultural imagination or worked equally well in tandem with television. Rather, when we talk about the astounding success of the first season's winner, Kelly Clarkson, we measure it in terms of the music industry, from her successful first single in 2002[3] to her current status as an indisputable pop star whose television start has been all but forgotten. Even finalists from later seasons who have found success in other media, such as Clay Aiken (season 2) on the stage or Jennifer Hudson (season 3) in film,[4] have done so by capitalizing on the publicity initially afforded them by the convergence of television and music media.

While its global format, media extensions and advertising tie-ins certainly make *American Idol* a franchise, its core success lies at the intersection of these two major industries, television and music, which on the one hand seem to fit hand-in-glove, yet on the other hand often represent conflicting production strategies, processes and aims. *American Idol* may be exemplary of new programming and marketing strategies, but it is nonetheless just an example: numerous other reality TV programs combine television with the purposes and products of a leisure or consumer industry, even an industry which is not necessarily media-based. Such a phenomenon requires that we broaden our notion of media convergence beyond technological multifunctionality to include more cultural and economic understandings of convergence possibilities.

In this chapter I will examine what I call the "industry convergence" sub-genre of reality programming: those programs that marry reality TV formats with the skills and products of a leisure industry like modeling, fashion design or cooking. Although this covers only a small aspect of the complex picture of media convergence, such a focused approach can be productive in two ways: first, it frees us from thinking of convergence as something that only refers to modes of technological sharing and cross-over, since the convergence in these shows takes place on an *industry* scale and operates specifically through the television medium. Second, it complicates the rather simple picture of convergence optimism, since the industries involved in such cross-over formats often represent production strategies and processes that *diverge* from those of television, even though this may well be a productive divergence. At base, the focus on industry cross-over shows helps to map a path through the confusing and often overly celebrated tangle of media convergences.[5]

In the age of "transmedia," or convergent media platforms, technologies and economies, it is often difficult to keep track of what is converging with what, to which purpose and for whose benefit. While the rhetoric of convergence has one foot in digital technology and the other in political economy, most understandings of media convergence start with the Internet, positioning it at the center of all convergence strategies and effects. Gracie Lawson-Borders, for instance, defines convergence "*as the realm of possibilities when cooperation occurs between print and broadcast for the delivery of multimedia content through the use of computers and the Internet*" (italics in original).[6] The Internet's ability to absorb and replay other media content is no doubt crucial to public perceptions of convergence, yet this approach leaves "old media" such as television to ride along or struggle to keep up. Jenkins offers a better, because broader, definition of convergence in his three-pronged approach: he uses the term to mean "the flow of content across multiple media platforms, the cooperation between multiple media industries, and the migratory behavior of media audiences who will go almost anywhere in search of the kinds of entertainment experiences they want."[7] Because Jenkins does not privilege "new media" or the Internet in his discussions, he is able to recognize *American Idol* as an important example of media convergence where television is front and center, its effects flowing on to other platforms and technologies, and in turn create the conditions under which numerous brand advertisers and service providers can be made economically "happy."[8] Whereas Jenkins focuses largely on the "behavior of media audiences," however, I want to foreground the notion of cooperation between media, as well as non-media, industries as a way of answering Jenkins' call to convergence theorists not to overlook the role played by cultural forms alongside technologies. For my purposes, such cultural configu-

rations are best understood by paying attention to the role of televisual specificity in the age of media and economic convergences.

Masquerading as little different from other competitive reality TV forms such as *Survivor, Fear Factor* or *The Amazing Race*, the industry-convergence sub-genre crosses television with another consumer or leisure industry, linking otherwise disparate shows like *American Idol* and *The Apprentice* with *Project Runway*, *Top Chef*, *Hell's Kitchen*, *Dancing with the Stars* and *America's Next Top Model*. In genre terms, what distinguishes these shows is the presumed skill or talent of the participants (as opposed to, say, *Big Brother*-style TV), but viewed through a convergence lens they are examples of industry cooperation that go beyond simple corporate sponsorship. Although all of these shows are driven by important sponsorship deals with advertisers, what sets the industry-convergence show apart from other reality TV formats is the way that the sponsors' interests intersect fully with the economic interests of the producers and the content of the program. This imbrication, or convergence, of interests means that it is too simple to talk about spot-advertising or clever product placement in relation to these shows; rather, what marks these programs is the ability of reality television, as an industry with its own conditions of commodity success, to overlap with and promote the products of other, often unrelated industries, such as fashion design or restauranteurism.

Industry convergence, nonetheless, is not seamless; compromises are forced on one or the other partner, usually on the sister industry by the production and reception conditions of television, which provides the main delivery platform. For instance, the two *American Idol* finalists of every series must pump out a single often within a week of winning the competition so as to exploit audience interest, but this is a ludicrously short production time for the music industry. Reality TV, in other words, both enables the possibility of media convergence and offers examples of how such convergence masks divergences. The capitalist context of the industry-convergence shows produces, I will argue, valuable linkages between audiences and products, while it also generates conflicts that cannot be resolved in terms of conventional single-industry marketing strategies.

The age of convergence

In an important sense, there was no reality TV before the era of converging media platforms and economies. Whether we mark the start of reality television with *Cops* (FOX, 1989) or see its more "mature" form as beginning with *Changing Rooms* in 1996 (the British lifestyle perspective[9]), *Big Brother* in 1999 (the European perspective) or *Survivor* in 2000 (the American perspective[10]), reality television is bound to and defined by the age of convergence. In the

early days of real-crime shows, disaster clips and docu-soaps, roughly corresponding to the first half of the 1990s, this relatively cheap programming was made possible by the convergence of the television medium with surveillance, CCTV (closed-circuit television) and handheld camera technologies,[11] along with the hybridization of television reportage and direct-cinema documentary formats.[12] In the more mature forms of reality TV, broadcasters encouraged producers to experiment with economic convergence through ancillary media sales and tie-in marketing, while modes of platform convergence quickly expanded to encompass the telephone and Internet. The hugely successful *Changing Rooms* (BBC, 1996–2004) in the UK can be said to have sparked the convergence of reality TV viewing with consumer behavior (you, too, can revitalize your bedroom with a new headboard and 20 yards of purple muslin), exploiting the ties between the property makeover show, book sales and consumer products. *Big Brother* (Endemol, 1999–), the first reality TV format to truly go global,[13] was a watershed moment in the platform convergence of television with the Internet and telephony, since this was the show that introduced audience voting[14] as well as, in most countries, running live feeds of the *Big Brother* house through an official website, sometimes at a membership cost. However, it was producer Mark Burnett's groundbreaking approach to preselling sponsorship for *Survivor* (CBS, 2000–) that launched the behemoth which has become the integration of reality television with brand advertising, setting up lucrative contracts for product placement and, later, developing the show itself as a brand available for marketing cross-over.[15]

In the bigger picture, the conditions for the rise of media convergence have also accompanied and supported the development of reality television programming. The deregulation of broadcasting that hit the television industry worldwide in the 1980s led to ongoing competition for networks and state-owned broadcasters from satellite and cable channels,[16] causing decades-long dwindling audience share and desperate (or creative) attempts to maintain broadcasters' superior footholds. At the same time, the efficacy of traditional TV advertising has been steadily decreasing in the face of technologies and changing practices that allow the viewer to zap, mute, watch the DVD or record a program on a PVR (personal video recorder) or DVR (digital video recorder) and see it without ads altogether. In terms of diminishing audience share, platform and technological modes of convergence have proven to be an effective means for broadcasters to reach more eyeballs while better customizing their outreach to targeted audiences (especially the sought-after 18–34-year-olds). In terms of advertising, the spread of ads across linked technological devices, which are already being used by audiences for entertainment and information purposes, increases audiences' exposure to brands precisely amongst those viewers who are technologically savvy enough to avoid

traditional advertising. Reality television, born in this same era, has done more than just share in the conditions under which such convergences have developed; it has also actively exploited these conditions, so as to extend its own popularity and reach.

As an example of reality TV exploiting the conditions for media convergence, *American Idol* (hereafter *AI*) is rich territory. Jenkins' phrase "transmedia franchise" could refer just as easily to the range of media technologies exploited by the show as to its deft extension across multiple media platforms. The very fact that viewers are encouraged to become weekly voters for their favorite performer means that watching TV spurs reaching for the telephone, either in its "old" or "new media" forms, to make a phone call or send a text message.[17] Viewers' interest in *AI* frequently takes them to the Internet, where they can visit an array of official and unofficial sites to replay clips, find out more information about the contestants, catch up on past episodes or argue the relative merits of performances on discussion sites. *AI* songs and performance clips are available for download to MP3 players, cell phones and handheld devices; indeed, the episodic, fragmentary format of the show, as well as its double form as audiovisual and audio-only media content, make this program particularly well suited to the era of mobile media consumption. While these considerations detail media-specific convergences of *AI*, its status as a franchise recalls the economic aspects of convergence. As Jenkins notes, this is a show that makes everyone happy – phone companies, advertisers, networks and media conglomerates[18] – by co-opting brand-marketing tactics into its programming strategies, thereby effortlessly converting viewers into consumers

Figure 5.1 American Idol (photo credit: Michael Becker/FOX, found at eonline. com).

through product placement (most notably Coca-Cola), new media use (encouraging cell phone contracts with AT&T) and transmedia sales (music singles, for a start). *AI* perfectly exemplifies Jenkins' claim that "in the world of convergence, every important story gets told, every brand gets sold, and every consumer gets courted across multiple media platforms."[19]

At the same time, *AI* is only one example of such integration of stories, brands and platforms through the conjunction of two entertainment and/or leisure industries. Subsequent programs have developed other means of making profit from industry convergences, such as through format sales, presenter branding and the advertising value of prize packages. Although *AI* offers the most successful convergence model of the *Idol* programs to date, it is neither the only show in this international franchise begun by *Pop Idol* (ITV, 2001), nor is it the first of the music reality TV shows. That honor goes to *Popstars* (TVNZ, 1999), which also spawned numerous music-group programs, the longest-running of which is Sean Combs' *Making the Band* (ABC/MTV 2001, a hip-hop version of *Popstars*).[20] *Making the Band* in turn is notable for the way that this show extends product placement by positioning rapper/producer Sean "Diddy" Combs himself as the product, or brand, on commercial display.

A similar branding of a person occurs in *The Apprentice*, in which producer Mark Burnett of *Survivor* fame extends his creative sponsorship approach to include Donald Trump, the man as well as the empire. Whereas Trump was already a self-conscious brand, however, reality-TV neophyte Tyra Banks made herself into a brand precisely by exploiting the trend in industry-convergence programming.[21] With the success of *America's Next Top Model* (UPN, 2003–2006; The CW, 2006–), it became clear that television could cooperate with industries other than music. Tyra Banks' success as creative and executive producer of the show had to do with her recognition, whether conscious or not, that modeling could function as a sister media industry to television, not least because of the co-dependence between modeling and advertising across a range of media platforms.

America's Next Top Model (hereafter *ANTM*) is also notable because it was set up from the start with an awareness of how sponsorship could be more fluidly integrated into programming strategies. Of course, the "message from our sponsor" is as old as commercial television itself, but TV program content has traditionally had to stop or be suspended to make room for sponsors' announcements. By contrast, *American Idol* has managed to fold sponsorship directly into the interstices of the set talent-show format – from Coca-Cola mugs on the judges' table to contestants' music videos for Ford which air in the commercial breaks – but it was *ANTM* producers who masterminded the prize package itself as the means of converging program and sponsors. While *AI* contestants potentially win (unspecified) contact with the music industry

and exposure to its consumers, the winner of an *ANTM* cycle receives two contracts, one with a modeling agency (first with Ford Models, then with Elite Model Agency) and one with CoverGirl cosmetics, in addition to a fashion spread in a popular magazine, initially *Elle* and then *Seventeen*.[22] What this recognizes, of course, is that exposure to industry-insiders as well as to consumers is itself the valuable commodity offered to *ANTM* contestants; but this is a two-way street, since exposure for the contestants translates into in-built advertising for the sponsors, whose brand value rises in accordance with the cultural stock of *ANTM*. Such dual exposure also provides the raison d'être for program content: CoverGirl Cosmetics, for instance, which has sponsored *ANTM* since the third cycle, is regularly integrated into one of the challenges, when the contestants are required to shoot a commercial for CoverGirl (and the editing makes sure that we hear the slogan "easy, breezy CoverGirl" over and over again, as spoken by a parade of challengees delivering the line more or less well). One is inclined to say that this is the kind of exposure money can't buy – but, of course, this exposure is the very cornerstone of the economic convergence between *ANTM* and its main sponsors in the modeling industry: a cosmetics company, a fashion magazine and a modeling agency.

Somewhere between *America's Next Top Model* and the style-makeover hit *Queer Eye for the Straight Guy* (Bravo, 2003–2007), the Bravo skill-based reality shows were born. These shows, such as *Project Runway*, *Top Chef*, *Top Design* and *Shear Genius*, blend reality TV competitive formats with what Bravo head Laura Zalaznick has called the "five affinity groups" of pop culture: fashion, food, beauty, design and pop (she goes on to add, "it's not coincidental that

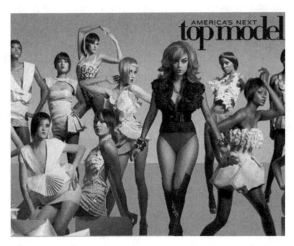

Figure 5.2 America's Next Top Model (photo found at: greyevilcat.files.wordpress. com).

the five guys in *Queer Eye* each represented one of those things"[23]). Not only does Zalaznick pinpoint the culture industries with which reality television is increasingly seeking to converge, but she also makes clear that convergence is no longer restricted to "cooperation between multiple media industries";[24] television may easily overflow the media/non-media distinction and find itself in bed with leisure and/or entertainment industries, which in turn use reality TV to extend their media profile and outreach. The very successful *Project Runway* (hereafter *PR*) takes a group of struggling fashion designers and challenges them to produce a different clothing design each episode, according to set specifications and limited resources, which they then exhibit on the "runway" before a panel of judges. *Top Chef* adopts a similar approach, but here struggling chefs face cooking challenges, again with set specifications, and are judged at table by a panel of judges.

The innovation in these shows lies in the convergence opportunities offered not just by the prize packages but also by the judging panels. In *PR*'s first season, for instance, the prize package consisted of $100,000 cash, a mentorship with Banana Republic (a major sponsor) and a fashion spread in *Elle* magazine. Although in later seasons Banana Republic was replaced by Macy's and then Bluefly.com, while Saturn came on board as a sponsor and added a new car to the package, the feature in *Elle* has remained – for the good reason that one of the judges was Nina Garcia, *Elle* fashion director, whose place on the panel in effect provided *Elle* with a consistent and voluble advertising presence (Garcia is now at *Marie Claire* magazine). In turn, designer Michael Kors' presence on the panel serves to brand his name and advertise his fashion line; indeed, one challenge in the second season began with a tour of his store before sending contestants out onto the streets of New York to find something inspirational. Presenter and panellist Heidi Klum, like Tyra Banks, is a supermodel making the transition into being a brand; her role not only on *PR* but also as Tyra's stand-in on *Germany's Next Top Model* (ProSieben, 2006–) reminds us of the triangulation between modeling, fashion and advertising.

Perhaps the most innovative element of convergence in *Project Runway*, however, occurs between television and the educational institution which provides *PR* with its shooting premises, Parsons New School for Design. Exterior establishing shots of Parsons, usually after each advertising break in the program, clearly claim that Parsons is the home of design. Moreover, the participants on *PR* are given guidance and constructive criticism by Tim Gunn (slogan: "make it work"), formerly Chair of Fashion Design at Parsons, whose role on the "inside" of the challenges establishes him as a walking embodiment of Parsons expertise. Since (reality) television flow enables convergences within and beyond the medium, it comes as no surprise that Tim Gunn's own personal brand so overflowed the Parsons institutional vessel that he has since

been named Chief Creative Officer of Liz Clairborne and now has his own makeover program, *Tim Gunn's Guide to Style* (which, in good intra-media cross-over form, was used to reveal the fourth season's participants of *Project Runway*). From the initial convergence of the television and fashion industries, *PR* has managed to grant exposure to numerous brands, sponsors and satellite industries in its orbit. Consider convergence, then, as a form of televisual overflow, encompassing popular clothing stores, fashion designer lines, fabric stores in New York's Garment District, Saturn cars and Trésemme hair products, *Elle* magazine, Parsons School, the brand names of Heidi Klum and Tim Gunn, and finally the becoming-brands of those contestants who have proven most successful through their exposure on television and the Internet, and at New York's Fashion Week.

Strange bedfellows

The ability of industry-convergence shows to publicize a raft of sponsored products and brands is clear, but such brands, sponsors and satellite industries must also negotiate criteria to make them available as cooperative and even interchangeable commodities in reality television formats. Indeed, the question remains open whether they are fully able to cooperate, since each industry has its own conditions of possibility and commodification. This includes, first and foremost, television as both industry and medium. Just as Jenkins reminds us that old media never die or even fade away,[25] we must keep in mind that, while television may be moving onto digital delivery platforms, the conditions that differentiate television from other media still prevail. Raymond Williams, of course, defined the main characteristic of the medium in terms of its "flow," which describes the effect on viewers of programs, advertising and other text types progressing in a (seemingly) undifferentiated stream. While changes in technology and viewing practices – such as the ability to watch programs without interruption through a PVR or DVD platform – have certainly altered this experience of television viewing, other kinds of flow have arisen that Williams could not have imagined. The now common experience of zapping from channel to channel, for instance, describes a sort of lateral flow that may take a viewer across tens or even hundreds of channels in a casual viewing session. The more recent possibility of downloading or streaming television content to other digital platforms can also be described as a form of flow, where television content overflows, as it were, onto whatever platform can technologically accommodate it.[26]

Aside from the characteristic of flow, the medium specificity of television can be characterized in terms of the program as the basic delivery unit. Although this represents the "old media" version of television, when TV

content appears as digitally transferred clips or bites, it is still the program that serves as the clip's contextual framework and guiding reference point, whether viewers watch an interview from *Good Morning America*, a popular segment from *Lost* or a performance from last night's *American Idol*. Nonetheless, while the program retains its status as both delivery unit and primary commodity of television, this proves to be a limiting perspective when we try to conceptualize the exchanges involved in the various commodity flows between television and other industries, despite the packaging of such possibilities within the framework of the program. Ultimately, these flows are defined by the conditions of production and distribution for the commodity itself, as well as by the target audience/consumers of that commodity. Because different industries – especially in cases of convergences between media and non-media industries – have different marketing strategies and target consumers, the industry convergence partnerships give rise to divergences within convergence patterns at the same time as they attempt to mask such divergences.

I have already mentioned the radically divergent production timelines of the television and music industries, which force music producers involved in the *Popstars* or *Idol* series to radically compress what would be the normal production period for a single or a video to match the more immediate temporality of television. In one telling moment on *Irish Popstars* (RTÉ One, 2002), music impresario Peter Waterman was filmed storming out of a recording studio where he had been working with the newly formed group Six, shouting "It's impossible to make a single in a day!" as he disappeared down the hall. In *Project Runway*, the structural divergence between the demands of television and those of the fashion industry has never appeared openly on screen, but its effects can be traced in the second season's tension between the winner, Chloe Dao, and runner-up Santino Rice. As Santino himself has said, although Chloe won the competition, "No one wanted to interview [her] ... I'm sure I did like 500 percent more interviews. That's what *I* won."[27] In that season, Chloe developed a reputation for "pretty but unremarkable clothes,"[28] compared with Santino, who designed clothes with visual flair and highly intricate tailoring. The choice of Chloe as winner may thus have come as a surprise to viewers – except for the fact that the prize package included a one-year mentorship with the program's main sponsor, Banana Republic, which surely had a vested interest, for the sake of its more mainstream if well-heeled target consumers, in making sure that Chloe Dao won the mentorship instead of Santino Rice. No doubt few in the *Project Runway* audience actually wanted to wear ultra-ruched lingerie designed on a *lederhosen* theme (one of Santino's more memorable creations), but the practical appeal of the clothes mattered little to them as television consumers, for whom the spectacle of the clothes and intimacy with the participants are at stake. By contrast, *PR*'s sister company,

Banana Republic, who is in the business of selling clothes, presumably had a strong say in naming Chloe as the winner of their sponsored prize, but it is worth noting that Banana Republic also withdrew from *PR* as a sponsor and mentor after the second season. Instead, the winners of seasons three and four – Jeffrey Sebelia and Christian Siriano – have been designers with the kind of flair that is better suited to television than to middle-class leisure wear. Television thus seems to have gained the upper hand in this partnership – for which, after all, it provides the medium of delivery – but the process of negotiating such contrasting criteria for winners spotlights the divergence between the needs of the television industry and those of the fashion industry.

Part of the fascination of these programs is that television and fashion, like television and restauranteurism, are industries that sell very different commodities under different conditions of production to different demarcations of target audiences/consumers. To some extent, this has always been a problem for the marriage of television programs and advertising slots, but the industry-convergence shows bring the tension of these divergences to the fore. For instance, responding to the criticism that no winner of *America's Next Top Model* has ever gone on to a successful modeling career, Tyra Banks has attributed this to the divergence between industry demands: "Of course I know what a supermodel looks like. . . . But I also know that a show filled with 13 girls that have the right look but no personality is not going to be relatable or watched."[29] Tom Colicchio, head judge on *Top Chef*, has in turn admitted that in the first two seasons, half of the 12 participants were cast more for the

Figure 5.3 Project Runway (photo found at: img2.timeinc.net).

purposes of the reality show than the cooking show: "The top chefs could always hold their own, but you walked into the kitchen and knew: *These other six people, there's no way they're going to be able to compete*" [italics in original].[30] While Colicchio insists that in later seasons the producers of *Top Chef* have come to understand that their audience base is "hard-core foodies" and have catered more to that audience, there is also a degree of defensiveness in this comment from Colicchio as a representative himself of the sister industry. Colicchio, after all, is hired by the *Top Chef* producers to instill and maintain the "foodie" integrity of the program, yet this integrity is by definition compromised by the producers' strategies and viewers' demands, however food-oriented this particular niche may be.

This core divergence between industry bedfellows becomes most visible in those moments when the interests of the sister industry are suddenly *not* at stake, thereby exposing the commodity conditions of the television medium. For instance, in the second episode of *Top Chef*'s first season, the judges found themselves choosing between Cynthia and Andrea for elimination, neither of whom were promising chefs. Colicchio declared that he would send both home if he could, which is to say that for him as a restaurateur, the decision did not matter. The result, then, came down to the simple TV-worthiness of these two participants: predictably, Andrea was eliminated because Cynthia – equal amounts self-combustible charm and foul-mouthed deprecation – made for much better TV. Such moments, when reality TV is caught pushing its vested interests, serve by contrast to remind us that divergence is usually a hidden characteristic of convergence partnerships, kept quiet for the sake of smooth operations of exchangeability in the interests of profit-making for all.

These masked but unavoidable divergences within the convergence partnership raise the larger question of television's boundaries and functions in the age of economic convergence, reminding us of the limitations of characterizing the program as television's singular or even primary commodity. A broader view understands that television offers particular conditions of commodification that other industries are finding they can capitalize on, rather than just commandeering ad slots within them. One way in which to track these new aspects of media capitalism is to focus on what Henry Jenkins calls "affective economics," which he understands to be "the emotional underpinnings of consumer decision-making as a driving force behind viewing and purchasing decisions."[31] Like marketers, Jenkins associates affective economics with program loyalty, which in turn translates into product loyalty. In my own terms, program loyalty should be considered an effect of intimacy, whose flow can be channeled from program to associated products, although its practical effects tend to be much less predictable. Not all programs, of course, generate the same degree of intimacy for the same kinds of audiences, but reality TV

programming has found a key device for generating intimacy by serializing viewers' contact with "real" people; as Jenkins recognizes, "[v]iewers get to know the contestants, learn their personality, their motives for competing, their backgrounds, and, in some cases, other members of their families."[32] To link together serialization with the continuity of "real" identities from one medium to another, as contestants move from television to print to Internet, for instance, is to understand how industry convergence programs differ from their previous television incarnations as talent shows and cooking programs. Serialization, says Jenkins, "may be why *American Idol* has become such a powerful marketing tool for launching the careers of young performers compared to earlier televised talent competition"[33] – and, of course, such a powerful marketing tool for selling the products of sponsors associated with the convergence industry. As compelling as this model of affective economics is, however, the focus on "loyalty" to brands continues to treat the programs themselves as sites of branding, rather than considering how the medium specificity of television facilitates new modes of cultural as well as affective convergence. Reality television, I would argue, serves as a particularly enabling framework for commodity transfer and convergence, not just because of its serialization or availability for product placement, but for the way in which it mobilizes a key component of the medium itself: its capacity for proximity, immediacy and especially intimacy.

As I have suggested earlier, one reason that reality programming found a foothold in TV schedules is that it developed under the same conditions that have given rise to models of media convergence. In this sense, reality TV belongs to the "new media" face of television. Its longevity, however, has less to do with its ability to be clipped and downloaded, than with the way that it fulfills and even extends the key attributes of television as "old media." A great deal of scholarship has been devoted to demarcating the spatial and temporal attributes of television in terms of immediacy and "liveness."[34] Suffice it to say here that the very word "television" reminds us of its core function: to enable viewers to see across a distance and, in doing so, to bring things and events close to viewers, into their very living room (or, now, their palms).[35] What often gets overlooked in discussions of the immediacy of television, however, is the way in which spatial and temporal proximity is translated through the viewing experience into relations of intimacy. Cecilia Tichi has approached this question historically, detailing the promises of intimacy made in 1940s and 1950s marketing campaigns for television,[36] while Margaret Morse has conceptualized the same point theoretically, drawing out an imaginary "Z-axis" that connects viewers to the screen through television's mode of direct address.[37] I would extend these arguments to claim that intimacy is a core characteristic of the television medium; if immediacy describes the deep-lying

structure of television, then intimacy describes its deep-lying affect.[38] Indeed, television itself as a marketable commodity has depended, since at least the post-war period, on its affective function. In the new media age, this characteristic of television does not disappear, nor does it fade away; on the contrary, the intimacy particular to the medium carries over and, I would say, drives consumers to pursue TV content onto other platforms and associated industries to pursue consumers through TV content.

Reality television is extremely good at creating connections of intimacy amongst participants, due to its fascination with conditions of proximity, as well as between participants and viewers, due to the continuity between participants' screen and real-world identities. Santino Rice, the charismatic runner-up of *Project Runway*'s second season, has nicely articulated the way that televisual proximity is experienced by reality TV viewers as an intimate knowing, which disregards screen/world boundaries: "Yeah, people feel like they know me ... there's no barrier there. I've been at parties where there've been a lot of actors, but people don't feel like they *know* them."[39] The distinction made by Santino shifts the line commonly drawn by television scholars between (film) actors and (TV) personalities, to a new line between performers in reality programming versus those in fiction: viewers feel an intimate relation with "real" people on screen which is not possible with "actors." While Santino, presumably like all participants in the industry-convergence subgenre, appeared on *Project Runway* for the chance to gain exposure, the counterpart of such exposure is the feeling of intimacy gained *by* viewers. Indeed, intimacy subtends and supports the exposure received by participants, extending from the screen to the people to the objects they make/wear/eat, etc. Intimacy on reality TV thus operates like a current: it can flow from the program which fostered it to other media programs, platforms and products; it can even flow as a current between erstwhile viewers and strangers in the world whom they feel they now "know." In its economic dimension, this current of intimacy defines not just the medium-specificity of television but also underpins the commodity flows which themselves define reality programming.

The currency of intimacy

Intimacy is the currency of reality programming, that which makes the various levels of commodity operating within reality TV – products, brands, celebrity, even exposure itself – all interchangeable, and hence able to be converged. Every commodity, such as the celebrity experienced by Santino, can be exchanged for a commodity of roughly equal value, such as the value of Santino's exposure on *Project Runway* or of the exposure accruing to the brand Tim Gunn through Santino's mockingly affectionate imitations of Gunn's voice.

This becomes possible precisely because all of these commodities are carried by flows of intimacy and made interchangeable in this current. Convergence in reality television, then, is a principle put into practice not by technological multifunctionality or platform cross-over, but rather by an affective flow experienced as intimacy. Although (a great deal of) money is involved in the making and franchising of these shows, it is to some extent invisible and, importantly, incommensurate: why should participants win $1 million, or $100,000 and a contract, or a house whose actual building costs we can only guess at (as in *Extreme Makeover: Home Edition*)? How do these sums match up with participants' labor on the one hand, and the balance sheet of the production companies on the other? More to the point, how do we put a dollar amount on a brand whose value is determined by cultural affect? Given the incommensurability of these units of value, it is the palpable flows of intimacy rather than the invisible flows of money that function as currency in these shows, and that in turn raise the value of the commodities and brands associated with them. In the industry convergence programs, the leisure industries buying into reality TV formats are keen to adopt their particular kind of currency – intimacy – in order to make a profit.

For television studies, this relation of "buying into" means that we must ask to what extent it is possible for a (reality) TV show, considered as a cultural, economic and especially an affective commodity, to serve two masters equally, the needs of television as well as of the industry that provides the content and sponsorship. The answer, of course, is that two masters are never quite equal, which means that in practice reality television tends to its own commodity conditions first, so as to generate and sustain the flows of intimacy from contestants to audiences to products that other entertainment and leisure industries want to invest in. In some cases, the divergence between commodities and target consumers is too great, causing sponsors to withdraw their support from programs. In other cases, however, the convergence partnership expands the possibilities of the televisual medium itself. The visual objects of leisure culture – modeling, fashion, dance, etc. – are obvious contenders for industry-convergence with television, as is the music/television cross-over, which has a rich history stretching from live musical performances on variety and talk shows to the inception of MTV and any number of music-video channels. What seems far less obvious, however, are partnerships with industries that rely on something other than visual and aural pleasure, such as the food industry on *Top Chef* or *Hell's Kitchen* (how do we as viewers know one dish tastes better than another?), or the corporate job "interview" on *The Apprentice* (how do we as viewers measure corporate success?). These programs suggest that it is industry convergences, rather than just technological or platform convergences, that are able to extend the arsenal of television's effects for viewers –

to the synaesthesia of taste, smell and even the more haptic experience of boardroom buzz or the swish of a good bias-cut skirt.

This ability to turn the visual pleasure traditionally associated with screen culture into a highly synaesthetic leisure experienced by viewers of industry-convergence programs goes to the core of reality television's elasticity, its ability to facilitate commodity transfers by exploiting the affective charges of the medium. Whether it extends the boardroom or food service to the screen, reality TV enables convergence by making intimacy more available for investors, and more intense and accessible – more "real" or felt – for consumers. The abstract surplus of intimacy produced by reality TV, over and above the "labor" of its participants, is the very currency of convergence; it is the means by which convergence partners who invest in reality TV programming are able to extend their profit margin. This is how I understand Jenkins' "affective economics" in terms of reality TV: the elasticity of the medium, which has to do with its proximity, presence and accessibility, transforms the work of participants in convergence shows into a new and highly profitable form of capital. This may make for some odd, as-yet-unimaginable industry couplings and even eccentric consumer decisions in the tides of capital flow, but the capitalism of new media exchanges also produces effects that cannot be controlled or recuperated purely in its own terms. To phrase this point in industry terms, there are always potential new convergence partners for this old medium. Thus, while industry-convergence programs are the current sophisticated solution to the ongoing problem of how to keep advertisers one step ahead of consumers, their success has a lot less to do with selling laundry powder or even Coca-Cola than with the televisual capacity for overflow – that is, for generating and channeling affective flows that serve but also exceed individual industry needs. This is the surplus from which potential partners profit, at the same time as it exposes potentially productive differences among convergence partners. Under the conditions of this divergent convergence culture, reality television overflows into non-visual and even non-media industries, making a lot of people "happy."

Notes

1. Henry Jenkins, *Convergence Culture: Where Old and New Media Collide* (New York and London: New York University Press, 2006), 59, 61.
2. Ibid., 2.
3. Ibid., 61. Jenkins adds that Kelly Clarkson's single, "A Moment Like This," "went on to become the top-selling U.S. single for 2002" (61).
4. Jennifer Hudson won both an Oscar and a Golden Globe in 2007 for her supporting actress role in *Dreamgirls* (2006) and is now poised to play Aretha Franklin in the biopic *Aretha: From These Roots*. American Idol Jennifer Hudson, "Jennifer Hudson News," www.americanidol-jenniferhudson.com/ (accessed February 22, 2008).

5. The optimistic approach tends to mark the discourse of technological convergence and includes the celebration, by marketers as well as consumers, of "on-demand" technologies, which now seem to occupy that heady place of promise once reserved for the term "interactivity." Jenkins, for instance, refers to the optimism of technological convergence as the "Black Box Fallacy": "Sooner or later, the argument goes, all media content is going to flow through a single black box into our living rooms . . ." (14), despite the evidence in our own homes that we are "seeing more and more black boxes" (15).

6. Gracie Lawson-Borders, *Media Organizations and Convergence: Case Studies of Media Convergence Pioneers* (Mahwah and London: Lawrence Erlbaum Associates, 2006), 4.

7. Jenkins, 2.

8. Ibid., 59–61.

9. See, for instance, Charlotte Brunsdon, Catherine Johnson, Rachel Moseley and Helen Wheatley, "Factual Entertainment on British Television: The Midland Research Group's '8–9 Project'," *European Journal of Cultural Studies* 4.1 (February 2001), 29–62.

10. See Richard M. Huff, *Reality Television* (Westport and London: Praeger, 2006), esp. chapter 1, "*Survivor*: The Start of It All," 1–10. Of course, *Survivor* was adapted from the Swedish-originated program *Expedition Robinson* (SVT, 1997–2003), which was in turn developed in the UK by Charlie Parsons, who retains an executive-producer credit on *Survivor*. (For more on the vexed origins of *Survivor*, see Sam Brenton and Reuben Cohen, *Shooting People: Adventures in Reality TV* (London: Verso, 2003); especially chapter 3, "Format Wars," 44–80.) The point remains, however, that *Survivor* was the first hugely successful reality TV show in the US and is often claimed as the starting point for American reality television.

11. See Amy West, "Caught on Tape: A Legacy of Low-Tech Reality," in *The Spectacle of the Real: From Hollywood to "Reality" TV and Beyond*, ed. Geoff King (Bristol: Intellect Books, 2005), 83–92.

12. See Bill Nichols, *Blurred Boundaries*, especially chapter 3: "At the Limits of Reality (TV)" (Bloomington: Indiana University Press, 2004), 43–62.

13. See Ernext Mathijs and Janet Jones, eds., *Big Brother International: Formats, Critics & Publics* (London: Wallflower Press, 2004).

14. Warning for American viewers who did not watch the first season of *Big Brother* (CBS, 2000): Endemol's original *BB* format stipulated that the housemates nominate two people for elimination each week, with viewers then voting on which of the two nominees would be eliminated. After the relatively poor ratings for the first season of *Big Brother* in the US, CBS hired Arnold Shapiro to revamp the format, with the result that the American format adopted a more *Survivor*-like voting process limited to participants. See Mark Andrejevic, *Reality TV: The Work of Being Watched* (Lanham: Rowman and Littlefield, 2004) for a detailed commentary on the first season of the US *Big Brother*.

15. See Ted Magder, "The End of TV 101: Reality Programs, Formats, and the New Business of Television," in *Reality TV: Remaking Television Culture*, eds. Susan Murray and Laurie Ouellette (New York: New York University Press, 2004), 137–156.

16. See John Downing, "The Political Economy of U.S. Television," *Monthly Review* 42 (1990), 30–41; and Chad Raphael, "The Political Economic Origins of Reali-TV," in *Reality TV: Remaking Television Culture*, eds. Susan Murray and Laurie Ouellette (New York: New York University Press, 2004), 119–136.

17. Jenkins reports that AT&T regarded the initial seasons of *American Idol* as a tool for habituating Americans to the use of text messaging, in order, of course, to expand the economic profitability of this mobile capability (59).

18. Jenkins, 59–61.

19. Ibid., 3.

20. Music RTV more recently has gone from nurturing neophytes to filling a spot in an established band, such as the *Rockstar* series (CBS, 2005/2006) and *Search for the Next [Pussycat] Doll* (The CW, 2007).

21. For more on the Tyra Banks brand, see Lynn Hirschberg, "Banksable," *New York Times Magazine*,

June 1, 2008, www.nytimes.com/2008/06/01/magazine/01tyra-t.html?pagewanted= 1&_
r=2&ref=magazine (accessed July 25, 2008).

22. Cycle 5 of *America's Next Top Model* included both a fashion spread in *Elle* magazine and a
cover photo for *Elle Girl*, the former shot by Gilles Bensimon, whose name has become
branded through its inclusion in the grand recitation of prizes that precedes the judging
segment of each episode.

23. Jennifer Senior, "The Near-Fame Experience," *New York Magazine*, August 6, 2007, http://
nymag.com/news/features/35538/index4.html (accessed September 8, 2007).

24. Jenkins, 2.

25. Ibid., 13.

26. For more on the notion of overflow, see Will Brooker, "Living on *Dawson's Creek*: Teen
Viewers, Cultural Convergence, and Television Overflow," in *The Television Studies Reader*,
eds. Robert C. Allen and Annette Hill (London and New York: Routledge, 2004),
569–580.

27. Senior, "The Near-Fame Experience."

28. Ibid.

29. Hirschberg, "Banksable."

30. Senior, "The Near-Fame Experience."

31. Jenkins, 62.

32. Ibid., 79.

33. Ibid.

34. See, for instance, Stephen Heath, "Representing Television," in *Logics of Television*, ed. Patri-
cia Mellencamp (London: British Film Institute, 1990), 267–302; Jane Feuer, "The Concept
of Live Television: Ontology as Ideology," in *Regarding Television*, ed. E. Ann Kaplan (Fred-
erick: University Publications of America, 1983), 12–22; and Philip Auslander, *Liveness:
Performance in a Mediatized Culture* (London and New York: Routledge, 1999).

35. See Lynn Spigel, *Make Room for TV: Television and the Family Ideal in Postwar America* (Chicago:
University of Chicago Press, 1992).

36. Cecilia Tichi, *Electronic Hearth: Creating an American Television Culture* (New York: Oxford
University Press, 1991).

37. Margaret Morse, *Virtualities: Television, Media Art, and Cyberculture* (Bloomington: Indiana
University Press, 1998).

38. See Misha Kavka, *Reality Television, Affect and Intimacy* (Basingstoke and New York: Palgrave
Macmillan, 2008), especially chapter 1.

39. Senior, "The Near-Fame Experience."

Part II

Creating authors/ creating audiences

The chapters in this section analyze the people and processes by which media texts are produced and consumed, and consider the corresponding redefinition of authors and audiences in a world of media convergence. The authors assess audiences and authors from varying perspectives, but all recognize how contemporary media convergences are blurring established categorical boundaries between those who make media and those who consume it.

These chapters often return to the concept of auteurism – an idea perhaps long thought outdated in television scholarship. The auteur theory, originally articulated by the French film critics of *Cahiers du Cinema*, had defined the "author" of the film as its director and posited that certain directors had achieved a level of creative mastery in their body of work to qualify them as film artists. Media convergence continues to challenge and complicate the notion of the text's author as a singular creative genius. How, for example, does the concept of authorship transfer across media in the ways that convergence culture demands? In what ways does auteurism continue to maintain its cultural cache, and in what ways has the concept become obsolete? This latter question is especially salient in a media culture where the boundaries between authors and audience members are consistently and increasingly blurred. Both official and unofficial fan blogs allow authors and audiences unprecedented access to each other and to the complementary processes of production, distribution, and consumption. Does this level of interaction demand a shift in understanding both authorship and consumption? Additionally, what role do audiences, marketers, critics, and others involved in the distribution of texts play in the process of authorship? Conversely, do shifting definitions of authorship compel a redefinition of the audience?

Whether explicitly or not, a number of this section's authors raise ethical questions, as well. These chapters interrogate the extent to which media convergences alter how individual selves are represented, constructed, and interpellated within and across media formats. For example, "reality" television

presents its subjects as "real" people who are, nevertheless, highly mediated. Producers and writers create commentary tracks and podcasts that presume to provide a glimpse of the author's real self and the real process by which texts are created, though these, too, undoubtedly offer only a very selective portion of such "truths." And corporate-created websites mimic the content that fans have traditionally produced in support of their beloved media texts.

Part II thus explores the ethics and politics of the interaction between producers and consumers, authors and audiences, facilitated by media convergence. The chapters question whether the invitations for involvement function as empowerment or co-optation, and whether the multiplication of mediated selves in a convergent mediascape democratizes the parameters of a shared media culture, or crystallizes the commodification of media authors and audiences. In raising these concerns, these chapters weigh the benefits of media convergence against some of its more adverse consequences and question whether contemporary media practices of making, experiencing, and remaking media have exceeded the binary author–audience model.

More "moments of television"
Online cult television authorship

Derek Kompare

In January 2006, Ronald D. Moore, executive producer and self-described "developer" of the revised *Battlestar Galactica* (2003–), opened his podcast commentary of "Black Market," the fourteenth episode of the show's second season, with a frank admission:

> [Today's] podcast we're gonna be do [*sic*] something a little bit different, actually, than the norm. We're going to be talking about an episode that I don't particularly like and discussing maybe the reasons why it doesn't work and the problems that I think are inherent in this particular episode.... The decisions that led to this episode being something that I'm not as enamored with really can all be tracked back to decisions that I made at various stages in the creative process. So this is really a podcast devoted to self-examination and self-criticism, more than anything else, and going through why this particular episode doesn't seem like it fits as well within the pantheon of what we've established.[1]

The significance of this statement lies not only in its content, in which Moore invites criticism of "Black Market," and his role in its execution, but its form, a podcast audio commentary track designed to be played alongside the episode, one of a regular series of such commentaries released in conjunction with new episodes. The very existence of such a media text, released on the official *Battlestar Galactica* website, raises questions about the parameters of media textuality in the digital age. Most directly: why does a television writer-producer record and distribute his thoughts about his work? Answering that question requires us to explore the relationships between different conceptions of "television" at this historical moment: as a cultural artifact, a capitalist product, a content distribution platform, a technology of citizenship, a human activity, and an object of scholarly study.

Running through all of these conceptions, however, is another, underexplored concern: authorship. Who, or what, "authors" television? The question

of "who" is the origin of the text we are presented with, and what, if anything, we should do with that knowledge has fueled entire fields of cultural and aesthetic inquiry. Regardless of the contentious metaphysics of "the author" as a textual force, however, actual "authors" – cultural, economic, and (not least) legal entities claiming that their labor and intellect create particular artifacts – exist. Authorship, then, as theorized (albeit differently) by both Pierre Bourdieu and Michel Foucault, has a material effect, as a category or "position," to use Bourdieu's term, that attempts to claim capital vis-à-vis association with the work(s) it ostensibly refers to.[2] Authorship is not only activated by ostensible authors, but by attributors as well: those who name and rename particular people and institutions as authors, to attain and maintain their own cultural and social positions. In contemporary society, these attributors include critics, editors, network and studio executives, journalists, fans, and educators (including, of course, literary, film, and media scholars). Despite its rejection in much recent aesthetic and cultural theory, authorship still wields considerable discursive and material power. The purpose of this chapter is to explore a small, but nonetheless significant, area of authorship in the early twenty-first century: officially produced cult television podcasts.

Although authorship has long been associated with the study of literature and film, it has not been a particular concern of television studies. Indeed, if anything it has been studiously avoided.[3] There are myriad, and historically legitimate, reasons for this, stemming largely from the particular confluence of social scientific and cultural studies scholars and methods that formed the epistemological basis of the field in the 1970s (and the contemporaneous "death" of the author in the adjacent fields of film studies and literary studies). Essentially, in order to claim academic legitimacy, television was reconceived at that time as a medium of "texts" and "readers," but no "authors," or at least none beyond the monolithic constructions of networks, studios, and media corporations offered up by Marxist theory and political economy.[4] This perspective served the field well, particularly in the cultural studies-derived audience studies of the 1980s and 1990s, helping transform the academic reputation of that most reviled cultural object into a medium of legitimate scholarly inquiry and potential political activation. Unfortunately, while it helped secure intellectual and material capital for television studies, this same conception arguably moved the field further away from understanding its object of study on its own terms, i.e., as "television." Indeed, for many cultural studies scholars of the time, television was useful only for how its polysemy theoretically activated cultural politics, usually in the forms of audience "pleasure" and even "resistance" to hegemony. However, as Jonathan Sterne writes in his critique of cultural studies' "instrumental notion of culture," this stance disavows its very object of study:

[alone], it is a political dead end: it carries with it a reactive notion of politics and a deferral of social and political imagination. . . . [it] contributes nothing to the project of conceiving a culture or society in which people would want to live.[5]

The work of John Fiske was a critical contribution to this model of cultural studies, especially in regards to television. Adapting structuralist semiotic analyses of television to a more post-structuralist brand of cultural studies, Fiske argued in the 1980s and early 1990s that popular, and indeed, popu*list* television was an important resource for "bottom-up" cultural politics. Since then, Fiske's work has been roundly, if often unfairly, criticized for its functionalist conception of culture and optimistic faith in "the people," and largely fell out of favor in the late 1990s.[6] Still, this doesn't necessarily negate his more promising concepts for approaching television as a cultural medium. One of these, implicit in his 1987 book *Television Culture*, and elaborated in a 1989 article, is the "moment of television":

> What the set in the living-room delivers is "television," visual and aural signifiers that are potential provokers of meaning and pleasure. This potential is its textuality which is mobilized differently in the variety of its moments of viewing. . . . There is no text, there is no audience, there are only the processes of viewing.[7]

While the functionalism of that brand of cultural studies rings loudly in this quote (e.g., the focus on "[provoking] . . . meaning and pleasure"), the idea that television is really about what happens *between* texts and viewers remains compelling.

However, while Fiske located these moments only in the junction of text and audience, I believe that the "moment of television" is not limited to the text–audience nexus, but extends to a program's ostensible authors as well. Authorship, in this case, is a connection, as well as a claim; it functions both as a relationship between producer and user, *and* a proprietary discourse, with particular cultural, legal, and social attributes. "Television" is not only what producers assemble, nor only the particular text on the screen, nor only what viewers make of it, but consists of *all* of this: all the institutions and practices that surround, produce, and contextualize those moments, i.e., *all that makes the very idea of "television" meaningful.*

In the 20 years since Fiske introduced his theories, "television" has changed considerably. "Television" now refers not only to a specific, scheduled encounter between national networks, viewers, and "the set in the living room," but an increasingly diverse array of activities, texts, and technologies. Moreover,

as the Internet, and not the television set, is increasingly the cultural hub of the global cosmopolitan household, more and more television viewing and contextualizing is occurring online. "Television" is now portable and malleable, taken in on screens of all sizes, filed away on DVD box sets, and remixed on YouTube. "Television" exists as a massive mobilization of capital, culture, and technology; as illicit but eternally circulating BitTorrent files; and as countless discussion threads on LiveJournal fan communities. Thus, a "television moment" today is much more likely to happen away from the set than it was in 1989, and much more likely to involve interactive networks of users, rather than isolated individuals generating their own resistant readings alone in their living rooms.[8]

The changes in television since the 1980s apply particularly to the issue of authorship, for at the very moment television studies abandoned the author as a viable avenue of inquiry, television itself began to increasingly foreground its ostensible authors. John T. Caldwell describes the television industry of this era as increasingly concerned with its distinction and "visuality," and importing established film director-auteurs as an important creative and competitive strategy.[9] This trend, driven by pressures of the megachannel television universe, corporate branding, and new distribution platforms, has continued and amplified since Caldwell's 1995 study, but has gone well beyond enshrining only established film directors as "television auteurs." Instead, by the early 2000s, it was more common for "distinctive" series to be associated with their "showrunners": writer–producers who oversaw and managed production of the medium's primary aesthetic form, the primetime serial. While visual style was increasingly important, its realization could be delegated to directors, art directors, and editors. The "source" of television authorship was re-attributed to the showrunner.

This particular figure, the showrunner, at this particular moment in television and cultural history, is significant in three respects, each calling into question the neglect of authorship in television studies, as well as its conceptual languishing in other fields. First, the prominence of the showrunner-as-author reminds us that television is indeed *made*: the result of intense collaborative, capitalist, and exploitative labor. The 2007–2008 strike by the Writer's Guild of America (WGA) against Hollywood studios and television networks opened the hood on Fiske's text machine, drawing attention to the creative labor behind it, and shutting it down for three months. That said, and acknowledging the important issues of ownership and compensation brought up by the striking writers, exactly how that creative labor is made meaningful is of course a more complex issue than the mere fact of its taking place. Examining the contexts and meanings of that labor is a necessary step toward a fuller understanding of mediated culture in general.[10]

This issue of capitalist labor brings up the second factor: television as a branded cultural product. Television programs have been increasingly fashioned as standard-bearers of distinction for their networks and production companies in order to gain market share in their targeted demographics, and TV "authors" have often functioned as the standard itself. For example, HBO's (in)famous tagline – "It's not TV, it's HBO" – is premised on the viewer understanding what that "it" is in relation to what "it" is not (i.e., the rest of "TV"). Often, the "it" is as much the presumed showrunners of their signature programs (David Chase, Alan Ball, Darren Star, David Milch) as it is the shows themselves (respectively *The Sopranos*, *Six Feet Under*, *Sex and the City*, and *Deadwood*), thus helping the network leverage its brand further and further up the distinction scale.

Finally, and closely related to the first two concerns, the notion of the television author is often an important factor in the formation of so-called "cult" audiences. As described by Matt Hills, while the term "cult" has usually been applied from outside fandom as an epithet (i.e., suggesting an anti-normative, neo-religious attachment to particular texts and practices), it has also been embraced in various ways from within fandom as a means of justifying and celebrating fan practices.[11] Indeed, since fans' "cult artifacts" are highly arbitrary, and vary widely, even within specific media "cults," it is difficult, even for fans, to pin down exactly why they are fans, or even what exactly they are fans of. That said, the figure of the cult "auteur," i.e., the attributed creator of the cult object, is important within most media fandoms, providing a nexus of fan critical activity, and, as with HBO above, anchoring the claim in traditional constructions of the author as Romantic genius. "Cult television," then, as a specific (if ultimately ambiguous) category informing the production and reception of television programs, provides a particularly useful concept around which discourses of authorship, affect, and difference can be articulated by fans, critics, scholars, media corporations, and television creative talent.

In this chapter, I examine these three factors in the production of the cult television authorship of the series *Lost* (2004–2010) and *Battlestar Galactica* (2003–2008) on the Internet via officially produced podcasts. These "paratexts" – i.e., material spun off from but relating back to the primary text – distributed on the series' official websites, as well as on the Internet's premier media retailer, iTunes, indicate how discourses of authorship, already critical to the formation and practices of cult television fandom, have taken on a new significance to cult television producers and distributors online. While they are transparently the products of an anxious media industry's attempts to augment what Henry Jenkins describes, in contemporary industry terms, as the text's "engagement" with its "loyals," I believe they also help to extend the scenario of Fiske's "moments of television" between "author" and "fan" (i.e.,

both "production," and "reception," in the classic formulation), with the text serving not only as a "semiotic experience," but as a stimulant to interaction between and among these parties.[12]

Granted, there are power differentials between and among these authors and their interested fans, but these must be analyzed and contextualized in their specific instances, rather than assumed a priori. My aim here is to examine these podcasts from the perspective of production; that is, to explore the ostensible forms and content – the "positions" and "position-takings" that Bourdieu theorizes constitute all fields of cultural production – of television authorship taken on its own terms, as textual attempts by television producers and production companies to engage in what has historically been a fan-driven domain.

"Authoring" cult television

Although the word "cult" is often avoided by fans and fan scholars, due primarily to discomfort with the neo-religious connotations it stirs up, it remains a useful category through which certain texts and practices can be articulated with wider cultural categories. In particular, it has served a key purpose for the media industry, helping them to identify which properties might likely attract potentially lucrative, and loyal, so-called "cult" audiences. I use the word here fully aware of such baggage, which I believe foregrounds the issue of a text's (and fandom's) perceived and projected relationships to "normative" texts and practices. "Cult television," then, anchors a set of discourses that shape how particular programs are produced, promoted, and used.

In his overview of the concept in *Fan Cultures*, Matt Hills writes that one of the key factors that typically drives the cult status of a television show is a conspicuous authorship. Cult television fan interest in series' narrative worlds has typically, though certainly not always, extended to interest in their producers, writers, and other production personnel. In other words, authorship per se, if not outright auteurism, has generally been a major fixture of cult television fandom, with certain creative personnel (most often showrunners) identified by fans as the originating intelligence(s) behind the object of their devotion. As Hills notes, this auteurism in turn propels fan discourses of high cultural status, as the figure of the author has historically been used by cult fans (as well as sympathetic mainstream critics) as a kind of guarantor of quality: "[auteurism] brings with it an ideology of quality: if much mass culture is supposedly unauthored – supposedly being generated according to formulaic industrial guidelines – then 'high culture' reading strategies intrude on this space through the recuperation of the trusted Creator."[13]

That said, any claim to authorship is a matter of context. All television, and all culture for that matter, is of course "created" by many individuals and

groups. The difference between virtual anonymity and ostensible authorship lies in how what they've produced is articulated with particular parts of the culture at particular moments and contexts, and how they, *as distinct individuals*, plot themselves, or are plotted, into those contexts. As Pierre Bourdieu argued in "The Field of Cultural Production," "[the] meaning of a work . . . changes automatically with each change in the field within which it is situated for the spectator or reader."[14] Thus, any shift in "where" a work is culturally situated alters its potential meanings, opening up spaces for potential reclamation. Bourdieu's term for such movement is "position-taking," suggesting that the contexts of cultural production can theoretically be strategically planned, or at least shaped after the fact.

The indefinite status of the term "cult" fosters a wide range of such position-takings, on both sides (i.e., production and reception) of the texts in question. As the general veneration of the author in "cult" television indicates, the "quality" tag, long associated with "authored" tropes such as high-minded purpose and/or formal sophistication, is a close discursive neighbor (albeit one with a more lucrative address). Many so-called "cult" programs have been categorized as "quality," and have benefited from an accompanying shift in cultural position.[15] In an era of brand extension and viewer engagement, the area in which these categories overlap has thus become a viable, if risky, television production category, exchanging the relative safety of known formulas for a smaller, yet more loyal audience. Both *Battlestar Galactica* and *Lost* function as "quality cult" shows in this manner, largely based on the ostensible aesthetic promise of their authorship. References to showrunners' "plans" and even "vision" are common in publicity and critical coverage of these series.

Cultural studies, however, has arguably been premised on the *destruction* of such formal qualities, or at least their political reversal (as in the championing of "popular" culture vs. "high" culture). Aesthetics in cultural studies has generally functioned as a means of textual politics, usually located in counter-hegemonic meanings generated by people using media. Hills argues that this conception has served to both reify the politics and disavow the aesthetic tastes of cultural studies scholars, thus reassuring them that they're not mere "consumers" or "fans."[16] As a way out of this perpetual (and unreflexive) reification of politics-as-aesthetics, Cornell Sandvoss suggests that aesthetics *can* re-enter media and cultural studies, but only if the field revalues the activity of "reading" (i.e., viewing, etc.) on its own terms:

> If we cannot locate aesthetic value in the author, text, or reader alone, it is in the process of interaction between these that aesthetic value is manifested. . . . By defining the act of reading as a form of dialogue between text and reader . . . , in fandom and elsewhere, we enter into a wider

social and cultural commitment as to what texts are for and what we believe the uses of reading to be.[17]

By focusing on the issue of "interaction," Sandvoss here effectively channels Fiske, though he reimagines the parameters of the political through aesthetics. In doing so, he is asserting a model of analysis that re-establishes understandings of fandom *qua* fandom, i.e., as an affective relationship between text and user, rather than a vehicle for scholars' pursuit of "good" cultural politics. I would add that this relationship, in cult television fandom at least, typically extends to texts' ostensible authors, i.e., that the aesthetic dimensions of many (though certainly not all) fan reading practices are enhanced by discourses of authorship. Authors may be discursive projections that efface the collaborative nature of television production and reify individual psychology, but they're also engaged with by fans and others as attributed agents of textuality, and have long served to channel sentiments and rationalizations about media texts.

Aside from the programs themselves and their accompanying publicity (including reviews, interviews, retrospectives, DVD commentary tracks, and "behind the scenes" features), the primary locations for such authorial "positions" and "position-takings" within cult television today are online, where fans have historically gathered to present and discuss cult texts. Moreover, since most cult television series have ongoing serial narratives, online speculation about narrative development is an important center of fan activity. Hills notes that online fan communities have done this since at least the early 1990s, as "practices of fandom have become increasingly enmeshed within the rhythms and temporalities of broadcasting." However, Jenkins points out that shows and networks have caught on to these fannish rhythms, and are trying to colonize fan activities, offering extended information and entertainment on their own "official" sites.[18] Accordingly, producers of cult programs are much more likely to interact in these spaces, posting on network message boards and blogs, and perhaps even hosting their own sites. Moreover, these authors increasingly participate in virtual real time, at the pace of the television season, rather than after the fact. While the degree and variety of this participation varies widely, and bearing in mind the thorny theoretical and methodological issues of online communication, the Internet is nonetheless the primary space where "authors" conceptually "meet" their "readers."[19]

As "official" paratexts centered on ostensible cult television authors, the *Lost* and *Battlestar Galactica* podcasts reveal a great deal about how author identities and industrial discourses are crafted for fans' consumption. As John T. Caldwell has argued, the industry's complex rituals and practices, including seemingly "outward-directed" discourses like podcasts and similar publicity, are far from transparent or monolithic. Indeed, according to Caldwell, "in many ways

these mediations *are* the industry."[20] The online texts studied here present such moments of industry-originated mediation to interested cult television fans, complete with the formal trappings of authorized industrial discourse. Thus, they display two distinct ways in which "the industry" – i.e., the established structures of operation and modes of address, *and* the individual agents which function through them – fosters extratextual television moments with its most engaged viewers.

The author show: the Official *Lost* Podcast

While most text-based forms of online interaction, such as blogs and message boards, mimic the transparency of informal interpersonal communication, podcasts typically deliver content in the familiar trappings of non-fiction audio broadcasting, with hosts, interviews, feature segments, intros and outros, standardized running times, and even theme songs. Significantly, even "amateur" podcasts, produced well outside established mainstream media corporations, utilize such normative formal elements. That said, like other "alternative" media texts before them (e.g., zines, fanfic, music bootlegs, etc.), most podcasts also venture further away from some of those normative codes. For example, podcasts may have "lower" production values, with imperfect audio and editing; or violate norms of broadcast speech, with more profanity, more rambling discussion, and less polished vocal performances. Yet regardless of their source or content, as a "new" media form, podcasts rely on an understanding of the normative limits of "old" media codes.

This hybridity is certainly evident in the "Official *Lost* Podcast," which features *Lost* showrunners Carleton Cuse and Damon Lindelof, and is hosted on the show's official website at ABC.com.[21] The podcast ostensibly functions as an outlet for further fan engagement with the notoriously attention-demanding ABC drama, and is explicitly connected to the "official" message board also hosted at the ABC site. The performances of Cuse and Lindelof, however, shift the proceedings into a complex "moment of television," an encounter between producer and audience fraught with conflicting discourses of authorship and fandom. While Cuse and Lindelof are formally structured in the podcasts as the series showrunners (consistent with all the series' publicity), their self-presentation shifts between being all-knowing authors, eager fans, and lowbrow Internet entertainers. The net result is an unsettled author-function that attempts to negate claims of authority (much as a typical podcast veers off the established path of broadcast media) while still orbiting back to them.

Running weekly during the regular season, and occasionally outside of it, episodes typically center on Cuse and Lindelof discussing the previous and upcoming episodes and answering questions posed to them by the users of the

Lost forum at ABC.com. Their formal role is to be the official arbiters of *Lost*'s serial textuality, which articulates well with the series' hermeneutic narrative structure as a dense, onion-like puzzle meant to lead eventually to closure and revelation.[22] The two are presented as the ultimate sources of the *Lost* narrative universe. Indeed, the questions they answer in each podcast are addressed directly to them, i.e., "Dear Carlton and Damon . . .," and are typically structured around issues of narrative coherence, with Cuse and Lindelof confirming, denying, or obfuscating in their answers.

However, rather than consistently act as the definitive source of all things *Lost*, Cuse and Lindelof instead present themselves as "Carlton and Damon": two goofy, ironic and punchy guys who happen to be the executive producers of *Lost*. This playful veering off the formal broadcast mode undermines the authority of the form, in much the same way David Letterman, Conan O'Brien, or even Jack Benny "played" at being broadcast hosts. The podcasts are produced relatively informally, a choice made not only to facilitate production but also to strategically enhance producer–fan engagement, conveying that "Carlton and Damon," as people, are not unlike listening fans. Most podcasts seem to be recorded while sitting on a couch in someone's office, rather than in the formal studio setting that would normally be expected from a major television network. Moreover, Cuse and Lindelof apparently record them each in one take, not only leaving in, but also riffing on, most miscues and tangents as part of their personas as laid-back guys who don't take much of this seriously. For example, over the course of the podcasts, they've spontaneously developed many running gags – Lindelof never wears pants, Cuse is a mean banjo player, season seven of *Lost* will be the "zombie season," etc. – that continually undercut their ostensible performance of traditional authorship.

Importantly, however, this tone, while mocking the idea of the all-knowing serious author, is also meant to engage with the more informal and jokey modes of fannish interaction. That is, by playing with the series' concepts in an ostensibly fannish way (e.g., by tallying "DPEs," the number of times per episode that the popular character Hurley says "dude"), they aim to reassure fans that they are "one of them," in sensibility if not in kind. This mode of address includes their fluency in fannish terms and concepts. For example, in the lone fall 2007 podcast (between the series' third and fourth seasons), Cuse and Lindelof used the terms "Jater" and "Skater" (terms by which *Lost* fans interested in particular relationships – i.e., "ships," in fanspeak – self-identify online) without hesitation or explanation, to discuss where the series' central love triangle might be headed, implying that they were familiar with that online fan debate.[23] Moreover, they have also periodically claimed that fan feedback alters their production choices. The characters of Nikki and Paulo, introduced at the end of the second season, were generally despised by fan

consensus online. Cuse and Lindelof acknowledged in a podcast that they realized the fans didn't like the characters, and killed them off midway through the third season.[24] Whether or not such feedback actually had this effect on their decision to dump Nikki and Paulo (instead of, for example, network notes), such explicit moments in the podcast seemingly convey the authors' acknowledgment of fan interest in the narrative, thus textually "paying off" the engaged fans who listen to the podcasts.

At the same time, however, their attitude toward fans can be more ambiguous. A recurring motif on the Q&A section of the podcast is naming the querying fan (by their *Lost* message board username) and revealing their "post count," i.e., the number of posts the user made to the *Lost* message board in the previous 90 days. On the April 20, 2007, podcast, after responding all season with varying measures of disbelief at users' post counts, they improvised a rubric for determining a "healthy" number of posts:

DAMON LINDELOF (DL): From Maxinova. 128 posts in the last 90 days.

CARLTON CUSE (CC): Okay.

DL: We have to make a chart that basically is like, "Here at ninety-nine posts you're sort of . . .

CC: Yeah.

DL: . . . is where the cutoff is." And then that way, when people get to the one-hundredth post, they'll actually think, "Gee, this is where I become insane."

CC: Stop. Yes.

DL: "This is where I literally start to hear . . . *[chuckles]* hear Aaron speaking to me." *[Both laughing]* Yeah. At around 190 posts, that's when you start to hear Vincent speaking to you. And, at a hundred — at around 205 posts . . .

CC: You start going to the *Heroes* website.

DL: Yeah exactly. You can actually begin to write on the show at 205 posts.[25]

In a similar manner, on the February 19, 2008, podcast, in response to a fan question about the relationship of aspects of the show to Hinduism, Lindelof claimed to be continually amazed at the references the fans bring up, and stated that "if we were just one-tenth as smart as you guys are, the show would be amazing, and make no sense whatsoever."[26] While these sorts of statements must be taken in the context of their presumed audience (cult television fans, rather than critics or even general viewers), and their relaxed, quasi-fannish self-presentation, which relies on self-deprecating "geek" humor to poke fun at fan "excesses," it's certainly significant that the points of "excess" they cite typically have to do with affective textual engagement, whether with the

episodes, the message board, or the myriad *Lost* paratexts in distribution. Apparently, even within their approachable, irreverent, and geeky personas, there are normative limits to fannish affect that are discursively enforced. The fact that the enforcers, in this case, are the declared authors of the series suggests the possible limits of this particular "moment of television."

Appropriately, the "official" *Lost* podcasts continually point back to the "official" text of the series, leaving further explorations and insights, such as might be found on external fan sites, outside its boundaries. While Cuse and Lindelof answer selected fan questions, their focus on narrative information (rather than discussion of the production process) and self-deprecating presentation constructs an author-function that both reaffirms and undercuts the series' (and networks') ostensible artistic aims. The hybrid podcast format, straddling formal broadcasting and freeform audio, strengthens this positioning. As a form of cult television authorship, the *Lost* podcast successfully reinforces Cuse and Lindelof's author positions. At the same time, the irreverent tone suggests that that "authorship" is indeed a construction, a function of network publicity, and of their showrunner jobs. Appropriately, the mediated peeks behind the scenes that the podcast offers present a creative process that is bash-it-out, collaborative, and workaday, rather than chin-stroking bursts of inspiration. Although this is also a construction, and does not go nearly as far in this regard as the *Battlestar Galactica* podcasts described below, it does suggest something particular about cult television authorship: that the ostensible process of production, unfolding over a long time period and experienced through cult paratexts, can hold as much fascination as the cult text itself.

Real authorship in real time: Ronald D. Moore's *Battlestar Galactica* commentaries

The Official *Lost* Podcast functions as an explicit paratext in that it is meant to be experienced separately from the program itself. In contrast, Ronald D. Moore's *Battlestar Galactica* commentaries are intended to be heard simultaneously with the episodes. The audio comments of production personnel synchronized with the video track of the object of their discussion would seem to be the ultimate conflation of text and author. However, of all the paratextual forms of contemporary film and television authorship, the commentary track is paradoxically the most ubiquitous and least analyzed. It has scarcely caught the attention of film and media studies as a significant phenomenon; only one scholarly article, in which Robert Alan Brookey and Robert Westerfelhaus explore how director David Fincher's commentary and other paratextual materials on the *Fight Club* DVD channeled meaning away from that film's per-

ceived homoeroticism, has directly examined the commentary track as a particular kind of authorship discourse.[27]

A cursory theorization, let alone a full history, of the commentary track has unfortunately yet to be written. Even so, we can begin to situate the form in 2000s media culture by analyzing where and how it functions. From the beginning of the form on laserdisc in the 1990s, the commentary track has been proffered as a high-end "extra," ostensibly adding more distinction to the media object. The vocal presence of the text's director, producer, writer, and/or star on the commentary track promises, regardless of whether it is ever heard, that it *matters*, that these comments were made by those who were not only "there," but allegedly instrumental in the creation of the text. It is difficult to conceive of a more direct assertion of authorship in a mass-distributed text.

When television shows began to be distributed in DVD box sets in the early 2000s, such trappings of distinction were imported whole cloth from their successful use in video releases of films.[28] Instead of directors, showrunners typically took the center stage in these commentary tracks, reinforcing their claim to authorship. When podcasting and other online media forms began to be featured on official series websites in 2005, downloadable commentary tracks began to appear alongside the usual episode guides, actor interviews, and message boards on a few cult series' sites. By releasing these tracks alongside broadcast episodes in the midst of the season, in addition to on the DVD box set typically released months later, the networks and studios have hoped to increase online fan engagement in "real time." Indeed, these commentary tracks' very existence (as weekly podcasts) suggests that such authorial exegesis is meant to be a normative part of the cult television viewing experience.

Ronald D. Moore, self-described "executive producer and developer" of *Battlestar Galactica*, has produced the most extensive set of online commentary tracks. In them, he presents what is arguably the model cult television author persona: a creator who revels in recounting minutiae of television production and passionately offers storytelling and management philosophies. In other words, he is a television author who performs authorship in a way that attempts to align more with fannish engagement than with the usual discourses of Hollywood publicity. Unlike Cuse and Lindelof, whose presented authorship is kept at a remove from direct commentary via the relatively circumscribed structure and mode of address of the *Lost* podcasts, Moore has seemingly made his commentaries a personal mission. The key factors that produce a particularly resonant assertion of authorship in these podcasts are the breadth and depth of his comments, which culturally convey deep engagement with the production of the series, and the "raw" aesthetic with which they're produced, which suggests the author is "authentically" low-tech and

thus uninflected. His presented author persona is so vernacular that it challenges the effective limits of Fiske's television moments, and raises important questions about the parameters and practices of the fan–producer relationship. As Suzanne Scott writes in her analysis of *Battlestar Galactica*'s paratexts, fans both welcome *and* criticize Moore's controversial podcasts for "precisely this combination of intimacy and authority."[29]

Moore's primary mode of address is candor. He will "tell it like it is," in much the same way his series, noted for its stark realism and rejection of clichéd generic codes, ostensibly does as well. In Bourdieu's schema, such codes of "authenticity" have traditionally appealed to literate upper-middle-class tastes: i.e., educated professionals (including college professors). This has particularly been the case on television of late, as series like *Damages*, *Deadwood*, *Friday Night Lights*, *In Treatment*, and *The Wire* are championed by television critics for their "gritty" and "unflinching" narratives and characters. What this means in practice is that characters and situations on these programs are perceived as "more real" relative to those on television more generally. *Battlestar Galactica* won its place in this category with the additional achievement of surpassing its generic source material (the original 1978–1979 series). In other words, by being "more real" than normative television science fiction.

Moore articulates this particular sensibility in his commentaries by consistently noting those moments of such "realism," and, more importantly, how they came about. This is akin to a novelist discussing the details of their craft, locating the text in the day-to-day work of writing. Moore often contrasts the realism of *Battlestar Galactica* with the fantasy of *Star Trek*, a television franchise he extensively worked on as a writer and story editor for most of the 1990s. This "realism" is manifest in everything from set design to dialogue, according to Moore. For example, in the commentary to "Scattered," the first episode of the second season, he critiques the "technobabble" that was standard at *Star Trek*:

> [When] I was working at *Star Trek*, there were times when we just had pages and pages of this tech kind of dialogue. I've probably ranted about this before on other podcasts, so forgive me if I'm really, if this is becoming a hobby horse, but I think a lot of science fiction, filmed science fiction and film and television, falls down on this front where there's just too much emphasis on all this gobbledygook stuff that doesn't exist and doesn't matter, ultimately. 'Cause it's really about the characters. It's about what choices they're going to make.[30]

Similarly, as the comment that opened the chapter indicates, Moore doesn't hesitate when the series fails to live up to its promise in this regard. His

primary critique of "Black Market" was that it was too much like "television": "very comfortable, very predictable. . . . You tune in to most hour-long dramas on the air and you know where the story's going as soon as you tune in."[31]

Moore consistently focuses on the mechanics of television storytelling, detailing the evolution of scenes and storylines, and explaining why and how they had to change. While this kind of "how the sausage is made" material (to use Moore's own description) has long been the subject of feature articles in cult television fan media, it is rare to hear a series showrunner regularly declaim on it in such detail. In doing so, Moore apparently hopes to convey his "unfiltered" viewpoint to fans, in real time, alongside the episodes themselves. While he is quite clearly set up via the podcast as the primary authorial voice of the series in this regard, he is sometimes joined by other production personnel, including his producing partner David Eick, primary series director Michael Rymer, actors Grace Park and Tamhoh Penikett, and the entire writing staff, as well as his wife, Terry Dresbach (known as "Mrs. Ron" on the SciFi.com message board). In these commentaries especially, he emphasizes the collaborative nature of television production, soliciting others' perspectives, and generally using a collective first person to refer to decisions (e.g., "we decided that the scene was too long"). In the case of the two multiple-part "writers' room podcasts," podcast listeners were even presented with "collaboration in the raw": presumably unedited story breakdown sessions from the *Battlestar Galactica* writers' room, where the plots of the episodes "Scar" and "Razor" were first developed.

While the degree of Moore's candor is certainly rare, he is still, as are Cuse and Lindelof in their own way, performing a role. That role – the authentic "author" – is enhanced through Moore's choice to record his podcasts with a low-end recorder at his home, rather than the usual studio-recorded commentaries featured on most DVDs. Moore's commentaries are filled with the routine sounds of his life: ringing phones, garbage trucks, cigarette lighters, cats, clinking ice cubes, and especially "Mrs. Ron." Fan reaction to these attributes is beyond the scope of this chapter, but their presence suggests that Moore wants his commentaries to reflect the "realism" of the series. This "realism," as presented through Moore, is of the domestic, heterosexual, middle-aged white male expressing his expertise between cigarettes and sips of scotch. Thus, by diminishing the production standards of the commentaries, he has increased these particular codes of his authorship, ostensibly hoping to be a "guy," rather than a "suit," and insuring that his personality represents the show on a regular basis.

It is too soon to tell whether Moore's distinctive approach to commentary tracks will be taken up by future showrunners. Most networks and studios are still loath to offer that much insider scrutiny to fans. However, Moore's

podcasts do represent a particular kind of "television moment," in which the producer (and his wife) ostensibly plops down on your couch as you watch the show. In the case of the podcast for the season three finale, "Crossroads, Part 2," that is *exactly* what happened, as Moore and his voice recorder attended a small "frak party" with fans in Berkeley, California, substituting their "real time" reactions to the episode for his commentary, but sticking around afterward to answer their questions, and be the "author." While this may have been the most direct fan–author moment yet produced in this new era of authorship, the discursive boundaries of "fan" and "author" were still intact throughout.

Conclusion: making it up as they go along

A common fan criticism of serial television showrunners is that they're "making it up as they go along." This epithet presumes a great deal about television production, assuming that the show would be "better" if only it were worked out entirely in advance. It stems from the longstanding Romantic conception of authorship that views creativity as a singular, teleological "A-ha!" moment, as if fully formed ideas spring intact from the author's brain onto the page or screen. Even the structuralist modes of auteurism once in vogue were premised on a similar conceit, replacing the author's individual genius with the uncontrollable impulses of his or her society and/or unconscious. If the study of authorship is to catch up with the burgeoning forms and practices of authorship, it should avoid this dead end by acknowledging creativity's dynamism. That is, by admitting that ostensible authors are indeed "making it up as they go along," and that this is not a Bad Thing.

At the textual level, "making it up" is standard practice in media production everywhere, as media texts are always "works in progress," never quite complete. Moreover, given the uncertainty of practices and textualities in contemporary media, "making it up" is increasingly standard *meta*-practice, informing theorizations of media form and function in corporate boardrooms, studio editing suites, academic conference panels, and anywhere people gather around screens of any size. That said, "making it up" still must draw from established forms, theories, and practices, i.e., cultural codes that attempt to anchor the unknown to the familiar. Just as Cuse and Lindelof must discursively separate themselves from the fans of *Lost*, and Moore must explicitly articulate his notion of realism in order to ground the sights and sounds of "his" show, the performative forms of these podcasts explicitly call upon the established codes of a hegemonic, Romantic, and decidedly masculine authorship to validate these authors' particular position-takings. The participants in the podcasts described here, and in other practices of authorship in twenty-first-

century media, are clearly "making it up," attempting to stabilize the meanings of their work (via established codes) but doing so through a medium and form that are far from stable.

As "moments of television," these podcasts thus create temporary and fluid subcommunities, particular "hot spots" of cult fandom, where the words and personae of series authors generate new dimensions of textuality and inter-action. These new dimensions may be more "collaborative" than "resistant," complicating the old cultural studies model.[32] However, the instability of their forms keeps these moments from unproblematically reproducing the Roman-tic author; the real gaps between cult TV fans and "the powers that be" remain, despite the discursive construction of the "fan-producer" in these podcasts and other forms of contemporary authorship. Like the narratives and styles of both *Battlestar Galactica* and *Lost*, the podcasts challenge fans and producers alike to "keep up" as they're "making it up."

The task going forward is to better understand not only practices of con-temporary television production, but practices of promotion and publicity as well. These online venues, and others yet to be developed, will continue to offer discourses of television authorship to fans and other interested viewers. In order to answer the question I posed at the beginning ("Why do these new forms of authorship exist?"), we must attend to how, in the processes of "making it up," "old" codes – authorship, "quality," "realism," etc. – are applied to new media, and what "moments" these new forms might produce.

Notes

1. Ronald D. Moore, "Black Market," podcast commentary, www.scifi.com/battlestar (tran-scription, http://en.battlestarwiki.org/wiki/Podcast:Black_Market) (accessed February 24, 2008).

2. Pierre Bourdieu, "The Field of Cultural Production," in *The Field of Cultural Production*, ed. and trans. Randall Johnson (New York: Columbia University Press, 1993), 30–31; Michel Foucault, "What Is An Author?", in *Language, Counter-Memory, Practice: Selected Essays and Interviews*, ed. and trans. Donald F. Bouchard (Ithaca: Cornell University Press, 1977), 113–138.

3. In his television criticism textbook, Jeremy Butler brings up the possibility of authorship (though limits his conception of it to "auteur theory"), only to dismiss it as incompatible with how the field has related to the medium: "[The] auteur theory is not just wrong, it is also unnecessary when it comes to understanding television." See Jeremy G. Butler, *Televi-sion: Critical Methods and Applications* (Third Edition) (Mahwah: Lawrence Erlbaum, 2006), 430.

4. There are a few exceptions to the evacuation of authorship from early television studies at this time, most notably in the works of Robert S. Alley, David Marc, and Horace Newcomb.

5. Jonathan Sterne, "The Burden of Culture," in *The Aesthetics of Cultural Studies*, ed. Michael Bérubé (Malden: Blackwell, 2004), 82.

6. See Matt Hills, "Media Academics as Media Audiences: Aesthetic Judgments in Media and Cultural Studies," in *Fandom: Identities and Communities in a Mediated World*, eds. Jonathan

Gray, Cornel Sandvoss, and C. Lee Harrington (New York: New York University Press, 2007), 33–47.

7. John Fiske, "Moments of Television: Neither the Text nor the Audience," in *Remote Control: Television, Audiences, & Cultural Power*, eds. Ellen Seiter *et al.* (New York: Routledge, 1989), 56–57.

8. This is not to say that such "networks of users" did not exist in the 1980s, only that the cultural and technological means through which they can network are now much more prevalent.

9. John T. Caldwell, *Televisuality: Style, Crisis and Authority in American Television* (New Brunswick: Rutgers University Press, 1995), 4–19.

10. For an extensive exploration of these contexts, see John T. Caldwell, *Production Culture: Industrial Reflexivity and Critical Practice in Film and Television* (Durham: Duke University Press, 2008).

11. Matt Hills, *Fan Cultures* (New York: Routledge, 2002), 117–130.

12. Henry Jenkins, *Convergence Culture: Where Old and New Media Collide* (New York: New York University Press, 2006), 25–92; Fiske, 59.

13. Hills, *Fan Cultures*, 133.

14. Bourdieu, 30.

15. It is not insignificant that many of these series have also been well-represented in television studies.

16. Hills states that "[as] if Derridean thought had never existed, this exercising of scholarly judgement assumes that clear lines can be drawn between the politically good and the politically bad text." "Media Academics as Media Audiences," 39.

17. Cornel Sandvoss, "The Death of the Reader? Literary Theory and the Study of Texts in Popular Culture," in *Fandom: Identities and Communities in a Mediated World*, eds. Jonathan Gray, Cornel Sandvoss, and C. Lee Harrington (New York: New York University Press, 2007), 28.

18. Hills, *Fan Cultures*, 178; Jenkins, *Convergence Culture*, 25–92. I don't make the point about colonization lightly. Cult television fan activity on the Internet was virtually entirely fan-driven until the mid-2000s, when network websites became much more elaborate, and began to offer message boards, downloads, and other interactive content. As Fiske would no doubt point out, however, like any colonization, there are always spaces that are not completely colonized. Indeed, in the case of online fandom, the "colonized" spaces of official websites are far outnumbered by the "non-colonized" spaces of independent fan communities.

19. These contacts are certainly not limited to series showrunners. Other production personnel also routinely participate in online fan spaces, including staff writers, directors, actors, composers, and technical crew. In addition, creative fans have long generated their own "authors" and authorship discourses as well, as key "fan producers" gain acclaim in their communities; see Karen Hellekson and Kristina Busse, eds., *Fan Fiction and Fan Communities in the Age of the Internet* (Jefferson: McFarland, 2006).

20. John T. Caldwell, "Cultural Studies of Media Production: Critical Industrial Practices," in *Questions of Method in Cultural Studies*, eds. Mimi White and James Schwoch (Malden: Blackwell, 2006), 115.

21. The podcasts are available at http://abc.go.com/primetime/lost/index?pn=podcast.

22. See Jason Mittell, "*Lost* in a Great Story: Evolution in Narrative Television (and Television Studies)," in *Reading Lost*, ed. Roberta Pearson (London: I.B. Tauris, forthcoming).

23. The primary relationship problematic on the show centers on the character of Kate, and whether she will ultimately choose the "safe" neurosurgeon Jack, or the "dangerous" con artist Sawyer as her true love. A "Jater" believes (or "ships") Kate will choose Jack; a "Skater" wants her to pair up with Sawyer.

24. Carlton Cuse and Damon Lindelof, "The Official *Lost* Podcast," September 21, 2007, http://abc.go.com/primetime/lost/index?pn=podcast (transcription, www.lostpedia.com/wiki/Official_Lost_Podcast/September_21%2C_2007).

25. Carlton Cuse and Damon Lindelof, "The Official *Lost* Podcast," April 20, 2007, http://abc. go.com/primetime/lost/index?pn=podcast (transcription, www.lostpedia.com/wiki/ Official_Lost_Podcast/April_20%2C_2007). On the series, Aaron is an infant, and Vincent is a dog. *Heroes* is another show altogether.

26. Carlton Cuse and Damon Lindelof, "The Official *Lost* Podcast," February 19, 2008, http:// abc.go.com/primetime/lost/index?pn=podcast.

27. Robert Alan Brookey and Robert Westerfelhaus, "Hiding Homoeroticism in Plain View: The *Fight Club* DVD as Digital Closet," *Critical Studies in Media Communication* 19:1 (2002), 21–43.

28. Derek Kompare, "Publishing Flow: DVD Box Sets and the Reconception of Television," *Television and New Media* 7:4 (2006), 335–360.

29. Suzanne Scott, "Authorized Resistance: Is Fan Production Frakked?," in *Cylons In America: Critical Studies in* Battlestar Galactica," eds. Tiffany Potter and C.W. Marshall (New York: Continuum, 2008), 218.

30. Ronald D. Moore, "Scattered," podcast commentary, July 15, 2005, www.scifi. com/battlestar/downloads/podcast/ (transcription, http://en.battlestarwiki.org/wiki/ Podcast:Scattered).

31. Ronald D. Moore, "Black Market," podcast commentary, January 26, 2006, www.scifi. com/battlestar/downloads/podcast/ (transcription, http://en.battlestarwiki.org/wiki/ Podcast:Black_Market).

32. See Scott, "Authorized Resistance," for an insightful analysis of "collaborative" and "resistant" fan/producer practices.

The reviews are in

TV critics and the (pre)creation of meaning

Jonathan Gray

One of the more exciting developments within recent years in television studies has been the greater level of attention paid to the multiple agents involved in making and consuming television. With due sophistication, the field has moved beyond crude notions of a single-celled entity variously called The Industry, The Producer, or The Network. However, this chapter contends that our established models of televisual creation are still in need of further refinement. In particular, television studies tends to conceive of industrial personnel crafting a product that is then handed off in pure exchange to the audience. In a brief moment, like a baton in a relay race, the industry's "work" moves over to the audience, thereby becoming a "text."[1] The common sense utility of Stuart Hall's encoding/decoding model[2] continues to affect our understanding of the production of meaning, as that process is imagined in terms of encoding that is enacted by one group of people ("the industry") and decoding that is enacted by another group ("the audience"). But what happens (and *who* happens) *in between* encoding and decoding? Or, rather, when does encoding stop and decoding begin? After all, "in between" the multiple moments of production and reception are multiple moments of mediation. Television shows are advertised across various other media and throughout our cityscapes. Increasingly, networks release teasers, trailers, and other transmedia material to pique interest. Shows such as *Extra!* and *Access Hollywood* conduct interviews with production personnel. Extant fans of the cast, showrunner, or genre begin to talk about the program. And so on. In between production and reception, and negotiating the meeting of encoding and decoding, are many industry- and audience-created paratexts, extratexts, and intertexts.

In this chapter, I will explore the role of an often-overlooked paratext, namely the press review. In the weeks before a show hits the air, we are accustomed to hype saturation for each new show. But beyond simply peddling enthusiasm, marketers often play a constitutive role in proposing actual decoding strategies, labeling a show with a genre, suggesting characters to identify

with, and proposing intertextual links to and similarities with other programs.[3] Marketers, in other words, often begin the process of transforming encoding into decoding, preferring certain readings and giving a text an identity within popular culture more generally. However, we are all of us aware, at least in theory, that we should "not believe the hype." Granted, the hype may prove hard to ignore, but within this context, press reviews hold the potential to play a unique mediating role, for they offer some of the first notices of a text that both (1) come from outside a network's marketing machine, thereby promising neutrality and objectivity, and (2) are based on authoritative, insider information. Press critics frequently see one or more episodes of a show before the general public has seen any. They are also professional television viewers, and hence self-appointed taste leaders.[4] Each September in particular, just as the season's new shows are about to hit television, press reviews catch the audience often at a decisive pre-decoding moment, just as the text is being born. With endless channels in most television households, as Amanda Lotz has noted, in a post-network era, "Critics become increasingly important as their reviews and 'tonight on' recommendations provided promotional venues to alert viewers of programming on cable and network channels they did not regularly view and as legitimate, unbiased sources within the cluttered programming field."[5]

Of course, just as audiences might miss or ignore the hype, they might miss or ignore critics' reviews. Nevertheless, upon release, as does a network's marketing machine, reviews too hold the power to set the parameters for viewing, suggesting how we might view the show (if at all), what to watch for, and how to make sense of it. Literary theorist Stanley Fish has shown the centrality of "interpretive communities" to the process of reception,[6] but though Fish was notoriously vague regarding how such communities form, I pose that press reviews make early gestures at creating such communities, and at creating dominant frames through which programs will be viewed. Importantly, too, texts have meaning for popular culture, not just for actual viewers,[7] and thus reviews may be some of the *only* interactions many individuals have with a show, rendering them just as powerful as the show itself, if not more so, at creating the text in its totality for many non-viewers and non-fans.

In what follows, therefore, this chapter will illustrate press reviews' potential to become involved in the processes of meaning-making, textual production, and textual reception. I will focus on over 20 reviews each of three prime-time hour-long dramas new to NBC in the 2006–2007 season, *Studio 60 on the Sunset Strip* (2006–2007), *Heroes* (2006–), and *Friday Night Lights* (2006–).[8] I examine the reviews not as a unified text – for few if any audiences would likely have read more than one or two such reviews – but for the rhetorical and hermeneutic moves they make in trying to position the show. While NBC was producing paratexts and hype aplenty about these shows in Fall 2006,

press reviews made their own bids at offering interpretive decoders. Reviews offered relevant intertexts, made firm evaluative judgments, suggested genre and other framing devices, and in general proposed many ways in which audiences could watch these shows. In studying these reviews, I hope to show how they could have played a key role in creating meaning for the shows, and in transforming the production personnel's "work" into a "text" that had meaning not only for certain viewers but for popular culture more generally. At times, the reviews' preferred meanings for their shows dovetailed with NBC's marketing paratexts; at other times, they rejected and worked against them, privileging interpretive strategies other than those of the network. Ultimately, then, my interests lie in how paratextual authors play an intermediary role between production and reception, as part author/encoder, part privileged reader/encoder. While it is a frequent retort by aggrieved creators to harsh critics to "do something" rather than "just" criticize, here I argue that their criticism very much "does something," mediating and hence co-authoring a television program at the constitutive moment when it becomes a text and launches itself into popular culture.

"West Wing-like sophistication": Studio 60 on the Sunset Strip

The critical darling in the run-up to the 2005–2006 season was NBC's *Studio 60 on the Sunset Strip*. Representing the return of critically acclaimed *West Wing* writer–director team Aaron Sorkin and Thomas Schlamme, *Studio 60* was set in a weekly late-night comedy sketch show, examining the politics and interpersonal interactions behind the show's production. Of the 23 reviews read, 21 were entirely enthusiastic. More fascinating than the critics' near-consensus regarding its quality, though, was the commonality of many rhetorical tropes across the reviews.

All reviewers insisted that it was a combination of "smart," "witty," and "intelligent," but many also quickly moved to superlatives, plastering it with the label of quality television. Alessandra Stanley of the *New York Times*, for instance, insists:

> it is hard to remember a time when there were so many good shows pushing up against the worst. Dramas [. . .] have never been as beautifully or thoughtfully made; few Hollywood movies come close. And "Studio 60" serves as exhibit A.[9]

Across town, Stanley's equally upscale *New Yorker* affirmed this evaluation, saying *Studio 60* evoked a "golden-age feeling [. . .] of the highest order."[10] The

show, it was said, was "sublime" and likely a "genuine TV classic,"[11] and "a great case for taking TV seriously."[12]

Rather than simply pile on the glowing adjectives, though, many critics invoked Sorkin, and often Schlamme, as the embodiment of quality television. Sorkin and Schlamme's previous joint outing on television with *The West Wing* had ended when NBC and producer Warner Bros. infamously parted ways with Sorkin and Schlamme in 2003, leaving the show in producer John Wells' hands. Sorkin and Schlamme's pedigree is mentioned in all reviews, and their return to network television is frequently reported with the air of the prodigal son. The critics universally praise *The West Wing*, and most elevate Sorkin to the status of a modern television legend. He is, we are told, "one of TV's very best writers,"[13] a "brand" who represents "intelligence. More intelligence and verbal wit per scene than many network series display during entire seasons."[14] Charlie McCollum gives the last word of his review to actor Timothy Busfield, who glows, "The way Mozart heard the music, that's how Aaron hears the writing [. . .]. He was just born to do it."[15] All the while, *The West Wing* itself is invoked at multiple points in most reviews to suggest a reliability of writing (pace Sorkin), filming (with Schlamme's trademark "walk and talk" style mentioned repeatedly), and serious, meaty issues on the table. Occasional reviews subtly pose that a show about a television show will be less likely to justify the lofty rhetoric of *The West Wing*'s rapid-fire political dialogue, but otherwise, all critics invoke the show and the creative team to suggest a *continuance* of excellence, not a break from it: this is "vintage Sorkin"[16] brimming with "'West Wing'-like sophistication."[17]

Throughout most reviews, then, the reviewers both marshal and create the intertexts of Aaron Sorkin and *The West Wing*. First, whether readers are familiar with Sorkin and *The West Wing* or not – and it is worth remembering that at peak the show only commanded 17.1 million American viewers in a country of over 300 million[18] – they are told that they *should* know writer and show, and, moreover, that they should know them as the pinnacles of good writing. Rather than simply insist that *Studio 60* is good, the reviewers give it an intertextual backbone. And while Sorkin, Schlamme, and *Studio 60* form much of this backbone, the other frequently invoked intertexts of *Network* and *Saturday Night Live* form the rest. The centerpiece of *Studio 60*'s pilot episode was a scene in which the producer of the "Studio 60" program castigates the program live, on-air, thereby setting the rest of the action in progress,[19] and most reviews recount this scene and/or quote from it. Almost all also liken the explosion to Howard Beale's "I'm mad as hell and I'm not going to take it anymore" speech from Sidney Lumet and Paddy Chayefsky's film *Network*. Meanwhile, several reviewers note the similarity between "Studio 60" and NBC's own *Saturday Night Live*, thereby seeing the embittered producer's

attack on "Studio 60" as a bold attack on *SNL*, and NBC's act of playing *Studio 60* as an acknowledgment of guilt. "The fourth-place network," writes Gillian Flynn, "seems to be issuing its own creative mea culpa,"[20] offering "proof" that it is no longer guilty of poor programming.[21] Again, then, two intertexts are mobilized to insist on *Studio 60*'s transcendence of mere television – it is at once both film-like and aware of its medium's sins à la *Network*, and definitively unlike the drab and "now lame"[22] *SNL*. Yet, as with Sorkin and *The West Wing*, viewers need not have seen *Network* or *SNL*, as the reviews carry with them their own interpretive decoder. Indeed, one might note that the reviews' act of harboring on these intertexts, and their seeming need to explain them, betrays a suspicion on the writers' behalves that many readers will *not* have seen them; instead, they are rendered as symbols and totems of what television could(n't) or should(n't) be.

So far, I have pointed out the degree to which the reviews insist upon the show's quality, and mobilize intertexts to affirm this quality. However, the reviews also preeminently tell viewers *how* to watch the show. In mentioning Sorkin, each reviewer is keen to tell audiences how autobiographical *Studio 60* is. Sorkin and Schlamme's on-screen avatars, they note, are stars Matthew Perry and Bradley Whitford's Matt and Danny. Sorkin's one-time girlfriend Kristin Chenoweth is Sarah Paulsen's Harriet. Sorkin friend, *Studio 60* consultant, and one-time ABC head executive Jamie Tarses is Amanda Peet's Jordan. Even the central dynamic is autobiographical, with the on-screen NBS's tail-between-legs courting of their one-time golden children Matt and Danny echoing NBC and Warner Bros.' tail-between-legs courting of their one-time golden children Sorkin and Schlamme. Moreover, in presenting this litany of biographical information, most reviewers marvel at how "authentic" and "real" this makes the show, and many see the *Network*-esque tirade as Sorkin's own "rant" against the industry. Hence, as potential viewers, we are encouraged to see the show as a manifesto and as a television program about television programs, as something that will name names and reveal the emperor in all his nakedness. Not only are viewers being promised a realistic view of television production, but it is television critics – those who would seemingly have a greater knowledge of the industry than the average viewer – who are judging its authenticity to be spot on. Meanwhile, though many reviewers rave about Perry and Whitford's performances in particular, not a single reviewer discusses *Studio 60* as a relationship drama. Given *The West Wing*'s considerable success on the back of being, in addition to a political drama, a show with considerable focus on relationships, and given the universal paralleling of *Studio 60* to *The West Wing* by reviewers, this absence is notable. In short, reviewers work to create an interpretive "plan" for audiences, one that encourages them to see the show as a smart, witty, quality metatext that is all about the ills of

television, but little if any effort is put into encouraging viewers to engage with the characters or relationships.

I have argued elsewhere that *Studio 60*'s trailers ultimately set the expectations for the show too high,[23] and here the reviewers were guilty of the same crime. But whereas the previews attempted to introduce audiences to a series of characters who we might engage with, mixing and matching most notably *Friends'* hugely popular Matthew Perry with *West Wing* fan favorite Bradley Whitford, the reviews cared little for the characters or relationships, instead posing a show about issues and industry: a less funny *Daily Show* for television production.

"Spandex, my friends, does not rock": *Heroes*

Although many reviews' relative inattention to the characters and relationships of *Studio 60* may have somewhat undersold the program, and may have proposed a rather limited set of meanings for it, ultimately their framing of it as "quality television" at the crest of a wave of contemporary televisual art no doubt echoed NBC's own promotional goals. Ironically, too, while NBC eventually cancelled *Studio 60* before the end of the season, the reviews' loud insistence that the program was brilliant (an insistence, of course, that could then be quoted and circulated further by local advertising) may have played a significant role in creating hype for NBC's overall lineup and for its "return" from the Nielsen basement more generally, reiterating that NBC was once more the home for quality television. However, while in this instance, NBC's promotional department and the reviewers were working in tandem, a look at the reviews of two of NBC's other 2005–2006 season newcomers – *Heroes* and *Friday Night Lights* – reveals an exerted campaign by many critics to correct perceived errors in NBC's promotional narratives for the shows. Not all critics contributed to this effort, as I will later detail, but many spent considerable time and effort to point out that the shows were *not* a cult comic-book show and a high school football show respectively.

In serious not comic-pulpy fashion, *Heroes* employs a large cast to examine the gradually intertwining lives of numerous people who discover they have super powers ranging from teleportation to invincibility. Of the 20 *Heroes* reviews read, most were complimentary. However, given the show's premise, many reviews exhibited clear anxiety that the show would be ignored as "just" a comic-book superhero story. For instance, with a title, "The Strength of 'Heroes' is its Psychological Nuance," Matthew Gilbert begins by declaring, "Spandex, my friends, does not rock. And that's one reason to love 'Heroes.'" Later, he insists that the show "isn't a comic book series with an alien-based mythology and exaggerated facial expressions. It

will certainly appeal to superhero fanboys, but 'Heroes' has a reality-tinged adult tone more akin to 'The Twilight Zone.'"[24] Similarly, Diane Werts, under a title, "Being Normal Makes Heroes Super," states that "What's super about this series isn't the powers that turn everyday people into the title wonders," and with great approval, notes that creator Tim Kring "isn't really a sci-fi/genre guy," and that he cannot even read comics due to a dyslexic disorder.[25] Kring's lack of a background in science-fiction, fantasy, or comics is a fact repeated by many of the reviews, frequently as flattery, never as critique. Though the writing room is full of sci-fi and comic-book writers, and though one could therefore imagine reviews that might point to this fact as evidence of the writers' credentials, the reviews mention Kring alone, and instead tout his non-"scifi/genre" background as the ultimate credential. Furthermore, though the show's mutant superhero premise had been widely circulated and discussed in other forms of hype, and had already led to many observing a parallel with Marvel's *X-Men* franchise, most reviewers seemed at pains, as above, to distance the show from such a comparison. Thus, Mike Duffy argues that the show "may be channeling the 'X-Men' spirit. But it does so with a fair amount of humor, humanity and beguiling mystery," before insisting, in a one-sentence paragraph for added effect, "You don't have to be a fantasy or sci-fi geek to have fun with it."[26] Variants of the assertion that *Heroes* is not *X-Men* appeared in 13 of the 20 reviews studied.

Amusingly, whereas those reviewers who liked the show were at pains to distance it from an aura of "comic-ness" and cult appeal, those who disliked it or were indifferent to it used these qualities to attack it. Robert Bianco, for instance, opened by rather snidely stating, "You can practically hear the *Heroes* cult forming," continuing that it "seems destined to attract an audience that is more loyal than large." He predicts that the show will do poorly with mainstream viewers, but that it will play well with "viewers who like genre series, even when those series take themselves a tad too seriously."[27] Here, "genre series" clearly stands in for "formula-driven series," and Bianco's suspicion of the "inevitable" cult audience and its low demands for quality run rife throughout the article. A key subtext of many of the reviews is that comic-book series – or anything remotely sci-fi/fantasy – are shallow, their "geek" and "cult" audiences lesser viewers. If, to Duffy, *Heroes* is *X-Men* with "humor, humanity, and beguiling mystery," *X-Men*, he implies, has none of the above. Gilbert contrasts the melodrama ("exaggerated facial expressions") of the child-like comic genre to the "reality-tinged adult tone" desired by more requiring viewers, and he observes its psychological nuance, almost surprised to have found it. And Bianco's criticism – indirect and subtle as it is – takes the form of complimenting the show as a good comic-book series. What we see in these reviews, then, is reviewers either scrambling to redefine or to confirm the apparent generic

boundaries of a forthcoming text. The reviewers replicate an elitist and igno-rant misreading of the depths of comics, perpetuate a tired and derogatory Oth-ering of fandom, and could be accused of doing so in part to perform their superiority as cultural consumers. But this performance aims to shift the generic goalposts that were being set around *Heroes*, moving the show out of the nether region of cult/comic/sci-fi/fantasy and into the accepted mainstream of "psy-chologically nuanced," "reality-tinged," "adult," "character-driven" series.

As with the *Studio 60* reviews, the choice of invoked intertexts proves telling too. Beyond, as noted, the prevalence of the "like/not like *X-Men*" frame, M. Night Shyamalan's film *Unbreakable* was often referenced, especially as an example of a supposedly similar comic-book film that was *not* a comic-book film. The few writers critical of *Heroes*, meanwhile, often reveled in *Star Trek* and *Star Wars* analogies and allusions, as a means to highlight the show's supposed geek factor. Or, for those eager to pronounce the program a non-comic-book show, *Lost* proved a valuable intertext. Robert Lloyd, for instance, wrote glowingly of *Heroes'* ability to bend reality and offer mystery in a *Lost*-like manner;[28] Gilbert posed that, like *Lost*, *Heroes* has the potential to grow into a cross-genre drama;[29] and multiple other writers stated simply that *Heroes* was this season's *Lost*, sometimes with no added explanation of the nature of the similarity. Thus, many reviewers marshaled the ratings giant and acknow-ledged "quality television" hit that is *Lost* in order to shelter *Heroes* under a safer intertextual shadow than the cult/"geek" shadow under which they feared it currently risked falling. *Heroes'* reviewers seemed determined to delineate its genre, tone, and appropriate audience, and their commentary and choice of intertexts stood either to "re-precode" *Heroes* for audiences (stating it is *not* a comic-book series), or to reiterate its precoding as comic-book series.

"More than a football drama for ESPN types": *Friday Night Lights*

A similar re-precoding act is evident in many reviews of NBC's *Friday Night Lights*. Set in the fictional town of Dillon, Texas, *FNL* centered its often gritty examination of small-town working-class life on the high school football team. Though the show's interest in high school football allows reviewers plenty of opportunities for football puns, most reviewers were quick to insist that the show is not "just" about football, or not even about football. Reflecting quite openly on the opportunity that the football show allowed him, for instance, Matthew Gilbert opens by noting:

> One way to praise NBC's "Friday Night Lights" would be to say, "It's a stand-up-and-cheer drama about football!" And then to use football

metaphors such as "Catch this TV forward pass." Because, as the show's Dillon High Panthers wrestle for a Texas state championship on the field, you'll want to stand up, cheer, and program the series onto your DVR. But "Friday Night Lights," which premieres tonight at 8 on Channel 7, is more than a football drama for ESPN types.[30]

The show was widely praised by reviewers, yet whereas most seemed already to want to like *Studio 60*, for instance, many seemed surprised by *FNL*. The cause of the surprise is obvious – many thought it would be "just" a football show, "just" a high school drama, or worse yet, just a high school football drama. Tim Goodman notes that *FNL*

> manages to be everything you don't expect it to be – a finely nuanced drama instead of "Beverly Hills 90210," a portrait of small town life instead of a cheesy back-lot fantasy, and even a sports story with real authenticity, from the preparation to the game action.

The show, he states, "has to overcome so many preconceived notions, so many reasons not to watch, that it's the dramatic equivalent of a Hail Mary pass falling miraculously into the hands of an open receiver," and thus he marvels that what producer Peter Berg

> manages to do here is wholly impressive. If you don't care for football, or high school football in particular, or even the concerns of a bunch of high school kids and their fanatical grown-ups – which plenty of viewers probably don't – Berg makes you care.[31]

The litany of "this is not a football show" resounds throughout a reading of multiple *FNL* reviews, as many reviewers share Goodman and Gilbert's dislike of football and/or football shows, and of high school dramas, yet also share their desire to paint the show as much more than either genre. Regarding the football, we're told that *FNL* "isn't just about the gridiron,"[32] that "football is only the kickoff,"[33] and that "even skeptics, even people who hate football, could easily be caught up in the drama."[34] While, on one level, this description is simply accurate, the declaration is often intoned with gratitude and relief, the "skeptics" of this latter quotation clearly including the critics themselves, who furthermore imagine their audiences to be skeptics themselves. Indeed, Doug Elfman states point blank that the show "makes me care about a subject I have zero, or possibly negative, interest in, no matter how rah-rah I was as a teen: high school daddy ball in rural Texas, where prayers are reserved for scoring touchdowns."[35]

Yet if the danger of a football show requires a hard defensive line to deflect, so too is the high school drama discussed as a lesser genre. Gilbert glows, for example, that "There's nothing corny or precious about Dillon – none of the soapy romanticism of the towns in 'One Tree Hill' or 'Dawson's Creek.' "[36] *One Tree Hill* proves a common intertextual contrast, as a "soapy" program that lacks *FNL*'s humanity, grit, and realism. Or, even if not actively distancing the show from the high school drama label, many reviewers are keen to crown it as the best of the lot, and another variety altogether. Hence, Werts states that, "none of this plays as soap opera, or perhaps it actually is soap opera in the finest sense, as a penetrating moral compass on the way humans privately direct their lives."[37] Hal Boedeker writes, "Television needs a good high school drama, and NBC's *Friday Night Lights* is a great drama."[38] And Melanie McFarland observes that *FNL* represents a new brand of family-friendly programming,

> stylish, intelligent and blissfully free of teen caricatures. Granted, the teenagers in "Friday Night Lights" are TV beautiful, but the characters are steeped in an authenticity that serves as an antidote to all the MTV reality images that have been pumped into our culture.[39]

As with *Heroes*, then, we once again have a case of reviewers keen to "rescue" a show from its low-culture connotations. Perhaps concerned that they need to justify the presence of their columns in a medium that is mostly regarded as higher and more literate than the object of their criticism, many press critics worked hard to frame *FNL* and *Heroes* as unlike the "low" genres of football shows, high school dramas, and cult sci-fi. Witness, for instance, Alessandra Stanley struggling to justify *FNL*'s inclusion in her decidedly upmarket publication, the *New York Times*:

> [*FNL* is] not just television great, but great in the way of a poem or painting, great in the way of art with a single obsessive creator who doesn't have to consult with a committee and has months or years to go back and agonize over line breaks and the color red.[40]

Stanley also invokes *Rebel Without a Cause* and *Splendor in the Grass* as similar (inter)texts, while *Slate*'s Troy Patterson compares the show to *Moby Dick*,[41] and Elfman calls it the closest thing network television has to HBO's critical darling *The Wire*.[42] The intertexts are mobilized to shepherd the would-be audience toward seeing the text as a very certain product: *The Wire*-, *Moby Dick*-, and poem-like, not *90210*-, *One Tree Hill*-, or ESPN-like.

Ironically, of course, such reviews might be *losing* audiences rather than, or in addition to, gaining them. NBC's loss of NFL broadcast rights had played a

key role in their ratings drop in the previous two seasons, and 2006 marked not only *FNL*'s premier, but the return of NFL to NBC; thus, the network would no doubt have loved to capitalize on NFL–*FNL* synergy if possible. Yet when the reviews work so hard to state that the show *isn't* a football show, they risk alienating a large segment of the potential audience, and when they similarly try to distance *FNL* from high school dramas, they also risk turning off the 18–24 demographic, a group that is much beloved by networks. Gilbert and Brian Lowry both almost snidely note that *FNL* is the kind of show that middle America longs for – set in a small, God-fearing town, focusing on family relationships – yet never actually watch;[43] however, most of the reviews (Gilbert's in particular) try to sever ties between a working-class audience and the show, by insisting upon its high-culture credentials. Little do they realize, then, that they may very well be contributing to the eventual failure of *FNL* to reach said audiences.

Admittedly, *FNL* is quite boldly innovative at mixing genres, and subsequently has succeeded in attracting a (small) high-end audience. All the same, many critics' odd rhetorical strategy of *excluding* audiences of football and high school dramas is shown to be unnecessary by Alan Sepinwall's review, a lone exception in my sample that welcomed and embraced the frame of it being a football show, even as Sepinwall shares his press critic colleagues' enthusiasm for the program. He writes:

> The best sports movies and TV shows provide us with a kind of certainty, the knowledge that you'll get to witness either a clear win ("Hoosiers," "Major League") or some kind of moral victory (Rocky going the distance, Rudy getting on the field). So when I say that virtually every development in the "Friday Night Lights" premiere will be telegraphed well in advance, I don't mean it as a bad thing. The drama is one of the season's best because it makes you care even when you know something big is coming – and because it finds pleasant little surprises along the way.[44]

To Sepinwall, the show can be a great football show *and* one of the season's best. Jason Mittell has written of the rocky path that genre hybrids frequently walk, as expectations and codings of each genre might conflict with the prospects for enjoyment and/or understanding of the other genre.[45] Many critics' reviews of *Heroes* and *FNL* expressed anxiety at the prospects for their beloved shows to fail, but their subsequent solution was to try to remove the shows from their rocky roads, and place them on what they saw to be a safer road called "quality television." Ultimately, though, this was an act with significant interpretive ramifications, for it involved framing the shows in certain ways that neglected and/or excluded other potential ways of enjoying them.

Conclusion

Television critics occupy liminal space in hierarchies of taste, on one hand writing for newspapers and working in the rather austere tradition of criticism, yet on the other hand writing of the "low" culture form that is television, and frequently consigned to the same section of their newspapers as reports on Paris Hilton's or Britney Spears' latest antics. In this regard, and as self-appointed taste leaders, they often play a key role in mediating television shows' standing on hierarchies of taste and value. What this chapter has argued, though, is that they play this role at a decisive moment in a text's creation. In coining the term "paratext," Gerard Genette described paratexts as functioning akin to an "airlock," acclimatizing one to a textual world upon entry.[46] Through the examples of reviews from *Studio 60*, *Heroes*, and *FNL*, I have shown how press reviews not only aimed to acclimatize viewers to the new textual worlds represented by these shows, but in doing so held significant power to create some of the contents and nature of those worlds. Rather than simply point us toward shows worth watching, reviews can tell us how to watch those shows, and hence what those shows are. As paratexts, reviews help to create texts, occupying the all-important gray area between encoding and the production of the work, and decoding and the production of the text. Rarely will these reviews work alone – networks usually cast the net of their hype campaigns widely enough to ensure that we all hear about new shows through the networks' own paratexts. However, as I have shown, reviews frequently reference these paratexts, even if only implicitly, as when many *Heroes* and *FNL* reviews rejected NBC's apparent generic framing of the shows.

Individual reviews' powers will of course depend upon the individual reader and on their own level of interaction with and regard for other paratexts and the show itself. On one end of a spectrum, for instance, we could imagine readers who have eagerly anticipated a show long before the reviews came in, and who do not care about them, while on the other end of this spectrum we might expect to find readers who have heard little if anything about the program, who greatly value the critic's or critics' opinions, and perhaps who do not even watch the show, comfortable to let the critics' opinions substitute for their own. Consequently, realizing the power of reviews to co-create texts does not necessarily allow us as analysts any special predictive powers of how popular culture will receive a text, and of what interpretive communities will dominate. Nevertheless, a close analysis of reviews does allow us greater knowledge of the semiotic environment into which new shows arrive, and of the reviews' role both in creating that environment and in co-creating the text.

Notes

1. See Roland Barthes, "From Work to Text," in *Image/Music/Text*, trans. Stephen Heath (Glasgow: Fontana-Collins, 1977), 155–164.
2. Stuart Hall, "Encoding, Decoding," in *Culture, Media, Language: Working Papers in Cultural Studies, 1972–1979*, eds. Stuart Hall *et al.* (London: Unwin Hyman, 1980), 128–138.
3. Jonathan Gray, "Television Pre-Views and the Meaning of Hype," *International Journal of Cultural Studies* 11.1 (2008), 33–50.
4. For both a history, and a rare discussion of press criticism, see Amanda Lotz, "On 'Television Criticism': The Pursuit of the Critical Examination of a Popular Art," *Popular Communication* 6.1 (2008), 20–36.
5. Amanda Lotz, *The Television Will Be Revolutionized* (New York: New York University Press, 2007), 109.
6. Stanley Fish, *Is There a Text in this Class? The Authority of Interpretive Communities* (Cambridge: Harvard University Press, 1980).
7. See Jonathan Gray, "New Audiences, New Textualities: Anti-Fans and Non-Fans," *International Journal of Cultural Studies* 6.1 (2003), 64–81.
8. Reviews were accessed via the online site Metacritic (www.metacritic.com), an aggregator of press criticism, and all reviews available for each show were read.
9. Alessandra Stanley, "Pitting Their Idealism Against Show Business," *New York Times*, September 18, 2006, www.nytimes.com/2006/09/18/arts/television/18stan.html?ei=5070&en=8d4a7cde47818e7f&ex=1159675200&adxnnl=1&adxnnlx=1159581825-YrvArDE9BkHQ7ZkiS7obVA (accessed July 1, 2007).
10. Tad Friend, "Backstage Angst," *New Yorker*, September 25, 2006, www.newyorker.com/critics/television/articles/060925crte_television (accessed July 1, 2007).
11. Mike Duffy, "From Pennsylvania Avenue to the Sunset Strip," *Detroit Free Press*, September 18, 2006, www.freep.com/apps/pbcs.dll/article?AID=/20060918/ENT03/609180338/1038 (accessed July 1, 2007).
12. Gillian Flynn, "Studio 60 on the Sunset Strip," *Entertainment Weekly*, September 29, 2006, www.ew.com/ew/article/review/tv/0,6115,1537707_3_0_,00.html (accessed July 1, 2007).
13. Duffy, "From Pennsylvania Avenue."
14. Matthew Gilbert, "In Brainy 'Studio 60,' Aaron Sorkin Reviles and Reveres TV," *Boston Globe*, September 18, 2006, www.boston.com/ae/tv/articles/2006/09/18/in_brainy_studio_60_aaron_sorkin_reviles_and_reveres_tv/ (accessed July 1, 2007).
15. Charlie McCollum, "Networking with Sorkin," *San Jose Mercury News*, September 29, 2006, www.mercurynews.com/mld/mercurynews/entertainment/columnists/charlie_mccollum/15542060.htm (accessed July 1, 2007).
16. David Hinckley, "A Laser Eye on TV Networking," *New York Daily News*, September 18, 2006, www.nydailynews.com/entertainment/ent_radio/story/453322p-381494c.html (accessed July 1, 2007).
17. Tim Goodman, "Aaron Sorkin Makes Dazzling Comeback Calling on 'West Wing'-like Sophistication," *San Francisco Chronicle*, September 18, 2006, www.sfgate.com/cgi-bin/article.cgi?f=/c/a/2006/09/18/DDG2VL68U51.DTL&type=tvradio (accessed July 1, 2007).
18. Tom Baldwin, "Ratings Cost West Wing Chance of Another Term," *Times of London*, January 24, 2006, www.timesonline.co.uk/tol/news/world/us_and_americas/article718467.ece (accessed December 10, 2007).
19. See Gray, "Television Pre-Views."
20. Flynn, "Studio 60."
21. Maureen Ryan, "'Studio 60,'" *Chicago Tribune*, September 17, 2006, http://featuresblogs.chicagotribune.com/entertainment_tv/2006/09/studio_60_how_m.html (accessed July 1, 2007).
22. Flynn, "Studio 60."
23. Gray, "Television Pre-Views."
24. Matthew Gilbert, "The Strength of 'Heroes' is Its Psychological Nuance," *Boston Globe*, Sep-

tember 25, 2006, www.boston.com/ae/tv/articles/2006/09/25/the_strength_of_heroes_is_its_psychological_nuance (accessed July 1, 2007).

25. Diane Werts, "Being Normal Makes Heroes Super," *Newsday*, September 25, 2006, www.newsday.com/entertainment/tv/ny-ettel4905898sep25,0,6377796.story?coll=ny-television-headlines (accessed July 1, 2007).

26. Mike Duffy, "Comic Charm in Everyday 'Heroes,'" *Detroit Free Press*, September 25, 2006, www.freep.com/apps/pbcs.dll/article?AID=/20060925/ENT03/609250334/1038 (accessed July 1, 2007).

27. Robert Bianco, "'Heroes' Has the Power to Engage and Confuse," *USA Today*, September 24, 2006, www.usatoday.com/life/television/reviews/2006–09–24-review-heroes_x.htm (accessed July 1, 2007).

28. Robert Lloyd, "Super, Within Reason," *Los Angeles Times*, September 25, 2006, www.calendar-live.com/tv/cl-et-heroes25sep25,0,1708171.story?coll=cl-tvent-util (accessed July 1, 2007).

29. Gilbert, "The Strength."

30. Matthew Gilbert, "Hard-Hitting 'Lights' Gives 110 Percent," *Boston Globe*, October 3, 2006, www.boston.com/ae/tv/articles/2006/10/03/hard_hitting_lights_gives_110_percent (accessed July 1, 2007).

31. Tim Goodman, "'Friday Night Lights' Defies Expectations and Has Something to Offer All Comers," *San Francisco Chronicle*, October 2, 2006, www.sfgate.com/cgi-bin/article.cgi?f=/c/a/2006/10/02/DDGPOLFJMH1.DTL&type=tvradio (accessed July 1, 2007).

32. Rob Owen, "'Friday Night Lights' Isn't Just About the Gridiron," *Pittsburgh Post-Gazette*, October 1, 2006, www.post-gazette.com/pg/06274/726170–237.stm (accessed July 1, 2007).

33. Diane Werts, "Where High School Football is Life," *Newsday*, October 3, 2006, www.newsday.com/entertainment/tv/ny-ettel4915030oct03,0,3498786.story?coll=ny-television-headlines (accessed July 1, 2007).

34. Tom Shales, "'Friday Night' Kicks Off With a Great Formation," *Washington Post*, October 3, 2006, www.washingtonpost.com/wp-dyn/content/article/2006/10/02/AR2006100201439.html (accessed July 1, 2007).

35. Doug Elfman, "NBC's Shining 'Lights,'" *Chicago Sun-Times*, October 3, 2006, www.sun-times.com/entertainment/elfman/80613,CST-FTR-elf03.article (accessed July 1, 2007).

36. Gilbert, "Hard-Hitting."

37. Werts, "Where High School Football."

38. Hal Boedeker, "Show Scores With Brawn and Brains," *Orlando Sentinel*, October 1, 2006, www.orlandosentinel.com/entertainment/tv/orl-lights06oct01,0,4196845.story?coll=orl-caltvtop (accessed July 1, 2007).

39. Melanie McFarland, "On TV: It Doesn't Get Much Better Than 'Friday Night Lights' and 'Nine,'" *Seattle Post-Intelligence*, October 3, 2006, http://seattlepi.nwsource.com/tv/287262_tv03.html (accessed July 1, 2007).

40. Alessandra Stanley, "On the Field and Off, Losing Isn't an Option," *New York Times*, October 3, 2006, www.nytimes.com/2006/10/03/arts/television/03heff.html?ex=1160798400&en=de71fb8a98f52f97&ei=5070 (accessed July 1, 2007).

41. Troy Patterson, "Touchdown TV," *Slate*, October 10, 2006, www.slate.com/id/2151266 (accessed July 1, 2007).

42. Elfman, "NBC's Shining 'Lights.'"

43. Gilbert, "Hard-Hitting"; Brian Lowry, "Friday Night Lights," October 1, 2006, www.variety.com/review/VE1117931742?categoryId=32&cs=1 (accessed July 1, 2007).

44. Sepinwall, Alan, "Bright 'Lights' Has Game," *New Jersey Star-Ledger*, October 3, 2006, www.nj.com/columns/ledger/sepinwall/index.ssf?/base/columns-0/115985153292400.xml&coll=1 (accessed July 1, 2007).

45. Jason Mittell, *Genre and Television: From Cop Shows to Cartoons in American Culture* (New York: Routledge, 2004), chapter 6.

46. Gerard Genette, *Paratexts: The Thresholds of Interpretation*, trans. Jane E. Lewin (Cambridge: Cambridge University Press, 1997), 408.

"Word of mouth on steroids"

Hailing the Millennial media fan

Louisa Ellen Stein

"Share it." These words, alongside icons of a monitor, cell phone, and portable media player, beckon the viewer of ABC Family's *Kyle XY* to follow *Kyle XY* from TV screen to multiple digital interactive platforms. The ABC Family website offers a range of digital engagement possibilities to the *Kyle XY* viewer-turned-"user," from the video-game-like "Cluetracker" area to exclusive "insider" blog to community discussion forums.[1] These elements are part of the network's effort to transform itself from its origins as Fox Family to a destination network for the desirable "Millennial" demographic, an industrially demarcated category designated to include current teenagers and young adults.[2] ABC Family's media consultancy offers a vision of the Millennial audience as a congregation of technology-savvy TV viewers who use new media to construct value-oriented life experiences and social networks.

By both constructing and then courting this audience category, ABC Family endorses a vision of a youthful contemporary viewership that approaches media with a sense of active engagement and ownership – qualities scholars of media often speak of as characterizing the behavior and values of media fans.[3] But where much work on media fans has emphasized their grassroots and transgressive properties, the case of *Kyle XY* offers a corporate-sponsored, -promoted, and -guided version of fannishness, packaged as contemporary youth identity. This chapter considers the ramifications of the corporate co-optation of fannish practices and values into a new generational brand.

Reconstituting flow: teen angst across media platforms

Kyle XY tells the story of a teenage boy who wakes up one morning with no history and no belly button. The first season follows his quest to discover his identity and ends in the revelation that he was created as a corporate lab experiment. Thus, in serial and episodic storylines, *Kyle XY* explores issues of

coming of age as a contemporary teen while being pursued by corporate interests, often dramatized by individual trespass of corporate space. Indeed, Kyle and friends seem to spend half of their time evading the reach of the corporation that created Kyle, and the other half breaking into corporate headquarters to wrest power for themselves – that is, when they're not writing the perfect song for prom or declaring their "re-virginization." With its multifaceted focus on teen identity concerns and corporate intrigue, or, in other words, processes of self-expression within corporatized systems, *Kyle XY* serves as a very fitting text with which to consider the relationship between individual/grassroots and corporate production.

In his work on media convergence, Henry Jenkins enumerates the tensions between two defining and yet contrasting dimensions of convergence: corporate consolidation and user command of media platforms. These tensions impact our understandings of the ideological work of media and the possibilities of audience engagement, including medium-specific notions such as televisual flow.[4] Indeed, because of its multimedia experimentation directed at the imagined technologically savvy Millennial audience, *Kyle XY* offers an opportunity to consider how corporate consolidation impacts the dynamics of transmedia flow.[5] Where once our understanding of televisual flow linked together multiple industrially authored texts into a larger flow of text and ideology, the example of *Kyle XY* prompts us to understand flow as a corporate-driven process in which story worlds (and their inherent ideological work) extend beyond their initial instantiation in the televisual source text to other media platforms.[6] This reorientation of flow must thus inflect our reading of (ideological) control through televisual authorship, as story worlds spill over into interfaces that allow for more direct modes of audience engagement and community interaction. *Kyle XY* offers one instance of such a reconstitution of flow in which contemporary television producers have deployed new media to attract and maintain (a specific demographic of) viewers. More specifically, the case of *Kyle XY* exemplifies how academic understandings of contemporary online media fan engagement may be made manifest (be it causally or indirectly) as online televisual marketing tools.

As televisual narratives and televisual experiences spread across multiple media platforms, digital extensions of television programming beg reconsideration of previously accepted dichotomies such as source text and paratext, diegetic and extradiegetic, author and fan.[7] The options at the official site for *Kyle XY* court potential Millennial fans by offering an expansive sense of character and story space that extends beyond a singular text or medium, thus blurring perceptions of medium specificity. This blurring in turn affects how media producers envision potential consumers and how visitors to and participants in officially sanctioned interfaces respond to their interpellation. To

consider this multistep process, this chapter interrogates the complex relation-
ships between the multiplatform text of *Kyle XY*, its imagined/constructed
audience, and its actual audience engagement.

Fans found and made: creating the Millennial fan

Through its concerted efforts to develop a fan base via new media extensions,
Kyle XY has achieved active participation on the official ABC Family site; inter-
estingly, however, this participation is not echoed in unofficial online spaces.[8]
This non-self-starting fandom may be exactly what the Disney-owned ABC
Family network wants – active participation without the threat of unruly
transgression that fans can be seen to pose. Even so, the case of *Kyle XY* and
ABC Family demonstrates the significance of fan modes of engagement as
translated into industrial logic and industrially constructed viewing positions.
Especially of interest in this case is ABC Family's conflation of viewing posi-
tions and perceived generation, as the network etches out its stake by con-
structing the Millennials as a desirable audience.

Trumpeting the success of *Kyle XY*, ABC Family ran a special advertising
section in *Advertising Age* that educated its advertisers as to the birth range, core
values, and behaviors of its target demographic – the generation labeled Mil-
lennials. In one move, this advertisement showcased why advertisers would
want to be affiliated with ABC Family, and why ABC Family's programming
and new media experimentation would make them a destination network for
this imagined set of desirable viewers. While not alone in positing and defining
Millennial as a generational category (indeed, the piece in *Advertising Age* cites
pop-social/psychological sources such as Strauss and Howe's *Millennial Rising*
as well as its own consulting company), the very existence of this advertising
piece suggests that the Millennial was not yet a recognizable category in the
industry and commercial sphere.

In its simultaneous construction of, and address to, the Millennial audience
via transmedia storytelling, ABC Family interpellates an ideal viewer who is
liminal and yet poised to be mainstream, expert at media and yet potentially
malleable for advertisers, willing to go the extra mile in terms of textual
investment and yet happy to play within the officially demarcated lines.[9] The
alignment of fan and adolescent is not a new one: popularized perceptions of
fannishness have often hinged on the emotive responses of adolescence, from
the teen Beatle fans' ecstatic shrieks to the teen fans of *Harry Potter* who have
discovered a love for reading and writing and dressing in Hogwarts uniforms.
What is of note here is ABC Family's preemptive configuration of the Millen-
nial as a generation that encompasses teen and young adult, and that uses teen
identity issues as metonymic of the individual's relationship to society – a

strategy employed by programming in the WB, UPN, and the CW, and laid out clearly in ABC Family's performance of self and audience branding.

Fans of *Harry Potter* and *Buffy the Vampire Slayer* may have made fandom especially visible as a youth-oriented phenomenon, but fans of course do not come only from the ranks of adolescents, be it the so-called Millennial generation, or from its more detached, ironic predecessor, Gen X. Media fandom has a long history pre-Internet, with participants of diverse ages, who have engaged with media fannishly from fan conventions and fanzines to today's online archives and social networking communities.[10] Contemporary online media fans, be they old or young, use the tools of new media to engage long-standing fannish traditions and concerns, expanding their favored series' story world and delving into the series' narrative questions, characters' personal development, and growing relationships between characters. They chase these revelations and explore their ramifications across multiple platforms, from the televisual texts of the programs themselves to officially affiliated video games to fan-constructed social networking communities. Through the tools and structures of new media, fans engage with the televisual text in a wide array of expansive/explorative ways, debating clues to a mystery in discussion boards, hunting down wardrobe choices across corporate websites and eBay auctions, or sharing fan fiction and art in archives and on social networking sites.

Fans often use new media interfaces in unexpected ways, creating role-playing games via linked online journals, or constructing fannish narrative worlds out of unaffiliated world-building games such as *The Sims*.[11] With these repurposed new media tools, fans create new instantiations of story worlds and characters ad infinitum, so that character and universe alike become immersive entities awaiting explorative play. For fans who participate in some or all of these ways, a television program is far more than an aired half-hour or hour text – it is a conceptual, spatial story world with expansive and emotive characters who are waiting to enact narratives and find fulfillment in romantic, platonic, and familial relationships often beyond those overtly imagined by the text itself.

While media fans, young and old, may make up only a small percentage of TV viewership, its modes of engagement are visible – online and in academic work/discourse within the industry.[12] However, media fans are not necessarily ideal audiences in the eyes of television networks. They may be (perceived as) too outspoken, too focused, too obsessive, or too transgressive.[13] But, even so, the modes of engagement fans model certainly offer some appeal to the industry; at the least they represent viewers who will come back for more, and who may be convinced to invest money in affiliated merchandise.[14] While not necessarily representative of TV audiences at large in terms of access or interest, media fans do represent an economically desirable viewing

base that can afford to access converged media and consume accordingly. With their use of and comfort with multiple technologies and interfaces, the behaviors of media fans parallel those assigned to the imagined Millennial audience desired by niche networks such as ABC Family, The N, and The CW – a perceived new generation of users/viewers who wield individual and community power through media.[15]

Thus, it is not surprising that a test site such as The ABC Family original drama *Kyle XY* – deployed to reach the tech-savvy, connected Millennials – might incorporate behaviors and values similar to those associated with media fans. In fact, the construction of the Millennial fan/viewer may ultimately be more appealing to corporate interests because it offers a more predictable, less potentially transgressive version of media investment than the – at times – infamous media fan. By recreating something akin to fannish modes of engagement (and thus speaking to fannish interests/values) as an address to envisioned Millennial consumers, the *Kyle XY* website interpellates its potential viewer (whether they perceive themselves to be media fans, Millennials, both or neither) into an industrial interpretation of fannishness, appropriating fanishness to bolster viewer brand loyalty and, in turn, advertiser faith in ABC Family as a viable venue with a compelling demographic reach.

Interpellating the *Kyle XY* fan

Producers and advertisers may be wary not only of fans but also of young audiences, who are seen as quick to bypass advertising or TV programming altogether in favor of playing a video game or texting a friend. However, the Millennial media consumer as advertised by ABC Family enacts a mode of engagement that capitalizes on viewer comfort with technology, using it as a tool for audience engagement and also folding it into the lifestyles on display in the network's transmedia offerings.[16] The combination of the Millennial and media fan, as offered by networks to advertisers, embodies an antidote to anxieties about hard to reach current and future media consumers, be they transgressive fans or elusive teens. In press releases and direct address to advertisers, ABC Family describes its goal of multiplatform engagement with Millennial viewers.[17] ABC Family's strategy foregrounds the incorporation of social networking sites and the promotion of audience as author, both of which are often considered defining elements of contemporary media fandom.[18]

Paul Lee, president of ABC Family Channel, has touted the network's strategic address to its niche audience, pronouncing "a new generation" that is "changing the way people watch TV or use other technology." He presents new media as a potent tool for promotion of television, describing the integra-

tion of online social networking as "word of mouth on steroids."[19] This approach is made manifest in ABC Family's revamped website, which was launched prior to the debut of *Kyle XY*. The website courts Millennial fans by offering online elements that expand the diegesis of *Kyle XY*, blurring lines between source text and metatext, viewer and character, official-producer and viewer turned author – a blurring resonant with fan traditions. The site combines community-oriented social networking with video-game-like explorative play in order to create spaces that will appeal to its desired Millennial fan base. Lee presents viewer social networking as key to establishing a dependable viewer base. He describes the website as a "full-scale online community that will allow our viewers to not only constantly connect with our shows and games, but also with each other. We're confident that this enhanced interaction will only help to strengthen our Channel's relationship with viewers." Rather than seeing viewers networking with each other as peripheral or potentially problematic, Lee poses such community building as a route to brand loyalty.

Furthermore, rather than viewing fan-authored texts as something that threatens copyright, ABC Family encourages fan production and the sharing of that production within the official site.[20] Lee emphasizes the centrality of user-generated content to network identity, describing the website as a potential "safe haven where ABC Family fans can upload their videos and share their stories about friends and family – two things we know our audience is deeply passionate about."[21] This "safe-haven" complicates traditional perceptions of authorship, but at the same time it also potentially contains and limits authorship to that which is encouraged by or allowed by the official interface, as is evident in Lee's comment: not just any stories are welcomed, but stories about friends and family – a topic resonant with the network's omnipresent tagline, "A new kind of family." This duality is perhaps a cornerstone of corporate-guided fan activity – while ABC Family may welcome and even go to great lengths to cultivate fannish behavior, it does so on its own terms. In the formulation of "a new kind of family," together with its definition of "Millennial," we can see ABC Family engage in ideological acrobatics, as the network seeks a young audience immersed in contemporary cultural change, and yet also works to maintain the more conservative qualities (such as family values) associated with its Disney and ABC corporate lineage. Indeed, ABC Family programming transgresses some traditional norms, allowing frank talk about sex, women in powerful positions, direct discussion of sexuality, gay teen characters, and viewer interpretations of nominally straight characters as gay.[22] John Rood, senior VP-marketing for ABC Family, describes the network's investment in the revised family values of its desired Millennial audience thusly:

[Millennials] seek relevance in their media. . . . For us, it meant storytelling that's genuine and real, and embraces families with all their dysfunction, heart and humor. . . . We learned that Millennials value their families. As a network called ABC Family, that was music to our ears. We realized through our research that it wasn't that America's young adults had a problem with family; it is that they had a problem with family television – specifically the stereotypical conservative, boring or insincere aspects of family television.[23]

In thus constructing the potential Millennial fan as a young adult with revised family values, ABC Family walks a fine line, as it strives to appeal to a demographic that perceives itself as somewhat resistant to proscribed dominant culture, and yet also strives to uphold the commercially driven values of its larger corporate identity.

Playing *Kyle XY*: exploring expansive space and character

In August 2006, ABC Family launched a redesigned website. Divided into a five-part rubric: "Share," "Play," "Go," "Celebrate," and "Watch," the new site cultivated a sense of encompassing community and opportunity for spatial exploration.[24] The site's offerings for *Kyle XY* encourage playful exploration as a mode of interaction with the televisual text, from the video-game-derived "Cluetracker" area to diegetically sealed websites professing to be official extensions of televisual fictional entities. Where some TV networks see online games as playful but limited extensions of the central televisual narratives, *Kyle XY* moves toward the more de-centered transmedia storytelling like that described by Henry Jenkins in the case of *The Matrix*.[25] ABC Family situates transmedia storytelling and interactive play as crucial components of outreach of its digitally savvy Millennial base. Furthermore, *Kyle XY*'s gamic extensions emphasize not simply spatial exploration but transgression of corporate boundaries by savvy media users.

The most apparent play-centered component of the official *Kyle XY* site is the "Cluetracker" area. To access this area, you are prompted by an image of a futuristic metal door to enter a password. Password entered, you are permitted "behind" the door, where you see a room containing a bookshelf, a climbing wall, and a desk with a computer on it. If you are familiar with *Kyle XY*, you will recognize the climbing wall as a challenge which Kyle had to overcome with the guidance of his mentor, Tom Foss. The bookshelf reveals a photo of Foss's dead wife and daughter, and a piece of note paper that indicates that their names serve as a username and password. Once applied to

Foss's desktop computer, this username and password give you access to files that provide further information central to the larger *Kyle XY* narrative. Each subspace/subgame within Cluetracker yields similar clues, which, put together, offer further insight into the mysteries posed by *Kyle XY*. Once you have completed all of the subgames in Cluetracker (a project that takes a fair amount of time and dedication), you gain access to a video clip that contains a significant clue to *Kyle XY*'s larger transmedia mysteries. This embedded narrative gameplay reveals many slippages: between yourself and the fictional character of Kyle, between story and game, between pursuit of "winning" and pursuit of narrative information, between your computer screen and the diegetic computer screen. These slippages resonate with fan modes of engagement which stress viewer identification with character, group unpacking of plot mysteries, expansion of singular narratives into encompassing story worlds, and the use of virtual environment tools to digitally inhabit the story world.

As part of their transmedia project, ABC Family also offers fake websites designed for fictional entities featured on *Kyle XY*.[26] For example, Madacorp.com represents itself as the official corporate site of the company who created Kyle, with password-protected areas contributing to its sense of verisimilitude. Fans pooling information discovered intricate layers to the Madacorp site, including a Madacorp intranet that, once broken into, reveals further clues to the diegetic mysteries of *Kyle XY*. Like Cluetracker, Madacorp.com offers expansive spatial exploration, embedded narratives, and character expansiveness, further contributing to the sites' sense of ongoing but private narrative progress.

Figure 8.1 The entrance to *Kyle XY* Cluetracker (screen capture, http://a.media. abcfamily.go.com/abcfamily/Standalone/cluetracker/).

Both Cluetracker and Madacorp.com encourage visitors to explore the subpages of ABC Family as a shifting spatial entity, connected to and encompassing the spaces of *Kyle XY*. The verisimilitude of the multiple subpages and the inclusion of password-protected areas create a sense of transgression and voyeuristic access to protected spaces. This sense of transgression is of course limited to fantasy, to officially sanctioned transgression of fantasy corporate spaces, rather than ABC Family or Disney. However, one could argue that the enactment of corporate transgression offered by ABC Family points the way to imagined critique and transgression of real corporate spaces. Indeed, *Kyle XY* glorifies main characters who pit themselves against corporate power.

Blurring the diegetic divide

In their creation of fantasy corporate spaces, both Cluetracker and Madacorp. com expand the series' story world, creating a sense of the *Kyle XY* diegesis beyond the TV episodes. In his study of gaming, Alexander Galloway adapts the notion of diegesis to illuminate the processes of video game play.[27] Just as the diegesis of a film includes its off-screen elements, for Galloway, the video game diegesis refers to the world not only enacted but imagined by the video game. We can similarly draw on the concept of diegesis to understand converged media texts like *Kyle XY* (including episodes and website). On the most immediate level, the Cluetracker diegesis encompasses digital imagery of Tom Foss's office. But, for *Kyle XY* viewers, the diegesis has a farther reach. A fan of *Kyle XY* brings to the Cluetracker story world information and expectations; she knows that the workspace she is being asked to search belongs to Tom Foss, and that the username and password for the computer are the names of his dead wife and child. She may even find resonance in any frustration she feels at the wall-climbing game within the game, as she knows that Kyle himself has faced a (non-digitized) version of this challenge and failed multiple times before he succeeded.

Indeed, the Cluetracker player comes to the interface with a diegesis already in mind, informed by her previous engagement with the televisual text and perhaps with other extratextual but diegetic elements as well. The gameplay of Cluetracker complicates that already-imagined diegesis, illuminating and solidifying aspects of it, perhaps altering others, depending on how seriously the viewer/player is willing to take the game. Thus, the game both creates and informs the *Kyle XY* diegesis. A similar cross-pollination of diegesis occurs with the "corporate" sites built into the ABC Family/*Kyle XY* universe. Fans bring their knowledge of the televisual diegesis to bear on their understanding of these websites, and then return to the episodes with the knowledge gained from their engagement with the online extensions.

These examples gesture to a more radical expansion of the notion of diegesis. In today's converged media sphere, we can usefully conceive of diegesis as reaching beyond medium specificity.[28] While we need not (and should not) ignore the relevance of medium difference, nor questions of access due to economic and cultural specificity, for some media consumers at least, the diegesis extends beyond the limits of any given medium, incorporating "off-screen" elements, or rather, incorporating elements from multiple screens.[29] The diegesis is ever-shifting and expanding, and so is dependent on a viewer/user who engages with the meaning of the text by imagining all of the pieces to construct a whole. The story world flows in the imagined spaces constructed out of these different media texts and the (imagined) user/viewer who interacts with(in) them.

This understanding of a de-centered, (over-)flowing diegesis resonates with fan engagement – made manifest not only in personal fan websites but also in discussions of, and play with, media on social networking communities, in blogs, and in video-sharing sites. The act of searching for stories outside of the original media text, as in the case of a casual fan who searches on the Internet for more of a given universe and its characters, requires a sense of an expansive diegesis not bound to medium or author. Similarly, sitting down to write a story outside of the official media text (fan-fiction authoring) or to create a visual essay about a media text by deconstructing the correlation of images of the source text (vidding) depends upon a notion of a continually expansive diegesis. Indeed, the nature of the diegetic from a fan studies perspective manifests precisely in extratextual elements – elements created by and/or sought out by fans (usually via new media interfaces) in order to expand or transform the diegesis. This reorientation – at once a return to and revision of the notion of flow as a seamless yet layered metatext with multiple authors and instantiations – decentralizes not only the source text but the source medium, ripping away its authority.[30] And it is this expansive and in-process sense of diegesis that ABC Family goes to great pains to create in its transmedia offerings, in its pursuit (and/or construction) of the desirable Millennial fan.

Thus, both fannish engagement and its corporate likeness encourage us to expand our notion of the diegesis to refer to an imagined transmedia story world rather than a medium-bound text. But, then, what can we understand as existing apart from the diegesis – as non-diegetic? Galloway posits non-diegetic elements in video games as "inside the total gamic apparatus yet outside the portion of the apparatus that constitutes a pretend world of character and story."[31] Adapting non-diegetic to converged media text like *Kyle XY*, we isolate as non-diegetic elements that facilitate viewer engagement with the text but do not in themselves constitute the "pretend world of character and story." Blogs, contests, and bulletin boards that hold fannish discussion may

exist in order to support the pretend world of character and story, but they are not, themselves, part of that story world. Still, they do serve as gathering locations for enacted fannish identities and explorative play in space. Discussion boards and blogs depend on senses of space for playful engagement with participants. Indeed, media fans understand themselves as authors and performers in online spaces, and often take pleasure in blurring the lines between diegetic and non-diegetic performance; they understand themselves as actors and as characters at once, for example, inhabiting characters outright in role-playing games.[32]

Faking a fan

This self-aware fannish blurring manifested in a set of striking interactions between fans and producers around the *Kyle XY* official site. In January 2008, visitors to the Insider Blog at the official *Kyle XY* site noticed something strange. Flickering images broke up the usual combination of text and promotional shots. What looked like a girl crying for help flickered midst the page's mise-en-scène, intermittently punctuated with broken, pixilated text. Enterprising fans in the site's forums brainstormed on what these images could be. Fans quickly dismissed notions of a real hacker hijacking the ABC Family website, especially when similar images appeared on Madacorp.com. Fans concluded that these were embedded narrative clues, clues to events that had not yet unfolded in the program's diegesis. One fan suggested layering the broken text that had appeared at the different sites. With the help of screen-capping software, multiple fans shared their results: a plea for help to some-

Figure 8.2 The flickering plea for help (screen capture, www.geocities.com/ kylexy_mystery/index.htm).

body named "Cooper." The fans hypothesized that the SOS came from yet another test-tube baby like Kyle, soon to be featured in later episodes. This set of circumstances seemed to offer a dynamic extension of the diegesis, revealing future plot possibilities to fans willing to dig for clues buried in the official online interfaces.

But an even more extreme extension of the diegesis, or rather, a blurring of diegetic lines was at play. For who was this Cooper hailed by the officially authored hacker performance? Was he or she a character to be featured on the show? Or a possible visitor to the site, a fellow fan? At around the same time that fans began to notice and analyze the strange flickering images, ABC Family drew attention at its Insider Blog to the "coolest new website by a *Kyle XY* fan": Coop's Scoop. Coop's Scoop presents itself as the blog of a young adult (Millennial) male, Cooper. In his blog, Cooper professes his love of *Kyle XY* and devotes his posts to unraveling the mysteries posed by the various *Kyle XY* websites. He offers an extensive walk through Cluetracker, and he provides hints about how to locate and interpret the clues embedded in the spaces of gameplay. The banner at the top of his site is a clickable image of his bedroom, on the walls of which he has plastered images of the various mysteries posed at the *Kyle XY* official website. Cooper's banner becomes an expansive space in itself, with embedded clues to the larger converged diegesis of *Kyle XY*.

Cooper presents Coop's Scoop as a fan website dedicated to unpacking the various diegetic extensions offered at the ABC Family site. He never breaks character, but after his website was hyped in such a direct and unusual way at the official Insider Blog, fans quickly discovered (by searching his site for clues, much as they had searched Madacorp.com) that it was copyrighted by ABC Family. Soon thereafter, a character entered the televisual episodes of *Kyle XY* who looked very much like Cooper. Fans on the ABC Family forums debated whether these two were played by the same actor, while at the same time interacting with Cooper as fan-construct-possible-character at his own (copyrighted ABC Family) blog.

Cooper's artificial construction and possible crossover status reveal a number of things. It reifies the crucial dimension of spatiality to transmedia diegeses – even Cooper's clues are offered in the form of an interactive image of his room/workspace. His existence also illuminates the difficulties a network may face when using (extra-)diegesis to shape fan engagement. Cooper seems to have been introduced as a tool to make sure that fans were being hailed effectively by the site. Thus, he becomes the site of producer discourse about what they think fans are and need.

Cooper sets into relief not only the constructed/diegetic nature of online personae, but also the way in which representation of (extra-diegetic) self and of transmedia diegesis can blur. Knowing Cooper to be a construct, fans

engaged playfully with him as yet another character, but one that has entered their (extra-)diegesis. Fans perceive Cooper as somewhere in between producer and character, available for them to interact with and as a text to mine for clues. Cooper blurs all the lines: he reveals clues to the diegetic story world and illuminates the constructed nature of online self-presentation; he seems to emanate from the program's diegesis, and yet he performs as a fan.

But what is most telling about Cooper is how untroubled fans were by his constructed nature and obvious corporate performance. The fans interacting with Cooper after his status fell into question seemed to move fluidly between the different spaces and performances, even given Cooper's uncertain status. The blurring of real and fictional is fairly commonplace in fan engagements, whether in RPGs or pseudonymous online interaction.[33] However, the clear corporate origin of Cooper perhaps changes the stakes of such identity play, implicating it overtly in consumerist frameworks.

A fan by any other name . . .

I close with the example of Cooper because I find him a fascinating instance of the corporate appropriation of fandom. Masking the official capacity of his authorship, he invites us into his digital "bedroom," which thus becomes a space for exploration like Madacorp.com or the imaginary transmedia diegesis of *Kyle XY* as a whole. In this move, he rehearses and transforms pervasive conceptions of fannishness and subculture – the space of the fan(girl)'s bedroom is now corporately constructed and has undergone a gender switch. A young male corporate fanboy construction invites us – the potential audience – to fannishly explore his performance of fan engagement. And fans continue to respond to his call, indeed more so than they have gathered around *Kyle XY* in non-official spaces like LiveJournal.com. These fans knowingly interact with Cooper's officially authored performance of fannishness and fan spaces, and are not averse to suspending disbelief in officially affiliated new media architecture.

Cooper and the fans who have gravitated to him prod us to consider how we value the work of media consumers in corporate spaces, and how our assessments may change as fan engagement becomes more orchestrated by corporate interests. I would suggest that the individual and collective work of the fans participating with the transmedia offerings of ABC Family – their performances, coordination, interpretation and authorship – may not be substantively different than the seemingly more subversive work of *Textual Poacher*-style media fans. Indeed, dichotomies of subversion versus co-optation break down into far more complex enactments of engagement with narrative, fantasy, brand identity, performance, and community, as we begin to look

closely at audience engagement in our contemporary media sphere. Probing these nuances will only become more pertinent in our attempts to understand the vibrancies and vagaries of contemporary media engagement, as networks like ABC Family venture further into new media extensions and transmedia storytelling.

Notes

1. Cluetracker can be found at http://abcfamily.go.com/abcfamily/path/section_Shows+Kyle-XY/page_Blogs (accessed August 13, 2008). The *Kyle XY* Insider Blog is located at http://a.media.abcfamily.go.com/abcfamily/Standalone/cluetracker/ (accessed August 15, 2008).
2. Disney-ABC purchased Fox Family in July 2001 and launched ABC Family in November 2001. Jeff Bercovici, "Disney Buying Fox Family Channel," *Media Life Magazine*, July 23, 2001, www.medialifemagazine.com/news2001/july01/july23/1_mon/news1monday.html (accessed August 15, 2008). Gary Levin, "Disney Refocusing Family Channel," *USA TODAY*, December 2, 2001, www.usatoday.com/life/television/2001–12–03-family-channel.htm (accessed August 15, 2008). Regarding ABC Family's address to Millennials, see Julie Lesse, "Getting to Know the Millennials," *Advertising Age* (July 9, 2007), brandedcontent.adage.com/pdf/ABC_Family_Meet_The_Millennials.pdf (accessed March 20, 2008). Neil Howe and William Strauss, *Millennial Rising* (New York: Random House Vintage Books, 2000).
3. Kristina Busse and Karen Hellekson, "Introduction," *Fan Fiction and Fan Communities in the Age of the Internet* (Jefferson: McFarland, 2006), 5–40. Jonathan Gray, Cornel Sandvoss, and C. Lee Harrington, eds. *Fandom: Identities and Communities in a Mediated World* (New York: New York University Press, 2007). Matt Hills, *Fan Cultures* (London: Routledge, 2002). Henry Jenkins, *Textual Poachers: Television Fans and Participatory Culture* (New York: Routledge, 1992). Henry Jenkins, *Convergence Culture* (New York: New York University Press, 2006).
4. Henry Jenkins, "The Cultural Logic of Media Convergence," *International Journal of Cultural Studies*, 7 (2004), 33–43, http://ics.sagepub.com/cgi/reprint/7/1/33.pdf (accessed August 15, 2008). Jenkins, *Convergence Culture*.
5. Raymond Williams, *Television: Technology and Cultural Form* (London: Fontana, 1974). William Urrichio, "Television's Next Generation: Technology/Interface Culture/Flow," in *Television after TV*, eds. Lynn Spigel and Jan Olsson (Durham and London: Duke University Press, 2004), 163–182.
6. Will Brooker terms similar extensions "overflow." Will Brooker, "Living on *Dawson's Creek*: Teen Viewers, Cultural Convergence and Television Overflow," *The International Journal of Cultural Studies*, 4:4 (2001), 456–472. Will Brooker, "Overflow and Audience," in *The Audience Studies Reader*, eds. Will Brooker and Deborah Jermyn (London: Routledge, 2003), 322–335.
7. Employing metatexts and extending a narrative as an address to a younger and/or fannish audience is not necessarily a new strategy; indeed, we might draw comparisons to Little Orphan Annie's decoder rings and other extensions of Little Orphan Annie as discussed by Avi Santo. " 'Who's That Little Chatterbox?' Radio Orphan Annie, Child Consumers and Authorial Moral Management." Paper presented at Society for Cinema and Media Studies, Philadelphia, 2008.
8. This chapter does not analyze unofficial extensions of *Kyle XY* such as fan fiction and art hosted at sites like FanFiction.net, FanForum.com, and the various social networking sites used by fans. At the time of writing, they are not comparable in breadth to the interactions at the official site. *Kyle XY* has limited unofficial fannish response, but it pales in comparison

to the hold taken on a site like Livejournal.com by a program such as *Supernatural*. On the other hand, the active embrace of the official ABC Family *Kyle XY* metatexts exceeds the participation of fans at official sites affiliated with *Supernatural*.

9. ABC Family extends the original birth range for Millennials from those born between 1985 to 2000, to those born between 1977 and 1996, thus constructing a somewhat older potential audience. Lesse, "Getting to Know the Millennials."

10. Francesca Coppa, "A Brief History of Media Fandom," in *Fan Fiction and Fan Communities in the Age of the Internet*, eds. Kristina Busse and Karen Hellekson (Jefferson: McFarland, 2006), 41–59.

11. Louisa Stein, "'This Dratted Thing': Fannish Storytelling Through New Media," in *Fan Fiction and Fan Communities in the Age of the Internet*, eds. Kristina Busse and Karen Hellekson (Jefferson: McFarland, 2006), 243–260.

12. The work of Henry Jenkins and others, as well as the publicizing of the Organization for Transformative Works in 2007/2008, has led the way for press coverage on fandom in a wide range of venues; at the same time, Will Brooker, Sara Gwenllian Jones, Robera Pearson, and Matt Hills suggest that fan audiences must be held in cultural and economic specificity, or as niche or cult audiences, not necessarily representative of media audiences at large. Jenkins, *Textual Poachers* and *Convergence Culture*; Brooker, "Living on *Dawson's Creek*: Teen Viewers, Cultural Convergence and Television Overflow"; Sara Gwenllian Jones, "The Sex Lives of Cult Television Characters," *Screen*, 43 (2002), 79–90; and Hills, *Fan Cultures*.

13. This position was suggested by Elizabeth Osder of Buzznet at the Futures of Entertainment conference in November, 2007, when she distinguished between "superfans" and more mainstream "consumers," with the latter offering sufficient ratings without the added complex ambiguities of superfan investment.

14. Jennifer Gillan links *Veronica Mars* fans' dedication to chasing down Veronica's wardrobe with their interest in solving the program's mystery. Jennifer Gillan, "Fashion Sleuths and Aerie Girls: *Veronica Mars*' Fan Forums and Network Strategies of Fan Address," in *Teen Television: Programming and Fandom*, eds. Sharon Ross and Louisa Stein (Jefferson: McFarland, 2008), 185–206. Will Brooker looks at fashion in *Dawson's Creek* as one of the relatively more common ways in which American fans related to the program in their everyday lives. Brooker, "Living on *Dawson's Creek*: Teen Viewers, Cultural Convergence and Television Overflow."

15. See Sharon Ross on the niche audience address of The N network and Valerie Wee on teen marketing by the now-defunct WB network. Sharon Ross, "Defining Teen Culture: The N Network," in *Teen Television: Programming and Fandom*, eds. Sharon Ross and Louisa Stein (Jefferson: McFarland, 2008), 61–77. Valerie Wee, "Teen Television and the WB Television Network," in *Teen Television: Programming and Fandom*, eds. Sharon Ross and Louisa Stein (Jefferson: McFarland, 2008), 43–60.

16. For a discussion of the incorporation of technology into *Veronica Mars*, see Gillan, "Fashion Sleuths and Aerie Girls: *Veronica Mars*' Fan Forums and Network Strategies of Fan Address."

17. Lesse, "Getting to Know the Millennials."

18. Kristina Busse and Karen Hellekson, "Introduction," in *Fan Fiction and Fan Communities in the Age of the Internet* (Jefferson: McFarland, 2006), 5–40.

19. Gina Keating, "Disney Tests "Watch-Chat" Features on abcfamily.com," *Reuters*, March 22, 2007, www.reuters.com/article/internetNews/idUSN2129837920070322 (accessed August 15, 2008).

20. Rebecca Tushnet, "Copyright Law, Fan Practices, and the Rights of the Author," in *Fandom: Identities and Communities in a Mediated World*, eds. Jonathan Gray, Cornel Sandvoss, and C. Lee Harrington (New York: New York University Press, 2007), 60–71.

21. Denise Martin, "ABC Family hones home page," *Variety* (April 11, 2006) www.variety.com/article/VR1117941383.html?categoryid=1009&cs=1 (accessed August 15, 2008).

22. Much like *The OC*, *Kyle XY* includes embedded components for multiple viewing audiences,

including playful nods to slash fans, no doubt to encourage a robust and multifaceted audience. See Louisa Stein, "'They Cavort, You Decide': Fan Discourses of Intentionality, Interpretation, and Queerness in Teen TV," *Spectator*, 25 (2005), 11–22.

23. Lesse, "Getting to Know the Millennials."

24. The website's revamped structure was outlined in a press release from ABC Family, accessible on the website The Futon Critic: "ABC Family Lets Viewers Share, Play, Go, Celebrate, and Watch Online with Next Steps for ABC FAMILY.COM," www.thefutoncritic.com/news.aspx?id=20060412abcfamily03 (accessed August 15, 2008).

25. Jenkins, *Convergence Culture*, 93–130. For more on transmedia storytelling see Henry Jenkins, "Transmedia Storytelling," *MIT Technology Review* (January 15, 2003), www.technologyreview.com/Biotech/13052 (accessed August 15, 2008). See also Jason Mittell, "Lost in an Alternate Reality," *Flow*, 4.7 (2006), http://flowtv.org/?p=165 (accessed August 15, 2008).

26. These fake websites function similarly to those for WB's *Dawson's Creek* described by Will Brooker in "Living on *Dawson's Creek*: Teen Viewers, Cultural Convergence and Television Overflow." Jason Mittell discusses similar extensions for ABC-owned *Lost* in "*Lost* in an Alternate Reality."

27. Alexander Galloway, *Gaming: Essays on Algorithmic Culture* (Minneapolis: University of Minnesota Press, 2006), 7.

28. Henry Jenkins' example of *The Matrix* as transmedia story world unfolding on multiple platforms serves as a highly orchestrated example of the potentials and pitfalls of this type of storytelling. Jenkins, *Convergence Culture*, 93–130.

29. The economic and cultural limitations to convergence in practice are considered by Will Brooker in his study of American and British *Dawson's Creek* viewers' interaction (or lack thereof) with official website extra, "Dawson's Desktop." Brooker, "Living on *Dawson's Creek*: Teen Viewers, Cultural Convergence and Television Overflow."

30. Many fans see the source text (or canon) as holding a different phenomenological status than fan-authored texts; but even these fans engage with a more expansive imagined diegesis that exists as a shifting set of meanings or interpretations, created by fannish interactions with the source text and with each other.

31. Galloway, *Gaming: Essays on Algorithmic Culture*, 7–8.

32. Kristina Busse, "'I'm Jealous of the Fake Me': Postmodern Subjectivity and Identity Construction in Boy Band Fan Fiction," in *Framing Celebrity: New Directions in Celebrity Culture*, eds. Su Holmes and Sean Redmond (London: Routledge, 2006), 253–267. Kristina Busse, "My life is a WIP on my LJ: Slashing the Slasher and the Reality of Celebrity and Internet Performances," in *Fan Fiction and Fan Communities in the Age of the Internet*, eds. Kristina Busse and Karen Hellekson (Jefferson: McFarland, 2006), 207–224.

33. See Busse, "'I'm Jealous of the Fake Me': Postmodern Subjectivity and Identity Construction in Boy Band Fan Fiction," and Busse, "My Life is a WIP on my LJ: Slashing the Slasher and the Reality of Celebrity and Internet Performances." See also Stein, "'They Cavort, You Decide': Fan Discourses of Intentionality, Interpretation, and Queerness in Teen TV," and Stein, "'This Dratted Thing': Fannish Storytelling Through New Media."

Masters of Horror

TV auteurism and the progressive potential of a disreputable genre

Heather Hendershot

American horror films are currently experiencing a box office renaissance. One might speculate about the sociological roots of this development, but the economic explanation is straightforward: while fantasies like the *Lord of the Rings* (2001), bursting with computer-generated special effects and fairly expensive stars, require massive advertising campaigns and huge box office returns to turn a profit, low-budget horror movies with no-name talent and low-rent special effects such as *Saw* (2004) and *Hostel* (2006) are virtually guaranteed, given merely adequate promotion, to succeed. There's big money in gruesome exploitation films.

Samuel Z. Arkoff and James Nicholson knew as much 50 years ago: to cash in on the rise in teen movie attendance and increased interest in monster movies, their American International Pictures distributed a shameless concoction whose title says it all: *I Was a Teenage Werewolf* (1957). Independent director William Castle milked the box office in the 1960s with gimmicks like electrically wired vibrating seats, corny ad campaigns, and even the "punishment poll," which allowed viewers themselves, theoretically, to decide the fate of the villain in *Mr. Sardonicus* (1961). Castle's films were good campy fun, and occasionally thoughtful about the dysfunction of everyday American bourgeois life. Roger Corman's pictures – *Wasp Woman* (1959), *Last Woman on Earth* (1960) – took this to a higher level, mixing monsters and violence with liberal social messages, topped off, as they say in *Sullivan's Travels* (1941), "with a little sex."

Unfortunately, the cheaply produced theatrical horror films of the 1990s and 2000s are largely lacking in both the humor and the occasional political edginess of the exploitation films of the 1950s and 1960s. Most also lack the big ideas that drove American horror's two previous Golden Ages, the early 1930s, as embodied by James Whale's films, and the 1970s, as embodied by directors such as Wes Craven, Tobe Hooper, and George A. Romero. Robin Wood and other critics have identified the films of the latter era as particularly

compelling for the critique they offer of "normality" and, more specifically, of the patriarchal family that sustains capitalism. Most of the 1970s directors have been under-performing for some time. Larry Cohen, for example, can no longer get funding for theatrically released films and has put most of his energy into writing for other directors. Romero can't afford to make films in Pittsburgh anymore and has made a number of ambitious but under-conceptualized (and barely released) films in Canada such as *Bruiser* (2001), although he's made something of a comeback with *Land of the Dead* (2005) and *Diary of the Dead* (2007). Corman, now in semi-retirement, is in the straight-to-video business.

With the *Masters of Horror* series (2005–2007), Showtime and series creator Mick Garris attempted to resuscitate some of the old-time directors – while also tapping some younger talents – by giving them low budgets, creative freedom, and non-theatrical, premium cable distribution. In theory, Showtime and Garris would enable these directors to make their most interesting, scary, and – for those so inclined – politically relevant work in years. They would have no-name actors and a minimal special-effects budget. While occasionally using digital tricks, episodes would also use actual prosthetic body parts and genuine fake blood, not the kind simulated by computers. Most of the directors had ten days to shoot in Vancouver, with Canadian actors, to benefit from the British Columbia Production Services Tax Credit. Each installment would be only one hour long, but the directors were told to conceptualize the episodes as compact feature films. The final products were uneven, if generally ambitious, but all the directors seemed to agree that it was being on *television* that gave them the freedom they needed to do their own thing, freed from the Hollywood studio micromanagers who, as John Landis puts it, "think you can make movies like they make light bulbs or iPods."[1]

Since they were not airing on a network, the Masters didn't have to strive to appeal to a mass audience; instead, they could shamelessly target their niche. "The relatively light FCC regulation in terms of language, action, and sexuality . . . and the freedom from the traditional broadcast confines of 'least objectionable programming' have all helped create an environment that allows for interesting, edgy shows to air" on cable.[2] As niche audiences have been increasingly exploited on television, there has been an insistent turn away from "bland, 'non-offensive' television that would appeal to a large mass of consumers."[3] This has resulted in "art TV" on one end (*The Sopranos*) and "trash TV" on the other end (*I Love New York* and other cheaply produced, deliberately tacky reality TV).[4] Freed from the limits of "good taste" that prevailed when CBS, NBC, and ABC were the only game in town, *Masters* ups the ante by offering not just edgy shows but deliberately offensive shows. If the Big Three networks in the old days mastered the principle of so-called Least

Objectionable Programming, *Masters* would strive for Most Objectionable Programming status.

Masters directors didn't have to worry about multi-million-dollar advertising budgets for their releases, a huge impediment to genre films in today's theatrical environment, in which small zombie movies without a video game tie-in are unlikely to even find a release. (*Shaun of the Dead* [2004], though hardly a blockbuster, was a wonderful exception to the rule.) With Showtime as their first release platform, the *Masters* directors knew their work wouldn't languish because it wasn't backed by an expensive promotional campaign to pump up opening weekend box office returns. Independent producer Christine Vachon notes that, "The big problem with theatrical exhibition now is that movies have to go in and perform right away, and if they don't – good-bye."[5] Vachon offers Mike Leigh's *Life is Sweet* (1991) as an example of an art film that profited from a slow-build, bringing in its best ticket sales in its *eighth* week in release, something unthinkable in today's market. Though the make-or-break opening weekend is generally considered dangerous for art films, it is clearly a problem for all kinds of small, independent movies. Only horror films that are part of a high concept franchise like *Resident Evil* (2002), or smaller films with big ad campaigns like *Saw* (which began as a quirky, if dumb, independent production and then became a sequel machine), can survive in this environment. TV looks better and better to directors more interested in stories and characters than video games and repeatable premises. In sum, with big distributors sticking to horror films with franchise potential, and small independent distributors having long ago breathed their last gasp, TV is an appealing distribution option for the kind of work featured in the *Masters* series.

Expensive, prestigious dramas like HBO's *Six Feet Under*, *The Wire*, and *The Sopranos* seek out an upscale audience – decidedly not the image of the horror audience. So it's no surprise that *Masters* would end up at Showtime, the poor stepchild of premium cable. HBO has trounced Showtime for years with its critically acclaimed programs. Showtime has retorted with *Weeds* and *The L Word*, its most widely known and reputable series, while floundering with many short-lived disasters (*Barbershop: The Series*, *Fat Actress*) and more ambitious shows that never quite caught on (*Dead Like Me*). With *Masters*, the network comes far from exacting bloody revenge on HBO, insofar as horror is a disreputable genre, widely disparaged and dismissed as the domain of pimply, sexually frustrated adolescent boys. The stereotype is ridiculous, but it does guarantee that no TV reviewer or Emmy voter would consider the possibility that a *horror* series on *Showtime* could possibly be on the same level with a "serious" HBO series. As John Carpenter puts it, "horror is viewed as a low-rent genre, just a notch or two above pornography."[6] *Showtime* dutifully sent out screeners of the best episodes of *Masters* to TV Academy members, but its only Emmy was for original music.

Television vs. filmic auteurism

What exactly does it mean to speak of "Masters" – auteurs – on television? It is widely acknowledged that film is a director's medium while television is a producer's medium. And just as many film directors focus on specific genres, TV producers tend to find a specialty and then stick with it. Grant Tinker's MTM and Norman Lear's Tandem had a reputation for "quality" and political savvy. Stephen Bochco and Dick Wolf produce cop shows and procedurals, respectively. Darren Star of *Melrose Place* (Fox, 1992–1999) and *Sex and the City* (HBO, 1998–2004) fame is good at creating serial drama with a campy, soap-opera edge. Ronald A. Moore, creator of *Battlestar Galactica* (SciFi, 2004–2009) and executive producer of *Star Trek: Deep Space 9* (CBS, 1993–1999), is known for science fiction and politically charged allegory. Most of these big-name producers began their careers as TV writers. They write for their own programs on occasion, but their framing as auteurs comes principally from their role as producers who create series and subsequently continue to develop characters and plot arcs. The writing staff draws on guidelines crafted by the producers, and actual script production tends to be a collaborative process, although some writers do surface as having a unique voice. Most fans of *Buffy the Vampire Slayer*, for example, have very strong opinions about the relative merits of writers Marti Noxon, Jane Espenson, and David Fury. From an unromantic standpoint, these writers are factory workers toiling on executive producer Joss Whedon's assembly line, with improvisational moments possibly only if they do not disrupt the pre-planned production process. From a more generous perspective, one might liken the *Buffy* writer's room to Rodin's workshop, where apprentices toil under the guidance of a mentor who is willing to sign his name to their work if it is good enough. Given enough masterpieces (and a good agent), the apprentice will eventually become a producer in his or her own right.

Where do directors fall into the picture? In film, they are usually considered the primary creators regardless of who has written their scripts. But on television, directors are quite often seen as just one notch above technicians. It is often hard to even recall the directors of our favorite series. It is the producers' and writers' names that resonate most strongly with loyal viewers. Showtime breaks with custom, then, by airing a series conceptualized around the very idea of "master directors." At first glance, one might think that *Masters* simply transferred filmic auteurism to television, but this assessment would be misguided, since the kind of autonomy that Garris offered does not currently exist for American film directors.

In fact, total artistic freedom has rarely existed for American film directors. There was certainly little freedom during the years of the studio system, in the

1930s and 1940s. The studios were happy that audiences flocked to some films specifically because they were directed by John Ford or Howard Hawks, but their ideal was competent directors working under contract, not independent geniuses. It was a system that made room for Hitchcock but chewed up and spat out Orson Welles. The notion of the American film auteur was only invented by critics after this system collapsed; Hitchcock, Hawks, Ford, and others were retroactively declared auteurs by the *Cahiers du Cinéma* writers and Americans like Andrew Sarris. The marvel – and there was some debate over whether or not this claim could be legitimately made – was that in an era when directors were under long-term contracts and assigned to films by studios, a coherent voice, style, and body of films could be linked to certain particularly talented directors.

Curiously, the critical celebration of the studio directors of the 1930s and 1940s occurred in exactly the years when directors finally had the opportunity to work outside of the contract system, when there was potential for a new kind of truly independent cinema. Once the old system collapsed, the window for independent feature production opened up and was exploited by actors-turned-producers like Kirk Douglas and producers and directors like Arkoff and Corman. In the old days, the studios gave directors large budgets and micromanaged how that money was spent. Under the new system, tight-fisted businessmen like Arkoff gave directors like Corman an extremely small budget and a catchy exploitative title, then told them to do their thing, as long as they could deliver a marketable product on time. Such working conditions did not guarantee that directors would make good films – indeed, in *The American Cinema*, Sarris lumped Corman in with "Oddities, One Shots, and Newcomers" and pondered that maybe he was "miscast" as a director and should have stuck to producing – but there was certainly a degree of directorial independence that had been more rare in the studio days.[7]

The majors stayed afloat with hits like *The Sound of Music* (1965), but more common were expensive flops like *Doctor Dolittle* (1967). Floundering on the edge of financial collapse, the studios began to have some sense that marketable auteurs might help them survive. Indeed, they had already tentatively tapped into the zeitgeist of European auteurism in 1967 with *Bonnie and Clyde* – once conceived as a vehicle for François Truffaut, and ultimately directed by Arthur Penn. They eventually mined the low-budget independent world for talent; noticing a successful little film named *Easy Rider* (1969), the majors decided to take a chance on a few weird kids like Martin Scorsese, Peter Bogdanovich, and Francis Ford Coppola (among other Corman protégés), who, if given some autonomy, seemed to be able to appeal to the youth audience and make a fair amount of money in return for a relatively low investment.[8] The exploitation market became a kind of greenhouse for new talent.

There was, in sum, a brief moment when American studios allowed a handful of directors to do their thing, and when small distributors existed who were willing to take a chance on films by independent horror directors like Larry Cohen of *It's Alive* (1973) fame. After Michael Cimino almost single-handedly destroyed United Artists in 1980 with *Heaven's Gate*, the studios tightened the reins on their directors. By the late 1980s, there were few remaining independent distributors for low-budget films, and drive-ins (the longstanding venue for exploitation pictures) were kaput. "Independent film" is now more a genre categorization for "quirky, bittersweet character driven films" (depressing, but not *too* depressing) than a genuine descriptor of films made with creative freedom.

Many of the *Masters* directors – Cohen, Carpenter, Hooper, Stuart Gordon, Don Coscarelli – made their names with films produced during the years when truly independent films, many of them low-rent horror, could still be produced and distributed. My point is not that *Masters* is on a level with the New American Cinema of the 1970s, or even with the best of Corman's and Cohen's theatrical releases – indeed, a number of the *Masters* installments are patently ill-conceived. But the scrappy, occasionally clever TV series *is* an interesting venue for directors who could have found a place on theatrical screens 20 years ago, when the market for low-budget genre pictures still existed. In today's environment, premium cable (or direct-to-DVD) is the only game in town for low-budget horror. Garris was, in a sense, offering these veterans a chance to return to the production environment where they had cut their teeth before studios became the micromanaging light bulb producers that Landis complained of. If *Masters* briefly brought a conception of directorial freedom to TV that had never quite existed there before, it was one that had only existed in American film for a very short period of time.

The masters at work

Masters seeks a cult audience strongly invested in the idea of the director-as-auteur. These viewers are fans of horror in general, not television horror specifically. Indeed, members of this subcultural fan base are likely to be wary of TV horror insofar as they assume that, on TV, the sex and gore that are central to the genre will be heavily censored. Garris struck the right note, then, in emphasizing that *Masters* allowed directors total freedom. This was almost true – Showtime forbad full-frontal male nudity and violence against children. (This does not stop the titular character of Dario Argento's *Jennifer* from eating a child – raw, I might add.) Ultimately, the series is violent and shows a fair amount of cleavage, but the gore only occasionally exceeds what most fans would consider "mainstream," and most of the directors are reluctant to push

at the extreme psychological boundaries that are explored, for example, in *Henry: Portrait of a Serial Killer* (1986). Indeed, when Takashi Miike went too far, Showtime simply declined to air his episode, *Imprint*. Miike is the director of *Audition* (2000), *Ichi the Killer* (2001), and *Visitor Q* (2001), all very extreme films. In the abject *Visitor Q,* the rapist of a corpse finds himself trapped when his victim's vagina contracts due to rigor mortis; adding insult to injury, her sphincter expels a half-digested load of corn on the perpetrator. Telling Miike he can do anything he wants, no strings-attached, is a risky proposition for those without a strong stomach.

Imprint is a thoughtful piece that has much in common with *Audition*. If the female characters in both works have monstrous qualities, it is only because the men who abuse them have drained them of their humanity. *Imprint* was censored, officially, because its overall tenor was simply too much for Showtime. The episode includes a torture scene that would be particularly difficult for viewers squeamish about trips to the dentist. But the central problem, I believe, is that *Imprint* features an abortionist who tosses dead fetuses into a river. They are strangely beautiful as they float away. Miike does not take a decisive political stance on abortion, and such a refusal is unthinkable on US television, where abortion is typically presented in a flatfooted manner as an "Important Issue Dividing America."[9] In *Imprint*, abortion is simply part of what women endure as they try to survive in a cruel world. If Miike had been strongly pro-choice or pro-life, Showtime might have more readily accepted his work. Instead, Miike shows us the evil of treating women like lumps of meat to be beaten or screwed. At the same time, he realizes that the ultimate horror, for an American audience, is not witnessing the abuse of women (which is painfully mundane in our mass media) but rather viewing a non-dogmatic – even indecipherable – perspective on abortion. Does Miike perhaps want to force American viewers to consider what it means that a dead fetus, with no consciousness, trumps a living, suffering woman as an intolerable horror?

Imprint is available on DVD and, Garris explains, "it played uncut on television in England, Australia, Japan and some other territories, and played theatrically in Japan, as well."[10] So the episode has not been censored out of existence, but its cancelled airing does point to hypocrisy on Showtime's part – let's not forget that their motto is "No limits." Indeed, Showtime premiered Adrian Lynne's remake of *Lolita* (1997) and Angelica Huston's *Bastard out of Carolina* (1996) to show its openness to stories that are "controversial but sensitively handled."[11] They may have gotten in just a wee bit over their heads, then, in seeking out auteurs likely to be deliberately insensitive. With *Masters*, the network clearly hoped to tap into an ardent fan base, but not at the expense of showing something that went "too far," which makes little sense

given that "too far" is exactly what horror viewers are looking for. Obviously, no one is going to tune in to a series like *Masters*, on a channel they have chosen to pay extra for, and then complain to Showtime that the horror is too disturbing. That's like subscribing to Playboy TV and then griping that there's too much sex!

Jeffrey Sconce explains that cult cinema aficionados

> celebrate the cultural objects deemed most noxious (low-brow) by their taste culture as a whole.... It is a calculated strategy of shock and confrontation against fellow cultural elites, not unlike Duchamp's notorious unveiling of a urinal in an art gallery.[12]

Viewed in this light, Showtime's censorship of *Imprint* raised the credibility of *Masters*, certifying it as noxious. Further, although horror fans oppose censorship, they also, as Matt Hills explains, celebrate censorship "by virtue of the fact that it makes certain media texts scarce, hard to find, and thus subculturally desirable and distinctive."[13] *Imprint* is not really hard to find at all, but its brief disappearance did fire up Miike fans and boost interest in the series. To be censored from premium cable is a badge of honor. But it also points to the real limits of auteurism within a conservative corporate climate. Any serious horror aficionado would point to Miike as one of the most important directors working in the genre today, but his films succeed because they produce a profound sense of discomfort in viewers. That's not what Showtime really had in mind.

Before it was picked up by Showtime, *Masters* was conceived as a straight-to-DVD project to be distributed by Anchor Bay Entertainment, "a Michigan based company that is doing for neglected cult films what the Criterion Collection does for established classics."[14] By releasing finely crafted transfers, Anchor Bay faithfully serves audiences tired of watching their rare favorites on creaky old VHS tapes. Although viewers were no doubt happy to see *Masters* in advance of its DVD release, cult horror fans don't really expect the stuff they like to be shown on TV and wouldn't necessarily perceive a Showtime premiere as a "step up" from a straight-to-DVD release. Indeed, horror devotees are more likely to have become familiar with their favorites on VHS or DVD than on either television or the big screen. Hardcore fans *expect* their favorite horror directors to produce work that has limited box-office appeal, is unreleased, or, by design or fate, goes straight to DVD. For example, Troma Studios, creator of the cult classic *The Toxic Avenger* (1985), has not had a wide theatrical release in some time, notwithstanding some recent, limited box-office success with *Poultrygeist: Night of the Chicken Dead* (2006). Straight-to-DVD Troma productions are "films" not "television," in that they are

feature-length and can function as stand-alone experiences – though they make more sense if you understand the Troma-verse.[15] Yet the idea of watching cheap, campy, utterly disreputable films like *Tromeo and Juliet* (1996) and *Cannibal! The Musical* (1996) anywhere but on a television set is almost laughable. Such films are lucky to get one premiere screening in New York City.

The directors selected for *Masters* are certainly several notches above Troma godfather Lloyd Kauffman in terms of respectability, having all worked with moderate budgets and released all or most of their films theatrically. But some are certainly much more accomplished than others. Tom Holland is best known for directing *Child's Play* (1988) and *Fright Night* (1985). He's not a bad choice for *Masters*, but certainly not on a par with better-known and critically acknowledged horror talents like Wes Craven. And Peter Medak is primarily a TV director (of all genres), although he made his name with a 1972 Peter O'Toole film *The Ruling Class* and made the wonderfully creepy feature *The Krays* in 1990. It's a stretch to describe him as "a master of horror," and his contribution, an episode operating on the shaky premise that George Washington was actually a cannibal, is an unmitigated flop. (This installment should have at least been funny.)

Medak aside, it's clear that Showtime and Garris offered the *Masters* directors a pretty good platform, and a number of them were able to deliver compelling, original work. John Carpenter, Joe Dante, and Lucky McKee represent three particularly interesting case studies. Carpenter is, most famously, the director of *Halloween* (1978), *The Thing* (1982), and *Escape from New York* (1981). Although he has made a handful of other interesting films, such as *Assault on Precinct 13* (1976) and *They Live!* (1988), he is widely acknowledged to have been off his game for some time. To be fair, Carpenter's initial success in the late 1970s was strongly linked to the era previously described, in which genuinely independent film production and distribution still existed. Carpenter is an exceedingly competent technician who made his name by producing low-budget genre pictures at a time when there was still a theatrical market for such work, and an apparatus in place to distribute it. If Carpenter seems to have been out of interesting ideas in recent years, he is also not the kind of director one would expect to thrive in a market divided between budget-bloated, CG-centered action pictures with little sense of character and prestigious, artsy dramas crafted to win Academy Awards. To succeed, Carpenter needs to make small pictures with no pressure to achieve blockbuster status. This is what Garris and Showtime offered him. Could television redeem him? Yes and no.

Carpenter made two *Masters* installments. *Pro-Life* takes place at an abortion clinic under siege by Christian fundamentalist maniacs eager to murder anyone willing to perform or have an abortion. Carpenter strives to reveal the mon-

strosity of patriarchy itself by including three fathers in the film: a demon who has raped and impregnated the daughter of a born-again psychopath, the horrible Christian patriarch himself, and a crude, unsympathetic man who has grudgingly accompanied his knocked-up daughter to the clinic. Ultimately, it is only the demon who shows compassion, for he feels despair when his spawn is shot shortly after it is birthed. It's a rather ham-fisted production, particularly flawed for its hackneyed fundamentalist stereotyping.

Carpenter has often been attacked as a reactionary, which, I would argue (in the minority), is unfair and reductive, although, admittedly, his political agenda does often lean more towards the libertarian than the progressive. Carpenter tends to set up politically interesting scenarios, only to resort to shoot-'em-up finales rather than fully resolve the issues the films have raised.[16] Barry Keith Grant argues that, "at best we could say that Carpenter's oeuvre is deeply ambivalent, his work constituting what Robin Wood might more generously call a series of 'incoherent texts' — works in which a failure 'toward the ordering of experience' exposes dominant ideology."[17] In attacking evil fathers and the hypocrisy of anti-abortion activists, *Pro-Life* does awkwardly tilt toward a progressive perspective. In the main, though, the episode fails, not so much because the politics are "off" but because the characters are too one-dimensional for a viewer to be very invested in the outcome.

Cigarette Burns is undoubtedly a more successful production. The premise is that a wealthy cinéphile, played by cult icon Udo Kier, hires a down-on-his luck movie-theater owner to track down a very rare, virtually unseen horror film, *Le fin absolu du monde*. *Cigarette Burns* shamelessly panders to its audience of horror nerds by catering to its fascination with directors and ephemera. Kier explains that he has never seen *Le fin*, having missed his only opportunity to view it at a festival when he opted instead to attend a screening of the first *Dr. Phibes* film. He wistfully adds that he had been hoping to meet Vincent Price. *Le fin* is renowned for making its audiences go completely insane. It has been screened very few times, and virtually no one has survived viewing it. *Cigarette Burns* ultimately contends that viewing horror films is a radically *personal* experience. Avoiding political sermonizing altogether, Carpenter goes straight for the gut (quite literally where poor Udo Kier is concerned) and succeeds simply by building anticipation for viewing a film-within-a-film that cannot possibly succeed unless the Showtime viewer loses his or her mind. Ultimately, *Cigarette Burns* works because it strikes just the right note of dread and because the lead is a believable, sympathetic shlump. *Cigarette Burns* is the work of an auteur who has refound his voice.

If Carpenter surprises by pulling off fresh new work, Joe Dante surprises simply by being good. Dante is a competent director of medium-budget genre films. Although his second *Masters* contribution, *Screwfly Solution*, is alternately

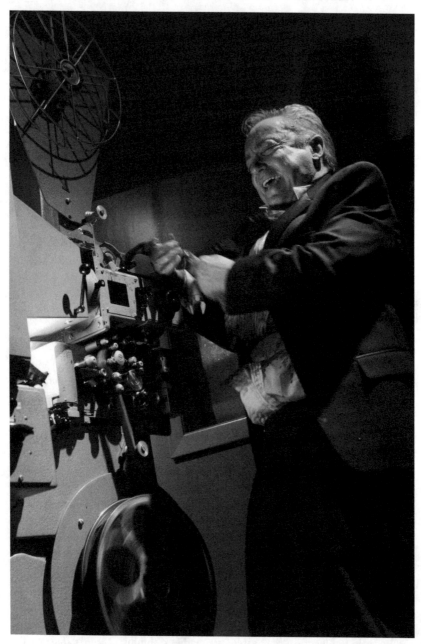

Figure 9.1 Cult icon Udo Kier threads his own intestines through a film projector in John Carpenter's *Cigarette Burns*.

politically incoherent and simply under-conceptualized, his first *Masters* entry, *Homecoming*, is certainly the most important installment in the entire series. Dante got his start working with Corman and directing *Piranha* (1978) (to cash in on *Jaws* [1975]) from a script by John Sayles. He is also known for directing *Gremlins* (1984) and *Gremlins 2* (1990). Dante is not a director whom one usually associates with any particular thematic concerns or artistic vision, although he has a generally liberal worldview, and his light children's movie *Small Soldiers* (1998) is in some ways a warm-up to his more serious anti-war *Masters* episode.

Homecoming offers a direct, stridently satirical attack on President Bush and the war in Iraq. Dante explains that, "this is a horror story because most of the characters are Republicans."[18] In the episode, American soldiers killed in Iraq are reanimated because they cannot be at peace until someone who will end the war is elected president. They don't want to eat people; they just want to vote. They can't be killed, but after they vote they drop dead. At first, the panicked Republican spinmeisters salute the power of American troops: nothing can kill our heroes! A Jerry Falwell stand-in proclaims the zombies to be a gift from God. But once the zombies start bad-mouthing the president, they are put in orange jumpsuits and trundled off to detention camps. Now the Falwell clone explains that Satan sent these disloyal soldiers. A highly unsympathetic Ann Coulter type – aptly described as "a skank" by one of the other characters and certainly more monstrous than *Homecoming*'s zombies – calls the reanimated soldiers "a bunch of crippled, stinking, maggot-infested, brain dead, zombie dissidents." Locking up the "formerly deceased" Guantanamo Bay-style ends up not really fixing the problem, and since there aren't really all that many of them, the Republicans finally allow them to vote so that they will die permanently. Many non-zombie citizens have been moved by the sight of the dead soldiers to vote against the president themselves, but the Republicans fix the election so that the president is re-elected. In response to the election fraud, Arlington cemetery explodes as the dead of World War II, Vietnam, and Korea rise to take over Washington. Dante's over-the-top episode ultimately contends that right-wing politicians and their machinations – "Lies and the lying liars who tell them," as Al Franken has put it – are much scarier than zombies.

It was precisely because Dante was working within the zombie sub-genre that he was able to create such a potent political statement. If horror is the best genre for literalizing our anxieties and fears, zombies up the ante by virtue of their very mundanity. Dracula is a fancy monster, a top-shelf creature who looks soulfully into your eyes before passionately sucking the life out of you. Zombies are rotgut, the old lady in the housecoat from next door who just wants to eat your brains out. Zombies scare us because, to use Romero's

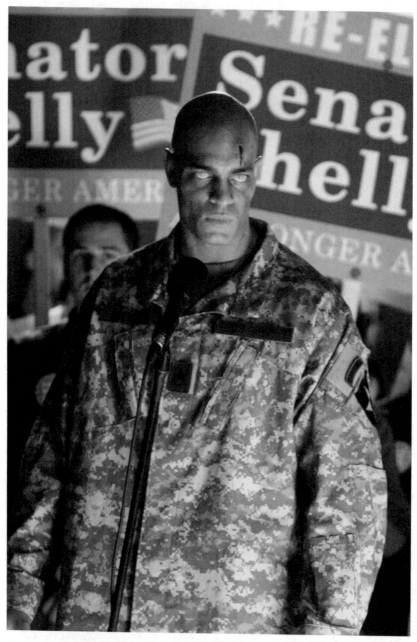

Figure 9.2 In Joe Dante's *Homecoming*, zombie American soldiers return from Iraq to vote Bush out of office.

refrain, *they are us*. At a literal narrative level, this means that in most zombie movies anyone can become a zombie, instantly making a switch from "normal" to "abnormal" (and, Romero insistently asks, which is which?). But at a more metaphorical level we are all zombies because we wander numbly through life, riding the bus to work, shopping at the mall, going through the motions of normality.

Zombies are, moreover, particularly apt monsters for allegorical manipulation. Depending on writer and director, they are imbued with varying levels of consciousness and desire, and unlike Dracula and Frankenstein, they don't require heavy back stories, they can't be sexy or develop a boring love interest, and they have no hope of achieving any kind of happiness.[19] These undead, decaying bodies are potent ciphers by virtue of their uncanniness. They are monsters, yet so much like us. They wander about wearing clothes we might have in our own closets: business suits, wedding dresses, nurse's uniforms, pajamas, or combat fatigues. Zombies have been particularly well used as anti-war figures, beginning with World War I and continuing right up to the war in Iraq. So Dante succeeded, in part, because he picked the right monsters for his story. If being a "master" means always getting it right, Dante is not quite up to snuff; even *Homecoming* suffers from its own plotting mistakes, its vilification of female sexual desire, and its propagandistic insistence on the wholesome goodness of our men in uniform. But there is no doubt that this is one of the more perceptive and entertaining entries in the *Masters* series. Speaking highly of Showtime for offering him total artistic freedom, Dante explains,

> I can't conceive of any other venue where we would have been able to tell this story. You can't do theatrical political movies; people don't go to them. You can't do them on [broadcast and non-premium cable] television, because you've got sponsors.[20]

Carpenter and Dante took advantage of *Masters* to prove that they were not over the hill. *Sick Girl*, conversely, was made by a relative novice named Lucky McKee. Garris describes McKee as a "young Turk," in contrast to the "gray hair folks" who dominate the series. McKee directed a psychological horror film, *May* (2002), which made it to Sundance. He then seemingly hit pay dirt with a United Artists production, *The Woods* (2006), which featured cult icon Bruce Campbell in a small role. *The Woods* has never been theatrically released, apparently lost in the shuffle when MGM bought out Sony/UA in 2004. McKee, who is short on experience and turned 30 while shooting *Sick Girl*, is actually a perfect choice for *Masters* insofar as he already has a small devoted following; his cachet is only increased by the shelving of *The Woods*, an ambitious little film notable mainly as an Americanized *Suspiria* (1977). Offered

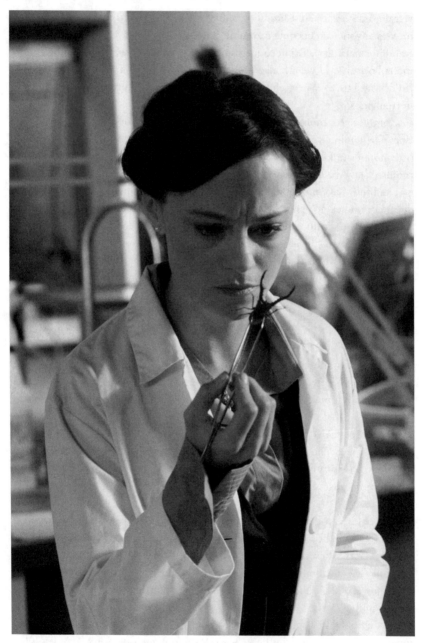

Figure 9.3 Lucky McKee's *Sick Girl* centers on a lesbian entomologist.

several scripts by Garris, McKee felt *Sick Girl* was the best match, but he made a major switch by transforming the lead character, a male entomologist, into a female. The result is a plucky lesbian romantic comedy horror film in which very idiosyncratic characters come together, drift apart after one is infected by a nasty insect sent by her father to sabotage the path of girl-on-girl love, and finally come together again as bulging, expectant mommies waiting to birth several hundred larvae.

Whereas the reproductive female body is pathologized in many horror films – the most obvious example being David Cronenberg's *The Brood* (1979) – here the entomophiliac lesbians are happy to have been impregnated by bugs, but motherhood itself is the farthest thing from their minds. After spawning, they will not have to endure the hassle of actually nurturing children. It's not particularly profound, but it is a welcome break from the psychopath-torturing-sweet-young-thing horror formula.[21] As in many of the best horror films, the literal monsters (the bugs) are not the true villains of *Sick Girl*. McKee is more interested in indicting a homophobic landlady and, more generally, in revealing the horror of human cruelty. Bugs are simply a handy catalyst. You can't hate the bugs anymore than you could hate Romero's zombies. If not yet a full-fledged master director like Romero, McKee at least shows potential.

Television: savior of progressive horror?

How does auteurism ultimately play out in *Masters of Horror*? Clearly, on one level, the directors chosen for the series simply function as marketable commodities linked to a devoted demographic. The discourse of artistic freedom is handily used to sell both the series and the DVDs to the fan base. In other words, as far as Showtime is concerned, directors are just brands. On the other hand, the series did allow some of the directors to pull off interesting and ambitious work that never would have been green-lit for theatrical distribution. Still, there is no reason to believe that *Masters* will lead to a more director-centered approach to television. In the summer of 2007, ABC did air a spin-off, *Masters of Sci-Fi*, which was centered on key sci-fi writers rather than directors. Since sci-fi is more or less dead theatrically (unless melded with horror or action-adventure), there were no great film directors to turn to, but Showtime knew enough to link the new series to the relatively well received original *Masters*. In other words, from Showtime's perspective, the *Masters* conceptualization is a handy gimmick. In 2008, Garris moved on to develop an anthology horror series *Fear Itself* for NBC, based on *Masters*; it was hoped that the new series would carry over the energy and creativity of the Showtime version, while keeping the gore at a network-appropriate level, but the series was widely panned.

The *Masters* gimmick seems to have played itself out, for now, and American horror may be at a crossroads, split between blockbuster tedium and minimally released low-budget innovation. I opened by referencing the 1930s and, especially, the 1970s as Golden Ages of horror. There is no denying that the best horror films of the 1970s were stunning not only because they were terrifying but also because they were full of ideas: about the family (*The Hills Have Eyes* [1977]), Catholicism (*The Exorcist* [1973]), Vietnam (*Deathdream* [1974]), consumerism (*Dawn of the Dead* [1978]), and even perception itself (*Suspiria* [1977]). Many of the most interesting horror films of these years contained strong allegorical elements, using monsters as metaphors to convey big ideas about sexual difference, capitalism, or, generally, the cruelty of human nature. This said, I think it is time to stop mythologizing the 1970s and gauging all the films that have come since in terms of how they measure up to their progressive predecessors. Instead of lamenting the fact that contemporary films like *Saw* and *Scream* aren't radical enough, we need to move forward and unearth the small number of horror films that are of value today.[22] It's a pleasant surprise to have found a number of these on TV.

On theatrical screens, most of the provocative work is now coming from Asia, but McKee points toward an American future that may be bright. The best films of the last Golden Age were rather apocalyptic, and that was their strength as well as their limitation. Only Romero fully succeeded in producing what Robin Wood calls a "positive apocalypse," where the destruction of the world forces survivors to strategize about how society might be remade. As powerful as the original *Hills Have Eyes* was in its critique of "normality," the film's ultimate conclusion was that we are all pretty much screwed. Why slog on, if patriarchy will inevitably kick our asses? An ambitious little work like *Sick Girl*, which pathologizes heteronormativity while offering the possibility of lesbian triumph, offers an interesting new twist on radical horror. Whether or not McKee will continue to deliver and become a true "Master of Horror" is an open question, but his work demands that we look forward, not back. McKee's priority is to scare viewers, but he's also got some interesting ideas to share.

On a basic level, of course, the point of horror is to frighten or thrill viewers, to provide stimulation, just as other forms such as melodrama and pornography – identified by both Linda Williams and Carol Clover as "body genres" – seek to send the bodies of viewers into convulsions, of tears or sexual pleasure. It would be both foolish and elitist to demand that horror films consistently pursue the kinds of progressive political allegories that they seem particularly well suited to. *The Descent* (2006) is a fantastic horror film not because of its central, liberal feminist idea (tough girls should stick together!) but because it fills viewers with such mortal terror that they are vir-

tually incapable of breathing while watching it. There's nothing wrong with a horror film that is "just scary." The question, then, should not be why aren't all horror narratives as radical as *Sick Girl* — or, for that matter, *Buffy the Vampire Slayer* — but, rather, why does TV seem to offer a bit more potential these days for more daring horror narratives?

I think it is, in large part, because budgets are lower on TV. It is precisely the disreputable and low-budget nature of horror that has allowed horror films, historically, to slide certain ideas in "under the wire"; the stakes are lower, the profit at risk less than for big-budget productions. Corman, for example, insisted his ultra-low-budget films include a liberal social message, in large part, because it made them more interesting without costing anything extra. A number of the *Masters* directors took advantage of horror's low-brow status to engage in social critique when they began their careers as independents some 30 years ago, and now they have had some opportunity to try again on the small screen. But the stakes are too high for a studio to allow horror directors — whether master or fledgling — to get "too political" when they are working on the fifth installment of a horror franchise that the studio hopes to milk still more sequels out of in the future. Thus, contemporary blockbuster horror franchises tend to center more on gore than complicated ideas.

Paradoxically, the rise of media convergence has created both problems and solutions for horror. If horror concepts didn't have to be developed with cross-platform synergy in mind, there would be more room for the kinds of riskier, smaller, character-centered films that old-school directors (and their younger protégées) are more inclined to make. It's doubtful that John Carpenter would refuse a big check in exchange for the video game rights to one of his films, but it is equally doubtful that he is interested in developing films — or, really, *brands* — that function equally well as films, TV, and games, and include his trademark synthesizer riffs so that they can later be marketed as cell phone ring tones. (He is, of course, canny enough to recognize himself as a brand and to stick his name as a possessive in front of all of his titles.) Whether or not they realize it, though, the older generation of horror directors can only be helped by certain contemporary developments such as the existence of niche cable, particularly the Showtime brand, with its "no limits" hype and ability to cross-promote its programs, sell them on DVD, and license them for video-on-demand.

Further, the rise of digital production and post-production technologies, the use of the Internet to market low-budget films, and the proliferation of online horror fandom has been hugely helpful for struggling horror directors. Romero's *Diary of the Dead* was produced on a minimal budget, released theatrically but not widely or with a massive advertising budget, and ultimately seen more on computer and TV screens than on theatrical screens. The film is

strongly critical of the youthful obsession with portable media, but it is easy to imagine exactly that demographic consuming the film on a two-inch screen (and clamoring for a video game spin-off). As the film's unlikeable, clueless central character slowly dies and turns into a zombie, he cries out, "Shoot me." The line is heavy with irony – he wants to be shot with a sleek little video camera, not a gun, but the end result is the same: death by technology. It is Sony that kills us today, Romero insists, not Smith & Wesson.

As unsympathetic as *Diary of the Dead* is toward virtually every type of digital technology and any instance of text messaging, blogging, e-mailing, or social networking, this kind of consumer activity is integral to media fandom today, and low-budget, non-franchise horror desperately needs fans to stay afloat. Like *Masters* directors Cohen, McKee, Carpenter, and Miike, Romero needs a devoted fan base more than ever to sustain his film production, given its thin theatrical prospects. A vibrant fandom, coupled with non-theatrical distribution on cable and broadcast TV, may finally keep interesting horror alive. Or, to put it more thematically, undead.

Notes

1. Cited in Bruce Kirkland, "Diabolical Family Fun: Landis turns *Cheers'* Wendt from Norm to Norman Bates," *Toronto Sun*, April 21, 2007, Entertainment Section, 46.
2. Sarah Banet-Weiser, Cynthia Chris, and Anthony Freitas, *Cable Visions: Television Beyond Broadcasting* (Durham: Duke University Press, 2007), 255.
3. Ibid., 256.
4. On art television, see Kristin Thompson, *Storytelling in Film and Television* (Cambridge: Harvard University Press, 2003).
5. Christine Vachon with David Edelstein, *Shooting to Kill: How an Independent Producer Blasts Through the Barriers to Make Movies that Matter* (New York: Avon Books, 1998), 314.
6. Cited in Marilyn Stasio, "The Horror Tales You Haven't Seen," *New York Times*, October 28, 2005, Section E, 1.
7. Andrew Sarris, *The American Cinema: Directors and Directions, 1929–1968* (New York: E.P. Dutton, 1968), 211. Of course, the earlier exploitation business studied by Eric Schaeffer exhibited a similar degree of low-budget independence. The difference is that the post-1948 directors had a wider market for their work because of Hollywood's product shortage and the ongoing post-war erosion of censorship. This was a climate ripe for the proliferation of genre cinema, as Kevin Heffernan has documented. See Eric Schaeffer, *Bold! Daring! Shocking! True: A History of Exploitation Films, 1919–1959* (Durham: Duke University Press, 1999) and Kevin Heffernan, *Ghouls, Gimmicks and Gold: Horror Films and the American Movie Business, 1953–1968* (Durham: Duke University Press, 2004).
8. Peter Biskind, *Easy Riders, Raging Bulls: How the Sex-Drugs-and-Rock 'N' Roll Generation Saved Hollywood* (New York: Simon and Schuster: 1998).
9. On television's approach to abortion, see Julie D'Acci, "Leading Up to *Roe* v. *Wade*: Television Documentaries in the Abortion Debate," in Mary Beth Haralovich and Lauren Rabinovitz, eds. *Television, History and American Culture: Feminist Critical Essays* (Durham: Duke University Press, 1999), 120–143 and Heather Hendershot, " 'You Know How It is with Nuns . . .': Religion and Television's Sacred/Secular Fetuses," in Diane Winston, ed. *Small Screen, Big Picture: Television and Lived Religion* (Waco: Baylor University Press, 2009), 201–232.

10. E-mail communication with the author, December 24, 2007.

11. John Dempsey, "Anders Opts for Showtime 'Sun' Run," *Variety*, March 19, 2001.

12. Jeffrey Sconce, "Trashing the Academy: Taste, Excess, and an Emerging Politics of Cinematic Style," *Screen* 36:4 (Winter, 1995), 376.

13. Matt Hills, *The Pleasures of Horror* (London: Continuum, 2004), 103.

14. Dave Kehr, "DVD: Movies 'Deluxe': Definitely Bigger, Sometimes Better," *New York Times*, December 15, 2002.

15. Rebekah McEndry, "Troma Pictures: Reel Independence," in John Cline and Robert G. Weiner, eds. *From the Grindhouse to the Arthouse: Films of Transgression, Exploitation, and Art* (Austin: University of Texas Press, forthcoming).

16. Heather Hendershot, review of Ian Conrich and David Woods, eds. *The Cinema of John Carpenter: The Technique of Horror* (London and New York: Wallflower Press, 2004), forthcoming in *Film Quarterly*, fall 2008.

17. Barry Keith Grant, "Disorder in the Universe: John Carpenter and the Question of Genre," in Conrich and Woods, eds., 18.

18. Cited in Dennis Lim, "Dante's Inferno: A Horror Movie Brings out the Zombie Vote to Protest Bush's War," *Village Voice*, November 29, 2005.

19. The *Masters* episode *Haeckel's Tale* diverges from the formula by offering sexually active zombies. It is not convincing. Andrew Currie's 2006 *Fido* offers sympathetic zombies who just want to be "normal," contrasting them to less sympathetic, conformist 1950s American suburbanites. The film ultimately upholds a fairly conventional, dull notion of what constitutes desirable normality.

20. Lim, 2005.

21. *Masters* engages this formula, with some critical edge, in Larry Cohen's *Pick Me Up* and Don Coscarelli's *Incident on and off a Mountain Road*. The former offers dueling macho psycho killers and a heroine who is particularly resourceful, only being defeated when she loses her edge and starts acting like a stereotypical girl in a horror film.

22. Identifying which films are "of value" is clearly a contentious task. Further, as scholars we should not limit our studies to films we judge to be politically progressive or aesthetically valuable. See, for example, Christopher Sharrett, "The Horror Film in Neoconservative Culture," in Barry Keith Grant, ed. *The Dread of Difference: Gender and the Horror Film* (Austin: University of Texas Press, 1996). Or, consider Matt Hills research on the *Friday the 13th* franchise, "Para-Paracinema: The *Friday the 13th* Film Series as Other to Trash and Legitimate Film Cultures," in Jeffrey Sconce, ed. *Sleaze Artists: Cinema at the Margins of Taste, Style, and Politics* (Durham: Duke University Press, 2007).

Chapter 10

49 Up

Television, "life-time," and the mediated self

John Corner

Michael Apted's *49 Up* (2005, First Run Features), the latest in his series of seven-yearly portrayals of the life-course of a group of people first examined as young children in 1964, has won widespread critical and public acclaim. Screened in prime-time in the UK and broadcast extensively elsewhere, *49 Up* has since been released internationally on DVD. The American critic Roger Ebert described the series as one of his "top ten greatest films of all time"[1] and the British writer Jonathan Freedland called it "the most powerful drama ever screened on British television."[2] The film review website rottentomatoes.com gave it a 97 percent "fresh" rating. The series has had tremendous impact internationally, both with audiences and within television production, encouraging a range of similar projects in different countries.

This chapter looks both at the integration of formal and thematic aspects of program design (for instance, the deployment of interview testimony and visual portrayal in the development of biographical portraits phased across many years) and examines the connections with broader cultural factors (such as shifts in the social structure of Britain and related changes in social values and personal expectations) that are made by this latest program in the series.[3] It does so with a particular interest in questions around the idea of "convergence," around an assessment of how the program compares with the wide range of "reality formats" emerging since the series was initially devised and designed. Articulations of "ordinary" selfhood as an area of cultural expression have clearly grown in scope and scale as a result of the design and styling of reality television across diverse models (*Big Brother*, *Wife Swap*, and shows such as *Pop Idol* and *The Apprentice*, for example, allowing different opportunities for personal display in interview and interaction). This range of biographic and autobiographic formats has been joined by various applications of the Web, particularly the uses of MySpace and Facebook. Such modifications and extensions to how the self is projected, audited, and oriented toward others, including toward "society," have shifted the context in which television versions of

the biographical and the autobiographical now generate their meanings.[4] What lines of "convergence" or, alternatively, of "divergence" can be seen when we look at *49 Up* and assess its recent success with contemporary audiences? In pursuing this analysis, issues will be raised about the program's ethics as it "uses" people to develop its account, the kinds of performance and self-display (sometimes uneasy) that it elicits from participants, and the relatively expansive, spacious approach it adopts in the presentation of life-times and in providing the audience with opportunities for engaging with what they see and hear. These are all issues where the practices of reality television have introduced new points of comparison, not available when the first programs in the series were made.

In exploring these questions I want to work with four connected subheadings, each of which carries the analysis into the specific qualities both of the series and the latest program and, at the same time, connects outwards to questions about values in a changing audio-visual culture and a changing society. First, I want to raise issues directly around the formal character of the program, which I think poses quite unique problems of communicative design. I then want to explore how the program plays the biographical and the sociological against one another in ways that have been a regular point of reference in critical discussion. In the third section, I want to examine the modes of the "mediated self" at work and the questions of ethics and of integrity raised by the series. In a final section, I will consider the frameworks of aesthetic and social appreciation (often explicitly personalized) used by critics and audiences in engaging with the program.

Formal design

As I noted above, many of the most important features of the program's formal character are largely a consequence of the fact that it places its "present" against the context of six different "pasts" for each of its 12 participants. Most documentaries with a biographical theme, having little or no recourse to earlier material shot for the express purpose of biographical audit, work with a highly selective and sometimes chronologically indeterminate version of "the past." They perhaps use commentary speech to provide a narrative frame for a range of materials having different origins and different kinds of status as biographic data (for instance, photographs, diary entries, anecdotes from friends and colleagues, dramatized reconstructions). Other programs, particularly those with historical themes, may have one moment in "the past," a year or a decade or the period surrounding a specific event, a "then" placed in a relationship of mutual significance against a "now." *49 Up* has material from all its previous programs as multiple points of retrospective reference. This leads to a

challenging textual economy (what to put where and for how long?), one with implications for the coherence of the account as it pursues its different bio-graphical trails.

It perhaps follows inevitably from this situation that the program will work with the basic design of taking each participant in turn (although sometimes continuing to work with the pairings and threesomes that were used in the very first program).[5] The alternatives, for instance an organization in terms of common themes or significant contrasts produced by selecting from across all the participants, would be thematically disruptive to the essential *biographic* appeal of the project as it has developed and, given the combined range of times and people, create problems of disjunction in the viewing experience.[6]

Nevertheless, even with the chosen approach, the scale of temporal move-ment within what I have called the "textual economy" is clear. For instance, in the opening "chapter" of the film, that concerning Tony, the East End working-class boy who is now a modestly successful businessman living in semi-retirement in Spain, there are over 40 time changes in 15 minutes as the program moves back and forth along the six points of prior temporal refer-ence, connected by Apted's retrospective commentary and Tony's self-accounting. On average, this is a time-shift every 22 seconds (throughout the program, most scenes from past episodes are identified by a caption in the lower right-hand corner). However, such a statistic is not too illuminating because the shifts vary between scenes that contain just a few seconds of com-mentary over action to those that involve extensive interview speech. The amount of time given to different "pasts" also varies; Stella Bruzzi interestingly notes how it has become a convention for each program in the series to give less attention to its immediate predecessor than to earlier episodes. The grounds for this, as she observes, are likely to be the continuing need to emphasize the "formative" years and the way in which the relative closeness of the time of the preceding program in the series to that of the new material is likely to reduce its contrastive or developmental interest for viewers.[7] This is particularly true, of course, for those many viewers, in Britain and abroad, who see the latest in the series without having seen any of the earlier ones.

Another significant feature of the program and the project as a whole, particularly when judged in the context of contemporary reality television formats, is the way in which the emphasis is on *contemplation* rather than *action*. Clearly, contemplative depth tends to increase with the age of participants and with the number of "former selves" that they are invited to reflect upon. Unlike in more recent reality formats, no specific action or circumstance is required to generate that strong sense of self-in-life that constitutes the pro-gram's main "offer" to viewers. The program's distinctive way of being "per-sonal" springs directly from the nature of the entire enterprise as one involving

sustained self-reflection, even though the interview settings are mixed with scenes of routine domestic and professional activities to support the sense of lives *being lived*. The contemplative emphasis extends to the speech, which is not much concerned with objective description beyond a few key details – often provided by Apted himself in voice-over – and which only intermittently engages with "opinion" or "viewpoint" as an extension of its focus on self-review and self-development. Although soundtrack music has been urged on him by others, as a way of cueing mood and increasing viewing interest by fulfilling generic expectations established by current reality formats, Apted has declined musical options and retained the relative "quietness" of the program's biographical spaces.

Given these production choices, the importance of faces and voices to the meaning and impact of the project as a whole can hardly be overestimated. Although close-ups are used with restraint, most of the shots allow for a sustained viewing engagement with participants' faces, while the thoughtful hesitation of what they say often contrasts sharply with the kinds of vigorous talk privileged in many reality formats. A concentration on face and voice underscores the identity of the program as a biographic document. It moves it away from the rhetoric of "exhibition" and "display" of much contemporary factual output and provides it with sustained "interiority" as an exploration of subjectivity over time. This is perhaps most evident when participant voice-over from the "present" is put across images from the speaker's past. Such an audio-visual approach also signals *change* in a way that is both decisive and poignant – the

Figure 10.1 *49 Up*, DVD cover – faces and times (photo credit: Granada Television/First Run Features).

progress of life through the six phases of seven years is a record both of a developing *experience* of life and of a physical change, in this latest program one that is now past the point of "prime."

The character of the sections given to each participant varies, but each one involves extensive use of material from earlier programs, recent interviews in homes (sometimes with partners), and recent footage showing family, leisure, or occupational activity both in interior and exterior settings. The function of the latter, as I have indicated, is to establish visually something of the "normal life" of each participant at the present time and to provide the opportunity, combined with the material from the past, for interview speech to be heard outside the context of the interview settings themselves. Apted's own framing and linking commentary is mostly restrained, although it occasionally cues biographical ironies and contrasts (here supported by the editing strategy) that the primary materials themselves might not have generated so sharply, if at all. Throughout, we regularly hear the interviewer's questions as well as participant answers, in many scenes setting up a sense of intimacy, derived from the repeated encounters over the years, that is a distinctive feature of the series and a part of its viewing appeal.

Biography and sociology

When *Seven Up!*, the first program in the series, was made in 1964 without any plans for updating, the project was essentially one of "snapshot sociology." The program was an edition of the weekly current affairs series, *World in Action*[8] and sought to present a contrastive exercise in the exploration of character formation, social class, and the national future. Without any concern for scientific sampling, a group of children of sharply different backgrounds was selected from schools mainly in the south but also in the north of England. An "event" was arranged to bring some of the children together. They were taken to the zoo, to a party, and to a playground in which a variety of items (climbing nets, slides, little log houses, etc.) was available to have fun with. The exercise worked partly by observation but principally by interviews. The Jesuit motto "Give me a child until he is seven and I will give you the man" provided a basic idea and the "hook" for a loosely ethnographic project in social inquiry.

Edited sections of the opening of the first program are repeated at the start of *49 Up*. The program begins with interview segments of five children giving short answers to the question of what they want to be and do when they grow up:

> I am going to work in Woolworths.
> When I grow up I want to be an astronaut.
> When I get married I'd like to have two children.

My heart's desire is to see my Daddy.
I don't . . . want . . . to answer that.

Then, over a sequence of the children at the zoo, the voice-over commentary notes:

> This is no ordinary outing to the zoo. It's a very special occasion. We've brought these children together for the very first time. They're like any other children except that they come from startlingly different backgrounds. We've brought these children together because we wanted a glimpse of England in the year 2000.

49 Up replays this opening and reframes it for 2005:

> In 1964, *World In Action* made *Seven Up!* and we have been back to film these children every seven years. They are now 49.

A contemporary sense of problems and anxieties around industrial relations (and the gender bias of the project) is revealed in a subsequent remark in the first program's commentary that the "shop-stewards and executives of the year 2000 are now seven years old." Gender is a relatively unexplored factor in the exercise. Of the 14 children chosen for interviews, ten are boys. This discrepancy posed a noticeable imbalance in subsequent instalments of the series, as later programs were viewed within changing frameworks of social value and expectation. The imbalance has been partly offset by the inclusion of interviews with some of the participants' wives, talking about marriage and family as part of the biographic testimony. However, as Joe Moran notes in his perceptive study of the series, issues of "social structure" have become increasingly displaced by individualistic, biographical concerns as the series has developed.[9] This is the case even though the lives of many of the participants bear witness to the continuing influence of the economic and educational inequalities established at the start.

There is a degree of inevitability in this displacement insofar as *retrospection* has become a primary and time-consuming part of the enterprise, grounded increasingly in the self-accounts of the participants in a way that would make any pursuit of a broader thesis by the program a challenging one to articulate. In order to sustain an emphasis on ideas of economic and class determination, the later programs would have had to work with an entirely different design, perhaps one in which the focus on the children of 1964 was heavily supplemented by a wider range of statistical data, exposition and "expert" interview. As commentators have pointed out, it might also have had to work with a broader and less polarized class profile, including more children from the large

and internally differentiated middle-class strata rather than a design essentially placing the working-class East End against a wealthy and established social elite.

In *49 Up*, "the social" has not disappeared from view but it is largely present as background, occasionally increasing in salience as a result of specific points of reference and comment made by those participants more inclined to "place themselves" socially in their interview speech. Of course, the mysteries of individual personality were a powerful factor right from the start, complicating any attempt at articulating too firm a sense of the likely influence of environment upon a life. The opening remarks of some of the children, as quoted above, clearly show engaging personal variations of mannerism and demeanor, as well as variations of broad social position.

However, by relying primarily on an interest in personal development and in "personal fate" as incrementally documented in the project's archive and its new materials (both "how they turned out" and "how things turned out for them"), *49 Up* poses some problems of *readability*. As viewers, we feel the need to make sense of the dense biographic particulars beyond our engagement with the participants themselves. Some kind of *inferential process* is presupposed in the program's design (and, I suspect, widely undertaken by its audiences). There is an implied move beyond the individual locus of attention to inter-individual and more general levels of significance. Initially, there is the comparison to be made between the different participants (as distinct personalities within their given and changing circumstances). Throughout, there is also the comparison between the participants and the viewer (them and me, their lives and my life), a comparison that will clearly have strong economic and social components as well as a directly physical and psychological dimension. In fact, processes of *inference* will inevitably work alongside processes of *deduction*, insofar as interpreting individual life-stories to get a broader social understanding from the program will link up with making sense of the individual lives through social categories and criteria already established in the viewer's mind and part of their basic interpretative frame. Reading the program involves a regular movement between individualized specificity and wider import, a movement in which the constituents of meaning are both "taken up" and "taken down" the levels of generality.

49 Up has no *propositional* case to offer, it does not make any explicit social or political claims about the world. There is therefore no question here, as there is in many other documentaries, of agreeing or disagreeing with the way participant testimony supports or not an emerging argument. Viewers watch, listen, and construct their own sense both of the individuals portrayed and the larger social picture. In such a circumstance, the most obvious upper level to which inference can project is that of the "human," a level which, if only temporarily, is likely to transcend categories of social structure altogether.

I want to look now at how four of the participants conclude their own sections of the program, "rounding off" their self-review. Many of the participants end their account with a strongly personalized sense of achievement, sometimes mixed with notes of regret. In the case of East End working-class girl Jackie, this carries a marked recognition of earlier inequalities. When she is asked about her hopes for the future she replies:

> What I hope to do. I'd actually ... I'd like to go back to school, so that I can hold a conversation with anybody in the world and know what I'm talking about. So that I'm not stuck. I know a little bit about that, but I don't really know enough. I'd love to know.... Actually, I'd really like to start my education all over again.

And then, in a comment that picks up on her dissatisfaction with the way in which she feels she has been manipulated by the project (I shall say more about this in the next section), she comments: "I enjoy being me. But I don't think you ever really expected me to turn out the way I have."

Neil is the articulate, merry child at seven whose apparent lack of "progress" in matters of career and of family, endless changes of location, and depressive tendencies have given the series its most anxious "hook" of narrative anxiety ("What will have happened to Neil?"). Not surprisingly, *49 Up* saves his story to last. Toward the end of it, Neil offers this reflective anecdote:

> If I can just tell a short story. I was just sunbathing and a butterfly landed quite close to me. Beautiful wings, deep red color and white sort of circles on them And ... these creatures don't last very long. It landed very close to me it wasn't ... it didn't seem frightened. And it just seemed to delight in opening and closing its wings and in just actually being beautiful for that period of time, enjoying the sunshine. And perhaps there isn't actually any more to life than that, in just being what you are, realizing that life goes on all around and that there are millions of other living creatures who all have to find their part as well.

Although not matching this in sustained transcendence, other participants are similarly encouraged by the very nature of the terms of their involvement to "pull back" in their concluding remarks and offer a wider perspective, if only briefly. For instance, Bruce, the melancholy schoolboy at seven who, at 49, after a varied career in teaching, is now working at a school as elite as the one he attended, sounds a "realist" note when asked to reflect on himself as portrayed in the first program and on his present "hopes":

Figure 10.2 49 Up, rearview reflections – Neil in his car (photo credit: Granada Television/First Run Features).

> I can't really recognize myself. He looks a little bit lost and a little bit sad. And I think I'm quite sort of surprised to be sort of contented and reasonably happy. You know when dreams go and the day to day living of ordinary life and family life takes over I think, I think we sort of live without our dreams.

Tony, the working-class boy living with his family in Spain, develops a similar theme of settling for core contentment when asked about what his dreams are now:

> To be happy, which I am. I'm happy now being healthy. With all my family we all want happiness and health for our family. Anything else would be a bonus. And that's all I really want. I don't want any more or less than that.

This is self-audit at its simplest and perhaps most resonant, the repetitions a seeming guarantee of the strength of feeling with which these "modest" ambitions are held.

Mediated selves

The way in which the *Up* series works with self-display and self-accounting raises a number of questions, not least because some of the participants have stated how the regular intrusions into their lives of the apparatus of television

have been disruptive and even traumatic. Critical comments of this kind are even contained in the interviews themselves, including those in *49 Up*.

There are two related but different kinds of issue here. One concerns the *ethics* of the series in relation to the impact (only partly predictable in advance) it has had on the lives of those it has selected, marking them as kinds of "public figure" at seven-year intervals.[10] The second concerns the way in which the design of the series, particularly in the later programs, involves a distinctive form of *performance*. This performance is one by people who have had a sustained experience of televisuality and a developing personal (but not always happy) relationship with the director/interviewer. It is also one in which the primary requirement to engage with former selves and the self-in-development produces, as we have seen, a strong sense of the contemplative.

Some participants in *49 Up* clearly seem more content than others with the distinctive performance requirements asked of them, and unhappiness in performance connects back to the question of the series' ethics. Jackie is the most explicit in voicing criticism of an inequality in the design and production of the series. She makes a directly personal issue of the control exerted by the director over the terms of her portrayal, accusing Apted of an unfair, distorting approach after he has posed a question to her that receives an indignant response. The following exchange takes place as she talks about one of her children:

J: He tends to be like the outspoken one. He's a bit like I was at his age really. In fact, he's very much like I was at his age.

APT: Is that a worry?

J: I think that's . . . that's terrible. How dare you say that to me! Is that a worry. Why should that be a worry? Do you think I've turned out badly?

APT: No . . . but sometimes when you look at yourself you don't always see things you like in yourself and you see them in your child and you think . . .

J: No . . . But I never said he picked up all of my traits . . . I actually think he's probably picked up the best.

[and after a discussion of her son's temper in relation to hers]

You will edit this program as you see fit. I've got no control over that. You definitely come across as this is your idea of what you want to do and how you see us and that's how you portray us. This one's maybe . . . maybe the first one [i.e. program] that is about us rather than your perception of us.

APT: So how up to now have I got you wrong?

J: How have you got me wrong? The last one was very much based on the sympathy and the illness that I've got and what I may and may not be able to do. It should have been about what I can do, what I am doing and what I will do.

While none of the other participants protest against the project with the same sense of personal injury as Jackie, they do articulate reservations about the impact of the series upon their lives. Nick, the farmer's son who went on to Oxford and is now a science professor at an American university, simultaneously describes the discomfort his appearance causes him and affirms its value both for him and for the audience:[11]

I think this film is extremely important. It's important to me but it seems to be important to other people as well. That doesn't make it an easy thing.... It's an incredibly hard thing to be in and I can't even begin to describe how emotionally draining and wrenching it is just to make the film and to do the interviews and that's even when I'm pretending that nobody else is watching it.

Nick, in this respect like Neil, has provided one of the more "marked" biographies of the series, his life providing themes both of career success and geographical displacement. In pursuit of the latter, the series brought him back to his family's Yorkshire farm for the shooting of 42 Up in order to provide continuity with the landscape footage from earlier years and to foreground his "engaging" dual identity as farmer's son and university scientist.

Figure 10.3 49 Up, Jackie's surprise at the interviewer question (photo credit: Granada Television/First Run Features).

An even sharper note is struck by John, one of the public schoolboys who followed a successful career at the Bar after studying at Oxford. His wife attempts to correct his critical tone, but he goes on to balance his initially negative appraisal by noting the value his television appearances have had for the overseas charity he supports. He then expresses his understanding of the fascination of the program, although he does this in terms that align it with contemporary reality television instead of according it distinctive value:

JOHN: It has to be said that I bitterly regret that the headmaster of the school where I was when I was seven pushed me forward for this series. Every seven years a little pill of poison is injected into . . .

WIFE: No no!

JOHN: Well . . . well it's the truth. There are times when I have felt that appearing on this may get causes near to my heart a bit of publicity and certainly when you came to Bulgaria for the *35 Up* program that did lead to us getting quite significant assistance which possibly we wouldn't have got.

I suspect that why this program is compelling and interesting for viewers, and I quite see why it is . . . is because really it's like *Big Brother* or *I'm A Celebrity Get Me Out of Here*, it's actually real-life TV with the added bonus that you can see people grow old, lose their hair, get fat, fascinating I'm sure. . . . But does it have any value? That's a different question.

What John is perhaps failing to recognize adequately here is those ways, discussed earlier, in which the forms of "display" of the program are really very different from those of the reality series he cites. They provide a viewing experience in which the issues of personal identity and of the interplay between "reality" and "appearance" are articulated across 42 years of audio-visual record and are openly explored across shifts of circumstance, including adversity, both by the program-makers and the participants. This kind of questioning of the stability and mutability of the "self" across the different phases of a life-time is likely to offer to many viewers a kind of "difficult truth" about coming to terms with change and with oneself that connects strongly with their own experience and thereby gives their relationship with those on screen an increased depth of focus and of feeling.

Frameworks of appreciation

The scale of popular response and critical acclaim, and the recurrent use of certain terms and phrases to describe the program's value, can easily be documented. The Rotten Tomatoes film-review site (rottentomatoes.com, accessed February 2008) contains critical remarks such as:

I can think of no single movie, fictional or factual, that more strongly awakens our common humanity, or that establishes such a marvelous, tight bond with its characters.

(*Chicago Tribune*)

Apted has constructed a peerless, suspenseful work that develops character to a depth that would make Tolstoy jealous.

(*New York Post*)

A deeply moving meditation on the natural evolution of existence.

(*Hollywood Reporter*)

The most remarkable chronicle of a slice of humanity in the history of cinema.

(*New York Observer*)

one of the most singular and transcendent expressions to emerge during the first century of this newest art form.

(*Christianity Today*)

Another US newspaper continued the spiritual emphasis:

an affirmation of life that feels like a gift.

(*Los Angeles Times*)

In the UK daily newspaper the *Guardian*, Jonathan Freedland discussed the series' "universal humanity" and the way in which it allowed viewers to "witness the narrative of human life itself."[12] He emphasized the difference between what was being done here and tendencies in reality television:

So in the era of *Celebrity Shark Bait*, let us give thanks for one of those rare occasions when television reaches beyond the banal, and touches the enduringly, inspiringly human.

(Freedland, 2005)

The Times (London) noted:

It makes you feel better about the human race.

Finally, Roger Ebert's interview with Apted, included on the DVD of *49 Up* and published in the *Chicago Sun-Times*,[13] sustains these core terms of appreciation:

I think it's the most notable use of film that I've been able to witness as a filmgoer. Noble in its simplicity and its honesty and its directness and its lack of pretension or grandiosity. Just the gaze of an interested observer coming into these lives and saying, "How you doin'?"

Like many viewers, Ebert aligns his own life with that of the participants in a way that involves both empathy and projection, together with a fair measure of the sentimental:[14]

I came aboard early in the series and I, too, have grown older along with it. In Tony's eyes at 7, reflecting in his mind his triumphs as a jockey, I can see the same eyes at 49, gazing upon his swimming pool in Spain. He ran the race, and he won.

As many commentators have noted, there is a strong interplay throughout the series between patterns of confirmation and patterns of surprise. In the former, personality traits and socio-economic contexts established early on are seen to be active determinants of the way in which later life develops. In the latter, what one might have expected from earlier indications is contradicted by what happens later. Here, *49 Up* works most obviously, if quietly, with the "success story" model, marked in the case of university physicist Nick with a clear sense of "who would have thought things would turn out like this?" Yet the program is keen to find something affirming in all of its stories, perhaps where the success has been of a more personal kind (as in the case of Neil's lonely struggle, in various locations, with depression – providing a regular point of anxiety and therefore of viewing interest throughout the later programs of the series).

The narratives of confirmation and surprise work powerfully from the audio-visual record of earlier expressions of personality, but they cannot help but be overlaid by the social categories through which this record was collected, the residual "sociological" frame. Who can be surprised that the preparatory school boys who so confidently announced their future public schools and Oxford or Cambridge colleges at the age of seven have gone on, via these institutions, to professional success and financial security? Who can be surprised that many of the working-class children have mostly not enjoyed careers in the professions and are in some cases financially hard-pressed? A sociological frame continues to play up against a more romantic sense of individual potential and growth. From scene to scene, the emphasis, including the kinds of surprise or of confirmation on offer, varies in relation to this interplay.

Conclusion

The ways in which *49 Up* works with and upon time are unique.[15] This is not only a matter of its textual economy but of its fundamental character as a viewing experience. "Lives in time" are what *49 Up* essentially documents, increasingly underpinning the entire venture with a strong, implicit sense of what a "life-time" is.

I have suggested that, for most viewers, the interplay between social system and individual character that *49 Up* portrays is a loose enough one to allow for a wide range of interpretations, depending on prior frameworks of social understanding. Although sharp inequalities are portrayed, including those of educational opportunity, these do not constitute anything like a "case," they do not become the evidence for a political argument, as they well might in another kind of film. This looseness is, of course, one of the principal factors in the popular success both of the series and this latest episode, providing the grounds for its wider, humanistic appeal. *49 Up* offers a view of lives and of living that combines both "easy" and "difficult" terms of engagement. It is "easy" in its relaxed affirmation, in its often strategic deployment of the "poignant" and the implicit foregrounding of the personal over the systemic. It is "difficult" insofar as it also regularly shows participants involved in a self-accounting and self-assessment which becomes, visibly, a trouble to sustain and articulate, and which is provocatively connected to the real complexities and contradictions of "growing up" and "growing older."

Although the program is, inevitably, structured in part as an "entertain-ment," with calculated appeals and a pleasing overall design, its versions of selfhood depart markedly, in their evaluation and tone, their reflective space and their depth of perspective, from those now familiar through the varieties of reality television. *49 Up* offers a provocative marker for looking more broadly at the ways in which television portrays "life-time" variously as a process within a system, a self-directed journey, and a series of encounters with chance and luck. As new conditions for the mediation of the biographic and autobiographic emerge across an expanding range of formats, modes of delivery, and genres, reconfiguring the options and expectations, it is likely that the series will continue to engage, fascinate, and move viewers. It will do this both by the particular manner of its deployment of the "long view" and its connections back to modes of portrayal that come from a less hectic period in the mutually shaping and problematic relationship between the terms of televi-sion and the terms upon which lives are lived.

Notes

This was originally given as a paper to a seminar of the "High Tension Aesthetics" project at Copenhagen University in Spring 2007 and I would like to thank Anne Jerslev and the members of the seminar group for their invitation and comments.

1. Roger Ebert, "Ten Greatest Films of All Time," *Chicago Sun-Times*, April, 1991.
2. Jonathan Freedland, "A Poignant, Human Drama in the Era of Celebrity Shark Bait," *Guardian* (Manchester), September 14, 2005.
3. Since the writing of the seminar paper on which this chapter is based, Stella Bruzzi's excellent study of the whole series has appeared: Stella Bruzzi, *Seven Up* (London: British Film Institute, 2007). It offers many perceptive comments about the making of the programs and their character as television and I have made reference to it at several points in my own discussion.
4. An excellent review of some of the ways in which the "subject" and subjectivity have appeared within different forms of documentary is to be found in Michael Renov, *The Subject of Documentary* (Minneapolis: University of Minnesota Press, 2004).
5. The series actively brings together some of the participants to recreate the circumstances of the first program. In *49 Up* this involves, among other things, bringing one participant and his wife over from Australia to meet up with his childhood friend of 1964. Bruzzi in *Seven Up* notes how there are minor variations in the regularity of appearance of some of the participants across the run of the series.
6. Although this method was used in the first three programs, when the volume of material and the length of the life-stories to date were more modest in scale.
7. Bruzzi, *Seven Up*, 63. She also talks of the repeated use throughout the series of "golden moments" from earlier programs, scenes which appear to sum up character and which have certain striking, perhaps amusing, features which can be relied upon to engage audiences and cue them into the ongoing biographies, whether for the first time or as returning viewers.
8. A history of this remarkable and influential series is given in Peter Goddard, John Corner, and Kay Richardson, *Public Issue Television* (Manchester: Manchester University Press, 2007).
9. Joe Moran, "Childhood, Class and Memory in the *Seven Up* films," *Screen* 43:4 (2002), 387–402.
10. The impact will be greater for some than for others, according to personal circumstance. The shaping pressures that being in the program has brought to participants have, on the whole, been different from the kinds of intensive and "invasive" media interest accorded to key characters in "reality" series.
11. There are some odd aspects to the treatment of Nick throughout. Established as a "country boy" early on, walking across the fields between school and home, his career is marked as a surprise success story in a way that only works if a strong social class contrast is assumed between the conditions of his childhood and his later achievement. However, Bruzzi observes that his father is really a farmer, not a farm-worker, and is a university graduate himself.
12. Freedland, "A Poignant Human Drama."
13. Roger Ebert, "Seventh Time 'Up' for Apted," *Chicago Sun-Times*, October 12, 2006.
14. Roger Ebert, *49 Up* film review, *Chicago Sun-Times*, November 3, 2006.
15. Although the German series *The Story of the Children of Gozlow* began three years earlier and was last updated in 2006. Its structure and biographical/sociological mix make an interesting point of comparison with the *Up* series, one currently being pursued in the context of a wider study of "longitudinal" form by the documentary scholar Richard Kilborn.

Technologies of citizenship

Politics, nationality, and contemporary television

While the chapters in the anthology's final section address considerably different objects of study – including television policy, Web videos, cellular imagery, sports, and reality television – these pieces share a common commitment with the anthology's other contributions to historicizing and demythologizing the revolutionary rhetoric that attends to the technologies and participatory practices of media convergence. Too often, information and communication technologies are heralded as offering users ever-increasing and innovative means of fostering interpersonal connection and opportunities for civic participation without limitations or costs (besides, perhaps, the price of hardware or subscription fees). As the pieces in Part III demonstrate, television and new media are not just vehicles that represent and transmit civic and political values, but these devices and mediated fora also structure the conditions under which political participation can take place, as well as affect public discourses about who should and should not be properly counted as a citizen.

A key question to keep in mind when reviewing this section's chapters is: how do television and new media technologies shape (and reshape) our thoughts about political participation, the public sphere, media access, language, race, and democracy? A nation's discourse about its political promise and the rights and responsibilities of its citizenry is always already mediated and maintained by media communiqués old and new. These chapters examine how new media convergences and televisual technologies that are celebrated for offering emergent pathways for self-authorship and expression (e.g., video blogs, mobile phones, Internet discussion boards) are nevertheless undergirded and driven by larger political and economic forces that actively delimit and prefigure the very civic possibilities that they promise to promote. The range of contemporary tensions examined herein include: how user-created content rich in intertexual insights provide citizens with ingenious ways of speaking about (and to) the body politic, even as these means are co-opted by

news and media firms; how the taken-for-granted ideas of a "national television" sphere in the US are complicit with xenophobic and ethnocentric attitudes that marginalize non-Anglo Saxon cultures; how a popular (and populist) format like reality television can be deployed in the service of promoting neoliberal ideals for winning foreign hearts and minds; how the transformation of a popular American motor sport reveals how media convergences can propel not only new parameters of audiencehood but also reconceptualizations of the nation and how it is instantiated via popular entertainments; and how mediated trauma necessarily exceeds and escapes the ability of citizen journalists armed with cutting-edge mobile devices to adequately chronicle social violence, irrespective of a given technology's high-resolution graphics or its quick connection speeds.

A nation's self-identity (its history and its mythological destiny) is voiced through numerous media artifacts and is repeatedly witnessed and rehearsed at different venues across time – from user-created videos on YouTube, to social networking apps on the iPhone, to corporate-sponsored community renovation projects on programs like *Extreme Home Makeover*. These converging media technologies and entertainment formats allow us to imagine our nation and connect with fellow citizens in increasingly complex ways. Of course, new media tools, genres, and practices are no social panacea, as they simultaneously and invariably elide those who find themselves on the other side of the digital divide (or, more likely still, digital divides). In the age of rapid media convergence, the challenge for critical analysis and progressive social action lies in cutting through the hyperbolic claims about technological interactivity and user choice, and distinguishing between those media tools, practices, and social configurations that best foster civic freedoms, and the others that only advertise better mobility and connectivity but do little to address (or may even compound) social ills such as racism, classism, and war.

Chapter 11

Television/televisión

Hector Amaya

On November 9, 2007, I entered the following search terms in LexisNexis: Television *and* network *and* CBS *and* ABC *and* NBC *and* WB *and not* Univision. The results were a staggering 1,766 entries that in one way or another discuss US network television without mentioning Univision (or any other Spanish-language network such as Telemundo, Azteca America, or Galavision). I then used the Boolean operators to add Univision to the search (Television *and* network *and* CBS *and* ABC *and* NBC *and* WB *and* Univision), and the search-engine returned 229 entries. Of the almost 2,000 total articles and trade news items, less than 12 percent included Univision in their discussion of American broadcast television. Even more startling, the vast majority of the 229 news pieces about Univision were ratings reports. These data refer to the televisual map predating the creation of the CW in 2006 (the WB and UPN merged to form the CW in January 24, 2006). Next, I conducted a similar search with more contemporary names or terms, typing CW instead of WB, and the results were somewhat different. A total of 983 reports excluded Univision and 470 included it; or, roughly 31 percent of news and trade press included the Spanish-language network. The press was perhaps atypically interested in Univision at this time, as the company was being bought and sold, and was involved in legal battles with Nielsen, the giant ratings corporation.

Another example of Univision's conspicuous absence appears in academic tools and institutions. The differences here are much more startling. I searched the Communication & Mass Media Complete database, restricting the search to peer-reviewed articles. I typed Univision *and* television: 59 entries. I then typed UPN *and* television (let's remember that UPN is now defunct and never enjoyed substantial ratings): 142 entries. I typed Fox *and* television: 2,463. The results with CBS, ABC, and NBC were all above 3,000. I was very surprised to learn that the number of articles about Univision was 1.5 percent of the number of articles about CBS. I searched syllabi on television studies within media studies departments across the United States and discovered that

the vast majority did not include research on Spanish-language television, and only a few departments even offered courses addressing Latino media. To add insult to injury – I am a Spanish-speaking Latino – during a recent visit to a giant media library of a prestigious research university, I was informed by the head of acquisitions that their massive collection contained not a single Spanish-language American television program. She kindly stated that "foreign language programming" is typically acquired by faculty request. Wait a second. "Foreign"?

These examples suggest a radical marginalization of language that I want to locate within the current discussions about media deregulation, convergence, and transnationalism. Deregulation has long been predicated on the utopian neoliberal principles of market competition and openness.[1] After the Telecommunications Act of 1996, these utopian neoliberal principles became the basis for the technological convergence of broadcast, Internet, phone, and cable. Echoing the assurances of neoliberal openness, transnational media flows promise to diminish the relevance of nation-state media systems. Given these three phenomena and their popular utopian connotations, it is tempting to imagine that our media industries obey the principle of radical openness. However, as my examples illustrate, a highly restrictive notion of the national is a structural force of the televisual map – deregulation, convergence, and transnationalism notwithstanding.

In this chapter I quarrel with the idea that convergence is in any way utopian and propose that "national television" is a concept that is at once necessary and limited. It is *necessary* because the idea of national television helps us define media as a cultural and civic space for public participation. It is *limited* because of our problematic definitions of nation. The relative marginality that Spanish-language television has for trade press writers and the practical invisibility it has for academics and media departments illustrate this fact. This marginality raises the important issue of how the national televisual map is constructed by these important social fields entrusted with creating the knowledge and discourses that define national television. I want to draw attention to this oversight and treat it as a naturalized violation of Spanish speakers' language rights that is echoed by media regulatory bodies. This conception of rights is new and not part of the FCC's regulatory/legal frameworks. I argue that we need to expand these frameworks to include the treatment of Spanish language within the context of legal rights. To make these arguments, I critically locate the omissions of Spanish in the US's systems of legal and cultural definitions of citizenship that constitute the US franchise. In these systems, language often becomes a proxy for ethnic battles, and the positions taken by groups trying to protect one language at the expense of others replicate the tensions between ethnonationalisms. Because of this, the omission of Spanish-

language television becomes a political act: the omission naturalizes English as the state language and it thus supports the claim that the Anglo Saxon[2] ethnicity and the US state are coterminous. This deceptive political act is complicit with neoliberalism, which claims its power is color-blind and ethnically neutral. To unpack this deception, we need better understandings of citizenship and cultural/language rights.

For current purposes, I am defining ethnonationalism as the act of imagining the United States through Anglo-Saxon ethnic and cultural markers. Ironically, the small changes we are seeing in the industry's own mapping are the result of market forces, such as advertisers and the corporations that now own Spanish media, who are eager to expand their reach in the Latino population and their increasing wealth. Media and television studies, by and large, have shared the industry's distorted view of our televisual landscape. As a consequence, media studies flirts with conservative and ethnocentric definitions of the state. Because of this glaring omission, I call for the re-centering of Spanish-language media in our curricula, believing it to be a key disciplinary responsibility. Below I elaborate on ethnonationalism and multicultural liberalism in order to frame language rights *as* citizenship rights. The broad frame of language rights is the legal and critical mantle on which the protection of Spanish-language media rests. Next, I briefly explore the complex role of Univision in the constitution of a national Latino political agenda, anchored in language specificity, and through their political roles in the Latino community. Finally, I examine the tensions between deregulation, convergence, globalization, and nation that come to bear in the case of Univision, its programming, and audiences. In this section I also use theoretical tools from multicultural liberalism to argue for the benefits of treating Spanish as a citizen's right and a language protected by the state.

Placing Spanish in the nation-state

Ethnonationalism refers to a strong identification with and abundant loyalty to a nation that is ethnically defined.[3] In the United States, ethnonationalism often refers to ideas and social actions rooted in the belief that the United States is and should remain an Anglo-Saxon state. Less often do we use the term to describe Latino, African American, or Native American perspectives that often use justice claims rooted in ethnonationalism; that is, in a strong identification with one's ethnic kin and the belief that one's sense of being depends, for its consistency, on the ability of one's culture and ethnic group to thrive.[4] My own use of ethnonationalism borrows from the latter. I reject any xenophobic use of ethnonationalism and strongly believe that ethnonationalism fits into a multicultural understanding of society that regards ethnic

egalitarianism as the basis for justice. In Citizenship Studies, this position is referred to as "radical multiculturalism" and is associated with the work of Will Kymlicka.

Let me be clear: I am neither arguing for ending ethnonationalism (that is a project for utopianism), nor am I interested in calling it unjust or burdened with ethical problems. With Jacob Levy,[5] I understand the feelings, discourses, and identifications of ethnonationalism to be part of social and political organizing, and the source of both good and evil. That said, in the United States, Anglo-Saxon ethnonationalism *is* a problem because of the ability of this ethnic group to control the corporate, legal, cultural, and political fields and, more broadly, for its ability to claim itself equal to the state. Here, I use the terms "nation" and "state" in their formal definitional senses. "Nation" refers to a group of people who believe they are connected and have been so for a long time. Thus, "nation" is closer to "kin," and connotes stock and ethnicity. The state, by contrast, is a relatively arbitrary political, geographical, and social institution.[6] Most modern states are multinational, and the United States is one of the most multinational states, sharing this characteristic with other states born through empire, such as the United Kingdom, Russia, and Mexico. I use the term "arbitrary" to define states, but nations also have a degree of arbitrariness and they change over time – either by hybridizing or simply assimilating different nations into one. Such is the case of current Anglo-Saxon identity in the United States which is the result of the constitution of whiteness as a racial category that trumped old-stock European ethnicities.[7] Thanks to the constitution of whiteness as a multi-ethnic nation, Irish, British, Dutch, and Polish were eventually able to claim kinship through Anglo-Saxon whiteness.

Throughout American history, the hegemony of Anglo-Saxon whiteness has meant that this hybrid ethnonationalism has been able to lead, or at least influence, citizenship law and, later, media policy. Anglo-Saxon ethnonationalism was the basis for nineteenth-century legal definitions of citizenship that disqualified racial and ethnic others from enjoying the citizen's franchise. This franchise provides access to a portfolio of rights and duties that are the basis of constitutive justice. Since the Fourteenth Amendment in 1868, race was no longer a disqualification for the franchise since, technically, everyone born inside the US jurisdiction could claim US citizenship. Yet, actual access to justice remains unequal for people of different races. This is not a Constitutional failure but the result of the myriad laws and policies that mediate people's access to the juridical system, and the ethnic formation of the juridical system itself, which is mostly populated by Anglo Saxons.

Ethnonationalism also shapes media policy. We have laws restricting foreigners from fully owning different broadcast and cable media, though loop-

holes have allowed for the increased weakening of these restrictions.[8] Famously, the Australian Rupert Murdoch was able to bypass these restrictions by claiming American citizenship. Less notably, Mexican Emilio Azcárraga Jr., head of Televisa, the largest Spanish-language television corporation in the world, has had partial (and at times quasi-total) ownership of Univision since its inception.[9] The Federal Communication Commission (FCC) has also played an important role in instituting ethnonationalism as a central regulatory principle by making market, and not political or social, concerns the most important factors in media regulation. This has typically translated into ownership rules and restrictions that benefit Anglo-Saxon ethnic groups. Although there has been an effort to define media as racialized social and political institutions (e.g., the 1968 Kerner Commission Report criticized television for its racial composition) thusly since the 1960s, this push has been losing strength.[10] Today, with increasingly weak regulations about ethnic and racial equity employment in media industries, the FCC's weak standing on minority ownership of media,[11] and lax rules on ownership that produce a media environment of limited competition, the state's media regulatory apparatus is achieving the goals of Anglo-Saxon nationalisms without invoking the unpopular discourse of ethnic preference. For instance, today, as a Latina/o citizen, you cannot burden the state with the expectation to intervene on your behalf to work in media, own media, or enter into competition with other media. You can only have such expectations as a citizen defined by the market, either as exceptionally qualified as a worker or as a person of exceptional wealth. Yet, as feminist and critical race scholars have convincingly argued, the market does not behave in an ideal way or make selections based solely on qualifications. The market is an embodied social network that reconstitutes itself in terms of gender, ethnicity, and class.

Ethnonationalisms have some fluidity and accept members, change character, and, at times, embrace otherness. Yet, this fluidity is often, if not always, structurally and discursively related to assimilation. And why should this not be so? Hoping that new members assimilate is consistent with attributing value to one's culture. However, when an ethnic group takes over the state, assimilation becomes an undue burden on people of other ethnicities. As most immigrants will testify, they have moved here to live in the United States, not to become Anglo Saxons. Because of the way the state is organized, and because of its embodied character, many Americans conflate the Anglo-Saxon nation with the state and seem convinced that assimilation, including linguistic assimilation, is a just burden placed on people of other ethnicities. This position is also shared by a portion of African Americans, Latinas/os and others, who are willing to place the burden of assimilation to Anglo Saxon ethnic markers on the newcomers, disregarding the assimilation asymmetry they have been part

of historically. Latinas/os or blacks who assimilate to Anglo-Saxon markers cannot remedy their racial difference and must enter into unequal social contracts with Anglo-Saxon whites, who continue to possess a disproportionate control of systems of power and language policy tools (e.g., educational, legal, and media institutions).

As should be clear by now, one of the major systems of social control is language itself. In political theory debates, the question "Is language a right?" hinges on whether linguistic membership corresponds to political membership. If so, forced linguistic assimilation is indeed a political injustice as is the political marginalization that comes from speaking languages other than the dominant language. But not all theorists take this position. As Helder De Schutter notes, some believe that language is a non-issue and others go as far as supporting assimilation so that ethnic minorities may enjoy equal social and economic benefits.[12] Often based on traditional views of liberalism, this position (which today is dominant) argues that the state should not prioritize between communities and institute policies that privilege some groups. This is not the same as the liberal argument that ethnic communities have no specific rights, but rather that community rights should derive from the state's broad and effective protection of individual rights. Thus, according to De Schutter, in matters of language policy, the state should foster the equal ability of individuals to have and use a language, but cannot interfere on behalf of communities needing and wanting state support for the protection or promotion of a specific language. Here, state neutrality and non-interference is the standard of justice.

Opposing these views are theorists like Will Kymlicka, who uses communitarianism to produce what is often referred to as multicultural liberalism. His influential position is that the liberal ideals of autonomy and individuality require the protection of the individual's cultural context of choice (e.g., ethnic or subcultural contexts).[13] With Alan Patten, he argues that the state must provide the structure of justice by protecting the ability of groups to exist in meaningful ways in horizontal arrangements. Thus, cultural minorities have the right to state support and protection of their cultural context of choice, including language.[14] Although I share Patten and Kymlicka's sensitivity to the need to foster horizontal ethnic arrangements, I cannot simply adopt their position. Their examples and arguments are meant to address more clearly defined political spaces, such as debates against English becoming the official language of the United States, or bilingual education, and are thus more useful for supporting the notion of "cultural citizenship." Also drawing on a communitarian and multicultural perspective, William Flores and Rina Benmanyor define cultural citizenship as activities that help Latinas/os

claim space in society and eventually claim rights. Although it involves difference, it is not as if Latinos seek out such difference. Rather, the motivation is simply to create space where the people feel "safe" and "at home," where they feel a sense of belonging and membership.[15]

The examples that Flores and Benmayor use are not corporate media. Yet, in thinking about the social stakes of cultural citizenship, Nick Stevenson argues that cultural citizenship must include media structures and the expectation that these structures are relatively free "from the excesses of the free market."[16] Returning to Kymlicka's expectation for horizontal ethnic arrangements, I argue that these cannot exist in today's society without considering corporate media as cultural citizenship. With Stevenson, Flores, and Benmayor, I propose that Latinas/os can only experience the freedom to be who they are when mediated contexts are properly provided and structured around political, not corporate and market, logic. Because Spanish-language television is one such space, I thus define it as a civic and cultural right.

Televisión and politics

Above, I proposed a theoretical framework to look at Spanish and Spanish-language media as interrelated rights, but it is still tempting to dismiss Spanish-language television as media that pertains to Latino citizenship. The reasons are manifold. For example, much of their programming is either Mexican, Venezuelan, or is otherwise imported from some other media system. Even the national programming is marked by transnationalism. The long-running Univision show *Don Francisco Presenta* stars Mario Kreutzberger Blumenfeld, a Chilean star. Likewise, Mexican and Venezuelan stars populate many of the sitcoms. If anything, Univision, Telemundo, and Azteca America are great examples of multinational media systems built on the strength of transnational markets, converging media systems, and Latin American diasporas. Given these realities, my claim that Spanish-language television should be understood as part of Latinos' access to citizenship seems to "nationalize" that which is global. I thus proceed with caution, aware that I am arguing for a pluri-lingual state map at a time where the winds of globalization seem to suggest that television, like most media, cannot, and perhaps should not, be defined primarily by national markets and state identities. However, the perceived wisdom of this position rests on the faulty logic that a system of transnational media is somehow accompanied by a system of transnational citizenship and transnational rights. This is not the case. The nation-state remains the arbiter of rights and citizenship dispensations and is thus the main broker for issues of justice – globalization notwithstanding. The nation-state regulates convergence, even deciding the types

of media technologies that ought to be considered, clearly embracing techno-logical and market convergences while bypassing political and social justice issues that could be considered under the heading of cultural convergence. Given this situation, constituting a national Latino public becomes a necessity for accessing equal rights, and media are a primary means by which to achieve a national Latino public. However profit-driven networks like Univision and Telemundo may be, they are nevertheless in a unique position to address a Latino viewership, and are Latinas/os' best hope for engendering an informed public. This is not to replicate the fallacy that all Latinas/os speak Spanish, but to assert that the political needs of Latinas/os, regardless of their language(s), are *not* served by English-language broadcasters.

There is one final theoretical concern. The bulk of my arguments rest on the fact that "we," Latinas/os, became part of the Union *with* Spanish. Our ethnonationalism is constitutive of this nation-state and we should stop the Anglicization of Latinas/os. However, the majority of Spanish-language televi-sion viewers are immigrants from Mexico and other Latin American countries, or were born in Puerto Rico.[17] Even Kymlicka, Patten,[18] and Levy,[19] when reflecting on US linguistic dilemmas, treat the Spanish-language issue as a case belonging to immigration, or as the minor case of Puerto Rico as an island geographically isolated from the mainland. Can I therefore argue for Spanish as a state language while also arguing for a sphere of justice benefiting mostly immigrants or the tiny island of Puerto Rico? Yes I can, and for multiple reasons. First, simply because most of the people benefiting from Spanish-language media are immigrants does not weaken the ethical and civic impera-tive to consider Spanish a language protected by the state. Second, a significant number of these immigrants are from Puerto Rico and Mexico – two states that were affected by US imperialism. Puerto Rico alone should force us to consider Spanish as a state-protected language. Third, that immigrants from other countries would benefit from this change only adds another reason for understanding Spanish as central to the state. Fourth, although millions of Latinas/os no longer speak Spanish (and thus may not use Spanish-language media), that does not mean that they would not benefit from having Spanish protected as their cultural right. Let us not forget that many stopped using Spanish because of the violent ways in which language policy affected them. This tragic memory is part of these communities' collective social fabric. On this issue, I deeply disagree with the historical normativity found in scholars like Kymlicka, Patten, and Levy.

Perhaps the most important issue supporting my argument that Spanish and Spanish-language media should be treated as rights is that we need to recast Spanish-language media as cultural and political platforms so that we can produce the studies, research, and arguments that will convince the FCC to

consider it as such. On this, my position is closer to what Ruth Rubio-Marín (2003) calls "instrumental language rights." She recognizes that at issue for the state are not only ethical and political principles, but types of decisions and policies that can best accommodate the needs of a reasonable majority. Our union includes hundreds of languages, but the state and the economy need, for their better functioning, to operate with a number that is reasonable, albeit while providing minimum accommodations for all people to participate in government and markets. Due to the number of Spanish speakers, and the historical contexts in which Spanish was absorbed by the state, it is reasonable to think of Spanish-language media as a right, and that this status can be reasonably accommodated by policies that are not cumbersome or costly to other ethnonationalisms. I agree with Rubio-Marín when she states that "language should not be a liability in the enjoyment of one's general status of civil, social, and political rights and opportunities in society."[20] The benefits of treating Spanish-language media as a right are significant. Let's briefly consider the potential benefits of this position.

If Spanish-language media is a right, then that right can function to alter the basis by which language policy happens today. Instead of producing policy that tries to accommodate Spanish speakers and minimize their linguistic marginalization, we would be forced to find ways in which Spanish speakers can exercise their right to equal access to the same cultural and political structures that English speakers currently enjoy. Because Spanish speakers do not have a territorial concentration (or claim) like the Quebecois or the Kurds, the only reasonable way by which to enable ethnonational political positions is national media. I believe that this could be the basis for forcing the FCC to re-define Spanish-language media as a political and cultural right.

There are reasons to believe that Spanish-language television can indeed become this type of useful political instrument that Latinas/os need for their enfranchisement. Univision, for instance, is not only the most successful of the Spanish-language networks and the fourth or fifth most important network in America, it functions as an element of Spanish-speaking Latinas/os' political culture. The "Project for Excellence in Journalism" sponsored by the *Columbia Journalism Review* (*CJR*) rates the news division – in terms of quality and professionalism – at the same level as the news divisions of English-language networks. However, there are two significant differences that speak to the role of Spanish-language broadcasting in Latino political culture. First, Spanish-language news programs are more likely to present foreign news from the point of view of other nations (chiefly Latin America) and deal with issues such as immigration in a sustained fashion and from a Latino and international perspective. Second, in places where they can afford local crews (and they have them in all large markets), Spanish-language networks present the point of

view of local Latinas/os in ways unlike other networks.[21] Federico Subervi's and América Rodríguez's research on Spanish-language print and broadcasting news support the *CJR* findings. According to Subervi, Spanish-language news addresses the particular needs of Latinas/os on issues like health and politics in a more consistent manner and with more cultural sensibility.[22] As importantly, Rodríguez observes that Noticiero Univision, with bureaus in Mexico City, Lima, Bogota, and El Salvador, dedicates almost half of the time to news from Latin America.[23] Because of this, and because Latino journalists are better at reporting on Latino local issues, Rodríguez argues that Spanish-language journalistic practices have been essential for Latino cultural maintenance and the creation of a Latino symbolic space in US culture.[24] In all of these cases, Spanish-language media, even with its deep-rooted flaws, its commercialism, and its tendency to address a weakly defined Latino audience, is better than English-language media at addressing the particular needs of Latinas/os. And these news broadcasts do not go unnoticed. According to DeSipio, 84 percent of bilingual Latinas/os use Spanish-language news; a number that speaks to the importance viewers place on language and ethnic perspectives.[25] Jorge Ramos, the top anchor of the evening news and host of the weekly *El Punto*, is acquiring the gravitas of a respected television journalist and is becoming a spokesperson for Latinas/os across the televisual landscape. For example, he co-hosted the Democratic presidential debate sponsored by Univision on September 9, 2007, and, with CNN, co-hosted a second debate on February 21, 2008, at the University of Texas-Austin. Univision also joined forces with the National Council of La Raza (NCLR) in a voter registration drive that had the goal of increasing the number of Latina/o voters in the 2008 presidential elections. In each of these instances, Univision performed as politically responsible ethnic media, aware that their mission is not only to seek profit but also to enfranchise their viewers.

What complicates matters is that these instances of a civic-minded Univision seem to support the notion that the types of regulatory policies that have given shape to this market-driven media system are indeed working to the benefit of Latinas/os. After all, the FCC has created policies to meet the particular needs of Latinas/os including, for instance, the institution of closed captioning (for the hearing-impaired and for those whose first language is not English) and ownership policies that prohibit the transfer of a broadcasting corporation that services ethnic minorities without a formal hearing.[26] Although these policies are somewhat useful to Latinas/os, the logic with which they are applied is based on market, not public interest, criteria. The ownership rules, for instance, are reduced to rules that secure competition and diversity of commercial offerings. Whatever citizenship rights the FCC recognizes Spanish speakers as possessing, they are rights defined by the

market, or what Thomas Streeter calls "corporate liberalism."[27] As Arlene Davila pointedly argues, in corporate liberalism, Latino communities are seen primordially as consumers and their political and cultural rights are redefined as consumer rights.[28] Two recent examples illustrate this point.

In the spirit of deregulation and convergence, the FCC allowed Univision to purchase the Hispanic Broadcast Corporation, the largest Spanish-language radio network in the United States in 2002, creating a mammoth conglomerate that Latino critics see as diluting media options for Latinas/os.[29] Although the FCC has two policies (H.R. 3207 and S. 1563) to safeguard ethnic, non-English media, these were not enough to frame the issue in terms of instrumental political culture, and the sale was approved. The FCC's policies require a hearing any time a transfer of ownership affecting minority languages is imminent, which forces the FCC to produce a report to Congress. Yet these safeguards are clearly not enough. Although many Latino civic organizations and legal suits challenged the sale, the government sided with Univision and its market-driven logic. The result is a Spanish-language mediascape dominated by Univision, a situation that activists and corporations fear will permanently endanger Latino political culture and consumer rights. This result is an outcome predicted by critics of deregulation such as Philip Napoli, who argues that technological convergence provides new ways of decreasing competition and limiting access, further hurting non-hegemonic communities.[30] Napoli also reminds us that the "diversity principle," which has the goal of maximizing sources of information and points of view available to citizens, has become a rhetorical tool to justify policy outcomes.[31] Despite evidence that the new Univision conglomerate would dominate 75 percent of revenue from Spanish-language media, the FCC declared that the merger "would not adversely affect competition or diversity in any media market."[32]

A second example of corporate liberalism comes from 2007, when the FCC approved the sale of Univision to a non-Latino international consortium headed by American investment companies and the Egyptian–Israeli–American magnate Haim Saban. Saban, a billionaire with a history of donating to politicians, supports the voting drive previously mentioned. Some argue that this is Saban's way of securing a Democrat in the White House (in 2001, the Saban Capital group donated $10 million to the Democratic National Committee, though he has also given millions to Republicans). Increasing the number of Latino voters, who traditionally vote Democratic, is a way of increasing the standing of the Democratic Party.[33] The issue of ownership becomes "political" when politicians and policy-makers regularly disregard the role of Spanish-language media in the constitution of multicultural and linguistic egalitarianism. Like the Black Entertainment Network before it, Univision shares the fate of other ethnic media under neoliberalism, which defines media as

corporate institutions, not as cultural spaces. Under neoliberalism, competition becomes the central good that the FCC dispenses to the public. Who controls media and to what ends become secondary issues. Clearly, if the FCC understood Spanish-language media as central to the exercise of Latino cultural citizenship and language rights, who controlled it would be a more relevant matter.

Spanish-language media must be understood as a cultural and political asset for Latinas/os, one required for the construction of a national public, and one central to Latino political participation. As previously mentioned, Univision aired the first bilingual presidential debate for the Democratic Party in 2007. The Democratic field included Hillary Clinton, Barack Obama, John Edwards, Mike Gravel, Bill Richardson, Christopher Dodd, and Dennis Kucinich. Of these, Richardson, a Latino from New Mexico, and Dodd, spoke Spanish fluently, but they were not allowed to demonstrate it during the debate. At one point, Richardson asked permission to use Spanish and Jorge Ramos, the moderator, responded in his Mexican Spanish that it was not possible and that those were the rules agreed upon by everybody. But why should the talking field be equal? When perfectly accented English is imposed on everybody wanting to have a "national" platform, why cannot Spanish be imposed on candidates wanting our (Latino) votes? Univision made history hosting the first bilingual presidential debate, but all the candidates were presented as speaking English. Only the hosts (Maria Elena Salinas co-hosted with Ramos) and listeners used Spanish. Regrettably, this is still an imperialist script and one that assumes English as the state language. This script is partly constituted through media convergence and deregulation, the two policy principles that shape Univision's current configuration, wealth, and unique position in the Spanish-language mediascape. It is also a script that requires or assumes linguistic assimilation for political participation. With the support of Univision, this replicates the idea that one ethnonationalism should "naturally" rule over the other.

Conclusion

We live in a time where the television landscape is changing quickly and frequently. It is becoming a transnational medium in terms of programming (e.g., *Bety la Fea* has been a hugely successful export from Colombia to the world), transnational adaptations (e.g., *Bety la Fea* is now *Ugly Betty*), and a fluid market of imports and exports that has created transnational regionalisms. Spanish-language television is one such example, with most of its programming coming from Latin America. This is partly due to the fluidity of the televisual language, but it is also due to immigration, diasporas, and trans-

national identities (e.g., US identities of class are still dominated by under-standings of quality that benefit the import of BBC programming). Technology and convergence also help this transnationalism, with satellite and the Internet providing viable means for television delivery. Yet, I believe one must be careful not to confuse a market-driven televisual landscape with the political landscape that television engenders. The former speaks to a globalization and convergent media structures where the stakeholders are corporations, govern-ment agencies, and a few privileged individuals. A political landscape, by con-trast, is always about people and the sphere of justice in which they exist.

This sphere of justice for Latinas/os is hugely dependent on whether Latino ethnicity, including language, can be considered on a par with Anglo-Saxon ethnicity. History suggests it should. Latinas/os became part of the polity as Spanish speakers. Many political theorists, including multicultural liberal theo-rists and supporters of instrumental language rights, argue that linguistic equal-ity is a prerequisite for justice and social equality. Although there is some recognition in legal and policy circles that Spanish speakers ought to have access to media in their language, this recognition is a far cry from defining media as the legal, cultural, and political right of Latinas/os. Television regu-lation is driven by corporate liberalism, which has narrowly cast the right of Spanish speakers to media in their language in terms of viewer access to pro-gramming. This neoliberal framing is not enough. Latinas/os must also control our media and expect our media to provide us with a public service. With Telemundo now controlled by Viacom, and Univision by financial companies and Saban, we are close to permanently defanging Latino television, and that would be a terrible blow to the political prospects of this complex commun-ity. Given that the current mediascape of technological convergence and own-ership deregulation is having a negative impact on Latinas/os' cultural and political spaces, I propose a new model of regulation that more forcefully takes into consideration the relationship of media to nationhood while abstaining from equating the nation-state to Anglo-Saxon markers. We need to re-imagine the reality of our changing populations and the necessity to reframe our media from corporatism to a pluri-national public sphere. However, a pluri-national public sphere will always be in danger of disappearing without adequate legal protections. Spanish, I believe, should be so protected by the FCC, not as a language for commerce, but as a language for community and politics.

Sadly, the FCC is not the only institution at issue here. Media studies departments across the United States consistently disregard Spanish-language media in their curricula and research agendas. When it receives any treatment at all, it is handled as a foreign-language issue. This disciplinary positioning is a naturalized violation of the right of Spanish speakers across the nation-state to

have their language understood as constitutive of the federation, and constitutive of our educational system. This chapter is a plea for reform and is offered with the hope that we re-evaluate the way academic social practices reconstitute Latino disenfranchisement.

Notes

1. Maria Simone and Jan Fernback, "Invisible Hands or Public Spheres? Theoretical Foundations for U.S. Broadcasting Policy," *Communication Law and Policy*, 11 (2006), 290.
2. I use the term "Anglo Saxon" to refer to the ethnic aspects of whiteness, which include language and culture. Although imperfect, I prefer "Anglo Saxon" to "white" or "Anglo" because both terms are used as racial descriptors.
3. Walker Connor, *Ethnonationalism: The Quest for Understanding* (Princeton: Princeton University Press, 1994), xi.
4. Anthony Giddens, *Modernity and Self-Identity: Self and Society in the Late Modern Age* (Palo Alto: Stanford University Press, 1991), 40–42; Jacob Levy, *The Multiculturalism of Fear* (New York: Oxford University Press, 2000), 10.
5. Levy, *Multiculturalism of Fear*, 10.
6. Connor, *Ethnonationalism*, xi.
7. Dana D. Nelson, *National Manhood: Capitalist Citizenship and the Imagined Fraternity of White Men* (Durham: Duke University Press, 1998), 17.
8. For an ethnonationalist take on this issue, see J. Gregory Sidak's *Foreign Investment in American Telecommunications* (Chicago: University of Chicago Press, 1994).
9. Emilio Azcárraga Jean took over Televisa in 1997, after the death of his father Azcárraga Jr.
10. For an excellent history of this push by different social movements, see Allison Perlman's *Reforming the Wasteland: Television, Reform, and Social Movements, 1950–2004* (PhD dissertation, University of Texas at Austin, 2007).
11. At the time of this writing, the FCC's new Chairman Kevin Martin has indicated that he would favor tax certificates for minority-owned companies, one key incentive eliminated in 1995 (February 28, 2007). Free Press, www.freepress.net/news/21384.
12. Helder De Schutter, "Language Policy and Political Philosophy: on the Emerging Linguistic Justice Debate," *Language Problems and Language Planning*, 31 (2007), 4.
13. Will Kymlicka, *Multicultural Citizenship: A Liberal Theory of Minority Rights* (New York: Oxford University Press, 1995), 46–47.
14. Alan Patten and Will Kymlicka, "Introduction: Language Rights and Political Theory: Context, Issues, and Approaches," in *Language Rights and Political Theory*, eds. Alan Patten and Will Kymlicka (New York: Oxford University Press, 2003), 26–31.
15. William Flores and Rina Benmayor, "Introduction: Constructing Cultural Citizenship," in *Latino Cultural Citizenship: Claiming Identity, Space and Rights*, eds. William Flores and Rina Benmayor (Boston: Beacon Press, 1997), 15.
16. Nick Stevenson, "Culture and Citizenship: An Introduction," in *Culture and Citizenship*, ed. Nick Stevenson (Thousand Oaks: SAGE Publications, 2001), 3.
17. Louis DeSipio, *Bilingual Television Viewers and the Language Choices They Make* (Claremont: The Tomás Rivera Policy Institute, 2003), 3.
18. Patten and Kymlicka, "Introduction," 4–8.
19. Levy, *Multiculturalism of Fear*, 14–15.
20. Ruth Rubio-Marín, "Language Rights: Exploring the Competing Rationales," in *Language Rights and Political Theory*, eds. Will Kymlicka and Alan Patten (New York: Oxford University Press, 2003), 63.
21. Laurien Alexandre and Henrik Rehbinder, "Separate But Equal: Comparing Local News in English and Spanish," *Columbia Journalism Review*, 41:4 (2002), 99–101.

22. Federico A. Subervi-Vélez, Michael Salwen, Jennie Haulser, and Astrid Romero, "The Mass Media and Hispanic Politics During the 1988 Presidential Primaries," in Sixth Annual Intercultural Conference on Latin America and the Caribbean. Miami, 1989; Federico A. Subervi-Vélez, *The Mass Media and Latino Politics: Studies of U.S. Media Content, Campaign Strategies and Survey Research: 1984-2004* (New York: Routledge, 2008).

23. América Rodríguez, *Making Latino News: Race, Language, Class* (Thousand Oaks: Sage, 2002), 100–102.

24. América Rodríguez, *Making Latino News*, 73–106.

25. DeSipio, *Bilingual Television Viewers*, 11.

26. Luis Nuñez, *Spanish Language Media After the Univision–Hispanic Broadcasting* (New York: Novinka, 2006), 1–3.

27. Thomas Streeter, *Selling the Air: A Critique of the Policy of Commercial Broadcasting in the United States* (Chicago: University of Chicago Press, 1996), 9.

28. Arlene Davila, *Latinos Inc.: The Marketing and Making of a People* (Berkeley: University of California Press, 2002), 11–15.

29. Tim Dougherty, "Merger Gets Green Light: The Federal Communications Commission Votes Along Party Lines to Sanction Univision's Merger with Hispanic Broadcasting Corp," *Hispanic Business*, November 2003, 72.

30. Philip M. Napoli, *Foundations of Communications Policy: Principles and Process in the Regulation of Electronic Media* (Cresskill: Hampton Press, 2001), 92–93.

31. Philip M. Napoli, "Audience Measurement and Media Policy: Audience Economics, the Diversity Principle, and the Local People Meter," *Communication Law and Policy*, 10:4 (2005), 350.

32. Claudia Adrien, "Latino Communication Merger Causes Controversy at U. Florida," *Independent Florida Alligator*, 2 December 2003, n.p.

33. Eric Burns, "Univision's Voter Registration Drive Stirs GOP Concerns," *Fox News Watch*, 12 May 2007, 6.40 p.m. EST. I don't have reason to doubt Saban's good intentions toward Latinas/os, but I question whether he can be consistently accountable to the political needs of Spanish speakers.

Chapter 12

The limits of the cellular imaginary

Eric Freedman

iPhone and the snuff film

On December 30, 2006, Saddam Hussein was executed in Iraq after being sentenced to death by hanging for crimes against humanity. Just over one week later, on January 9, 2007, Steve Jobs was introduced on stage to the tune of James Brown's "I Feel Good," and proceeded to unveil the iPhone as part of his keynote address at Macworld in San Francisco. Though both men were on public display for quite different purposes, and on quite different stages, they were inevitably bound together by certain cultural logics of new media.

By mid-January 2007, a two-and-a-half-minute clip of Saddam Hussein's execution had been viewed 15,605,630 times on Google Video and had received a rating of four out of five stars (ranking it "above average"). But this clip is just one of many on this subject cataloged by Google Video, each of which has a unique title. While most of the entries feature the same video, recorded by a witness to the execution using a cell phone, others take some liberties with the footage, including a four-minute piece titled, "Swinging Saddam Execution Video," described as a "groovy" video "starring GeGe the Go Go girl and her new dance the 'Saddam Swing'!" Another, "Hanging Saddam," features a one-and-a-half-minute still image montage, a chronology framed by traditional wipe, dissolve, and documentary ("Ken Burns-like") effects, shaped into essayistic form by intertitles, and underscored by Green Day's "Good Riddance (Time of Your Life)."[1]

At the end of June 2007, Apple released its iPhone to consumers in the United States and began to make its first inroads into the telecommunications business. Jobs proudly points out that the company's latest device is *not just* a mobile phone, but also a widescreen iPod and an Internet communicator. The iPhone is, of course, part of a larger industrial history of cellular technology, and like the developments that precede it, the result of a persistent engagement with an evolving and inherently ideologically charged visual interface.

The architecture of the mobile phone platform is, after all, a language, and the latest "revolution" in user interfaces marks the degree to which hardware and software are conceptualized in tandem. In his discussion of cultural transcoding, Lev Manovich suggests that the computer layer and the cultural layer push against and shape each other, to the extent that the general computerization of culture in the digital age gradually substitutes existing cultural categories and concepts with new ones that derive from the computer's ontology.[2] Computer hardware and software shape culture, and the ability to generate, organize, manipulate, and disseminate data – though part of the developmental trajectory of computer programming – has a much broader impact, influencing how we process the world around us. Computational space has become part of lived space (we live in an interface culture), and computing itself now privileges interaction over computation. A recent Apple press release suggests that the iPhone "completely redefines what you can do on a mobile phone." These pronouncements suggest that Apple has thought through what consumers should do with their mobile phones and has a few ideas about what consumers will actually do with their mobile phones, but according to an on-demand delivery logic of production, purposefully leaves open other possibilities. While the appropriated execution video has been subjected to what seems the logic of Apple's iLife suite (embodying the simple material practices of audio and video mixing made possible by consumer-grade desktop editing tools), certainly phone manufacturers do not envision their devices being witness to an execution.

This latest push in the pursuit of a digital lifestyle leads me to certain questions about the relationship between two forms of integration – one accomplished and evidenced by technological convergence and the other associated with the domain of trauma therapy. The former is of a physical and mechanical nature and the latter is psychical and biological. What connects these two enterprises (of integration) is the common push toward embodiment, as well as their mutual dependence on media.[3] As part of a developmental trajectory, one of the aims of trauma therapy is to localize sensation, delimiting what was once excessive, and to reattach the subject; this is especially the approach in trauma theories based on dissociation, which emphasize the importance of retrieval, abreaction (the release of emotional tension, often by acting out), and integration on the path toward psychotherapeutic change. Likewise, the push toward a singular (and coincidentally, Cingular, in the case of Apple's United States locked cellular network provider) manifestation of the digital lifestyle can be read as a narrative about localizing sensation, investing in one device and channeling distinct media along one conduit, though the change being actuated is a bit more oblique.[4] Is this a change in technology, character, or culture? As Jobs suggests, the interface itself is fluid and responsive, its

malleability an assurance that the iPhone can adapt to changes in the media landscape and retain its centrality. The "buttons" themselves are virtual and can be remapped; the hardware of the iPhone is almost as fluid as the software. Apple's "Instead" campaign shapes the iPhone into a phantasmagorical digital hub, touting: "Here's an idea. Instead of carrying an iPod and a phone, why not carry an iPod, with all your favorite music and your favorite movies, *in* your phone." The iPhone is imbued with the phantom limbs of its predecessors. While its functionality may seem rather open, the device is not simply an empty vessel; it is shaped by our experiences with earlier media forms, and it is launched within a prevailing cultural attitude.[5]

Trauma and the technobiographic subject

> *"Everywhere you go, there you are."* Motorola's vision of Seamless Mobility is to make your life all about you. It's about devices that share information so you don't have to remember where the file is. It's about intelligent networks that automatically know who you are and the information you need. It's about making your home more connected, your car more aware, your office more mobile and the world around you more personal, more predictive, and more accessible. By linking together every networked device in your life, Motorola wants to make it possible for you to find everyone and everything, everywhere you are.
>
> (Motorola 2004 Analysts Meeting[6])

At the 2004 analysts meeting at the Westin O'Hare Hotel in Rosemont, Illinois, Motorola celebrated two enterprises – making seamless mobility real and making liquid media real. The realness in both cases was marked by the materialization of concepts, their embodiment (taking on physical form) in several distinct software, hardware, and interface technologies. Reviewing the former of these two pronouncements, Motorola's press coverage claimed, "Seamless mobility – the interconnection of devices between operating systems, platforms, and media – was living and breathing at the Motorola 2004 Analysts meeting."[7] Seamless mobility is, in part, about marking the terrain, making the general field a space for autobiographical work; our personal data trails bridge and brand physical locations. But in commercial discourses, autobiography is not a privileged term, even though it is trotted out as a powerful conceptual hook in countless advertising campaigns. Instead, seamless mobility suggests the consumer is continuously connected to relevant content, across devices, networks, and physical environments; and, in this series of exchanges, the personalization of protocols is the only trace of the end-user's psyche. Autobiography is shaped into a very limited form of self-expression, registered in the

myriad ways we engage with and control technology. But how enlightening are such exercises? While my interest is in the autobiographical work accomplished by mobile consumers, "work" may be an inappropriate term here, for it begs the question: "What type of work is actually being performed?"

Motorola's vision of user experience invokes a world where, according to the company's promotional literature, consumers are "mobile, informed, entertained, secured, connected and empowered."[8] Yet this laundry list of actions is displayed as self-evident, and reads as a series of empty slogans, each of which begs any number of inquisitive retorts. "Secured against what?" "Empowered how, exactly?" Certainly Motorola's vision of empowerment does not parallel social movement rhetoric; instead, the company foregrounds the personalization and control of communicative acts. What is evoked is only the most obvious expression of productivity, in step with the workaday logic of business – not business as usual, but more business than usual. In this chapter, my goal is to explore the terms of productivity more forcefully, and to identify moments of activity that seem to be either off-limits or out of bounds, to examine those spaces and actions that seem either unproductive or counterproductive. Empowerment is a forcefully agentive concept, yet in Motorola's hands it seems a rather passive construct, reduced to a matter of conceptualization rather than a call to action.

In the field of contemporary telecommunications, mobile producers and carriers are not simply corporations but acquaintances, hailed by such pleasantries as "Hello, Moto," and we are asked to celebrate consumption, value, and technophilia, being urged to "Get More." Moreover, cellular producers and providers, building on the planned obsolescence inherent to selling technology, call attention to the new, to the evolving interface with reality – perfecting verisimilitude and integration, measured in megapixels and transmission rates and other data sets, and coded through the familial iconography of their advertising campaigns. Yet, in the same moment, the world is being more forcefully re-imagined and pointedly re-imaged. The relationship between vision and reality is not simply allegorical. The selective tethering of the two terms has material consequences, and we must be attentive to who is constructing the reference frame. The media frame, be it a hardware device, a software interface, or a matter of content creation and management, can contour our imagining of the world beyond the window. We must consider who is re-imaging the world and what collaborative partnerships (industrial, governmental, popular, or otherwise) are shaping our knowledge of the public realm of everyday events and actions.[9]

The general trend toward seamless mobility heralded in the research and development of new technologies (the integration of multiple feature-rich media devices and operating platforms – in the home, in the car, and at the

office) is part of a larger projection of the future of liquid media (taking media and shaping it to the various circumstances that people find themselves in) that also wants to embroil the subject in the technology.[10] New media industries are drafting biographical practices that can be subsequently attached to individual authors. The aim is to create new media frameworks that replicate subjectivity and merge the lived context with an apparatus of production, fostering the development of "technobiographies" that write the self through the post-industrial logic of new media.[11] Responsive technologies seem to situate end-users as unique social actors, as inscribed data (though not governing code) accumulates and becomes symptomatic of our presence. New technologies may seem to operate freely, to the extent that they act intuitively, but their intuition is by design; it is inherently the result of a script (of a coding activity brought to fruition by developers). As we become conscious of the possibilities for remapping technology, do we overlook the limits of our own subjectivity, itself the product of an unseen script? Referencing Sigmund Freud's work on the formation of subjectivity, E. Ann Kaplan pointedly reminds us

> how one relates to a traumatic event depends on one's individual psychic history, on memories inevitably mixed with fantasies of prior catastrophes, and on the particular cultural and political context within which a catastrophe takes place, especially how it is "managed" by institutional forces.[12]

Trauma opens us up to the willful pursuit of a particular (cohesive) subject position. Not surprisingly, an industry has emerged to fill the drives of this recognizable state of transience and ultimately being.[13] In part, by speaking about trauma, I aim to speak about the business of desire and its relative freedom as a commodity.

An August 2006 CNN.com article on the Israel–Lebanon conflict featured an image, recorded on a cell phone, of a building struck by a Hezbollah rocket.[14] And one year earlier, the *Washington Post* ran an article featuring cell-phone images shot by people in the aftermath of the London terrorist attacks, highlighting pictures of transit passengers caught in a tunnel near King's Cross station.[15] Framed by the popular news media as a form of citizen journalism, from a more immediate vantage point, these sites of imaging shared both locally and across the blogosphere create a fabric of intimate communication, allowing photographer and viewer to shape the lexicon of terror.

If the cellular imaginary is in part the product of venture capital, what are the stakes for any photographic act that is not simply a recording, but potentially a working through? Or is working through even possible when dia-

chronic continuity meets an assumed zenith in seamless mobility? These questions are clearly engaged with the role of the individual in convergence culture, where experience is framed not simply by more obvious and centralized media formations (such as commercial broadcasting and its catalog of images and narratives), but also by a host of desired technologies, personal and portable. These technologies, however intimate, are still industrial fabrications. Dissemination is not simply about sending out messages, but also about distributing devices. Similarly, a narrative is not simply a self-contained news story, but also a protocol for using any given technology (for thinking about its use-value).

Ironically, the battle cry to decentralize the media seems less urgent now that many of us have the necessary tools to communicate. We have gained the freedom to take our own images and forge our own communiqués. With this apparent openness in mind, my goal here is to examine the relative freedom and utility of our exchanges by looking more closely at one of our dominant toolsets – the mobile phone – and to consider whether more communication means better communication. To this end, I focus on one particular artifact – the documentation of traumatic events – and more purposefully I review a number of events that have moved beyond any singular personal register to become signposts of the nation. By reading trauma that has been cellularly transposed, my aim is to study the role of technology at two distinct pressure points – where the individual meets the nation, and where industry meets culture.

Convergence, integration, and flow

Far from simply communicating, sending images across the Internet, the cell phone user at ground zero is both witnessing and translating trauma. As trauma, in critical discourse, has been inherently linked to modernity and its dissociating effects, we must consider the conflicted role of the citizen journalist who is creating cultural memories within the framework of being a traumatized subject. Documenting and transmitting from the field, the citizen journalist is trapped between the spheres of the private and the public. Nevertheless, the moment seems to be a media bonanza; it is an opportune occasion to emote and analyze (or, in practical terms, to participate and watch). But this individual also occupies a split subject position; as analyst and analysand, this field reporter seems to be forever closing off the possibility of secondary revision. Is post-traumatic integration even conceivable when images of terror never serve as meditative points divorced from an original act, never function as screen memories but instead as visible, contemporaneous evidence? As the temporal gap between production and distribution is closed, so too is the lag

between occurring and witnessing. In the face of immediacy, the role of memory (the ability to recall) is becoming more tenuous, even as the proliferation of visible evidence never lets us forget. Any event seems perpetually lodged in some database, readily retrieved as a subset in a catalog of Google images. I want to draw out what I believe is a subtle but important distinction between remembering (memory in action) and not forgetting (a residue of memory in action). The former seems to call on the individual, while the latter seems to be more firmly ensconced in cultural sanctions that privilege certain events as forever memorable (ascribing a collective value to them).

In the examples scattered throughout this chapter, I have already moved from the gallows to the London Underground. Yet I am not suggesting that an execution and a bombing are parallel traumatic events, for an execution itself is not necessarily a site of public trauma, and the clandestine recording of an execution is not necessarily a journalistic act (though the act has subsequently become part of journalistic discourse). Yet, once imaged, the artifact, the record itself may become its own site of trauma – this seems to be decidedly the case with the execution, where the act of producing and distributing (of recording and circulating) has created its own cultural rift. And as phones become rich HTML Web browsers, no longer are images simply circulated as free-floating artifacts, but rather they are positioned alongside parallel or divergent discursive threads that exist simultaneously on Google Video, YouTube, or other database interfaces. In these frameworks, meaning is anchored by a series of preordained social bookmarks that seem to alter the type of working-through that is possible. Saddam Hussein and the Go Go Girl are bound together, and an execution is situated concentrically with the iTunes store.

Figure 12.1 Apple iPhone "Instead" advertisement.

As the narrator of Apple's 2007 "Instead" campaign concludes his sales pitch, an incoming call presses against the horizontal frame of a Hollywood blockbuster movie playing on the phone's screen. Footage shot and sent from any ground zero might similarly intrude; the recipient might get the urgent call and its attachment while watching or listening to other media. The footage would be immediately inserted into a divergent contextual media flow – a flow birthed not from the producer's personal experience but from other cultural products. While convergence has been positioned as liberating, media integration may randomly generate cultural discord. What may be produced is an extremely unstable supertext.[16] As the journalistic field expands to include bloggers and cell phone videographers, the new catalog of images produced by these groups poses a conceptual challenge to ethics codes and general notions of newsworthiness; and at a purely logistical level, as these images stream into already-rich media conduits, they can produce semantic chaos.[17] Conversations intersect and media pathways do not simply converge, they pass through each other, breaking each other's flow only temporarily. One dialogue yields to another; the music is paused until the talking is over, the film frame is frozen or the image is put away until time permits further viewing. Structural analysis itself becomes an impossible affair, as whole new grammatical systems are invented. Yet, despite this complication, the flow is still decipherable and the messages remain meaningful.

Drawing on the work of John Berger, Edward Soja asserts that space is returning with a vengeance in contemporary life, fundamentally changing our modes of narration, forcing us to engage with the prospect of simultaneity.

> We can no longer depend on a storyline unfolding sequentially, an ever-accumulating history marching straight forward in plot and denouement, for too much is happening against the grain of time, too much is continually traversing the storyline laterally. . . . Simultaneities intervene, extending our point of view outward in an infinite number of lines, connecting the subject to a whole world of comparable instances, complicating the temporal flow of meaning, short-circuiting the fabulous stringing-out of "one damned thing after another."[18]

To become more active and engaged with the communicative process, we need to pay closer attention to movement, to migration. What happens as any enunciation traverses space? The haunting underground pictures taken by transit passenger Alexander Chadwick moments after the July 7, 2005, bombing at King's Cross station did not simply circulate through the commercial news circuit, they also appeared on the public photo-sharing site Flickr, where they were variably tagged and copied into personal photo albums, and

became part of the site's larger rubric, finding a home in the "London Bomb Blasts Community" group. Within the group, the images were woven into a broad tapestry, inserted into a composite of terrorism throughout the city, narrated through multiple perspectives, registered as part of a national memorial, and though grouped together in an album, easily redeployed as geographic markers using Flickr's virtual mapping.[19] As part of both traditionally centralized broadcast fare and the more open conduit of Flickr, Chadwick's photos became readily lodged in a narrative web, one that seems perhaps an all-too-satisfying portrait revealed in ever-increasing detail as it moves us toward meaningful wholeness. We experience this not only in the manner that images are framed (becoming part of a singular narrative trajectory) by broadcast media, but also in the manner that publicly malleable image-sharing sites, as openly collaborative endeavors, readily invoke their readers. When hosted on Flickr, each image accumulates a trail of comments and tags that speak to and about an audience. The comments form a temporal trail of annotations, a

Figure 12.2 King's Cross Station, London (photo credit: Alexander Chadwick).

Figure 12.3 King's Cross Station, London (photo credit: Alexander Chadwick).

Figure 12.4 King's Cross Station, London (photo credit: Alexander Chadwick).

chronology that moves further and further away from the date of the original post, and tends to meander, much like an old-fashioned game of telephone, into tangential terrain; oftentimes the conversational thread leaves the original object behind to speak to the trail of posts as an object in and of itself. And the tags, part of a new folksonomic logic that is beginning to govern the Web, form an integral part of a bottom-up taxonomy, a user-friendly indexing system intended to make the Web more responsive to end-user preferences.[20] Despite any initial urgency or call to action, the transiency of images and texts is concealed by the simultaneous display of their accumulated tags and trails. The images become a meaningful text in their own right; what is evidenced here is not a trail of social actors but rather a quantity of blissfully active readers. This leads me to two related questions. What is revealed in this set of signs and what has escaped transcription?

E. Ann Kaplan reminds us that an important element in the consideration of trauma is an understanding of one's specific position vis-à-vis an event. In her discussion of trauma, she relates the importance of distinguishing different positions and contexts of encounters with trauma. To this end, we must insert not just notions of biological or kindred attachment (how far genetically we may be removed from those suffering, what form of familial or communal relation we have with those subjects under duress), but also other degrees of directness and indirectness, of which temporal, spatial, and other mappable psychic geographies are a part. And, as many of us encounter trauma through the media, or at least encounter many more sites of trauma than we would otherwise be privileged to experience because of a media presence, we must also consider not simply how we access trauma or are exposed to trauma, but also its unique aspects as both a real and mediatized phenomenon that may alter the genetics of the event.

Vicarious trauma, as Kaplan suggests, is simply a response, temporally and spatially at least one step removed from the experience of trauma itself. It may

be mediated through either centralized modes of production and distribution, or migrate through the margins; in either case, it is belatedly induced by some form of exposure (often through images). One of the strongest examples of vicarious trauma appears in Susan Sontag's *On Photography*, in a passage where she considers the quality of feeling evoked by still photos. How does one channel moral outrage at a point where only reflection is possible?

> One's first encounter with the photographic inventory of ultimate horror is a kind of revelation: a negative epiphany. For me, it was photographs of Bergen-Belsen and Dachau which I came across by chance in a bookstore in Santa Monica in July 1945. Nothing I have seen – in photographs or real life – ever cut me as sharply, deeply, instantaneously. Indeed, it seems plausible to me to divide my life into two parts, before I saw those photographs (I was 12) and after, though it was several years before I understood fully what they were about. What good was served by seeing them? They were only photographs – of an event I had scarcely heard of and could do nothing to affect, of suffering I could hardly imagine and could do nothing to relieve.[21]

What interests me about this story is not simply Sontag's revelation about the power of photographs, but also her very narrative. She recalls a chance encounter in a bookstore, which suggests just moments before she was engaged in another act – perhaps meandering, browsing, or reading. Within this chronology, the act of viewing can be understood as an interruption, to the extent that it constructed an abrupt divide in her conscience – an interruption she acknowledges in the abstract (one that bisected her life). But it also constructed a more overt divide in her actions. The narrative has both emotive and physical aspects, which is not surprising, as time, especially in its relation to trauma, is an embodied phenomenon. Yet the contradictory sense of time is also experienced, for an essential dimension of psychological trauma is the breaking up of the unifying thread of temporality; thus, one of the clinical features of trauma is described as dissociation, the effect of being ripped out of time. In lieu of the physical experience of time, space takes on a temporal and affective dimension triggered through an optical relay (in Sontag's case, the act of looking at the photograph) – space substitutes for the body, especially in the process of recalling the moment of trauma (the bookstore is an important aspect of Sontag's experience).

Earlier in her essay, Sontag oversimplifies the concept of flow. She suggests: "Photographs may be more memorable than moving images, because they are a neat slice of time, not a flow. Television is a stream of underselected images, each of which cancels its predecessor."[22] While television may have a less

meaningful affective dimension because of its randomness, what I would suggest is that the experience of images of trauma inside televisual flow is less meaningful not because of any negation, but simply because it interrupts other culturally determined signifiers rather than one's own travels. More importantly, my consideration of trauma is grounded in the terrain of new media where, as Manovich notes, we may encounter a logic of "addition and coexistence."[23] The concept of cancellation does not seem useful, especially in non-broadcast data streams which may be wide and occasionally random but are certainly not an underselected aggregate; deliberation and choice must be considered as fundamental elements in the push and pull of production and reception (especially in a new media landscape where we are just as likely to contribute to flow as we are to be its recipients).

I also feel it is necessary to complicate Kaplan's own analysis of trauma. She refines the general category of vicarious trauma by offering a series of distinctions structured around the relative perception of an event. Of the five categories, three merit some revision:

1. direct experience of trauma (trauma victim);
2. direct observations of another's trauma (bystander, one step removed);
3. visually mediated trauma (i.e., moviegoer, viewing trauma on film or other media, two steps removed).[24]

What is the status of the trauma victim who simultaneously witnesses and mediates, making and distributing media while becoming a traumatized subject? And what does it mean to be a bystander, receiving media that relays the traumatized subject's optical point of view? New media frameworks call into question the very nature of visually mediated trauma, a term that otherwise seems to collapse distinctions between media forms, each of which may have different temporalities (some are more proximate to instantaneity), different spatialities (not all screen spaces are equal), different contextual fields (not all flows are the same), and varied degrees of narrative closure (not all texts are complete, some are simply fragments).

At the extreme dissociated end of vicarious trauma, Kaplan situates "empty" empathy, "elicited by images of suffering provided without any context or background knowledge."[25] Yet in new media spaces, context is hard to avoid. Consider a July 2006 clip on YouTube – a 50-second, low-resolution video recording of several Israeli bombs exploding in Beirut; the brief video is accompanied by the author's explanatory text:

> Listen to the horrifying blasts of Israeli bombs exploding in the Lebanese capital, Beirut. This video brings back haunting memories from the 82

Israeli invasion of Beirut. I was then only 4 years old, but the lasting impact of these blasts has never left me. For those lucky enough to have not experienced a war during their lifetime, it may appear to you that you understand all about it by watching CNN, BBC, or reading the papers. This video is an attempt to give you a more realistic sense of how terrifying a war can be on innocent civilians . . . and kids, just like me, 24 years ago![26]

The author's narrative is followed by a trail of comments and responses, part of YouTube's open architecture – comments that not only respond to the author and the source footage but also drift in other directions as secondary commentators begin to speak back to one another. What begins as a more universalizing appraisal of the horrors of war becomes a tale of two sides in the chorus of responses that follows; and what reads as an intimate and purposeful narrative of retrieval (remembering the 1982 bombings of Beirut, experienced as a child) and abreaction (acting out, in the current moment, through recording, listening, and writing – or more generally, through exposition) becomes a sign in and of itself. Responding to the initial entry, a June 2008 post reads: "Haha damn straight and plenty more where that came from. You motherfuckers stay on your side of the borders and we won't blow your sorry asses to pieces."[27] Integration is a personal affair, and psychohistory is a tale of individual progressions; so when the narrative becomes part of a national symbolic it begins to unravel. People experience and recover from trauma; nations (as constructs) do not. It is not surprising that personal narratives become less cohesive when they are asked to stand in as expressions of collectivity; to do so, they must be re-opened, re-examined, and rewritten. The testimonial becomes a decidedly multi-vocal affair, subjected to the logic of hypertext and hypermedia. A one-page post becomes a multiple-paged trail of indictments that centers any number of subjects – Israelis, Lebanese, Arabs, Muslims – and engages in both national and personal agenda setting.

The space of new media seems to obfuscate an already-eroding boundary between individual and cultural trauma; by its very nature (as a dynamic text), the networked landscape continuously reframes personal experience and provides its own commodified contextual markers. Beyond the machinations of overt dialogue (such as the inventoried comment cited above), folksonomic tags (descriptive keywords) attach the video and its commentaries to a user-generated list of associations – in this case, "Lebanon, Beirut, Israel, bombs, war, explosion, aggression, Hezbollah, civilians, death." Folksonomies cut across the personal and the social, borrowing and benefiting from both realms. They suggest a potentially democratic inroad into privatized site management, allowing end-users to insert missing terms into a site's taxonomic infrastruc-

ture; but at the same time they reflect the work of more broadly held cultural vocabularies. More importantly, tags place rather arbitrary limits on meaning; moving images become knowable as text-based systems. A video becomes attached to a series of terms; visual culture must be rigorously categorized if the search engine is to function.

To this end, as trauma is dispersed across new communications channels, we must come to understand the complexity of catastrophe as it registers through multiple positions, not all of which are purely spectatorial, nor separate from one another. We may at one time or another find ourselves at ground zero, and see our representation, see ourselves translated and watch our experience migrate, or we may only experience vicarious trauma, which may seem less privileged, but which merits consideration because it provides an entry point for assessing the work of the apparatus (of distribution and exhibition, for example). Even vicarious experience is not a uniform phenomenon. Our understanding of an event is affected by how we access it; and not all media pathways are created equal. Any data set may be conformed to more than one interface. And the interface, more than simply the product of script and code, is perhaps the most immediate form of context setting.

Mediation is a complex phenomenon in the field of trauma, for media artifacts may occupy more than one position relative to traumatic experience. Developmentally, traumatic affect states are understood in terms of the relational systems in which they take form, systems that play a significant role in tolerance, containment, and modulation. Understood as just such a system, certain media forms may be a critical component of post-traumatic integration. Three modalities are used to conceive of trauma in the psychoanalytic model: remembrance, repetition, and working-through. Interpreting Freud's comments on the connection between past and present, a temporal flux that is critical in psychoanalytic theories of trauma, Linda Belau relates: "The trauma pertaining to an event is less an inherent aspect of the event itself than it is an effect pertaining to the impossibility of integrating the event into a knowledgeable network."[28] The fluctuation is not simply temporal, but more importantly it is about a movement between the two poles of knowledge and being. Repetition implies a certain impossibility, that of integrating trauma into remembrance, while working-through as a final and more over-reaching view of the process forces us to see the impossibility of integrating trauma at all. We are asked to understand and accept its very nature.[29]

Representations play a significant role in the understanding of trauma, calling out the very nature of an event as traumatic; on reflection, we see that an image is not able to carry the full weight of an episode, is unable to suture over our psychical wounds. The online cellular archive, one facet of the readily searched database of recent and past events on YouTube, suggests a movement

toward integration, but is perhaps only a simulacrum (a distortion of a real process – in this case, of synthesis – that nonetheless stands in as a truth in its own right, despite its questionable authenticity). The flow of responsive comments and essayistic video clips on YouTube gives evidence of working-through, but these are just signs of a process and not a measure of any subject's progress toward embodiment, toward grounding a state of knowing. The fact that these pieces of visible evidence are embedded in a literal network (of things, of other objects), and easily embedded in other contextual frames (in the case of YouTube, a repurposing made possible through Adobe Flash), simply suggests a more ready deployment. But what is signified in the ready and rapid circulation of particular artifacts? How do we make sense of a clip's popularity? What meaning is to be ascribed to a number of views? We may have an active register of the number of times an object is consumed, but as with any media text, we have very limited knowledge that suggests to what end. The processes of cutting and pasting, embedding and hyperlinking, shooting, dialing, and sending suggest synthesis at the level of hardware and software – at the interface. But the more important sign of synthesis, of a re-embodied subject position, cannot be found online or in a device.

I suggested earlier in this chapter that simultaneity may interfere with post-traumatic integration, collapsing past and present; images of lived experience may circulate at a speed that naturalizes the screen, and press into our lives quite dramatically. Yet images that may at first spread like wildfire will ultimately find their place in the database, and their transitory nature will shift. An assumed collective experience (at first simply anecdotal) is ultimately given material form, and collectivity itself is made manifest – once thought, now seen, as discussions are mapped out in the Internet of Things. Lodged in the archive, still frames, motion replays, and edited (and editorialized) versions of traumatic events seem firmly integrated. Yet as history literally repeats itself, thanks to the playback controls of the media player or the more generalized openness of the Semantic Web, we become aware of a certain instability – our memories evolve as the narrative continues to be publicly written or as the event's trace simply moves to another domain. In fact, the neurological literature on representation and memory suggests, "representations are best described as emergent phenomena that undergo constant change as processing continues."[30] Online archives serve us well if we do not use them as simple points of investment; instead, we should allow them to open us up to the possibility that traumatic events, by their very definition, cannot be contained by a URL. The evolution of the online narrative, within the field of trauma, might be read as an objective trace of the operation of self.

Survival tactics

A tagline, stated in the form of a question, from a 2005 *USA Today* column still calls out to me: "In the age of digital and 'delete' are we losing something?"[31] The article cites a statistic from a survey by the International Data Corporation that suggests 23 percent of all images captured by digital cameras are deleted and never exported. Social theorist Erving Goffman suggests that individual performance, as a simultaneous presentation both inward and outward, is used to construct identity. In this vein, we might also position a particular performative mode – that of the photographic act – as an act that includes both taking the photo and circulating it. Despite any apparent and unmitigated excesses of self-expression online, these acts are clearly a controlled working through that reflects a sophisticated understanding of the nature of the medium and its audience. The difficulty we encounter is when particular social fronts get institutionalized, become representations of collective expression. Social behavior in public places is controllable; we have only to look at urban design to understand the relative openness of online space. In the late 1960s, William Whyte launched a multi-year study to observe pedestrian behavior in public settings. As part of the grant-funded Street Life Project, Whyte set up a series of time-lapse cameras that enabled him to describe the substance of urban life in an objective way, and with considerable detail. In his published findings, Whyte suggests, "A good new space builds a new constituency. It stimulates people into new habits – al fresco lunches – and provides new paths to and from work, new places to pause. It does all this very quickly."[32]

As we send our images into public spaces, following YouTube's imperative to "broadcast ourselves," the consciousness that we bring to praxis needs to inform our post-praxis tactics.[33] To put it more simply, now that we have been invited to participate, we might think twice about our actions. We need to consider the unique dimensions of any public forum, as well as the trail of outcomes that will most likely follow our otherwise spatially and temporally bound acts of recording. My goal here has been to call out a series of questions concerning media mobility, about losing control, about the allure of technology, and about the latent intersections between democracy and technocracy. Trauma is a powerful phenomenon, one that often precludes deliberation and hesitation. Despite the desire to heal, or despite the positive push of the therapeutic impulse, we might pause for a moment to explore rupture itself as a powerful force, a space in which the promise of convergence goes unrealized if only because discourse of any kind seems insufficient. Why do we willfully seal over certain cracks and fissures with an outpouring of words and images? Before we begin to document and narrate, let us pause to explore those moments where speech truly fails us.

Notes

1. Since the time of my original research, most of the execution footage has since migrated to YouTube or can be found across Google Video and YouTube (as well as on several ancillary video-hosting services). And while Google Video began showing the number of views for each of its hosted videos in September 2006, it no longer posts such data, reverting instead to a less transparent popularity rating. The transient nature of Internet video makes documenting a working URL a difficult task, but as of June 2008, the clips discussed in this essay can be found at the following addresses: "Unedited Saddam Hanging" (http://video.google.com/videoplay?docid=6404914135939160727); "Swinging Saddam Execution Video" (http://video.google.com/videoplay?docid=6185219928333240724); "Hanging Saddam" (http://video.google.com/videoplay?docid=-4660889599328574037).
2. Lev Manovich, *The Language of New Media* (Cambridge: MIT Press, 2001), 46.
3. The concept of embodiment, used several times throughout this chapter, has multiple inflections. My use is drawn from the work of phenomenologist Maurice Merleau-Ponty. In the *Phenomenology of Perception*, Merleau-Ponty distinguishes between embodiment as it relates to the actual shape and innate capacities of the human body, a body whose abilities are determined by its physical dynamics, and embodiment as it relates to affordance, what the body is called out to undertake or perform. In simplified terms, we may distinguish between the body's innate skills and those that are acquired, distinguishing between motor habits and culturally determined actions, both of which are nevertheless important in our experience of the world. I am suggesting that cellular technology can transform our understanding of the world at large, not simply as it mediates, but more significantly as it becomes integrated into our basic patterns of perception and knowing by shaping the body's actions. Understanding the material nature of new technologies (their engagement with the physical body) is just as important as understanding their psycho-social nature. See Maurice Merleau-Ponty, *Phenomenology of Perception*, trans. Colin Smith (New York: Routledge, 1962).
4. My play on words ("singular"/"Cingular") is perhaps now obsolete; following AT&T's merger with BellSouth in December 2006, Cingular Wireless was solely owned by AT&T and was subsequently re-branded.
5. Apple's negotiation between a closed and open system is reflected in its approach to third-party application development for the iPhone. The launch of the company's iPhone App Store in July 2008 has left independent developers with a difficult choice — to continue developing on their own or to come under the company's watchful eye. Apple's goal seems to be quality control — to maintain the stability of its platform. And while a partnership with Apple would guarantee that third-party developers see their tools finding a wider audience, it would also rule out certain otherwise functional applications. This calculated approach to development, both collaborative and responsive, seems key to making the iPhone a central lifestyle portal, capable of gaming, networking, and performing work-based, consumer-based, and leisure-based tasks.
6. Motorola Media Center, "Motorola 2004 Analysts Meeting," www.motorola.com/content.jsp?globalObjectId=2622.
7. Motorola Media Center, "Motorola 2004 Analysts Meeting," www.motorola.com/content.jsp?globalObjectId=2738.
8. Motorola Media Center, "Motorola Seamless Mobility Solutions," www.motorola.com/content.jsp?globalObjectId=2364-8176.
9. Much in the same manner, geopolitics is bound to spatial politics, and reveals the causal relationships between political power and geographic space; natural resources can shape social and political relations, and those very same relations are capable of pushing back against the physical terrain. On the subject of ontological remapping, the shrine city of Kazimain is now home to a Camp Justice franchise, one of several United States military bases in Iraq and one of many such installations across the globe. Law can reclaim fixed points on a compass once claimed by faith; and satellite images reveal the number of distinct institu-

tional footprints that mark the land. Justice can be made elastic and modifiable (the structures of Guantanamo Bay can be ported and erected elsewhere); it can be architected to fit any set of legalistic circumstances, and it can literally remake the political landscape in its own image. Beyond allegory, justice has decided physical properties and consequences; it claims space and has malleable dimensions. I take this detour through geopolitics to more forcefully illustrate how dangerous it can be to speak of "vision" and "reality" only in the abstract.

10. The concept of the subject is a complex one in critical theory, and there is a general tendency to complicate the notion of the autonomous individual capable of self-knowledge by introducing the shaping influences of discourse and ideology; such theories commonly suggest that the subject is best understood as a compromised position formed by the outward push of an innate root persona and the inward push of more universal cultural forces. Here I suggest that technology must be added to the mix of decidedly exterior, cultural determinations that shape the subject. And with regard to the more specific terrain of trauma therapy, trauma psychology focuses on consciousness and commonly does so by considering both space and time as two distinct principles of consciousness; in the first instance, space consciousness arises through the body's relationship to the environment, and in the second instance time consciousnesses emerges through the experience of trauma work (through building psychic structures, engaging in the mental process of making sense of events). So in trauma theory, too, the individual/subject is not considered independent or autonomous, but rather best understood as attached to the environment.

11. The concept of post-industrial logic can be counterposed with the industrial logic that precedes it. Industrial logic (associated with the rise of the industrial age) aptly describes a factory or assembly line mode of production, and offers waiting consumers a rather homogeneous product. Post-industrial logic suggests production on-demand, inviting consumers into the production process by promoting either customization or post-assembly adaptation.

12. E. Ann Kaplan, *Trauma Culture: The Politics of Terror and Loss in Media and Literature* (New Brunswick: Rutgers University Press, 2005), 1.

13. I use the terms "transience" and "being" here to convey the temporal dimension of trauma therapy, which charts the forward movement of a traumatized individual toward a point of synthesis. Time is of particular interest in the study of trauma, as admitting the sovereignty of time, its movement with or without us, is in itself a potentially threatening act, exposing the limits of the ego.

14. Marsha Walton, "Cell Phones: A New Tool in the War-Zone Blogosphere," CNN.com (August 1, 2006), www.cnn.com/2006/TECH/internet/08/01/newblogs.

15. Yuki Noguchi, "Camera Phones Lend Immediacy to Images of Disaster," Washingtonpost.com (July 8, 2005), www.washingtonpost.com/wp-dyn/content/article/2005/07/07/AR2005070701522.html.

16. In contrast to what might be understood as the planned and orderly flow of commercial broadcasting (irrespective of any audience work that might complicate the path laid out by networks and advertisers), the concept of the supertext introduces the notion of clutter, and suggests the need to consider a program in relation to various interstitial materials (ads, previews, promos, etc.). These fragments impinge on any attempt to simply deliver meaning (through a program's narrative), as they too make meaning. In the context of new media, I am suggesting that as the number of recombinatory elements increases, programming yields to interstice (to the moments in-between). The fragment becomes the norm as we navigate multiple media forms and pathways; meaning becomes an ever-more-unstable construct, and the master narratives that bind together the whole affair become quite messy, if they ever indeed truly materialize. Is there a big picture to be grasped, or are we left with simply a series of disjointed communiqués?

17. Susan Keith, Carol B. Schwalbe, and B. William Silcock, "Images in Ethics Codes in an Era of Violence and Tragedy," *Journal of Mass Media Ethics*, 21:4 (2006), 247.

18. Edward W. Soja, *Postmodern Geographies: The Reassertion of Space in Critical Social Theory* (New York: Verso, 1989), 23.
19. Flickr's map function allows users to drag-and-drop their photos and videos onto a two-dimensional map, to indicate each image's origin; these "geotagged" elements are re-territorialized, understood as an aggregate of geographic proximities with no marked temporal distance. The virtual geography of the Flickr map transcribes place in the absence of time. As I suggested in my earlier discussion of geopolitics, a virtual geography is not necessarily an ideologically neutral one; the proximal relations produced within Flickr can be quite meaningful, both in terms of what they highlight and in what they erase, as the site's ever-widening catalog of images is reduced to a series of coordinates.
20. "Folksonomy," a term credited to information architect Thomas Vander Wal, refers to the collaborative and seemingly unsophisticated way in which information can be categorized on the Web, as end-users mark various Web-bound artifacts with terms crafted from their own vocabularies. Instead of using a centralized form of classification, users are encouraged to assign freely chosen keywords to pieces of information or data, a process known as "tagging." As a collective act, the process adds more vocabulary for describing data, though the result can be either helpful or anarchic. For a more comprehensive discussion of folksonomies, see Thomas Vander Wal, "Explaining and Showing Broad and Narrow Folksonomies," *Personal InfoCloud* (February 21, 2005), www.personalinfocloud.com/2005/02/explaining_and_.html.
21. Susan Sontag, *On Photography* (New York: Anchor Books, 1990), 19–20.
22. Ibid., 17–18.
23. Manovich, *The Language of New Media*, 325.
24. As for the final two varied relationships to trauma, Kaplan lists: "4) reading a trauma narrative and constructing visual images of semantic data (news reader, three steps removed); 5) hearing a patient's trauma narrative." Kaplan, *Trauma Culture*, 91–92.
25. Ibid., 93.
26. Msoubra, "War on Lebanon (1) July 16, 2006 – (AUDIO)," YouTube (July 18, 2006), www.youtube.com/watch?v=QvZ_qR8xwvo.
27. Nollie96, Reply to "War on Lebanon (1) July 16, 2006 – (AUDIO)," YouTube (June 16, 2008), www.youtube.com/watch?v=QvZ_qR8xwvo.
28. Linda Belau, "Remembering, Repeating, and Working-Through: Trauma and the Limit of Knowledge," in *Topologies of Trauma: Essays on the Limit of Knowledge and Memory*, eds. Linda Belau and Petar Ramadanovic (New York: Other Press, 2002), xvi.
29. Ibid., xvii.
30. Patricia McKinsey Crittenden, "Toward an Integrative Theory of Trauma: A Dynamic-Maturation Approach," in *Developmental Perspectives on Trauma: Theory, Research, and Intervention*, eds. Dante Cicchetti and Sheree L. Toth (Rochester: University of Rochester Press, 1997), 42.
31. Maria Puente, "Memories Gone in a Snap," *USA Today* (January 21, 2005), 1D.
32. William H. Whyte, *The Social Life of Small Urban Spaces* (New York: Project for Public Spaces, 2001), 16.
33. I use the term "post-praxis" to highlight those activities that are productive, but less explicitly producerly. While shooting and editing might be positioned as primary practices by YouTube's broadcast mandate, we also need to consider other facets of production, distribution, and exhibition that are equally meaningful (for example, embedding, hyperlinking, sharing, reading, and replying).

Extreme Makeover: Iraq edition

"TV Freedom" and other experiments for "advancing" liberal government in Iraq

James Hay

> In the new era that is coming to Iraq, your country will no longer be held captive to the will of a cruel dictator. You will be free to build a better life, instead of building more palaces for Saddam and his sons, free to pursue economic prosperity without the hardship of economic sanctions, free to travel and speak your mind, free to join in the political affairs of Iraq. And all the people who make up your country – Kurds, Shi'a, Turkomans, Sunnis and others – will be free of the terrible persecution that so many have endured. . . . You deserve better than tyranny and corruption and torture chambers. You deserve to live as free people. And I assure every citizen of Iraq: your nation will soon be free.
>
> (George W. Bush's address to Iraqis in the inaugural television broadcast of "Toward Freedom," April 10, 2003)

Introduction: converging on Iraq with "rapid reaction media" and "TV Freedoms"

In the months leading up to the US-led military intervention in Iraq, the rationale for invasion coupled two objectives. One was US and global *securitization*, which was supposed to be achieved by locating and disarming "weapons of mass destruction." The other objective was *liberation* – a campaign to replace the autocratic rule of Saddam Hussein with liberal, democratic, constitutional government.[1] On March 16, 2003, a few days before the invasion commenced, Vice-President Dick Cheney confidently stated that US soldiers would be greeted as "liberators" in the streets of Baghdad. "Freedom" was the political mantra, commercial brand, and operational codeword for the military campaign – first dubbed Operation Freedom and later Operation Enduring Freedom (in Afghanistan), and then Operation Iraqi Freedom. Well before this litany of military "campaigning," prominent neo-conservative think tanks such as the Committee for the Liberation of Iraq had rationalized an invasion as "advancing" liberal government and democracy in order to "free" the Iraqi people, empower citizens to govern themselves, and thus assure the political

modernization of the region – with the model and benchmark of political modernity and "advanced democracy" being the United States.[2] Once citizens in Iraq "tasted" democracy and liberal government, there supposedly would be no stopping its spread throughout the Middle East. In the months following the invasion of Iraq, as efforts to verify the existence of weapons of mass destruction proved futile, the discourse of liberation became increasingly prominent in US justifications for the invasion, at least until the strategies for installing liberal democratic government made securing Iraq a project of locating and disarming different kinds of weapons than those first cited. Operation Iraqi Freedom's reasoning about freedom required nothing short of an absolute measure – the forceful correction of the excesses and irrationality of "bad government" (which had denied individual liberties to assure the absolute sovereignty of Hussein) with the goodness of government predicated on the rights, liberties, and sovereignty of individual Iraqis.

Of all the reasons used to justify "liberating" Iraq, installing "free" TV or "TV Freedoms" was never high on the list most often recited by the Bush administration. Yet for months prior to the military campaign, one of the under-reported or "secret" strategies devised by the US Department of Defense's offices of Special Operations and of Low-Intensity Conflict involved preparation of an "Iraqi Free Media Network" by a Rapid Reaction Media Team (RRMT).[3] The advance team was conceived by the Defense Department's invasion planners as providing:

> a "quick start bridge" between Saddam Hussein's state-controlled media network and a longer term "Iraqi Free Media Network" in a post-Saddam era. After the cessation of hostilities, having professional US-trained media teams immediately in place to portray a new Iraq (by Iraqis, for Iraqis) with hopes for a prosperous, democratic future, will have a profound psychological and political impact on the Iraqi people. It will be as if, after another day of deadly agit-prop, the North Korean people turned off their TVs at night, and turned them on in the morning to find a rich fare of South Korean TV spread before them as their very own. In addition, a *re-constituted* free, domestic Iraqi media can serve as a model in the Middle East where so much Arab hate-media are themselves equivalent to weapons of mass destruction.
>
> (emphasis added)[4]

Although there have been many reasons offered for the invasion, this statement underscores not just the vital importance ascribed to media (and particularly TV) in the campaign's rationale, undertaking, and objectives; the statement affirms that, for the invasion's planners, TV Freedoms may have been just as important as any other reason for the campaign.

"Free" is an ambiguous (or textured) keyword applied to TV in the rationale – a new TV regime brought by "liberators" who free the Iraqis from their restraints, a new regime of TV that comes free of charge, a televised and televisual state guaranteed by Iraqi's forthcoming *liberal* government. However, as the final sentence of the statement makes clear, the institution of civil liberties and TV Freedoms would act as a natural/organic agent to settle and thus secure the region. The brief's use of the word "reconstituted" is significant in this regard. "Reconstituted" promises the return of a substance (the Iraqi state and its TV) to a natural state, as when water is added to processed or "evaporated milk," a basic substance and technique for remote or arid living. "Reconstituted" also gestures toward the liberal reform of media access through constitutional government, which will both provide and regulate the irresistibly "rich fare" for hungry consumers (the tempering effect of good government as kitchen management). In these senses, the planners assumed that the welfare or well-being of self-governing citizens (liberated consumers with healthy choices) required a new diet of TV Freedoms. "Reconstituting" televisual fare was nothing short of reconstituting citizenship – a new political *recipe* and experiment for making TV Freedoms a basic civic right and a civic virtue.

As the planning memo for the RRMT affirms, broadcast media and particularly television were envisaged by the invasion planners as technologies of government and citizenship. After the invasion, the RRMT's quick start bridge became a television broadcasting facility under the auspices of the Coalition Provisional Authority (CPA), christened "Toward Freedom." In early 2004, the CPA authorized the first two TV channels of the Iraqi Free Media (IFM) network: Al Iraqiya (broadcast from Saudi Arabia) and Al Hurra (broadcast from Virginia). Television was supposed to be a starting point for modernizing and reinventing Iraq's "antiquated" model of government – a model of bad government in part because it prohibited privatized media. Creating "free TV" and a "free media network" recognized the televisuality of liberal government – not just making freedoms visible (the tele-visual evidence of freedom) but engineering the networks through whose supposed "free" and unimpeded circulation liberal government could work, act, and thrive. In both senses, TV Freedoms were supposed to facilitate the dispersal of government throughout Iraqi society – the creation of a program and network of government and citizenship in daily life.

This chapter does not see media convergence only, or even primarily, as new synergies among commercial, technological, and cultural practices. Those practices do converge (and diverge) to produce new media practices and environments; however, they are the most-often cited practices for explaining contemporary media convergence, or a "convergence culture," as something recent. More importantly, they are fairly old, familiar, and reactive touchstones for understanding media power, and global media power as merely

ever-expanding media markets and cultural imperialism. This chapter consid-
ers somewhat alternative questions about Iraq as a laboratory for political
recipes/experiments in media convergence. It examines how the strategies of
media convergence are authorized through what Foucault has described as
governmental rationalities, how media convergence comprises networks that
distribute and coordinate the dispersed forms and applications of "governmen-
talities," how multiple governmental authorities in turn rely and act upon spe-
cific forms of media convergence, how media convergence involves the
production of specific forms of citizenship and civic technologies as vehicles of
freedom, how the formulas for converging "technologies" of government and
citizenship are continually tested and reinvented (often as a result of failure),
and how media convergence is an on-going process of governing and authoriz-
ing divergence. Through this way of thinking about media power, "media con-
vergence" is not generalizable, but is geographically specific and uneven, and it
is not a guaranteed or predictable outcome but a process of testing the strat-
egies of government and the technologies of citizenship. Understanding media
convergence thus requires an *analytic of government* – a form of analysis
explained in the next section.

The analysis offered by this chapter considers how the RRMT, Toward
Freedom, the Iraqi Free Media Network, Al Hurra, and various private forms
of broadcasting that emerged in Iraq following the invasion, materialized
through a political formula and rationality (one particularly active in the US)
that was oriented toward "reinventing government" – a "neo-liberal" (or "neo-
conservative") model of government that valorized the transformation of the
"public sector" through "the spirit of enterprise" and the expansion of "public–
private partnerships" for managing state services and social welfare. In the
period just before and after the invasion, these trends were represented in the
US by a war campaign that contracted unprecedented numbers of private busi-
nesses to manage both military and civilian projects. However, the practice of
outsourcing a major military campaign was an extension of a broad set of
domestic US policy initiatives already sponsored by the Bush–Cheney
administration.

This formula for reinventing government authorized and made useful spe-
cific forms of televisuality – programs produced in the US, the Middle East,
and Iraq, as well as networks connecting Iraq to other parts of the Middle East
and to the US. Reinventing government in Iraq required (to use the felicitous
expression of the RRMT's planners) "reconstituting TV" – developing forms
of TV that demonstrated the rules, processes, techniques, and knowledge
necessary for self-government, or at least for a do-it-yourself form of citizen-
ship whose virtues supposedly had been proven by neo-liberal programs and
policies in the US. The conjoined programs for reinventing government and

reconstituting TV ("TV Freedom" as part of Iraq's "extreme makeover") offered a US-cultivated formula and techniques of responsible, disciplined citizenship that not only would make self-government rational, but would also demonstrate to Iraqis, the region, and the world the winning-ness of this rationality in an environment that daily and increasingly tested citizens' capacity for self-enterprise, self-government, and self-reliance. As that happened, reconstituting television as a civic laboratory (a laboratory for inventing new forms of citizenship) became a central *problem* for producing and securing liberal government in Iraq.

In its consideration of the relation between reinventing government and reconstituting TV in post-invasion Iraq, this chapter considers the sometimes synergized and sometimes conflicting interrelation of various forms of convergence. As a study of a historical conjuncture, it examines the points of interface between residual and emergent media forms and networks. As an account of the networks for reconstituting TV and reinventing government, it also maps these residual and emergent televisualities as "geographies of power" and "technics of space." And because constituting TV Freedoms in Iraq has been in many ways different from any other part of the world, it devotes particular attention to how the televisual programs and networks of liberal government organically developed as an extension of plans and strategies (a rationality) for a military campaign and security operation. The post-invasion (mostly US-led and authorized) efforts to deliver and reinvent TV in Iraq particularly provide a useful way of thinking about the implications of the current interdependence or "convergence" of liberalization and securitization through media. The third and fourth sections of this chapter describe two ways this convergence happened in Iraq – the deployment of "TV Freedoms" through a network of military assault, and subsequently through strategies for introducing "programs" of liberal citizenship. The last two sections of the chapter demonstrate that, whatever success or failure have been attributed to experiments such as the Iraqi Free Media Network or other institutions of television in Iraq after the invasion, their development out of military, police, and security programs provide a riveting instance of the current convergence of military and civilian – wartime and peacetime – uses of media.

Advancing liberalism and the powers of "TV Freedom"

One of the lessons of Foucault's writing about liberalism as a "governmental rationality" concerns the paradoxical way that freedom refers both to a break from sovereign rule (liberation) and to the multiplication and dispersion of the technologies of government ("governmentalities") that assume and act through

the "natural" rights and rule of individuals. From its earliest forms (the ones that most interested Foucault), liberalism has affirmed the virtue of freedom and individual autonomy (breaking the shackles of restraint) while rationalizing the technical resources through which freedom and individual autonomy can be exercised properly. Freedom is practiced through specific (and specifically authorized/rationalized) rules and techniques of government. Power in modern societies thus works both to individualize government (affirming the rights and autonomy of individuals as citizens) and to multiply and maximize the means of government (continually coordinating, testing, and reinventing the mechanics of discipline, cultivating the proper arrangement and networks of government). In describing liberalism as a governmental rationality, Foucault emphasized the thought and attention given to the *right* exercise of freedom, to the specific kind of knowledge (the technical procedures) necessary for government, and to the proper organization, distribution, or arrangement (the networks) of these technologies. From this perspective, he proposed a study of power and political liberalism that examined not only the multiple rationalities and technologies of government through which the rights and freedoms of individuals are *normalized* (made natural and normative) but also the on-going problematizations, instabilities, and resistance around which these rationalities and technologies form.

There are many considerations that could be and have been brought into studies of governmentality, but in this section I mention *three* that guide my interest in considering TV Freedoms through an analytic of government in order to provide an alternative perspective about media convergence. The three issues under consideration include: (1) governmentality as securitization; (2) what is new about the neo-liberal governmental rationality that authorizes the current regime of media convergence; and (3) the current geographic reach and limits of US programs and networks (in part a media convergence) for "advancing" and securing global government.

The first consideration concerns the longstanding relation that Foucault raises between liberation/empowerment and social securitization. Particularly interesting to Foucault were the two forms of policing (the maintenance of Law and Order) that accompanied political modernity and liberalism.[5] One was a form of policing which looked after the positive aspects of life (watching over the "state of things" and caring for the "health" of that state). The other involved forms of policing that attended to the negative aspects of life (the criminal, the dispossessed, the insurrectionist). In this way, the problem of "welfare" (which Foucault saw as a fundamental problem shaping the birth of the modern state) was profoundly a problem of social security, policing, and (in those senses) government.

From this perspective, liberation and securitization were not contradictory or newly intertwined objectives of the US-led "regime change" in Iraq. They

were part of the longstanding problem for modern/liberal government, even as liberalism developed through a narrative of freeing or unchaining the natural virtues and potentialities of individuals and society (i.e., even as freedom was couched as the opposite of control). The US never has been quite completely in the role of either police or liberator in Iraq; it operates through programs that instrumentalize the one through the other. And, in many ways, the project of reconstituting Iraq has required strategies of hyper-securitization, even securing the institutions that provided the social services and that looked after the "positive aspects of life."

If we do not see power as simply repression, but as strategies and programs ("regimes") for circumventing, holding off, and *managing* conflict, confrontation, and resistance (as a provision of social welfare and social security), then how are the politics of liberal government "a continuation of war *by other means*" – what Foucault referred to as "silent war?"[6] How is civil peace predicated upon the on-going development of technologies for this silent war, for policing (in both the senses that interested Foucault), for "waging" and "keeping" peace, for assuring that society remains "civil?" By conceptualizing the relation between war and government this way, Foucault offers a useful way to rethink the meaning and practices of propaganda.

A second implication of Foucault's view of power and government for an analysis of TV Freedoms has to do with the newness of neo-liberal governmentalities. As noted above, liberation and social securitization/welfare were problems around which liberal government initially formed, and thus are not necessarily new to its governmental rationalities, in the US or in Iraq. A Foucaultian view of governmentality (and modern forms of power) also underscores that liberalism has never been a historically uniform practice or arrangement of government and that its longevity has had much to do with the continual invention, reinvention, and multiplication of public and private programs and entities for maintaining the health of society and for governing individuals and populations that way. This spirit of invention informs liberalism's preoccupation with political modernization and advancement, with a watchful eye always on the on-going potential for (or its own history of) failures, disruptions, and breakdowns.

Some accounts of contemporary liberalism have focused on the gradual dismantling of a model of social welfare and security that had developed over the nineteenth and early twentieth centuries. Since the late 1980s, "reinventing government" became one of the most common terms used by policy analysts and advocates to describe their aversion to the public sector as the primary administrator of social assistance.[7] Although this term and trend gained considerable traction during the Clinton administration (most famously the Welfare Reform Act), the first five years of the Bush administration even more aggressively

promoted and enabled this reasoning about the aims of liberal government, as in the campaign during 2005–2006 to "overhaul" Social Security by allowing citizens to manage and individualize/customize their own financial futures. The Bush administration's Ownership Society calculated the path (the cost/benefit) of "reinventing government" in three ways: as a federalism that off-loaded welfare and security onto state and municipal government, as the cultivation of "public–private partnerships" that deputized corporations to become providers of social assistance, and as the *personalization* of welfare that "empowered" and "freed" individual citizens to customize (to "choose" among mostly private resources) in order to look after their own welfare. This political rationality, particularly in the US, has made the empowerment/liberation of individuals through privatized resources (the formation of a *new* entrepreneurial citizen-consumer) into a fundamental objective and strategy of government. This syndrome of governing through the programs and techniques of personal empowerment is thus doubly preoccupied with what Nikolas Rose refers to as the "powers of freedom."[8]

The political rationality for "reinventing" and "overhauling" government naturalized the liberation and reconstitution of Iraq through the powers of TV Freedom. Although the US-led invasion was justified as necessary for "freeing" Iraqis, for reconstituting natural liberties, and for importing the universal virtues of liberalism, TV Freedom (as both a strategy and outcome of invasion) was designed through a governmental rationality which understood "reinventing government" as a natural program of reform. TV Freedom was both an extreme and proven strategy of government – an instrument for opening Iraq to the "powers of freedom," but powers whose outcome and stability required engineering a televisual form of government that could not easily be separated from military and policing operations. As a program for "advancing" liberalism in *that* way, as "the most expensive foreign media undertaking by the US government since the Voice of America," TV Freedom was an extension of the Homeland Security experiment, itself the most conspicuous reorganization of the federal government, and the largest new federal agency, in over 50 years. It bears noting that the program was designed (as the government's response to Hurricane Katrina in 2005 demonstrated) to off-load public services onto local responders, private and non-profit organizations, and individual citizens.[9]

The third implication of understanding TV Freedom as authorized through a "neo-" or "advanced" liberal rationality concerns the current geography of governmentalities. Foucault's account of securitization through social medicine and welfare in the late eighteenth and early nineteenth centuries described a set of practices and programs that were specific to France and a few other Western European countries. Applying Foucault's observations to the US requires acknowledgment of its specific history of welfare, social medicine,

and liberal government that in some respects has developed differently than in Europe. It is precisely through this US history that the discourse and initiatives for "reinventing government" developed so energetically.

A related geographic consideration is global governmentality. Neo-liberalism is not simply the global liberalization of markets and production, nor is it driven by a single determination (financial forces); it involves the global dispersion of governmentalities which operate on different spatial scales, and it involves catalyzing and acting through multiple rationalities, technologies, and networks of government differently in different parts of the world. Whereas Rose has described liberal government as "governing at a distance" (the liberal state's acting on the dispersed, private mechanisms for shaping conduct and citizenship), studies of global governmentality consider how this tendency occurs across and beyond the borders of nation-states, how governing at a distance is a matter of reach and distance, and how government at a distance has invented various technologies, mediums, and networks to manage mobility.[10]

As the Defense Department's rationale for the RRMT attests, reconstituting Iraq through the powers of TV Freedom involved combating and altering the media geography of the region. To the extent that the invasion was an extension of the Bush–Cheney administration's "War on Terror" and formation of Homeland Security, the powers of TV Freedom offered a means of governing another part of the world "at a distance." The geography of media delivery at the time of the invasion was capable of being exploited for a venture such as this, as much as that geography posed certain threats and problems for that venture and for the political rationality authorizing it. That media geography also made the policing thrust of TV Freedoms a decidedly different exercise or experiment than the one that had launched the Voice of America during and immediately after World War II. The regime of Saddam Hussein had supported more than ten TV stations and sought to curtail citizens' access to foreign broadcasts by imposing fines for illegal use of satellite dishes during a period when the number of channels available in the region had grown to over 100. The invasion's planners and early administrators sought to maintain control over their introduction of the powers of TV Freedom by destroying some of that regime's media infrastructure, and subsequently by closing Al Jazeera's office in Baghdad and other smaller stations with programming considered counterproductive to the authority of TV Freedoms. The following sections examine how various forms and strategies of media networking and programming developed through the interdependencies of military, public, and private media entities, how these interdependencies contributed to a changing media geography (as both battlefield and governmental arrangement), how they were authorized through a neo-liberal rationality about

government and freedoms, and how they simultaneously supported, complicated, and undercut the powers of TV Freedom in post-invasion Iraq.

"TV Freedom" as network-centric warfare

As Foucault noted, a central objective and problem for liberalism in the nineteenth century was the ability to govern *extensively* over territory, as nation and empire. He pointed out that communication networks, along with electrical power and transportation networks, thus developed as strategies of government and as preoccupations for those nation-states and empires most committed to liberalism.[11] Armand Mattelart, in a slightly different way, points out that the modern idea of "communication" developed through a swarm of discourses and projects about *free* movement within circulatory systems.[12] In that sense, communication developed not only through systems of transportation but through the sciences for maintaining healthy, free-flowing circulatory systems, and communication within a robust laissez faire (a healthy economy and "free market") that depended on solving the problem of laissez passér (free movement). Andrew Barry, still writing about the nineteenth century, takes this thought further, suggesting that the liberal state was "defined" by its relation to bodies in motion over territory, and that communication networks were crucial to managing conflict over distance, even as this task required strategies for maintaining the freedom and sovereignty of individuals: "How could public authorities respond rapidly to external and internal threats to the nation? How could the flow of persons and messages be managed in a way that did not restrict unduly the liberty of the individual?"[13]

Because this book considers current examples of "media convergence," this section underscores how the design of TV Freedoms in Iraq occurred not simply as a convergence among formerly separate media but as a convergence between military and civilian communication networks, and in ways that complicate older conceptions of propaganda and older distinctions between military, public, and private communication networks. This section also highlights how the "convergence" of communication networks is organized through and secured by a political and governmental rationality for assuring that freedom *goes particular ways* – in particular directions and down particular paths. While it is important to recognize, after Hardt and Negri, that "the network form of power is the only one today able to create and maintain order,"[14] it is also necessary to recognize that current forms of warfare and government (as securitization) occur through strategies for synergizing and managing *multiple* communication networks (military and civilian), often to prevent or confront the convergence of multiple communication networks that are considered potentially resistant or unmanageable. As the deployment of TV Freedoms in Iraq

vividly underscores, acting on civilian communication networks is not only a means of waging military wars and the "silent wars" of peace-keeping; the proliferation of private communication networks also figures prominently in rationales for securitization – both as an objective of military intervention and a "threat" to the authority of "free nations" globally and domestically.

One of the significant features of the development of the invasion force's Rapid Reaction Media Team was its reliance upon the US military's capability to construct ad hoc communication networks, a strategic component of what the military refers to as "network-centric warfare" (or, in the parlance of the business organization model which inspired it, "network-centric operations"). The concept was theorized in 2000 by the Office of the Assistant Secretary of the Defense (Office of Networks and Information Integration) and the MITRE Corporation (which conducts research and development for the Department of Defense (DoD) through its Center for Command, Control, Communications, and Intelligence), and it became the paradigm of warfare during the tenure of Donald Rumsfeld as Secretary of Defense.[15] Network-centric warfare emphasizes the value of "information sharing" through multiple media in order to coordinate diverse field operations. It is highly reliant upon GIS (Global Information Systems) and Global Information Grid capabilities for mediating dispersed communication sites, sometimes thousands of miles apart, in order to direct attacks. In 2005, a Defense Department report on "implementing net-centric warfare" pointed to Afghanistan and Iraq as success stories, quoting General Tommy Franks (commander of the Iraqi Freedom invasion) as saying:

> I believe one of the lessons of well [sic] identified as enduring [in Operation Enduring Freedom and Iraqi Freedom] is the power of a net-centric approach. . . . I've died and gone to heaven and seen the first bit of net-centric warfare at work.[16]

Franks' out-of-body experience bespeaks a broader transformation in the US military's commitment to the net-centric paradigm. The appeal to the US military of an organizational model developed mostly for the management of businesses with increasingly dispersed units of production linked by communication networks was just one way that the "public–private partnership" ideal was refashioning the operations of state government.

One area of research and development for net-centric warfare is referred to as the Future Combat Systems program. Its objectives involve transforming the ground soldier into a relay-subject capable of operating within the net-centric paradigm. As Boeing, one of the contributors to this research and development states:

The Future Combat Systems program is an Army modernization initiative designed to link soldiers to a wide range of weapons, sensors, and information systems by means of a mobile ad hoc network architecture that will enable unprecedented levels of joint interoperability, shared situational awareness and the ability to execute highly synchronized mission operations.[17]

The program makes individual and group combatants points in a communication/monitoring relay system, as well as networking manned and unmanned attack agents.

To say, however, that the net-centric paradigm is predicated operationally on GIS technology understates the ambition attached to the US plans for a Global Information Grid (GIG). Managed by the US National Security Agency and Central Security Service, the GIG has been conceived as

a net-centric system operating in a global context to provide processing, storage, management, and transport of information to support all Department of Defense, national security, and related Intelligence Community missions and functions-strategic, operational, tactical, and business-in war, in crisis, and in peace.[18]

The GIG aspires to a system of total global awareness for serving supposedly any kind of "security" and "management" operation – tying cyber-security with ground combat, business security concerns with military readiness:

The Global Information Grid vision implies a fundamental shift in information management, communication, and assurance ... [providing] authorized users with a seamless, secure, and interconnected information environment, meeting real-time and near real-time needs of both the warfighter and the business user.[19]

In this sense, the GIG not only mediates different geographic sites, but also the managerial logic/model of state, military, and commercial organization engaged in multiple forms of "warfare" that is "net-centric."

The deployment of the Rapid Reaction Media Team, and its relation to net-centric warfare, occurred through a network rapidly constructed through the continual circulation of Commando Solo aircraft over Iraq, an exercise that materially and technologically linked (via satellite relays) a communication command and control center in Nevada with the new broadcast facility in Baghdad. The Hercules transport planes were equipped with enough transmitting equipment capable of broadcasting simultaneous high-power MW, HF,

Figure 13.1 Boeing's artistic rendering of the Global Information Grid (photo credit: Boeing).

FM, and TV signals, initially from on-board tapes and mini-discs but more recently (by the time of the Iraq invasion) from live satellite feeds. In this respect, each of them can operate as a flying command and control center, as a mobile/adhoc broadcasting or surveillance unit in a global network, and as jamming facilities (directing listeners to desired frequencies and channels). They were deployed in the 2002 Afghanistan invasion, broadcasting radio advisories to the Afghan population and Taliban soldiers, but were indispensable components in the construction of the Iraq Media Network and the Toward Freedom broadcasting initiative. And their role in delivering the first broadcasts in post-invasion Iraq is one of the material and technological links between the televisuality of Toward Freedom and what military planners refer to as "tele-operations."

As a civilian-oriented broadcasting network conceived and adapted through the net-centric paradigm, the US production of TV Freedom was managed by personnel whose mode of operation was in security networks rather than the traditional broadcasting networks. The RRMT, the initial phase of the Iraqi Media Network (Toward Freedom), and the planning for Al Hurra (TV Freedom) were all managed by Scientific Applications International Corporation, perhaps the most consistent recipient of contracts from the Pentagon and the CIA for development of surveillance and information-sorting technologies. The cost of this no-bid contract grew from $15 million before the invasion to $82 million over the first year after the invasion. In this respect, the governmental rationality for bringing TV Freedoms to Iraq was profoundly about converting networks of securitization into the "powers of freedom."

All of these network systems operated through and on behalf of a manage-rial rationality for delivering TV Freedom as an instrument of securitization. Collectively they represent a recent way that liberal government and citizen-ship are materially, technologically, and geographically (globally) assembled and "advanced" as liberating and securitizing. Bringing liberal government and TV Freedom to Iraq involved nothing short of disabling the national broadcast-ing network under Saddam Hussein and installing in its place the most rapid and expensive broadcasting initiative ever undertaken. This operation eventu-ally acted upon certain components of the disabled Iraqi broadcasting network, re-orienting the network to the powers of TV Freedom and the governmental rationality authorizing it.

Immediately following the invasion, only 13 percent of Iraqis were esti-mated to comprise the national TV network – a percentage so low as to make the Iraqi Media Network mostly irrelevant; however, one effect of the inva-sion was Iraqis' rapid acquisition of satellite dishes. By 2004, 35 percent of Iraqis were estimated to own the dishes, increasing the number of channels available from 14 to roughly 200. Well over half the homes in Iraq used satel-lite dishes by 2005. Turning Iraqis "toward freedom" occurred in part by turning their satellite dishes toward US-authorized local TV, a US-engineered Iraqi (Free) Media Network, and US and British TV channels (initially deliv-ered through Toward Freedom). However, these dishes also placed US chan-nels in an array of regional (Middle Eastern) channels. Collectively, these networks "channel" as well as compete over regimes of citizenship, and thus, in a contest over citizenship rights (and the right to citizen-consumers), TV Freedom began and continues to operate as an instrument of warfare. As a networked space where citizen-subjects are constituted at the intersection of competing regimes of citizenship (through multiple forms of networking, and through diverse forms and regimes of programming), it also transforms cit-izens into soldiers, while delivering the right training (the arts/sciences) for citizenship on this televisual battlefield. The televisuality of liberal government in Iraq makes Iraqi citizens by virtue of their being subjects of intersecting net-works, each of whose territoriality (national, regional, Western) pulls them – as citizens – into multiple governmental regimes. And whereas the intersection of these TV channels in post-invasion Iraq may have brought a kind of plural-ism that the US campaign Toward Freedom was bent on limiting/regulating, the intersecting networks and their programming make Iraq (albeit in various ways) a laboratory for the convergence of civic technologies and the latest technologies of (net-centric) warfare.

Programming the powers of TV/freedom: when the TV sets go dark, there are solar-powered radios[20]

In its last days, Iraqi state television continuously broadcast patriotic songs. In the first weeks of the invasion, as the broadcast transmitters and network in Iraq were disabled, the Rapid Reaction Media Team undertook its mission to quick-start a new era of "free media" in Iraq, and a new televisual stage for the powers of freedom. As an extension of the net-centric paradigm, the team was embedded with military personnel as well as in the cadres of technicians, engineers, and managers being outsourced for the campaign – as a reinvention of the "citizen soldier" and para-military Special Operations. The RRMT's role in establishing its "quick start bridge" to the Iraq Free Media Network thus operated from the various techniques and platforms that made Iraq a laboratory for net-centric experiments. In its planning and earliest stages, the transformation ("reconstitution") of Iraq envisaged by the invasion's planners acted on and through a convergence of old and new military applications of communication media, particularly as this convergence conjoined the technical networks linking military and civilian media practices. Just prior to the invasion, the US military deployed old media (warnings with loudspeakers and air-dropped leaflets), newer communication technology (e-mails and cell-phone warnings), and hybrids of the old and new (bombardments of solar-powered radios programmed to broadcast announcements amidst Western and Arabic pop music).

The programmers of the music on these radios reportedly were recruits from Radio Sawa, which roughly a year before the invasion had begun broadcasting US and Arabic music in the region, along with newscasts in Arabic. One of the first new projects of the Bush administration's Broadcast Board of Governors (the entity that replaced the US Information Agency in 1999), Radio Sawa used satellite transmissions from its studio in Washington, DC. Whereas the Voice of America had developed through short-wave radio networks, Radio Sawa was one of the first ventures that not only redefined the capacities of foreign broadcasting sponsored by the new Broadcast Board of Governors, but was also shaped through the operational rationality of net-centric warfare.

This section begins with a reference to the solar-powered radio's programming because its form of "programming" most closely resembles older forms of "psy-ops" (conditioning subjects and battlefields through information assaults), and because the forms of programming discussed below converge in Iraq with it – competing with and acting on it, with the stated goal of securing and "liberating" Iraq. Replacing Iraqi state TV's programming of patriotic

songs with Arab and US pop music served both as background for the bulletins and as the point (the immediate signifier) of Iraq's re-orientation "toward freedom." The co-option of programming techniques from Radio Sawa into the Iraqi campaign also underscores how easily the former could be converted into "rapid reaction media" programming for military battlefields.[21]

A coalition of the willing Western programmers

Beginning on April 10, 2003 (following the inaugural addresses to Iraqis by President Bush and Prime Minister Blair), the RRMT commenced programming the first television under the Toward Freedom brand. Broadcasts were initially five hours a day, with four hours devoted to US-produced news, and one hour to British-produced news. The broadcasts were transmitted via satellite from these countries through the network over Iraq created by Commando Solo aircraft. In order to provide programming rapidly, the RRMT mobilized the major US TV networks and the BBC to provide their own programming – the first time that such an arrangement had been orchestrated on behalf of a US military campaign.

The arrangement between the US government, the Toward Freedom initiative, and private broadcasting companies was robust. In addition to news programming from the US about the invasion (reporting which seldom mentioned Iraqi casualties), the RRMT was directed by the Defense Department to program films such as *Uncle Saddam* (a 2000 expose by a French film-maker, which had been programmed on Cinemax and covered by CNN just a few months before the invasion) as well as productions from the History Channel such as "Saddam's Bomb-Maker" and "Killing Fields." By late 2003, after Toward Freedom had formally morphed into the Iraqi Free Media Network, whose first channel was the public-broadcast entity Al Iraqiya, the US TV networks available through the satellite menu in Iraq included: America Plus, Animal Planet, Cartoon Network, CNN, Comedy Channel, Discovery, Disney, MTV, NBA TV, ESPN, Playboy, Showtime, The Travel Channel, and VH-1. While there is little about this menu that suggests a particular consistency of genre or market, collectively the menu bespeaks how quickly and profoundly the "coalition of the willing" TV networks had made the virtue of "public–private partnership" integral to securing and liberating Iraq (notwithstanding any direct consultation with the Bush administration or Defense Department). The Iraqi Free Media Network and its Al Iraqiya began operations in May 2003 (just over a month after the invasion) by broadcasting an image of the new Iraqi flag accompanied by a traditional song, "My Homeland," and in light of the large number of US TV companies offering their programming, the provision of welfare and social security over which this TV flag waved was a collective effort for advancing liberalism in the Middle East.

Overall, this arrangement was not particularly extraordinary given the war's general reliance on "outsourcing" and the increasing role of the major networks by 2003 in advancing forms of public "outreach." These practices were evident in certain veins of reality TV programming such as ABC's *Extreme Makeover: Home Edition* and the network's website that linked the show to non-profits such as Habitat for Humanity, which the network identified as its part-ners.[22] These practices formalized a public–private partnership – a network of commercial, privately administered welfare – that folded into the general rationalization of "liberating" Iraq.

Extreme makeover: Iraq edition

The US template for the public–private provision of TV as social welfare in Iraq may or may not help explain the quick footing gained in March 2004 by Iraq's *first* privately owned (satellite) TV channel, Al Sharqiya (translated into English as "The Eastern One"). This channel was financed by Saad Al-Baazaz, a former director of the Iraqi state press and broadcasting who had left Iraq in the mid-1990s and began the first Arab-language newspapers in the UK. Sig-nificantly, Al Sharqiya's primary programming over 2004 and 2005 was rela-tively inexpensive reality TV.

As Al Sharqiya quickly became one of the most watched channels in Iraq, one of its most popular programs was *Labor and Materials* (*L&M*), a series that followed many of the conventions of the contemporaneous ABC series, *Extreme Makeover: Home Edition*. The two series are linked by the Iraq invasion. The premiere episode of the first regular season of *EM: HE* (February 2004) fea-tured the Wolsum family whose precarious foothold in their new, sparsely furnished suburban home was interrupted by Mr. Wolsum's deployment to Iraq as a member of the National Guard.[23] In an agreement between the Department of Defense and ABC, the Guardsman was allowed an extra-ordinary leave of absence from his military duties in Iraq in order to particip-ate in the episode's production, which involved his surprise return to help improve his house (and "home") while his wife and two sons were vacationing in Disneyland. The episode's opening rationale for having selected this family emphasized the father's service. The completion of the family's "home make-over" was marked in the episode by the erection of a large US flag on the newly landscaped front lawn, replacing a more modest flag. This punctuation mark to the renovation simulated the famous photo of the flag-raising on Iwo Jima during World War II.

ABC's website for *EM: HE*, even in its initial season, displayed links to other private and non-profit charities, thus representing their place in a network of privatized public service and social welfare.[24] And the Wolsum family episode

clearly demonstrated that ABC was a recruit (part of the corporate "coalition of the willing") in the Iraq campaign. In the months following, as news stories emerged about extended tours of duty and the US military's and federal agencies' lack of proper care for veterans, the ABC series connected the "home front" and the "front line," offering other demonstrations of TV's role in addressing that need (including an episode in 2005 about a home-makeover for a wounded vet, and an episode in 2007 about the surprise return of another Guardsman).

Labor and Materials, which began a few weeks after the premiere of *EM: HE*, was also styled as an intervention in the lives of a needy family, though the family's need usually resulted from their house/home's having been damaged by the war. Like *EM: HE*, *L&M* thus exhibited the workings and virtue of TV as charity and public welfare. In order to promote both the series and its good work, the producers of *L&M* regularly hung a sign in front of their projects stating "Al Sharqiya Builds Here!" Al Sharqiya's investment in the reality TV format, and particularly in the charity vein of that format, continued in its other programming – often representing its private aid-giving as compensation at a time when Iraqi citizens were demanding war reparations for personal damages. While *L&M* rebuilt houses and dramatized the restoration of normal life for subjects fortunate enough to be selected, other Al Sharqiya series such as *Congratulations!* and *Ration Card* offered a (modest) financial reward for the lucky holder of a certain number on their ration card (in a decidedly less extravagant version of the Publisher's Clearing House Giveaway in the US). In another Al Sharqiya series, *Wedding Song*, a young, unmarried couple without resources were awarded a marriage ceremony paid by the series' producers.

Figure 13.2 Iraqi reality TV show, *Labor and Materials* (photo credit: Christoph Bangert/Polaris, for the *New York Times*).

One of the writers of *L&M*, Majid al Samarraie, was quoted as saying that reality TV "is the only good thing we've acquired from the American occupation."[25] Whether the US did in fact bring reality TV to Iraq is questionable, though the devastation brought by the war certainly creates a new front for the kind of TV as social welfare that US reality TV, Al Sharqiya, and other relatively successful Arab-language TV networks from the region have offered as prime programming. Al Arabiya (based in Dubai, like Al Sharqiya) is a relatively pro-US and pro-Saudi network that began broadcasting the same month as the Iraq invasion. Al Sumaria, which began broadcasting from studios in Iraq and Lebanon in 2004, is the network of *Iraq Star*, the country's version of *American Idol*.

Reality TV series such as the ones discussed from Al Sharqiya suggest that the new, post-invasion regime of TV programming is about helping Iraqi citizens help themselves – albeit through a TV program as regimen. TV offers the "materials" and the examples for the kind of "labor" necessary for actualizing "independence"; the "powers of freedom" in that context are a matter of daily survival. Though it is a simplification to say that the US introduced reality TV to Iraq, the devastation brought by the war certainly created a new front for a regime of TV-as-social-welfare that US reality TV, Al Shaqiya, and other fledgling Arab-language TV networks from the region all mobilized through their prime-time programming.

Terrorism in the hands of the powers of freedom: programming justice

In its first two years, Al Iraqiya programmed mostly various news and current events shows. In early 2005, the network broadcast one of its first modest successes, *Terrorism in the Hands of Justice*. In this series, a subject identified as a terrorist and/or Jihaddist confessed to the TV audience the details of his crime, while the broadcast re-enacted the crime and the capture. Despite the heinous details of the crime, the series affirmed that such crimes could be and were being managed – that the invisible movements of Jihaddists could be made visible, and that the justice process could be verified (albeit in an ad hoc way) through television. The series followed certain conventions typical of programming on Court TV (now TruTV) as well as Fox's *Cops*. However, its connection to news and current-affairs programming on Al Iraqiya made it particularly instrumental for inserting crisis management into the daily events of a reconstituting Iraqi state. The series was publicized in part by the considerable discussion generated in Iraq about it, and through that process viewers' reactions (frequently publicized in newspaper accounts in Iraq) became part of the judicial process – overtly about the supposed criminals' fate but also about the future of liberal government in Iraq.

In part, the success of this series (and its boost to Al Iraqiya) can be attributed to the change in the network's relation to the (battle-)field of TV viewing. By early 2005, Iraqis began to have access to new Arab-language channels such as Al Arabiya and Al Sumaria, as well as the unprecedented abundance of satellite channels from the West. *Terrorism in the Hands of Justice* followed the vein of newly imported reality TV that exhibited the success stories of public–private partnerships in providing for social security and welfare. But outside Iraq, the series was less of a hit, and was frequently condemned for its lack of authenticity, particularly its scant verification (other than the televised confessions) that the subjects had committed the crimes. Some of the confessors appeared to be drugged and incoherent, and there were sometimes visible signs of their having been beaten.

The series also followed closely on the heels of the emerging controversy surrounding the photos of abuses and torture by US military police at Abu Ghraib prison. While there was no way to ascertain definitively whether the televised "terrorists" had perpetrated the crimes or had not been tortured at the hands of their captors, the series demonstrated the role that TV could play not only in establishing Law and Order but also correcting the injustices of Abu Ghraib (and thus affirming the powers of freedom in that way). During a period just before the referendum on the national Constitution, when the court system and other institutions of government were all "provisional" and overseen (guided/authorized) by the Coalition, the series demonstrated the power of TV Freedoms to rapidly fill the void (even as a form of institutionalized vigilantism) in shaping a civil society that was on the verge of civil war. Justice could be programmed; it could become part of daily life as on-going televisual intervention.

Programming the free zone

The final form of programming that I want to acknowledge pertains to what arguably was the goal of the invasion that this chapter examines: the production and securing of TV Freedoms as a technology of government and citizenship in Iraq. As noted at the outset of the chapter, there is a sequence of events that pointed all along to this objective – the vision of an "Iraqi Free Media Network" as part of Operation Iraqi Freedom, the institution of "Toward Freedom" as an ad hoc network and communication center under the Coalition Provisional Authority, an Iraqi public broadcasting facility sponsored by the Coalition Provisional Authority, and finally Al Hurra ("The Free One," "Free TV," or "TV Freedoms"). After Radio Sawa, but significantly more costly and ambitious than radio broadcasting, Al Hurra is produced in Virginia and transmitted by satellite to Iraq. It began broadcasting in February 2004,

operated by a staff of over 200 employees, and funded its first year alone at over $60 million.

While Al Hurra currently broadcasts to most countries in the Middle East, it was conceived specifically through the rationale for liberating and securing Iraqi media – a rationale that considered Middle Eastern media a threat to liberal government. The governmental solution to the problem was the implementation of a televisual demonstration of the powers of freedom that would be so compelling (so powerful) as to convert the Middle East through the battleground of TV networking and programming.

In the first year of its broadcasts to Iraq, the channel programmed various news and current events shows, many widely ignored by Iraqi citizens. One of its longstanding talk-shows, *The Free Zone*, staged discussions by civic leaders about the successes and impediments to Iraq's future as a state committed to liberal government. Alongside US Agency for International Development productions such as *Our Constitution*, *The Free Zone* was a venue of televisual civic education that constructed its identity through the legacy of Jefferson. While instituting a free zone in Iraq bears testament to a geography of government forged through global media networks and Rapid Reaction Media Teams, it also implicitly conjures (as its alter ego) the Green Zone – the walled, hyper-securitized bastion of US state and private administrations in Baghdad. Mapping the connection between *The Free Zone* and the Green Zone is where I want to end this section, underscoring a few ways that the current project of looking "toward freedom" cannot advance the powers of freedom without technologies of policing and securitization.

Conclusion: programming the new Iraqi televisual constitution

As noted at the beginning of this chapter, reconstituting television in Iraq was nothing short of reconstituting citizenship – a new political formula and experiment for making TV Freedoms a basic civic right and a civic virtue. Reconstitution was envisaged by the Bush administration as empowering Iraqis by providing the media resources for liberal self-government (i.e., the government of oneself) and for the US to advance liberal government in the region by making Iraq an example to the region and the world, not unlike the way that ABC makes an example of households who need assistance in *Extreme Makeover: Home Edition*. Reconstituting Iraq through TV Freedoms and free media networks (Iraq's televisual "extreme makeover") was also supposed to be a stepping-stone toward a constitutional document – a fundamental resource for self-governing citizens and states in need of formalizing, among other things, their new TV Freedoms. TV's reconstitution thus would *mediate*

(authorize and regulate) Iraq's conversion to a new political constitution. TV's reconstitution would embed the constitution in daily life (Iraq as a televisual stage for reconstitution) and would demonstrate daily to Iraqi citizens the virtue of a *neo*-liberal governmental rationality about the powers of freedom.

This televisual reconstitution of Iraq involved various technical convergences such as the ones discussed above. In certain respects, all of the developments cited here led toward the problematic design and enactment of a new Iraqi Constitution. After the invasion, the ratification of a Constitution in Iraq frequently became the benchmark in and outside Iraq for the success of the military campaign to liberate the country (and secure the region). Between 2003 and 2004, under the Coalition Provisional Authority, a Law of Administration for the State of Iraq for the Transitional Period was drafted. Both authorities sanctioned for that period a National Communication and Media Commission in Iraq which regulated media programming and licensing, at one point effectively prohibiting certain broadcasting deemed detrimental to the furtherance of liberal, democratic government there. In October 2005, the Iraqi Constitution was ratified in a national referendum. Chapter Two of the Constitution – "Liberties" – contains Article 36: "The State guarantees in a way that does not violate public order and morality . . . freedom of the press, printing, advertisement, media, and publications." This was the Constitution's only direct provision regarding broadcast programming.

The televisual and media materials through which the path to reconstitution were laid is worth recognizing, as a conclusion to this chapter. One striking example of how a neo-liberal rationality about the powers of freedom informed Iraq's reconstitution was the confidence surrounding the launch of the Iraqi Community Action Program by the USAID during the first year after the invasion.[26] This program was rationalized as a regional/de-centralized network for *rebuilding* Iraq through "communities" and individual entrepreneurialism, commemorated in its website's account of "an entrepreneur [who] expands his shop, creates jobs, and satisfies his nation's sweet tooth," Nawfal Sahar a "war victim [who] becomes entrepreneur," and the USAID's funding of a sewing shop that "provides jobs and hope . . . employing 35 widows and disabled people that represent a range of Iraq's diverse ethnic and religious groups."[27] As a strategy for reconstituting Iraq, the Iraq Community Action Program developed out of the political rationality that produced the Bush–Cheney administration's first major policy initiative, the Faith Based and Community Initiative, even though the latter program was less celebrated in the aftermath of September 11, 2001 (in part because of the problem of funding, not to mention surveilling, Islamic community agencies).

In June 2005, the USAID- and ICAP-funded women's radio station was exhibited on the former agency's website as the first "independent" radio

station in Iraq, and as "freeing" and "empowering" Iraqi women.[28] Alongside the examples of reality TV as social welfare discussed above, the station exemplified the virtues of a governmental rationality that cast welfare (media technology) as self-directed and community-driven. As the ICAP's website for the women's radio station stated: "The women who work at Iraq's first independent radio station are redefining their community's understanding of freedom as they broadcast music and talk shows championing the rights of women."

In the months leading up to the referendum about the Constitution, the USAID sponsored various events (publicized on their website as "success stories") about the agency's role in guiding, training, and educating Iraqis on the virtues and responsibilities of designing a Constitution. These included "art rallies" for mobilizing citizens to vote on the referendum, and the agency's support of the Iraq Civil Society Program and that program's special event "Incorporating Human Rights into the Constitution." In April 2005, as part of its campaign to educate Iraqis about the virtues, responsibilities, and technical procedures surrounding the referendum, the USAID also produced a series on Al Iraqiya entitled *Our Constitution*. Programs and initiatives such as *Our Constitution* affirmed that, in addition to the virtue of televising voting on the day of referendum, Iraqi citizens needed to be trained (converted) into active participants in the process. This training as a path to conversion (the resources and materials for a make-over culture in the new state) made *Our Constitution* as instrumental as *Labor and Materials*. Furthermore, it certainly involved the "help" and "outreach" of those who possessed the resources – US agencies such as the USAID (on behalf of an administration eager to have the Constitution's ratification vindicate the invasion). Installing the "networks" and "programs" of training and conversion required nothing short of a new regime of TV Freedoms, rationalized as a new form of public assistance for Iraqis who would learn to "govern themselves." In this sense, showing the way to reconstitution involved assembling the proper/strategic resources out of the various media networks and programs of community and neo-liberal government which were *converging* on the new state.

Notes

Special thanks to Ian K. Davis for his suggestions about reference materials, to Peter Asaro for suggestions about section three of this chapter, to Charles Acland's and the ERSTIC group's comments about an early draft of the chapter, and to Laurie Ouellette who helped me clarify some of the chapter's arguments about television and citizenship.

1. Saddam Hussein had served as President of the Iraqi Republic since 1979. He also intermittently served as the Republic's Prime Minister. He was both President and Prime Minister at the time of the invasion. Iraq's first, monarchical constitution was imposed by the British authorities in 1925, and remained in effect until the 1958 revolution established a republic.

Interim constitutions were adopted in 1958, 1963, 1964, 1968, and 1970, the last remaining in effect de jure until the Transitional Administrative Law was adopted. In 1990, a draft constitution was prepared but was not completed due to the onset of the Gulf War.

2. The Committee for the Liberation of Iraq developed out of close links with neo-conservative think tanks such as the Project for the New American Century, The American Enterprise Institute, and The Center for Security Policy (whose motto is "Peace Through Strength"). The Committee has dismantled its website, but its early statement of purpose referred to the Committee as a non-governmental entity comprised of a "distinguished group of Americans" who want to "promote regional peace, political freedom and international security through replacement of the Saddam Hussein regime with a democratic government that respects the rights of the Iraqi people and ceases to threaten the community of nations."

3. In March 2003, just days before the invasion, the Department of Defense allocated $15 million for initiating the Iraqi Free Media Network.

4. The "Rapid Reaction Media Team White Paper" was initially classified for distribution only among the campaign's planners. It is, in that sense, a way that the planners rationalized the campaign to themselves. The document was made public in 2007 and is available at: www.gwu.edu/~nsarchiv/NSAEBB/NSAEBB219/iraq_media_01.pdf.

5. Foucault's lecture on governmentality was embedded in a seminar about policing and securitization, though others' applications of his argument have not always followed up on the implications of the latter in explaining liberal (or "neoliberal") government. For Foucault's discussion of two forms of policing, see Michel Foucault, "The Political Technology of Individuals' Power," ed. James Faubion (New York: New Press, 1997), 403–417.

6. Michel Foucault, "Society Must Be Defended": Lectures at the College de France, 1975–76, eds. Mario Bertani and Alessandro Fontana, trans. David Macey (New York: Picador, 2003), 16.

7. See for instance David Osbourne and Ted Gabler, Reinventing Government: How the Entrepreneurial Spirit is Transforming the Public Sector (Reading: Addison-Wesley, 1991). See also the introduction to Laurie Ouellette and James Hay's Better Living Through Television (Boston/London: Blackwell, 2008), where we have elaborated why this term is useful in thinking about contemporary TV in the US.

8. Nikolas Rose, The Powers of Freedom: Reframing Political Thought (Cambridge: Cambridge University Press, 1999).

9. For more on the Homeland Security's formation within the practice of "outsourcing" and privatizing "public services," and within the expectation or requirement that citizens shoulder the burden of providing for their own welfare, see "Homeland Insecurities," a special issue of Cultural Studies, eds. James Hay and Mark Andrejevic, June/September, 2006.

10. Wendy Larner and William Walters, Global Governmentality (London/New York: Routledge, 2004), 16.

11. Michel Foucault, "Space, Power, Knowledge," in Power: Essential Works of Foucault, 1954–1984, vol. 3 (New York: New Press, 2001), 349–364.

12. Armand Matterlart, The Invention of Communication (Minneapolis: University of Minnesota Press, 1996).

13. Andrew Barry, "Lines of Communication and Spaces of Rule," in Foucault and Political Reason, eds. Andrew Barry, Thomas Osborne, and Nikolas S. Rose (Chicago: University of Chicago Press, 1996), 127.

14. Michael Hardt and Antonio Negri, Multitude: War & Democracy in the Age of Empire (New York: Penguin, 2004), 59.

15. See David Alberts, John Garstka, and Fred Stein, Network Centric Warfare: Developing and Leveraging Information Superiority, 2nd edition (Washington, DC: CCRP, 2000); David Alberts, Information Age Transformation: Getting to a 21st Century Military (Washington, DC: CCRP Publications, 2002); Department of Defense, The Implementation of Network-Centric Warfare (Washington, DC, 2005).

16. Department of Defense, The Implementation of Network-Centric Warfare, 23.

17. Boeing, "About the Future Combat Systems Program," www.boeing.com/defense-space/ic/fcs/bia/.
18. National Security Agency, "Global Information Grid," www.nsa.gov/ia/programs/global_industry_grid/index.shtml.
19. Ibid.
20. There is no way that a single analysis, much less one designed for a single chapter, can adequately address the range of programming that comprised the few years following the invasion with which this chapter deals. The reader should think of this section as televisual in its design – a melange or convergence of programming techniques, strategies, and experiments for shaping ("reconstituting") a liberal citizen-subject in post-invasion Iraq, sometimes in paradoxical ways.
21. While the Commando Solo aircraft were used in both Afghanistan and Iraq to transmit advisory bulletins and instructions to those populations, I have found no evidence that the pop music was part of that project in Afghanistan, though the former invasion coincided with the creation of Radio Sawa.
22. Laurie Ouellette and James Hay, *Better Living Through Reality TV* (Boston/London: Blackwell, 2008).
23. This was not the first broadcast of *EM: HE*. In November 2003, the series premiered as a "special episode"; the first season did not begin until the following February with the Wolsum episode, which was energetically promoted by ABC for weeks before its broadcast (including ads during that year's Super Bowl).
24. See *Better Living Through Reality TV*, op. cit. Also, in December 2005, Laura Bush appeared in an episode of *EM: HE* that repaired the damaged house of hurricane victims in Mississippi. In interviews about the episode, she stated that the series was her favorite.
25. Edward Wong, "In War's Chaos, Iraq Finds Inspiration for Reality TV," *New York Times*, August 28, 2005.
26. As of the writing of this chapter in 2008, the Iraq Community Action Program was still administering to Iraqis – its website still touting the initiative's accomplishments. www.usaid.gov/iraq/accomplishments/cap.html.
27. For a discussion of the Iraq Community Action Program's early statements of purpose, see Hay, "The New Techno-communitarianism & the Residual Logic of Mediation," *Residual Media*, ed. Charles Acland (Minneapolis: University of Minnesota Press, 2007). In 2007–2008, the program's website stated its mission this way:

> USAID's Iraq Community Action Program's (CAP) overarching objective is to promote grassroots democracy and better local governance via a project process paradigm of demand-driven community development. Working directly through community action groups (CAGs) and in consultation with local government counterparts, CAP is continuing to create representative and participatory community groups.
> (www.usaid.gov/iraq/accomplishments/cap.html)

28. USAID, "Radio Gives Women a Voice," www.usaid.gov/stories/iraq/ss_iraq_radio-women.html.

Chapter 14

Representing the presidency

Viral videos, intertextuality, and political participation

Chuck Tryon

Perhaps the most common claim that has been made about the 2008 election is that the widespread popularity of online video has radically altered political discourse. Days after Phil De Vellis's "Vote Different" appeared on the Web, pundits eagerly declared the 2008 presidential race as "the YouTube election."[1] The video, a mashup of Ridley Scott's famous 1984 Apple advertisement and Hillary Clinton's presidential campaign announcement, identified Clinton with the Big Brother figure associated with IBM in the original Apple advertisement. This connection worked not only because of the original advertisement's enticing narrative of rebellion against a repressive status quo but also because of preexisting narratives about Clinton herself as a kind of Big Brother figure who threatened personal liberties. Although the video was later revealed to be the work of a supporter of Democratic candidate Barack Obama, its critique of Clinton was immediately readable because of the public image that Clinton's right-wing rivals had carefully crafted in order to discredit her plans for universal healthcare in the 1990s. The video also offered a sharp blend of popular culture and political discourse in ways that seemed to be calling forth a new form of media literacy, one that required familiarity with both the Apple ad and Clinton's public reputation. But regardless of the video's specific depiction of Obama and Clinton, "Vote Different," in part because of its allegory of transformation, also proved to be the first truly viral video of the 2008 Presidential election, drawing in millions of viewers, provoking widespread discussion on TV, and opening up a wider debate about how political videos would shape the 2008 election.

Because of its allegory of citizen empowerment, "Vote Different" seemed to introduce a significant break with the past. If the past four decades have been characterized by the concept of "the living room candidate," political figures who knew how to manipulate the formal attributes of television, we now seem to be entering an era of YouTube presidents, characterized as much for their ability to survive a vast, swirling array of online videos. In this

context, I will be looking at a loose category of online videos that I am calling "prezvids," which are typically produced by amateurs seeking to comment on, or participate in, the United States presidential election. While many of these videos use popular culture intertextually to convey their message, others, including many of the questions posted during the YouTube debates, instead draw from direct personal experience. Many tend to be subversive or playful in tone, challenging what normally gets included within political discourse, a factor that influences my choice of the informal, if somewhat clunky, term of prezvid. Finally, I have resisted calling these videos "citizen-generated videos" because US citizenship is not a prerequisite to post videos and, in fact, many prezvids have been produced by people living outside the United States, complicating notions of citizenship and participation, while raising awareness that US policies affect people living outside the country's borders.[2]

As this definition suggests, prezvids have become a kind of shorthand for new forms of political involvement, such as the opportunities for participation and involvement in a presidential campaign. Echoing a claim made by Henry Jenkins and David Thornburn about the promises of new media and democracy, Gene Koo argues:

> There won't be a singular moment that captures the ascendancy of the Internet in the way that the Kennedy–Nixon debates marked the arrival of television. In part this is, of course, because television dictates the "must-see moment," while the Internet connects us in both more diffuse and more pervasive ways.[3]

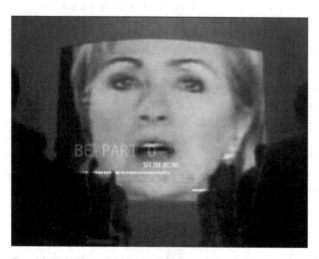

Figure 14.1 Hillary Clinton as Big Brother in Phil De Vellis's "Vote Different" (screen capture by author).

Thus, for Koo, the shift is more or less inevitable, with the result that political discourse will be more fragmented and less controlled but more integrated into our daily lives. However, what Koo's comment ignores is precisely the intermedia circulation of images, or the ways in which TV remains a crucial means by which new media images circulate and are understood. Even though there may not be a singular "must-see moment," the 2008 election has presented a series of interlocking moments, all of which circulated both on the Web and on television and were reinterpreted by TV pundits. Thus, while it is clear that the creation of political videos represents new opportunities for participation and, potentially, new models of citizenship, it is also important to caution against mythologizing these shifts. As Jenkins and Thornburn remind us, the introduction of a new medium such as viral political videos cannot alone alter political culture, but these videos can – and often do – provoke discussions of political practice.[4] While online political video appears to be a seemingly new form of participation, it is important to acknowledge the ways in which these videos circulate both on the Web and in other media, especially given that many people continue to rely upon traditional news sources to get information about the election and TV's ability to frame interpretations of Web video. In addition, an uncritical celebration of online political videos not only remains complicit with the public relations of the major media corporations, such as CNN, that stand to benefit from these narratives, but they also potentially align themselves with dominant political practices, potentially closing off more radically democratic possibilities.

Questions from snowmen: the YouTube debates

The tension between television and new media became explicit when former Massachusetts Governor Mitt Romney initially refused to participate in a debate co-sponsored by YouTube and CNN. The debate invited voters to submit questions via the video-sharing service, which would then be broadcast on CNN for the candidates to answer. Referring to one question during the Democratic debate in which Billiam, an animated snowman, asked a question about climate change, Romney scoffed that "the presidency ought to be held at a higher level than having to answer questions from a snowman."[5] Romney's response betrayed a concern that in the era of media convergence candidates would have less control over their public images. His comment also ignored the fact that Billiam the Snowman's video contained an important and substantive question about the candidates' positions on global warming. Finally, Romney's remarks also promoted models of democracy that seemed to exclude large numbers of participants who have been enticed into politics via the Internet.

As Henry Jenkins points out, the role of online video in framing the 2008 election can be illustrated through a brief comparison with the town hall debates that were instituted in the 1990s in order to make the candidates – and the election process – more accessible to a voting public that appeared to be increasingly alienated from the political process.[6] While the town hall format allowed candidates such as Bill Clinton to demonstrate empathy for their constituents ("I feel your pain") or a new level of informality ("boxers or briefs?"), the format continued to emphasize a divide between the candidates and the citizens who addressed them. The YouTube debate format, by contrast, had the potential effect of further grounding the questions, with many of them being posed in the questioners' own personal spaces and rhetorical styles. In fact, one powerful video depicted Kim, a 36-year-old housewife from Long Island, who removed her wig in order to call attention to the effects of the chemotherapy treatments she had been receiving while asking a question about healthcare costs. Jenkins argues:

> The people asking the questions are speaking from their own homes or from other spaces that they have chosen to embody the issues they want the candidates to address. The language is more informal, the questions are more personal, the tone is less reverent, and the result forces the political candidates to alter their established scripts.[7]

As Jenkins implies, Kim's question was all the more poignant because of her willingness to ground her question in her personal experience and was likely enabled by the opportunity to record her question at home rather than asking it live on national television. In this sense, the YouTube debate opened up new political possibilities for people to participate in the political process and to have their voices heard in a wider public.

However, the YouTube debate also allowed CNN to regain some degree of control over these emerging forms of online political expression. While the questions that were posted to YouTube could in some contexts alter the script, the campaigns themselves quickly recognized how to tap into the power of the intersections between popular culture and political discourse. It is also significant that CNN still chose the questions, rather than allowing YouTube users to select them. In particular, CNN chose to ignore what turned out to be the "most popular" question, according to some observers, which focused on whether or not George W. Bush should be impeached.[8] However, while the debate over which questions should be included did raise important concerns about the "wisdom of crowds," it was clear that CNN was unwilling to trust YouTubers in choosing the questions that were used.[9] Thus, the structure of these debates reflected Douglas Schuler's fear that major media

conglomerates such as CNN would "act as gatekeepers for the many, where elites can speak and the rest can only listen."[10] In the CNN–YouTube debate, CNN retained its role as a "gatekeeper," allowing only certain questions to be shown on television and placing other voices, many of which challenged the political status quo on issues such as impeachment, on the sidelines.

The president as sign

While the "snowman controversy" likely had little bearing on the campaign, it did help to crystallize some of the primary narratives that have been used to characterize the 2008 election. In *Convergence Culture*, Jenkins outlines the implications of the increasing intersection between political culture and popular culture. In particular, Jenkins sees the possibilities for a more inclusive political process, one in which groups who normally feel disempowered by the political process can be empowered by applying their skills as fans to the presidential campaign.[11] And yet, we must also be attentive to the ways in which the YouTube debates engage with what might be described as the presidential image – the semiotics of the presidency. When Romney worried that the YouTube debate would degrade the presidency, what he is attempting to control is the representational role of the office of president, what Anne Norton has referred to as the idea of the "President as sign."[12] While a number of critics have emphasized the role of online video in fostering greater participation, less attention has been paid to the significance of the strategies that video-makers use in order to comment on or engage with the "narratives" or semiotics associated with individual candidates. While these narratives, such as the perception of Obama as an agent of change, are often difficult to revise once they have been established, prezvids consistently engage with representations of individual candidates.

In the case of online political videos, depictions of presidential candidates offer new representational strategies, both for amateur video-makers and for the campaigns themselves. This takes place through the use or citation of other popular culture texts, through a technique Richard Edwards and I have called "critical digital intertextuality," in the videos' creative meshing of popular culture and the political sphere.[13] The concept builds from Jonathan Gray's concept of critical intertextuality, which he situated in shows such as *Family Guy* and *The Simpsons* that use intertextual reference to comment on current events, often in ways that are highly critical of the status quo.[14] Because many video-makers are familiar with these shows, critical intertextuality is readily adaptable to online video, a powerful technique for commenting on presidential politics. In this sense, video-makers demonstrate tremendous skill in making use of seemingly disparate imagery in order to comment on or parti-

cipate in ongoing political debates. As James E. Porter observes, a skilled manipulator of intertextual references learns to "borrow traces effectively and to find appropriate contexts for them."[15] Further, while these texts may influence political discourse, they are also shaped by the audiences that receive them. In other words, successful videos – the ones that circulate most widely on the Web – must make their connections in a language that will be understood by the audience, thus potentially limiting the kinds of connections that can be made. Thus, "Vote Different" built upon already familiar narratives that had been formulated a decade earlier when conservatives sought to derail Clinton's healthcare proposals. Similarly, will.i.am's "Yes We Can," a remix of Barack Obama's New Hampshire concession speech, found a wide audience not simply because of the celebrity participants who performed in the video, such as Scarlett Johansson and John Legend, but also because the video reinforced the perception of Obama as the candidate most identified with change. Using a minimalist black-and-white look, the video sought to link Obama with past historical figures – John F. Kennedy and Martin Luther King, in particular – who have become identified with changing American political culture for the better. In addition to these historical references, favored popular culture texts or figures – including the celebrities who appear in the will.i.am video – can produce what Matt Hills has described as a "semiotic solidarity" with others who share similar political beliefs or popular culture tastes.[16] In this sense, political parody videos can use intertextuality affirmatively, not to criticize a given candidate or policy but to affirm standard campaign narratives, such as Obama's campaign slogans endorsing change and voter empowerment ("Yes We Can").

As the examples of "Vote Different" and "Yes We Can" suggest, the videos that tend to receive the most attention are typically those that reinforce existing narratives about the campaign. However, all of the major candidates have seen their public images defined – and sometimes redefined – by online videos circulating on the Web. And what becomes clear is that the most popular and most widely circulated videos are those that remain wedded to the collection of meanings that circulate around a specific candidate. In addition to shaping the presidential race, these meanings also comment on the ways in which we think about concepts of citizenship and national identity. In this sense, I am less interested in the question of whether prezvids are a means of empowering citizens than I am in the ideologies of citizenship, democracy, and participation they foster.

In *Republic of Signs*, Norton identifies a complicated slippage between the dual logic of the executive and the semiotic forms of representation associated with the office of the Presidency. Drawing from Alexis de Tocqueville, Norton argues that "the President serves first as a symbol and, secondly, as a rhetorical

strategy."[17] Thus, the president – or even a presidential candidate – brings together diverse strands of representation, tying together national identity, the government, and even a political party or governing philosophy. In this context, Norton concludes that "changing the [political] party's representative changes the meaning of the party."[18] And, as the hotly contested Democratic Party primaries have shown, citizens have sought to become involved in this process, something that is, perhaps, most explicit in the videos endorsing Obama's brand of "change," where the concept of change becomes identified not only with a change in direction for the country's policies but also with the electoral process itself.

At the same time, this new mode of citizenship, played out in the intertextual nexus of citizenship and consumerism, presents an opportunity for what Patricia Zimmerman refers to, in a slightly different context, as a "rapid response to world events."[19] Because the material for remixes, mashups, and other videos is often readily available online, users can quickly assemble a video response to an important news event, such as a particularly noteworthy campaign speech. As the Iowa caucuses approached, for example, a number of liberals were troubled by what they saw as former Arkansas governor and Republican candidate Mike Huckabee's attempts to present himself as a political moderate when his record as Arkansas governor suggested otherwise. One video-maker was able to quickly assemble a video, "Mike Huckabee's Message to Iowa," that compiled many of Huckabee's public policy addresses in a humorous and creative way in order to caution voters about Huckabee's conservative governing record.

As a result, the emerging participatory political culture seems to be defined by three relatively distinct properties: inclusivity, intertextuality, and immediacy. The YouTube culture characterizes itself in terms of its inclusiveness. All video-makers who wish to participate are ostensibly welcome to engage in the process of making videos and circulating them. While cable channels such as CNN may attempt to restrict that inclusiveness by privileging certain videos over others, many online video-makers have criticized the network for this choice. In addition, most political parody videos are intertextual in nature, whether through the use of found footage to create a kind of intertextual montage, or through popular culture references embedded in the video. These intersections with earlier texts can produce a kind of semiotic solidarity as video-makers and viewers connect over shared political and cultural tastes. Finally, the videos themselves are characterized by their immediacy, or perhaps more precisely, their ephemerality, in responding quickly to relatively urgent concerns – an upcoming primary, a Senate vote, or even a prior video. In this sense, the best online video-makers are forging for themselves a kind of "monitorial citizenship," to use Roger Hurwitz's terminology, as they help

Internet surfers to become more aware of a particular issue.[20] Monitorial citizenship typically entails ad hoc organizations that organize around a specific issue, usually a political crisis, much as MoveOn.org originally formed around the issue of Bill Clinton's impeachment hearing. Of course, because MoveOn recognized the power of their organizational model, they have continued to use e-mail, petitions, and online video in order to engage in monitorial activity. Because these videos circulate widely among political bloggers and e-mail lists, their message is disseminated for the most part through "word of mouth" techniques and, as Hurwitz observes, actions taken in the monitorial model can take place with little deliberation or information. While not all video-makers seek to forge an identity for themselves as monitorial citizens, even a parody of the political process, as witnessed in something like Barely Political's "I've Got a Crush on . . . Obama," the first video by the comedy troupe Barely Political to feature ObamaGirl, can be read as having monitorial tendencies.[21] Even though the Barely Political videos avoid directly calling for specific actions, their videos often serve as rapid responses to news events and political controversies. In order to map out how these characteristics manifest themselves in political parody videos, I will now turn to three distinct genres of political parody video in order to see these videos engage with or perform some of the new forms of citizenship and new forms of media literacy that are emerging on the Web.

Crush videos

One of the most common genres of political parody video is the "crush video," in which a singer proclaims his or her admiration for one of the 2008 presidential candidates. The crush video depicts the cultural and mediated practices at work in many of these citizen-produced videos, illustrating not only the intertextual referentiality by which these videos make meaning but also the intermedia circulation through which they find audiences. The most famous – and influential – example of the crush video is Barely Political's "I've Got a Crush . . . On Obama," which had received well over eight million views on YouTube, as of May 2008. The video prompted a number of imitations, and the team at Barely Political managed to milk their notoriety to produce a number of other campaign videos and see them played on a number of cable news shows on CNN, MSNBC, and Fox News. Like Phil De Vellis's "Vote Different," the original ObamaGirl video initially disrupted the "politics as usual" atmosphere of political discourse, challenging expectations about the norms of expression during political campaigns. While we must not ignore the fact that the video potentially plays to the cultural discomfort with sexual relationships between black men and white women, "I've Got a Crush On . . .

Obama" does offer an implicit – and potentially submerged – critique of political rhetoric, specifically Obama's charismatic appeal to younger voters. While it is important to recognize that these videos draw from a much longer history of political parody on television – such as the *Saturday Night Live* skits that the Barely Political comedy troupe cite as a clear reference – crush videos also demonstrate an awareness of the principles of viral media. Even though the implied critique of Obama's personality-based political campaign may have been lost in other debates about the "appropriateness" of the video, and about whether it would hurt or help Obama's campaign, it also reflected the emerging forms of political and media literacy.

The original ObamaGirl video opens with a sound mix of Barack Obama's 2004 speech at the Democratic National Convention (DNC) with "Obama-Girl" leaving a message on Obama's answering machine while the song's opening notes begin to play. Using the tropes of Top 40 music videos, the video shows ObamaGirl whispering a message on her crush's answering machine while reclining on the loveseat in her apartment. Meanwhile, an issue of *Wired* magazine featuring LonelyGirl15 actress Jessica Rose is prominently displayed on the table in front of her, suggesting that yet another Internet starlet is born and establishing an intertextual relationship with an older, more famous YouTube star. This subtle reference to LonelyGirl15 cannot be read as accidental. While the video itself was posted in June 2007, the issue of *Wired* dates to December 2006, suggesting a deliberate decision to identify Obama-Girl with LonelyGirl15. From there, according to the fiction of the song, ObamaGirl's "crush" begins when she sees his now famous speech at the 2004 DNC ("You seem to float onto the floor/Democratic Convention 2004"), recalling the adulation that Obama's speech received. Subsequent shots of ObamaGirl dancing in a bikini in front of a famous photograph of Obama wearing swimming trunks serve to satirize Obama's charismatic appeal, while also, perhaps unintentionally, playing to cultural anxieties about the appeal of black men to white women, a dynamic that was exacerbated because of the public discourse that had depicted Obama as a "post-racial" candidate. As a number of observers, including Jack and Jill Politics blogger Jill Tubman, pointed out, the video echoes the infamous Harold Ford "Call Me" commercial, in which an African-American Senate candidate from Tennessee was visually linked with a white woman who refers to an encounter between the two of them at the Playboy mansion.[22]

As Tubman's comments suggest, the ObamaGirl video defied easy interpretation, and as a result it quickly became fodder for cable news pundits such as Ann Coulter, who felt the need to weigh in on crush videos and ask whether they would be good for the various candidates or whether they had been "authorized" by the campaigns themselves, while others worried that user-

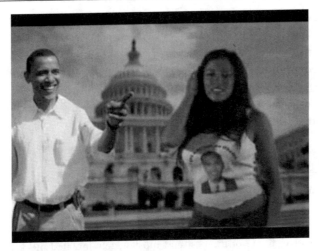

Figure 14.2 ObamaGirl (screen capture by author).

generated content in general could pose a "problem" for candidates. Significantly, Obama himself was pressed to comment on the video, and observed that it had "confused" his daughter, illustrating the degree to which the campaigns remain concerned with keeping careful control over a candidate's public image. While Obama's strategy of emphasizing his status as a father is a savvy one, the video itself became one of the most widely cited, discussed, and imitated viral videos of the 2008 campaign, although many of the videos failed to capture ObamaGirl's irreverent satire of campaign politics.

What many interpretations of the ObamaGirl videos failed to acknowledge was the degree to which crush videos functioned not to promote a specific political viewpoint but to comment on the political process itself. In fact, after the popular success of ObamaGirl, the group at Barely Political felt compelled to make a video satirizing themselves and the attention they had been receiving and sharply criticizing the hype being thrust upon online video. Commentators also overlooked the ways in which the satire was directed at the news media coverage of the Obama campaign. In fact, Coulter herself became the object of satire in one of Barely Political's follow-up videos, "Perfected: The Ann Coulter Song," in which Barely Political songwriter Leah Kauffman mocked some of Coulter's anti-Semitic comments by singing about her "decision" to convert to Christianity based on the conservative pundit's offensive comments that Jews needed to be "perfected."[23] Here, the semiotics of the crush video work to parody the extremist viewpoints spouted by Coulter and tacitly promoted by the cable news hosts that invite her to appear on their shows. At the same time, the crush videos popularized by Barely Political are among the most widely imitated forms, with several performers, including former

American Idol competitor Taryn Southern taking on the genre with her "Hot 4 Hillary." In this sense, the reception of the video opens up what might be referred to as "the politics of the crush video," with pundits, candidates, and even other video artists attempting to make sense of the political implications of these videos, as they shape our perceptions of the candidates both in terms of their representational status in relationship to the national political parties and their inflection with specific racial and gender categories.

Mock political advertisements

The second major category of videos involves an explicit parody of political advertising on TV. In most cases, these videos initially appear to be straight commercials for a candidate, but as we watch, the advertisement's claims become increasingly excessive. Some of the best and most widely imitated mock commercials have been produced by comedy writers Andy Cobb and Lee Stranahan, who have each produced a number of similar videos criticizing Republican candidates. Like crush videos, mock political ads frequently make use of intertextual montage, connecting two or more texts in order to make a larger political point. Their videos also have an immediate quality and typically respond to recent events or popular Web videos. This use of found footage turns the video-maker into what Edwards and I have referred to as an "editor-producer," who makes meaning through the creative assemblage of pieces of found footage.[24]

These creative editing practices allow Stranahan and Cobb to make some fairly explicit political critiques. In Stranahan's "Mitt Hits Huckabee: Values," the video initially appears to be a straight Romney attack advertisement faulting Huckabee for being softer on gay marriage – or perhaps, more precisely, boosting Romney's conservative credentials. As the ad unfolds, we "learn" that gay marriage in Massachusetts has led to all sorts of problems, including thousands of children who are suddenly transformed into orphans and eventually giant flesh-eating rats that dominate the streets of Boston, a joke reinforced visually with a shot of a statue of a giant rat. Similarly, Andy Cobb's "Democrats for Romney" seizes upon a blog comment by Markos Moulitsas on DailyKos.com that jokingly encourages Democrats to "cross over" and vote for Mitt Romney in the Republican primary in order to keep his faltering campaign alive, a proposal made in response to Rush Limbaugh's sincere attempts to manipulate the Democratic nomination process by encouraging his "ditto head" listeners to vote for Clinton.[25] Like "Mitt Hits Huckabee," "Democrats for Romney" initially appears to endorse Romney before gradually revealing its true purpose by depicting Romney as willing to change his positions repeatedly in order to get elected by digging out footage of Romney in 1994 promising to protect abortion rights and intercutting that footage with more recent

depictions of him promising to overturn *Roe* vs. *Wade*. The video also highlights Romney's willingness to use strongly worded attack ads, even against members of his own political party.

However, the intertextual montage techniques of the editor-producer do not automatically lead to oppositional political meanings. They may reinforce dominant meanings, even while presenting witty depictions of the candidates. This use of intertextual montage can be seen in a video produced for *Slate*, "Hillary's Inner Tracy Flick," which compares the presidential candidate to Tracy Flick, the overachieving high school student in Alexander Payne's political satire, *Election* (1999) by cross-cutting between Payne's film and footage of Clinton. Like Payne's movie, the video positions the viewer to read Tracy as being willing to do anything to win – a characterization extended to Clinton in the video. In fact, both *Election* and "Hillary's Inner Tracy Flick" seem to fault the female candidates, unlike their male rivals, for being overly ambitious, for taking this politics stuff way too seriously. In this sense, the *Slate* video, perhaps more than most, seems consistent with relatively dominant narratives about Clinton that have been established in newspapers and on television. While "Hillary's Inner Tracy Flick" departs slightly from the mock campaign ad structure, it also relies heavily on intertextual reference in order to make its critique of a political candidate readable. At the same time, the video requires the viewer to have a significant amount of cultural and political capital in order to make sense of its intertextual montage techniques.

Hillary Soprano, or campaign videos go viral

As the major political campaigns became increasingly aware of the viral power of prezvids, they began creating their own videos with the hopes of creating a viral hit that could identify their candidate with a specific popular culture iconography. Few campaigns have been more successful in creating this association than the Clinton campaign's "Hillary Soprano" video. The video, which appeared just a few days after the much-discussed finale of the long-running HBO series *The Sopranos*, was a playful way for Clinton to announce the campaign's theme song.[26] The Clinton campaign had learned from other viral videos how to take advantage of the big popular culture event of the season, and piggybacking off of *The Sopranos* was a creative way of making the video part of a larger story, as audiences continued to debate what happened to Tony Soprano at the end of the final episode. Like the crush videos and mock ads, videos produced by the campaigns often have an irreverent tone, one that proceeds through intertextual reference. At the same time, they are an attempt to regain control over the candidates' images, to police against negative images of the candidates by using popular culture in more affirmative ways.

Like the mock political advertisements, "Hillary Soprano" requires a viewer who is knowledgeable about both *The Sopranos* and Hillary Clinton's political campaign, inserting "inside jokes" that only *Sopranos* fans or political buffs will recognize. The video itself is a relatively faithful adaptation of the end of the episode with Hillary – playing Tony – arriving at the diner first to be met later by Bill, while the two of them wait for Chelsea, in the role of daughter Meadow Soprano, to parallel park her car. In fact, at one point, Vincent Curatola, the *Sopranos* actor who played mobster Johnny Sack, even crosses paths with the Clintons, glancing toward Hillary who returns a sly double-take, illustrating how the Clinton campaign sought to depict the Senator as a typical TV fan, someone trying to make sense of one of the most puzzling scenes in recent television history. Once again, the intersection of popular culture, gender identity, and politics come to the forefront. Like the crush videos, the "Hillary Soprano" video is attentive to the intersections between political and popular culture. Because the intertextual associations with popular culture can be somewhat "dangerous," there is some risk in identifying a candidate's public image with a popular culture figure. This was especially true in the case of the "Hillary Soprano" video. As Douglas Rushkoff argued, "Hillary Clinton put herself in the role of Tony Soprano. He is a sociopath and a killer, willing to do anything for power. Why would a candidate present herself in such a role?"[27] Rushkoff adds that Tony's history of infidelity will remind viewers of the video of Bill Clinton's White House dalliances with Monica Lewinsky. In this sense, Rushkoff sees the video as "emitting a new semiotic" for the Clintons, one that depicts them as power-hungry and ambitious.

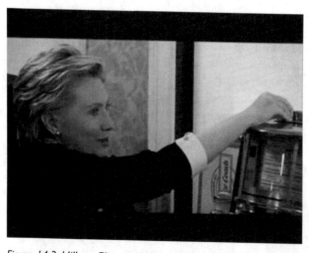

Figure 14.3 Hillary Clinton in *Sopranos*-inspired campaign video (screen capture by author).

However, a second, perhaps more "obvious," reading holds more sway than Rushkoff's. While many commentators have noted the potential implications of identifying Hillary with one of television's most famous mobsters, this reading fails to account for the extent to which fans of *The Sopranos* were starting to experience nostalgia for the show, and fails to acknowledge the semiotic of the television series itself. By associating herself with one of the most acclaimed TV series of all time, Clinton is also depicting herself as cultured, as having good taste in popular culture texts. At the same time, we see Bill and Hillary in a family diner, in a setting with Cub Scouts and families nearby, suggesting that the Clintons are just like us, fans of *The Sopranos* who are trying to make sense of one of the most discussed endings of a TV series in recent history.

Like Hillary Clinton, Republican candidate Mike Huckabee was attentive to the potential of a creative mixture of popular and political culture in his use of 1970s martial arts icon Chuck Norris in a number of online videos. As with other online videos, it is important to acknowledge the degree to which Huckabee, banking on Norris's star power, was likely aware that these videos would provoke the kind of attention that would ensure that they would be broadcast on television talk shows.[28] In "Chuck Norris Approved," Huckabee and Norris trade "facts" about each other, with Norris attesting to Huckabee's conservative credentials on gun rights, illegal immigration, and taxation, while Huckabee describes Norris performing improbable feats of strength. The video culminates with Huckabee joking that: "Chuck Norris doesn't endorse. He tells America how it's gonna be."[29] The video implicitly links Huckabee with Norris's conservative appeal, while also positioning Huckabee as a populist when it comes to tastes in popular culture. In addition, the video plays off of Chuck Norris's cult status as an actor. Thus, like the "Hillary Soprano" video, Huckabee demonstrates a willingness not only to engage with popular culture but a willingness to define his image as a candidate in part, at least, through popular culture texts.

Conclusion

Candidates such as Clinton and Huckabee have sought, with varying degrees of success, to identify themselves with the participatory ethos of prezvids, embracing their intertextual use of popular culture in order to shape their public image. While it would be easy to conclude that the Huckabee and Clinton campaigns have reclaimed the power of prezvids for their own purposes, the ongoing circulation of videos suggests that their public images remain contested. As we have seen, many popular user-generated videos, such as "I've Got a Crush On ... Obama," participate in the shaping of the

candidate's image. And even though user-generated videos can be appropriated, reworked, and reframed, they do offer audiences and video-makers alike new ways of imagining political practice. They can be read as allegories of citizen empowerment, even while failing to interrogate the concept of citizenship and how it has come to define participation in the political discourse of the United States.

At the same time, many of these videos proceed through what might be described as a kind of semiotic solidarity, one that is reinforced by two modes of digital intertextuality, one that is explicitly critical and another that is affirmative. Finally, political parody videos must be understood in terms of the limitations imposed on them with regard to the kinds of political assertions they can make. In other words, because of the means by which prezvids circulate, both online in the political blogosphere and on television, videos that raise familiar questions are more likely to circulate than those that challenge political norms. In addition, videos that receive more page views are promoted to YouTube's front page, further reinforcing their "popularity." This is not to suggest that prezvids are not doing vital political work but to argue that their political significance depends, in large part, on the intermedia and intertextual circulation of meanings that make them possible.

Writing this chapter in the midst of two heated primary campaigns and in the earliest stages of the general election campaign has presented an unusual challenge, as video-makers continue to adapt, and to create new forms in order to get their voices heard. While prezvids have been treated as offering a more authentic election discourse, one that is shaped less by the candidates themselves, their highly paid consultants, or by the major media conglomerates, it is important to remain attentive to the ways in which campaigns make use of the populist rhetoric associated with YouTube and other video-sharing sites. These videos, quite frequently, have been read as representing an online "community" of YouTube users who are engaged with politics in new and vital ways. However, as Raymond Williams reminds us, "community is a word that will be exploited by commercial operators."[30] Uses of terms such as "community" must be carefully interrogated in an age of media convergence, in which videos circulate through multiple media systems, often serving multiple, even contradictory, interests. In this sense, prezvids operate as a crucial site for the ongoing struggle over definitions of citizenship, democracy, and access.

Notes

1. James Wolcott was one of several cultural critics to describe 2008 as the YouTube election after seeing the "Vote Different" video; however, the phrase "YouTube election" actually dates back to the 2006 Congressional elections. James Wolcott, "The YouTube Election," *Vanity Fair Online*, June 2007, www.vanityfair.com/ontheweb/features/2007/06/

wolcott200706. See also Ryan Lizza, "The YouTube Election," *New York Times*, August 20, 2006, www.nytimes.com/2006/08/20/weekinreview/20lizza.html?partner=rssnyt&emc =rss; and Chuck Tryon, "'Why 2008 Won't Be Like 1984': Viral Videos and Presidential Politics," *FlowTV*, March 21, 2007, http://flowtv.org/?p=143.

2. In fact, one of the best-known political mashups, "George Bush's Imagine," a remix of several of George W. Bush's speeches to the tune of John Lennon's "Imagine" and "Give Peace a Chance," was produced outside the United States.

3. Gene Koo, "Obama's Message is in the Remix," *techPresident*, February 22, 2008, www. techpresident.com/blog/entry/22107/obama_s_message_is_in_the_remix. See also Henry Jenkins and David Thornburn, "Introduction: The Digital Revolution, the Informed Citizen, and the Culture of Democracy," *Democracy and New Media*, eds. Henry Jenkins and David Thornburn, 2 (Cambridge: MIT Press, 2003).

4. Jenkins and Thornburn, "Introduction," 5.

5. Jose Antonio Vargas, "But Don't Ask Him on YouTube," WashingtonPost.com, July 26, 2007, blog.washingtonpost.com/the-trail/2007/07/26/but_dont_ask_him_on_youtube_ 1.html.

6. Henry Jenkins, "Answering Questions from a Snowman: The YouTube Debate and its Aftermath," Confessions of an Aca/Fan, August 1, 2007, www.henryjenkins.org/2007/08/ answering_questions_from_a_sno.html.

7. Ibid.

8. Rory O'Connor, "CNN's YouTube Debate Failed the American People," AlterNet, July 24, 2007, www.alternet.org/mediaculture/57807.

9. Sarah Lai Stirland, "CNN–YouTube Debate Producer Doubts the Wisdom of the Crowd," *Wired*, November 27, 2007, www.wired.com/politics/onlinerights/news/2007/11/cnn_ debate.

10. Doug Schuler, "Reports of the Close Relationship Between Democracy and the Internet May Have Been Exaggerated," *Democracy and New Media*, eds. Henry Jenkins and David Thornburn, 69 (Cambridge: MIT Press, 2003).

11. Henry Jenkins, *Convergence Culture: Where Old and New Media Collide* (New York: New York University Press, 2006), 206–239.

12. Anne Norton, *Republic of Signs: Liberal Theory and American Popular Culture* (Chicago: University of Chicago Press, 1993).

13. Richard Edwards and Chuck Tryon, "Political Video Mashups as Allegories of Citizen Empowerment," *First Monday*, 14(10), 2009, http://firstmonday.org/htbin/cgiwrap/bin/ ojs/index.php/fm/article/view/2617/2305.

14. Jonathan Gray, *Watching With The Simpsons: Television, Parody, and Intertextuality* (New York: Routledge, 2006), 43–68.

15. James E. Porter, "Intertextuality and the Discourse Community," *Rhetoric Review*, 5.1 (autumn 1986), 37.

16. Matt Hills, cited in Henry Jenkins, *Fans, Bloggers, and Gamers: Exploring Participatory Culture* (New York: New York University Press, 2006), 156.

17. Norton, *Republic of Signs*, 87.

18. Ibid., 82.

19. Patricia R. Zimmerman, "Digital Deployment(s)," in *Contemporary American Independent Film: From the Margins to the Mainstream*, eds. Chris Holmlund and Justin Wyatt (New York: Routledge, 2005), 247.

20. Roger Hurwitz, "Who Needs Politics? Who Needs People? The Ironies of Democracy in Cyberspace," *Democracy and New Media*, 109.

21. Barely Political, "I Got a Crush On ... Obama," YouTube, June 13, 2007, www.youtube. com/watch?v=wKsoXHYICqU.

22. Jill Tubman, "ObamaGirl Video – Harold Ford-style Fraud?" Jack and Jill Politics, Friday, June 15, 2007, http://jackandjillpolitics.blogspot.com/2007/06/obamagirl-video-harold-ford-style-fraud.html.

23. Barely Political, "Perfected: The Ann Coulter Song," YouTube, October 24, 2007, www.youtube.com/watch?v=ye_2a7Lrl80.
24. Richard Edwards and Chuck Tryon, "Political Video Mashups as Allegories of Citizen Empowerment," 2009.
25. Markos Moulitsas, "Let's Have Some Fun in Michigan," Daily Kos, January 10, 2008, www.dailykos.com/story/2008/1/10/2713/87225/55/434206.
26. This discussion of the "Hillary Soprano" video expands on the analysis of the video in Richard Edwards and my article, "Political Video Mashups as Allegories of Citizen Empowerment," 2009.
27. Douglas Rushkoff, "Hillary Soprano: Ill-Conceived Media Virus," Douglas Rushkoff Blog, June 20, 2007, www.rushkoff.com/2007/06/hillary-soprano-ill-conceived-media.php.
28. For background on the collaboration between Norris and Huckabee, see Ed Stoddard, "'Huck and Chuck' Show Adds Punch to Campaign," Reuters, January 7, 2008, www.reuters.com/article/politicsNews/idUSN0632860320080107.
29. Mike Huckabee, "Chuck Norris Approved," YouTube, November 18, 2007, www.youtube.com/watch?v=MDUQW8LUMs8.
30. Raymond Williams, Television: Technology and Cultural Form (New York: Schocken, 1974), 149.

NASCAR Nation and television

Race-ing whiteness

L.S. Kim

NASCAR has become the second-most watched professional sport on television in the United States, ranking only behind the National Football League. Internationally, NASCAR events are broadcast in over 150 countries. NASCAR has turned the corner at high speed from margin to mainstream, from regional to international, and arguably, from hick to hip. The rise of NASCAR (an acronym for the National Association of Stock Car Auto Racing) has been built on a carefully constructed scaffold of whiteness, class, and fandom in the convergent universe. Taking from its Southern white male roots, NASCAR's owners have used television and now new media to recruit a broad new fan base while permitting long-time NASCAR loyalists to relish their cultural history and identity.

This history is bound inextricably to the history of television – from local broadcasts and coverage of stock car racing by Southern television stations at a time when much of television's programming was locally produced, to the hyperslick, graphics-intensive, heavily produced live national broadcasts by major networks every weekend during NASCAR's current race season, replete with dozens of cameras, including live in-car feeds with a near video game aesthetic. Culturally, NASCAR was at the heart of the long-running TV series *The Dukes of Hazzard* (CBS, 1979–1985). (A part of the NASCAR narrative, its "creation myth," is that NASCAR emerged from the world of Southern moonshine runners. The myth is actually rooted in fact.) Even legislatively, NASCAR's rise to prominence on television was triggered by a landmark piece of social engineering – the 1971 ban on tobacco advertising on television.

Tracing its origins to Prohibition, stock car racing became formalized by the 1950s, entered the modern era in the early 1970s, and has gained worldwide media attention in the new millennium. Television has been the lead vehicle in this transformation, along with heavy corporate sponsorship and the promotion of racing stars. Dale Earnhardt in the #3 car, Dale Junior, Jeff Gordon, Danica Patrick, Juan Pablo Montoya, and the 2007 Indy 500 winner,

Ashley Judd's husband Dario Franchitti, are mixing different categories of racing into a recognizable culture of race car driving.[1] And, recently, cast members of the reality TV program *Fast Cars and Superstars* (ABC, 2007) have tried their hands at the wheel.

Televised racing typifies media convergence, functioning simultaneously as live spectator event, reality TV (in the form of race-day interstitial programming about drivers, crew members, team owners, as well as NASCAR-related reality shows and talk shows), live broadcasts on Fox and ABC, and cable narrowcasts on the Speed Channel and ESPN-branded channels. There have been NASCAR-themed movies, including *Days of Thunder* (1990) starring Tom Cruise, and Will Farrell's parody *Talladega Nights: The Ballad of Ricky Bobby* (2006). There are country music songs, video games, and even romance novels linked to NASCAR. NASCAR-focused websites, chat rooms, podcasts, and interactive online polls complement live radio shows, magazines, and newspaper columns. The signs and symbols of racing abound on hats, shirts, bumper stickers, and body tattoos. What is perhaps most significant about NASCAR is that it has successfully harnessed "old" mass media strategies coupled with new media technologies to expand a local, classed culture into a national one. NASCAR and television together represent, reinforce, and re-negotiate national identity vis-à-vis whiteness, and through convergence as a site of heritage.

Why is NASCAR the fastest-growing sport? How and why did a regional sport with a Southern, white, working-class support base get mainstreamed into a middle-class spectator sport that appeals to men and women throughout the country and across ethnic lines, without alienating – indeed while embracing and tacitly exalting – its core base? In part, that core was upwardly mobile (through the very use of new technologies such as HDTV, computer interactivity, mobile phones) alongside NASCAR itself, rising in affluence, becoming politically resurgent and self-confident, and taking advantage of convergence to come out of the isolation of the hollows and hills of the rural South. What happened to the sport in the process, and what does this convergence tell us about whiteness? The discourse of whiteness is adaptable, flexible, and the definition of, or presumptions about, the NASCAR fan are not as clear-cut as the notion of "the NASCAR Dad" of the 2004 US Presidential campaign suggests.[2]

My concern is that as NASCAR reaches "Victory Lane" in television and popular culture as a kind of rags-to-riches Cinderella story, it will be attributed to a teleological explanation of convergence and there will be an assumption that NASCAR is better because of all that is new (and less Southern or working-class). This, in turn, contributes to problematic logics such as: 1. the old is shed and abandoned; 2. those in the margins wish to move into the center; 3. the flow of cultural influence moves in one direction; 4. that televi-

sion flow develops uni-directionally from relative past to relative future; 5. that television, itself, is justified when it is aligned with technological innovation (and less respected when it is aligned with viewers, especially those perceived as parochial). The key to NASCAR's success is not merely the fact of its incredible sponsor support, but the structure of sponsorship that imbricates car–driver–fan in a bond that personalizes economics and legitimizes a particular cultural identity. There are two operating myths that the rise of NASCAR challenges: that Southerners lacked business savvy and a sense of self-awareness, and that "television" (production power) emanates from Hollywood or New York and not from geographic hinterlands.[3] NASCAR is both parochial and culturally significant, both traditional and innovative.

The speed of the race car is a metaphor for the technological advancements in television. And while there might be a shiny "new NASCAR" that new fans are coming to know, NASCAR has been around for decades, and television has had a relationship with cars for almost as long. While media convergence is exciting, as is writing about it, this chapter echoes the sentiment of the larger collection about an uncritical embrace of convergence as transformatively new. I argue that NASCAR's phenomenal success has come through innovative business relationships with sponsors that ultimately reiterate traditional modes of television sponsorship, and that, therefore, viewers remain central and liveness is still relevant vis-à-vis flow. What NASCAR and television have developed together is simultaneously old and new. Furthermore, the articulation of national identity is central to the cultural formation of NASCAR, and media forms both old and new facilitate this articulation as well as a negotiation of identity; it is an articulation that expands the boundaries of "whiteness" as raced, classed, and regionalized. NASCAR Nation has announced its presence and expands its reach through new media forms (borrowing discursive modes honed in the network television years) in a way that appeals to its core fans and also invites others in. That is, NASCAR Nation acknowledges its particular whiteness and yet displays its openness. At a time when television has waned as a "mass" medium, NASCAR demonstrates that electronic media remain culturally, economically, and politically relevant as a means to reflect and refract contemporary nationhood.

TV builds a nation

Without television, there would be no NASCAR as we know it. While stock car racing began in the 1930s, it took television to cohere the NASCAR culture, and then build the NASCAR Nation. The National Association for Stock Car Auto Racing was founded in 1947 by Bill France, Sr., a former gas station owner who moved to Daytona, Florida, and started promoting

organized events in the 1940s.[4] The first races took place on the beach, and the cars were plain vehicles "not like today's racecars, which are built from the ground up by multimillion-dollar teams and tuned specifically for racing. If drivers wanted to race back then, they could drive the family car right onto the track!"[5] The winner might go home with a set of tires, or a pair of sunglasses.

When stock car racing was still principally for fans in the stands, sponsors saw the cars as rolling billboards, and the drivers – helmeted, goggled, and tucked inside the vehicles – were at least partially anonymous. Television broadcasts did more than just make the sport accessible to many more people than could fit into the grandstands at a local track. The camera turned the cars into rolling commercials able to generate revenue on a scale that far exceeded ticket sales, fundamentally changing the economics of the sport. And with the camera came the interview, which created an entirely new relationship between fan and driver. The cars supported the sponsors' products; the close-up on white faces with heavy rural Southern accents reinforced Southern white culture.

But therein lay an eventual conflict of commerce and culture. Being freighted with signifiers of the "down-market" Southern white male was a limit to growth. NASCAR is, however, first and foremost a business. Its owners[6] have managed to use virtually every medium to create an interactive relationship between fans and a new generation of telegenic drivers, many of whom come from parts of the country other than the South and who have personal styles very different from the folksy, country-roots racers of previous generations. In so doing, they have moved NASCAR beyond its gender- and region-specific origins to establish a new sponsored product–driver–fan nexus that has brought a broad swath of America into a direct embrace of those same signifiers, which have never gone away. NASCAR broadcasts are replete with references to the golden past. Old drivers are frequently interviewed. On-air commentators frequently make proud remarks about the incredible success of the sport, about "how far the sport has come," in reaching out to the rest of America. The remarks aren't boastful; rather, they are offered with a down-home humility.

This dialogue between old and new not only allows more people to fit comfortably inside the NASCAR tent; it also sets up interesting marketing opportunities that address directly some of the values underpinning the good ol' boy mentality that can interfere with business. A case in point is Toyota's recent entry into NASCAR's premiere racing series.

From the 1940s, Detroit automakers and their dealers have supported NASCAR as a promotional tool. NASCAR initially required that all race cars be essentially "stock," meaning the cars were available for purchase at local dealerships and raced with little modification. Drivers would "run what you

brung," the racing term for driving to the track and racing in the same car. These were all-American cars for which manufacturers and retailers used the motto: "Win on Sunday, sell on Monday." Over time, more and more modifications were permitted, but it still remained possible for customers to buy a car from a dealer that was quite similar to what they saw at the track. NASCAR "stock" from-the-factory evolved into purpose-built race cars having almost nothing in common with vehicles available for purchase except that, unlike other auto racing sanctioning bodies, NASCAR insisted that the cars maintain the basic shape and outward appearance of suburban family sedans, each of which was still called a "Ford Taurus," a "Chevy Monte Carlo," or a "Dodge Intrepid." A fan typically was a "Ford man," a "Chevy man," or a "Dodge man." The "National Association of Stock Car Auto Racing" may no longer have been racing stock cars, but a close and lucrative connection had developed between fans and the three Detroit automakers – Chevrolet, Ford, and Dodge – that supported NASCAR.

In 2007, working closely with NASCAR, Toyota entered three Camry race cars into the competition. This created a stir among many diehard NASCAR fans, who felt that NASCAR should be exclusively "American," as if supporting a team sponsored by a foreign company competing against American-backed race teams was unpatriotic. Patriotism is, of course, a recurring theme in NASCAR culture. American flags are ubiquitous at NASCAR events, and the relationship between NASCAR and the military is a close one, as discussed in the following section. There was considerable debate about Toyota in NASCAR-themed chat rooms, sports talk radio shows, and newspaper and magazine articles. The conversation took place on television, too, during pre-race shows, televised race commentary, and on the talk/interview programs airing on ESPN and the Speed Channel. The commentators hewed to the NASCAR line, which was that the introduction of Toyota "is good for the sport." Most interestingly, they raised the question, "What is an 'American' car anyway?", pointing out that many of the Fords, Dodges, and Chevrolets that the race cars are named after are assembled in Canada and Mexico, while Toyota's Camry and other models are assembled in the US, employing thousands of American blue-collar workers.

Perhaps it was this dialogue itself, more than advertising per se, that Toyota was looking for by sponsoring cars in NASCAR. After all, Toyota does not market the Camry (the ultimate example of the sedan as middle-class appliance) as a performance car, making the link between a "Camry" in Victory Lane on Sunday and sales on Monday somewhat tenuous. Aware that it would generate controversy by supporting cars in NASCAR, Toyota did so in part to spark race-day television commentators to encourage fans to see Toyotas as, at least, partially "American."[7]

Toyota and NASCAR partnered together to utilize the intertextual struc-
ture of sponsorship (which imbricates car–driver–fan) to hold a values debate
and to reframe the nature of patriotism in the consumer marketplace. That
debate was held on a grand scale. Nearly seven million fans attend NASCAR
Cup Series races (which is four-times the attendance in 1980), and more than
280 million viewers watch NASCAR Cup Series events on television. Stock
car racing is the number 1 sport in brand loyalty, the number 2 rated sport on
television, and generates over $2 billion in licensed sales.[8]

Thanks to our sponsors: turning "tobacco into gold"[9]

In the early days of stock car racing, sponsors consisted of local motels,
garages, or car dealerships.[10] In 1971, the US Congress passed legislation
barring cigarette advertising on television. Companies like R.J. Reynolds
(RJR) and Phillip Morris, key sponsors of beloved television programs like *I
Love Lucy*, looked to NASCAR: "With the cigarette-advertising ban in place, it
seemed like the perfect time to take the plunge. It was perhaps the greatest
business decision ever made in the history of NASCAR."[11] First, RJR put up
$100,000 for the prize for the Grand National Series in 1972, which would
become the Winston Cup Series. (Prize money has skyrocketed since then.
For example, in 2003, the *last* place finisher of the Daytona 500, Ryan
Newman, took home $195,663.) Second, RJR cleaned up NASCAR – tracks
were repaired and refurbished, transformed from rough and rowdy to family-
friendly. Third, this in turn brought folks to the racetrack. RJR customers
"were the lower- to middle-class Americans who in 1972 smoked like chim-
neys, drank Budweiser beer, and drove nothing but American-made cars and
trucks." Richard Petty who, with his father Lee and son Kyle, belongs to one
of racing's most famous families said: "RJR came to the races and looked up in
the stands and saw their customers. They brought their business partners to
the track and they looked up in the stands and said, 'Those are my customers,
too.' "[12] It was nothing less than an epiphany. One that turned tobacco into
gold.

In addition to tobacco companies, NASCAR saw an influx of Fortune 500
companies like Proctor & Gamble, Kraft, General Foods. While certainly
Budweiser, Miller, Skoal, and General Motors were major sponsors, more
mainstream, and specifically female-oriented brands began to come into the
sport. For example, Folgers, Maxwell House, Tide, and even Underalls (a
brand of women's pantyhose) became NASCAR sponsors, complementing the
support of more traditional sponsors such as beer, chewing tobacco, and car
companies. Moreover, Mark Yost points out that even though Tide was expen-

sive for the mostly lower-middle-class audience, "the kinds of folks who made ends meet by buying bargain-brand laundry detergent," NASCAR fans bought Tide to support Rick Hendrick's car driven by Darrell Waltrip.[13] In 1979, Waltrip famously said in Victory Lane at Riverside, California: "I've got to thank God, Gatorade, and Goodyear for the way we ran today." Now a sports commentator who makes regular broadcast appearances throughout the NASCAR season (which is the longest in professional sports, lasting nine months), Waltrip embodies perfectly the new NASCAR driver/spokesperson.[14] Furthermore, racing is a family enterprise as his younger brother, Michael Waltrip, currently runs in the Cup Series, owns a NASCAR car, and also makes frequent television appearances as a commentator and in NASCAR-related commercials.

NASCAR thrives because the NASCAR family is made up of actual families, their favorite drivers, and the sponsors of those drivers. Fans, often multi-generational, show their love and loyalty by buying from the companies that sponsor their favorite drivers. A recent study revealed that 76 percent of them use NASCAR sponsors' products.[15] NASCAR is more effective than television advertising alone in creating brand loyalty. It is the confluence of fandom, sports heroism, regional identification, and an earnest belief in the American dream – for the driver as well as for oneself – that has propelled NASCAR's success as an advertising mechanism and cultural phenomenon.

By the end of the 1980s, some of the early sponsors were replaced by more common consumer brands such as Country Time Lemonade, Kool-Aid, DuPont, and Red Baron frozen pizza. Indeed, there has been a significant diversification of sponsorship. Today, we see brands like Target, Best Buy, Circuit City, Home Depot, Lowe's, and Menards, all of which connote family and domestic life. The appeal to NASCAR Nation is clearly similar to advertising in the early age of television for home appliances, home improvement, achieving middle-class comfort and family stability. "With the dot-com boom of the 1990s came sponsors such as AOL, DirecTV, and cellular telephone companies".[16] In 2003, Nextel replaced R.J. Reynolds as the title sponsor and the top NASCAR series went from being called the Winston Cup to the Nextel Cup. NASCAR has not only attracted the Fortune 500 firms, but the more exclusive Fortune 50, including Allstate, Bank of America, Caterpillar, Cingular, Coca-Cola, FedEx, Goodyear, Gulfstream, Kellogg's, Kodak, M&M Mars, Office Depot, Sunoco, UPS, Visa, and even international brands like Tissot, the Swiss watchmaker which became the official time-keeper of NASCAR in 2006. Yost writes in the first chapter of his book, *The 200-MPH Billboard: The Inside Story of How Big Money Changed NASCAR*, "I'll look at the starting grid not as a lineup of some of the best drivers in the world, but as a lineup of the most powerful and influential

corporations in America."[17] These names are prominently and colorfully painted on the hood of the car, and all along the sides (the more strategically placed for the camera shot of the driver during the race, the more expensive it likely is); the drivers' suits are equally decorated; and the phrase, "he wears many hats" is literally the case with drivers who, after winning a race, do the "hat dance" where they must put on and take off dozens of caps with different sponsor logos on them as photos are snapped. "I put the sponsors right up there with the fans," Richard Petty has said. "Without either of them, I wouldn't be able to do what I do."[18]

Tobacco advertising was worth $230 million to the networks in 1970. Think about where all that money went. Even car companies were withdrawing sponsorship of stock car racing in the 1970s due to the general economic recession – particularly as domestic auto sales slowed. But as major corporations came to NASCAR, the picture changed and the spotlight grew:

> It was no longer just some redneck sport populated by country bumpkins who ran mostly on half-mile ovals in small southern burgs that no one had ever heard of. It had the backing of one of the richest and most profitable corporations in the world.[19]

Corporate sponsorship brought legitimacy, which brought television coverage like never before. In 1975, CBS paid NASCAR more than $650,000 for five races, reportedly the largest television contract in the history of auto racing at that time. In 1976, NASCAR drew 1,431,292 fans to the racetracks, which was the first time that NASCAR was the number one auto sport worldwide, beating Formula 1's attendance of 1,190,500 fans.[20] 1979 was the year of the famous first "flag-to-flag" (start-to-finish) coverage of the Daytona 500 with the kind of ending Hollywood producers dream of – complete with drama, suspense, and unscripted fisticuffs on live television. In 1999:

> NASCAR took a page from the NFL playbook and consolidated television broadcast rights, signing its first national television contract with Fox and NBC for a cool $400 million a season for six years. In the 1980s, when NASCAR races were broadcast on a slew of cable networks – ESPN, TNT, TBS, and others – the broadcast rights to a single race cost just $200,000. Over a thirty-one-race season, that's a little more than $6 million. So you can see what a huge deal the $2.4 billion national television package was for NASCAR. More important, the TV package gave NASCAR the big league legitimacy that it has longed aspired to, both as a sport and as a business.[21]

NASCAR's move toward legitimacy in the context of mainstream popular culture continues into the new millennium.

The Winston Cup Series' sponsor, R.J. Reynolds, was able to get around the ban by advertising tobacco vicariously. Among the transformative factors that RJR contributed to NASCAR is that it started the practice of corporate hospitality, as well as the business-to-business deals – referred to as B2B – that define the business of NASCAR sponsorships today.[22] Basically, B2B means that sponsors do business with each other, not only with the NASCAR organization or with NASCAR fans. For example, Newpage Corporation, a paper company, provides NASCAR with thousands of paper supplies (29,000 tons in 2004): reams of paper for everyday business, catalogs and mailings on a weekly basis, programs and signs for race weekends, etc. More than this, Newpage interfaces with NASCAR's other sponsors in hopes of gaining their business. The main B2B goals are: 1. to find new business at the track; 2. to increase sales to existing customers; 3. to retain at-risk business; and 4. to serve the NASCAR community directly. Since joining forces with NASCAR, Newpage has met and exchanged services with UPS, Callaway golf equipment, and contracts with Sprint Nextel for Blackberry wireless service for its employees. These are "interwoven business relationships as a result of the cooperative spirit and the NASCAR B2B Council."[23] Again, it is about building loyalty, creating business families and communities, and proffering a sense of what it means to be an American. Brand loyalty serves as a metaphor for good citizenship.

"Be all that you can be"

NASCAR sponsors imbricate themselves into – and personalize and embody – what it means to be a part of NASCAR Nation. One of NASCAR's strongest sponsors is the United States Military. Every branch of the US Military is involved with NASCAR: Army, National Guard, Navy, Air Force, Marines.

The military connection to stock car racing is a long-standing one. Many of the early drivers in the South in the 1940s and 1950s were World War II veterans, and many pit crew members received their training in the military. Yost relays the story of Humpy Wheeler, "the undisputed P.T. Barnum of NASCAR" staging a scene from the Gulf War in the infield before the start of the 1991 Coca-Cola 600 at Charlotte Motor Speedway. He writes that "honoring our military just fit with the culture of NASCAR. With all this patriotism surging through the NASCAR garage area, it only seemed natural for the armed forces to become fulltime NASCAR sponsors."[24]

In recruiting at the racetrack, class appeal is apparent. Senior Chief Jeff Priest, who heads up the US Navy's NASCAR sponsorship, has said:

We're trying to reach the influencers. The moms, the dads, the uncles. We're trying to let them know what the Navy is all about and why it might be a good place for some of their kids to start their career, earn money for college, whatever.[25]

The military had the same epiphany that many of NASCAR's business sponsors had, that the captive audience of NASCAR was their audience too. Furthermore, as with the corporate sponsors who have a shared sense of community and purpose with NASCAR and its fans, the armed services share a likeness to NASCAR:

"This is *just like* what the Navy does." It's high-tech. Speed and accuracy is important. You have to be concerned with the minutest of details: tire pressure, tire wear, shocks, aerodynamics. This is not just a bunch of guys going around in circles [emphasis added].[26]

Another "like NASCAR" example is that Air Force training is very high-tech and high-speed, and the relationship between the pilot and crew chief is similar to that of a driver and his/her crew chief. The connection with the military moves beyond analogy. NASCAR itself is able to encompass a sense of unified American identity.

Former Georgia Senator Max Cleland, a Vietnam vet, head of Veterans' Administration in the Carter Administration, and avid NASCAR fan, said:

I think all the services, ever since the elimination of the draft, have had to be innovative. They're going after the same cohort, seventeen- to twenty-one-year-old males, basically. But more and more it is a high-tech force. It's a force that thrives on adventure and excitement and technology and speed. And in some ways, NASCAR may be more in that zone than most.[27]

The US military has a strong presence at every NASCAR race in the form of military colors, glee clubs, and the US Navy F-14 Tomcats flying overhead in pre-race shows.

Before a race begins, a prayer is said as drivers hold children in their arms, stand next to their spouse, alongside their crew on the field, all in uniform and all silently listening; it is an unashamedly Christian crowd. Religion meshes with patriotism as the national anthem is also heard in unison, with voices singing and hands placed over hearts. Drivers are introduced, and they line up on the grid. As engines rev behind the pace car in the warm-up lap, thousands of fans in the grandstands and hundreds of thousands of television viewers

eagerly await the green flag to wave the start of the race. There is a harnessed energy and collective pleasure in watching a NASCAR race. And it stems from its liveness. Its mode is one of ritual – of participation and belonging in the moment. While tied to a specific cultural origin, the pleasure is nonetheless accessible; the patriotism, pride, and sense of celebration are an open invitation.

NASCAR and the US military use analogous marketing strategies on a number of levels, including a recent and conscious effort to address the need for more diversity. Women and drivers of color are not currently in prominent or dominant positions, and motor sports racing has been called a very "white sport." Figures like Lewis Hamilton in Formula 1 (open cockpit) racing, and Juan Pablo Montoya who has moved from Formula 1 to NASCAR, receive press coverage; moreover, Juan Pablo Montoya is featured in advertising campaigns aimed at increasing a Latino audience. But the number of racers of color remains noticeably low, and this virtual absence[28] is something that is a subject of concern particularly since NASCAR has moved into the big leagues of sports broadcasting:

> With that growth, the lack of a black presence is no longer just a regional or cultural anomaly. It has become a costly business problem, as well. . . . There's money to be made by attracting black participants and more black fans. And out of a newly formed black fan base, NASCAR just might discover its first black superstar driver – the stock car version of Tiger Woods. "We understand it could be a win–win for everyone," says Dora Taylor who NASCAR hired in 2002 to spearhead the NASCAR Diversity Initiative.[29]

Rainbow Sports director Charles S. Farrell has said that NASCAR is "an intoxicating sport. . . . But when you look on TV and you still see the Confederate flag waving, and you see people almost embracing that good ol' boy image, of redneck American, it's not appealing to blacks."[30] What NASCAR does successfully is "clean-up" its image while still maintaining a self-image that core fans can believe in. NASCAR is conscious about change, marking trends in its growing African American fan base, keeping track of minority employment (bringing more African Americans and women onto pit crews), and supporting a team run by African Americans (for example, Hendrick Motors helped with the launch of BH Motorsports, a team to be run by Sam Belnavis and Tinsley Hughes, who are African American). NASCAR also sponsors or runs the following: a ten-week summer internship program that gives minority youth a chance to explore careers in motorsports, the Philadelphia-based Urban Youth Racing School, and the NASCAR Technical Institute, a place

where both minorities and whites can receive scholarships to learn how to work on a pit crew.

Still, NASCAR is about whiteness – about representing a particular white culture and also about the negotiation of whiteness vis-à-vis class, race, and gender as the fan base of the sport and as media technology are changing. In a "Talk of the Nation" NPR interview on the occasion of the fiftieth anniversary of NASCAR in 1998, racer Kyle Petty described the changing demographics: the first group of NASCAR fans were male "gearheads" when sponsors were Valvoline and other car-care products, the next wave were women when sponsors like Crisco and Heinz Ketchup joined, and the third phase drew in families with sponsors like Hot Wheels. (Today, nearly 40 percent of fans who attend races are women, up from 15 percent in 1975.) It has yet to be seen how the sport will shift in terms of widening its racial diversity; it is from both without and within that the notion of NASCAR as "white" is being projected.[31]

The notion of the NASCAR Dad is a prime example of, on one hand, stereotyping a Southern, white, male, religious, conservative from a small town with working-class tastes and, on the other hand, idealizing a good American father figure. Matt Stearns describes the NASCAR Dad as

the successor to the Soccer Mom, the well-off suburban woman whom politicians chased in 2000. Political strategists think he's holding the key to victory next year, although many people who know both politics and NASCAR find the concept a bit daft.

Nevertheless, many of NASCAR's most loyal fans remain small-town and blue-collar. "Whether they're swing voters is a subject of some debate ... those voters tend to be socially conservative, often religious. They savor the nationalistic fervor that permeates each NASCAR event, including military fly-overs."[32] The concept may be simplistic, but the recognition being given to this market demographic and voting segment is real.

Tradition: NASCAR as family, economy, narrative

When people talk about the NASCAR family, they don't mean just the competitors. NASCAR fans tend to "adopt" a certain driver to root for, and he becomes a member of their extended family.

(NASCAR Cup Series driver, Mark Martin[33])

Once upon a time, old beat-up cars ran liquor through the hills of North Carolina, Georgia, and other parts of the South. The roads were rough and the

cargo (moonshine or corn whiskey) was illegal. The drivers had to outrun the authorities as a matter of financial livelihood, though they had some fun doing it. The roots of stock car racing designate class, whiteness, and regionalism, and it sets up the notion of "tradition" in several senses: as a particular history, as ritual practice, and as cultural identity. There was a time when those who were involved in stock car racing shared a social position vis-à-vis these three elements of tradition; but, today, there are many more who have joined NASCAR Nation and who have little to do with that shared history. Are the newcomers, then, distanced or disdainful, admiring or idealizing of a blue-collar, red-state sport?

Today's NASCAR drivers, while stars (and increasingly so), are also depicted as regular people:

> During a time when many athletes are out of touch with the fans who pay their bills, NASCAR drivers are seen by many of their supporters as the guy next door ... many retain an innate humbleness, which comes from remembering the early days of their careers when they built and worked on their own cars. They also recognize that without fans, NASCAR wouldn't exist.... NASCAR drivers are also known as family men, who bring their wives and children to many races.... Many attend church services on the morning of a race and are very aware they are role models to kids and teens watching their every move.[34]

Champions like Bobby Allison, Dale Earnhardt, Richard Petty, and Junior Johnson displayed little pretense and strong Southern accents. The newest generation of racers, like Jeff Gordon, Tony Stewart, Kasey Kahne, Karl Edwards, and Kyle Bush, while enormously popular and seen regularly in numerous widely promoted advertisements, have not joined the same cult of celebrity that other superstar athletes have (yet). Arguably, Jeff Gordon has been tapped and pap(arazzi)'d and, concomitantly, he is not as popular among "true" NASCAR fans. His talent has received respect, but as a native Californian, he has also been seen as suspect, especially when he first entered the professional circuit as a young phenom in 1992.

We have two concepts: authenticity – of the drivers and the fans; and authorship – who has the capability to represent NASCAR culture and history? The question of who and how one is a real fan is raised in the foreword to the book, *The 200-MPH Billboard: The Inside Story of How Big Money Changed NASCAR*:

> Is it in your blood? ... Does the spectacle of the first, full-speed lap at Talladega or Bristol cause your chest to thump and bring tears to your

eyes? Or did you read about the sport in *Time* magazine and watch the Daytona 500 from a glassed-in, luxury hospitality suite?[35]

Authenticity rests on regional heritage and class difference. Garry Whannel states:

> The class character of many sport cultures is particularly visible.... Yet in television representation it is rarely explicitly alluded to, and generally suppressed.... Performers are rarely offered as classed individuals – differences that could be rooted in class are frequently displaced onto regional variation or individual idiosyncrasy.[36]

NASCAR does not hide its class origins and, in fact, thrives because of the pride its core fans have. Whannel also argues that sport performers have a three-fold function for television: as stars they are the bearers of the entertainment value of performance; as personalities they provide the individualization and personalization through which audiences are won and held; and as characters they are the bearers of the sporting narratives.[37]

Stock car racing is a prole sport. Eldon Snyder and Elmer Spreitzer write:

> Prole sports include such events as motocross racing and professional wrestling, place an emphasis on speed and power rather than physical grace of skill. [Snyder and Spreitzer are wrong about that – despite ostensibly driving in circles, successful NASCAR racers are actually highly skilled, gifted athletes.] These sports are attractive to working-class people ... because the events derive from artifacts common in the proletariat lifestyle, such as automobiles and motorcycles, and fans can identify socially with the participants.[38]

As a check for authenticity, one might be asked whether s/he has been to a local track, "where fans encounter the sport in its purest form. The drivers are builders, mechanics, and plumbers by day ..."[39] The renegade driver has become a professional athlete. The neighborhood event has become a grand spectacle.

Dale Earnhardt, "the Intimidator," won 76 NASCAR Cup races from 1975 to 2001 (he died following an accident during the last lap of the Daytona 500 that year) in a period that represents dramatic change of the sport from bang-em-up old-school home-built cars to bright, shiny, more "clean driving" of sponsored vehicles. One of Earnhardt's sponsors, Stetson Hats, featured an ad with him wearing a black Stetson holding the championship trophy. Such an ad is an example of the bridge between stock car racing's Appalachian roots and

its future as a marketing wonder: "Despite no revealing text, the ad's intent was clear – Dale Earnhardt, like the frontiersman, had conquered the toughest territory in America, the 17 speedways of the NASCAR Winston Cup Series."[40] Cultural historian and car enthusiast Mark Howell was browsing a NASCAR collectibles store in Ohio and came across a t-shirt with a Western motif (cowboys on horseback) and the shirt read: "Cowboys and Engines"; Howell described it as "another testimony to Dale Earnhardt's role as a symbol of American individualism ... connecting the iconography of Dale Earnhardt and the cultural mythology of the American West."[41] While the appeal to Americana remains a part of stock car culture, the drivers and the sponsors are changing. As Howell describes:

> Unlike the stock car driver of the past who learned mechanical and/or driving skills at the hands of a parent or relative, today's drivers are being acculturated to meet the demands of corporate responsibilities. Success as a racecar driver means working as a company spokesman, being articulate at a sales meeting as well as fast on the racetrack. Many drivers have managed to secure their racing careers on the merits of being a popular figure with consumers.[42]

What has remained consistent, and consistently imperative, is the sense of community – of family – between fans, drivers *and* sponsors. Howell describes the unification:

> The sport itself is a community ... participants look to each other for solidarity. The drivers, mechanics, officials, media people, and families of NASCAR move about the nation as a group with its own rules, ethics, and etiquette ... to be a part of NASCAR is to be part of a community.[43]

However, the solidarity has not necessarily been complete or on the terms of those considered "low-brow." There is a sentiment that I find problematic because of its description of less-desired fan activity and of the implied meaning of the word "respect": "as NASCAR's grip on family-entertainment dollars tightens, such improper behavior [as people fighting, playing loud music, displaying inappropriate signs] will be less tolerated. Fans throwing chicken bones, beer bottles, and profanities in the grandstands are steadily being displaced by families and respect."[44] The acceptance and progress of the sport seems based on cleaning up the game, that is, the look, the crowd, for television sponsorship and viewership.[45]

The shift in drivers, track locations, and fans is directly connected to a shift in sponsors. There are major, associate, and contingency sponsors of teams

and cars/drivers; there are naming sponsors of individual races and NASCAR tracks, like Lowe's Motor Speedway in Concord, North Carolina; and there is the title sponsor of the entire NASCAR Cup Series, known as the Winston Cup Series from 1972 to 2003. For 30 years, RJR invested, profited, and brought NASCAR into the twenty-first century. Starting in 2008, the NASCAR race is for the Sprint Cup (formerly called the Nextel Cup before Nextel merged with Sprint). From moonshine to tobacco to telecommunications. NASCAR's come a long way, baby.

NASCAR today: from hick to hip

The executives of the new, modern National Association of Stock Car Auto Racing hope that this is the time to make the full transition from Southern-bred phenomenon to national pastime. The hope is to "become more and more a part of the fabric of the society," says Dick Glover, the former ESPN executive who is now NASCAR's vice president of broadcasting and new media. "One of the best ways is to try to be a part of pop culture."[46] If you watch the beginning of a NASCAR race broadcast, there are several, alternating theme songs that you will hear: "Let's Go Racing, Boys" sung by an energetic female country singer, "Born to Be Wild" a guttural American rock anthem, and "How Far We've Come" performed by hipsters Matchbox Twenty in an image campaign video marking NASCAR's 60-year history. The infusion into (or convergence with) popular culture is undoubtedly effective, sophisticated marketing. The invitation to watch the race casts a wide net – and hence, casts country, rock, and twenty-something musicians. But beyond the big television opening, what is it about the sport, itself, that is so appealing?

First, almost everyone can relate to racing because they drive. We can relate to the feeling of operating a car, the desire to be in motion and to go places, the dream to drive fast and free. Some of us have hit 90 mph in our civilian cars, but 200 mph? It is within the realm of comprehension and that constant tie to the reality of an extreme sport like racing is unique and compelling. While some have had the experience of playing football or baseball, and arguably these spectator sports have fans who are close to the game having played it, not many of us know what it is like to, say, box or ice skate. Although the spectator's relationship to these kinds of sports can be visceral or sensorial, it is not as phenomenological as it is with race car driving. Racing has a distinct sight (the colorful, numbered cars on the track), sound ("gentlemen, start your engines"), and smell (of fuel and burning rubber). And for anyone who drives, we've all had a taste of speed.

What makes NASCAR on television exciting is that the nearly 40 races broadcast over almost every weekend from February through November are

live, televised events. It was on February 15, 1979, that CBS broadcast the first live flag-to-flag coverage of the Daytona 500.[47] Mark Yost describes the historic television event:

> On the last lap, in front of the largest television audience NASCAR had ever seen, Cale Yarborough and Donnie Allison crashed into each other going down the back straight. Much of the postrace coverage – live on CBS and in newspapers across the country the next day – focused on the raucous fist-fight that followed. At one point, all the cameras caught of the melee was Cale Yarborough's helmet swinging through the air, with an unseen Allison its obvious target. Unrefined and brutish? Yes. But Americans ate it up. At a time when professional sports were becoming more sanitized, polished, and corporate, the country began to fall in love with a sport that was filled with real people, driven by real emotions and a very real desire to win.[48]

Every NASCAR Cup Series, Nationwide Series (formerly the Busch Series), and Craftsman Truck Series race is broadcast on television. For newbies:

> If you're curious about racing but not ready to devote yourself to it, you can catch a peek of the sport before you dive into it as a fan. Turning on your TV is the first step. It won't be long until you stumble upon a racing show, on which races, qualifyings, and practices are dissected, and every-one from the driver to the car owner to the guy that puts gas in the car is interviewed. You can find out more about racing than you ever wanted to know if you watch these shows long enough.[49]

NASCAR.com provides among its numerous informative pages an effective primer including NASCAR history, decade by decade, 50 greatest drivers, women of NASCAR, names to know, famous families, glossary, a description of The Chase (for the Sprint Cup), and an explanation of the point system. SPEEDTV.com is also a strong resource, providing information as well as pro-moting a viewing culture for motor sports. Watching the race can be a multi-media experience (television, radio, computer, phone), with special telemetry developed for broadcasting. In 2007, NASCAR and DirecTV began offering a new service called "Hot Pass" that covers the races from the team's perspec-tive. That is, there are five separate channels, allowing fans to watch an entire race through the point-of-view of a single driver's windshield; there are also overhead cameras, pit box cameras, and corner cameras all providing the tele-vision viewer a far better and fuller view than if s/he were at the actual race. Imagine bumper cams and crash cams from the comfort of your own living room.

Home and nation come together – through sport, television technology, and a sense of tradition. Fans are not subordinated to drivers; rather, we are family and history. NASCAR Nation refers broadly to the millions of viewers of the sport, and it includes die-hard fans, long-time fans, and people who follow the races throughout the season and are able to attend an event or two. The significance of the term, of the phenomenon, is two-fold: first, it represents the facilitation of bringing many more new fans to the sport via television broadcasting; and, second, NASCAR Nation indicates a mode of address, one that invokes its historical roots and simultaneously invites new members into the fold. The NASCAR experience is one that hails a subject as a fan, television viewer, consumer, member of a particular regional cohort, and American citizen.

As Garry Whannel has written: "Television has aided the growth of a star system in sport, enabling sport stars to become personalities and celebrities. Plainly, television celebrates nationalism and national identity, and mobilizes viewer identification."[50] Moreover, the race car driver has become intertextual through the seamless broadcasting of commercials starring the drivers themselves (during races and at other times, too), through online chats, "Speed on Demand" on the Web, the marketing of merchandise and collectibles, the injection of non-racing celebrities (such as cut-aways to stars attending races or stars trying their hand at driving a race car[51]), the integration of racing celebrities into pop culture (Jeff Gordon making *People Magazine*'s 50 Most Beautiful People list or Helio Castroneves winning *Dancing With the Stars*). And then there is the car itself. The cars are flexible texts connoting freedom, power, agility, daring, masculinity, technological ingenuity, and of course they are advertising texts covered in corporate logos, which is why they exist in the televisual universe. The signifying power of the automobile is what fuels its continuation as one of the most and best-used symbols in culture.

In his book *From Moonshine to Madison Avenue*, Mark Howell describes two levels of interpretation for NASCAR racing which I would call material and ephemeral: "It is a sport of numbers and statistics, a sport suited for quantitative analysis: laps led, races won, engine revolutions per minute turned, gear ratios used, seconds needed per pit stop, prize money earned, and championship points awarded." It is also involves "symbols, rituals, and images. It is a sport rooted in cultural mythology."[52] The car is connotative, denotative, visually stimulating, and economically powerful. It is, indeed, a vehicle for the representation of identity. Through NASCAR, the car has transported fans, drivers, and dollars. And through television, NASCAR Nation has converged upon America.

Notes

1. On July 1, 2008, Franchitti's team announced that they were suspending the #40 car due to lack of sponsorship. While they state that they would like to continue to support Fran-

chitti's development as a stock car racer, they cannot afford it. While Franchitti is a champion Indy car driver having won the premiere race, the Indy 500, in 2007 he did not place higher than twenty-second in NASCAR races. There is talk that Chip Ganassi Racing has an eye to bring up a 19-year-old rookie driver from the Nationwide series: www.nascar.com/2008/news/opinion/07/04/rswan.bclauson.dfranchitti.40car/index.html.

2. Democratic pollster Celinda Lake is credited for coining the term "NASCAR Dad," which was picked up by political strategists and journalists alike. Generally, it is meant to describe rural and small-town voters, especially white men in the South, who once voted Democratic but who have turned to the Republican Party in recent presidential elections as the two parties have taken different stances in social issues such as race, gay rights, and guns. Such "traditional values" are projected onto the NASCAR Dad and often in condescending or prejudicial ways by an intellectual elite.

3. See Victoria E. Johnson's *Heartland TV: Prime Time Television and the Struggle for U.S. Identity* which "examines the ways that presumed Midwestern ideals and the Midwest as imagined, symbolic Heartland have been central to television's promotion and development and to the broader critical and public discourse regarding the medium's value and cultural worth" (New York: New York University Press, 2008), 5.

4. "Big Bill" France (whose son, Bill France, Jr., became president when his father retired, and whose grandson, Brian France, is now CEO and Chairman of NASCAR) had several goals in the beginning: to make racetracks safe, to establish rules of racing that didn't change from week to week or race to race, to have a set schedule (and enable a national champion who could be recognized at the end of the year), to devise a uniform point system (to calculate drivers' performances throughout the season), and to establish an insurance and benevolent fund for drivers.

5. Mark Martin, with Beth Tuschak, *NASCAR for Dummies*, 2nd edition (Hoboken, New Jersey: Wiley Publishing, Inc., 2005), 10.

6. NASCAR itself is owned by the France family as a private enterprise, but there are also car owners (the equivalent of the owners of teams in other professional sports) and venue owners, who together manage the sport and share broad economic interests. For convenience, I'll refer to all of these as the "owners" of NASCAR.

7. Manuel Castells proposed the term "Cultural Toyotism" to refer to a flexible management system and a conscious approach to gain the support of a new audience/set of consumers. See David L. Andrews and Michael Silk, "Global Gaming: Cultural Toyotism, Transnational Corporatism and Sport," in *Sport, Culture and Advertising: Identities, Commodities and the Politics of Representation*, eds. Steven J. Jackson and David L. Andrews (London and New York: Routledge, 2005), 172–191.

8. Martin, 9.

9. Chapter 4 in Yost's book is called, "From Rages to Riches: Junior Johnson Turns Tobacco into Gold." It is thanks to Junior Johnson – for turning down R.J. Reynolds' offer to sponsor him, and instead, suggesting that they think much bigger and enter talks with NASCAR to sponsor the series – that NASCAR took a turn in history.

10. As Mark Yost describes, "These deals were sealed with a handshake, not the bevy of corporate attorneys, agents, and corporate CEOs who negotiate today's NASCAR sponsorships." Yost also wrote about the subsistence racing lifestyle in the days before drivers entered the lucrative world of professional sports teams:

> Drivers would mortgage their house or farm on Wednesday, use the money to buy tires and parts, race all weekend, and, if they were lucky enough and good enough, win enough money to pay back the bank on Monday morning.
> (Mark Yost, *The 200-MPH Billboard: The Inside Story of How Big Money Changed NASCAR* (St. Paul, Minnesota: Motorbooks, an imprint of MBI Publishing Company, LLC, 2007), 30)

11. Yost, 29–30.
12. Yost, 31–32.

13. Yost, 33.
14. As television has become a way for the driver to market him/herself, it puts pressure on drivers to speak well and behave in front of the camera, says Mark Martin. "Every time drivers climb out of cars, camera lenses are watching, and reporters with microphones are asking questions ... the cameras and microphones are waiting. And at the end of the race, no matter how frustrated or angry or hot or sweaty or thirsty or tired you may be, reporters are there waiting for you to talk to them the instant you crawl out of your car." Unlike pro football or other players who get to cool off in the locker room, "for NASCAR drivers, that immediate media blitz has become a way of life" (Martin, 29).
15. Martin, 24.
16. Martin, 34.
17. Martin, 39.
18. Martin, 38.
19. Martin, 79.
20. Martin, 91. Well-known Formula 1 (open-cockpit, road course) events include LeMans in Monte Carlo.
21. Yost, 36.
22. For more on the business-to-business strategy and the B2B Council, see chapters 1, 2, and especially 8 in Yost's *The 200-MPH Billboard: The Inside Story of How Big Money Changed NASCAR.*
23. Yost, 178.
24. Yost, 229.
25. Considering the changing demographics of NASCAR – more affluent, more female, more educated, more urban – Yost asks: why does the military continue to target this audience? Yost, 230.
26. Yost, 231.
27. Yost, 235–236.
28. Wendell Scott beat the field in a 200-mile race in 1963 in Jacksonville, but as the story goes, NASCAR officials were worried about how the predominantly white crowd might react to seeing a Black man hold up the winner's trophy. So another, white driver was declared the winner; soon after the crowd left, a review revealed that there had been a "scoring error" and Scott was declared the winner.
29. "The Race to Diversity: NASCAR Struggles With Issue," *Charleston Gazette*, December 28, 2002.
30. "The Race to Diversity."
31. In chapter 3 of my book manuscript, *Maid for Television: Race, Gender, and Class on the Small Screen*, I explore shades of whiteness:

 By analyzing how whiteness operates according to race, class, and gender, we can see whiteness as a form of racialization. Class differences within whiteness exist, certainly, and can move working-class whites into a category of otherness or of less-whiteness. This helps conceptualize if not illustrate "white" as involved in both racial and class designation (much as "Black" is simultaneously raced and classed).

32. Matt Stearns, "'NASCAR Dads' Are Latest Hot Political Demographic," Knight Ridder/Tribune News Service, October 4, 2003.
33. Martin, 14.
34. Martin, 14.
35. Yost, 9. Foreword by Brian Williams, anchor of NBC *Nightly News*.
36. Garry Whannel, *Field in Vision: Television Sport and Cultural Transformation* (London and New York: Routledge, 1992), 126.
37. Whannel, 122.
38. Eldon E. Snyder and Elmer A. Spreitzer, *Social Aspects of Sport*, 3rd edition (Englewood Cliffs: Prentice, 1989), 179.

39. Yost, 11.
40. Mark D. Howell, *From Moonshine to Madison Avenue: A Cultural History of the NASCAR Winston Cup Series* (Bowling Green: Bowling Green State University Popular Press, 1997), 130.
41. Howell, 130.
42. Howell, 69.
43. Howell, 10.
44. Howell, 10.
45. See also "It's Not Your Father's NASCAR: Bending the Rules – OK, Cheating – Was a Bedrock of Stock-Car Racing, But Corporate Influence Has the Sport Turning Its Back on Its History," *Chicago Sun-Times*, February 18, 2007, which reads in part:

> NASCAR says it's trying to clean up its sport, but what's really happening is this: NASCAR is trying to clean off its past, to shine it up for ESPN and Toyota. This is a made-for-TV shakedown – NASCAR has put itself in an uncomfortable spot, trying to trump its own nature and building blocks with something its founding fathers would have hated. It is trying to balance the slick marketing world with the guy under the hood, the Beverly with the Hillbilly. There's a cultural thing going on here. When I say that NASCAR is a dirty-fingernailed Southern sport, I mean that in the nicest way possible.

And:

> So much of the history of stock-car racing has been to find any little edge. I mean, that's the point. Now, NASCAR has come up with corporate America and all these rules. It tries to even out the technology, create parity, so the cars all will be bunched together at high speeds. That adds to the thrill of potential crashes and also makes it easy to fit a bunch of cars on our TV screens at the same time. It also flies in the face of everything this sport has stood for. And there's something lost when the officials of a sport change the game, homogenize it, just to accommodate outsiders.

46. "Driven: While Politicians Want That NASCAR Demographic, The Auto Racing Outfit has its Eye on Hollywood," *The Boston Globe*, March 14, 2004.
47.

> While many mark 1979 as the first year the Daytona 500 was broadcast live, that's not exactly true. TelePrompTer, then the largest cable network in the United States, used twelve cameras, slow-motion instant replay, and trackside interviews to produce a live broadcast of the 1971 Daytona 500. It wasn't shown on television, but broadcast into movie theaters around the country.
>
> (Yost, 126)

48. Yost, 26.
49. Martin, 27.
50. Whannel, 191.
51. For example, Ryan Seacrest, host of mega-hit *American Idol*, is a DJ on LA's most-listened-to radio station KIIS-FM where he has a morning show. He also co-hosts a daily entertainment news program on E!, and he continues working on the weekends doing the Top 40 radio countdown. He is the new millennial Dick Clark – not only a ubiquitous host of all media, but, in the footsteps of Clark, he has started a production company, Seacrest Productions. Seacrest is skilled, hard-working, ambitious, and he is known throughout television, radio, magazines, and YouTube by audiences ranging in age, class, race, and gender.
52. Howell, 5.

Contributors and editors

Hector Amaya is Assistant Professor of Media Studies at the University of Virginia. He writes and teaches in the areas of global media, Latin American film, comparative media studies, and Latinas/os media studies. His manuscript *Film Criticism in Cuba and the USA* is a comparative study of film reception of Cuban film, cultural criticism, and citizenship in Cuba and the USA from the 1960s to 1985. Amaya's journal articles have appeared in publications such as *Television & New Media*, *Studies in Hispanic Cinemas*, *New Cinemas*, *Critical Discourse Studies*, *Latino Studies*, and *Text and Performance Quarterly*. Amaya is currently writing a second book, tentatively titled *Media and Citizenship: Latinas/os, Immigrants, and Transculturation*, in which he explores the relationship of media to citizenship and the impact this relationship has on Latinos/as.

Marnie Binfield is a doctoral student in Radio-Television-Film at the University of Texas at Austin. She is also an academic mentor in the Athletics Department. She received her Master's degree in Women's Studies from San Diego State University. Her research interests include popular music, especially hip-hop, and its roles in social and political formations, music video, and women's cultural production. Her dissertation focuses on hip-hop fandom and its relationship to politics, and she served as a coordinating editor of FlowTV for volumes III, IV, and V.

Jack Bratich is Associate Professor of Journalism and Media Studies at Rutgers University. He works on the intersection of autonomism, subjectivity, and culture. He has written articles that apply autonomist thought to such topics as reality TV, audience studies, political intellectuals, and popular secrecy. He is co-editor, along with Jeremy Packer and Cameron McCarthy, of *Foucault, Cultural Studies and Governmentality* (SUNY 2003) and *Conspiracy Panics: Popular Culture and Political Rationality* (SUNY 2008). He is currently working on a book on reality television and affective convergence. www.scils.rutgers.edu/~jbratich/

Daniel Chamberlain is a doctoral candidate in the Critical Studies department at the University of Southern California's School of Cinematic Arts. His research is focused on the cultural impact of film, television, and new media, particularly on how emergent media technologies produce new types of urban spaces and inter-

faces. He previously earned a Master's degree in Critical Studies from USC and a Bachelor's degree in Economics from the University of Michigan.

John Corner is Professor in the School of Politics and Communication Studies, University of Liverpool. He is an editor of the journal *Media, Culture and Society* and the author and editor of many books on television, including *Popular Television in Britain*, *Television Form and Public Address*, *The Art of Record*, *Critical Ideas in Television Studies* and, most recently, the co-authored *Public Issue Television*.

Eric Freedman is an Associate Professor and Director of Multimedia Studies in the School of Communication and Multimedia Studies at Florida Atlantic University. His early scholarly work on public-access cable television is included in *The Television Studies Reader*, *The Television Studies Book* and the journal *Television and New Media*. His forthcoming book with the University of Minnesota Press examines the assumptions that underpin the exhibition of personal images, occasional photographs and amateur video in public domains such as the Internet.

Jonathan Gray is an Associate Professor in the Department of Communication Arts at the University of Wisconsin at Madison. He is currently working on a book for New York University Press, about film and television "paratexts" – all those things that surround film and television, from games to trailers, spinoffs to spoilers, toys to hype, reviews to fan creations. His other books include a co-edited collection (with Jeffrey P. Jones and Ethan Thompson), *Satire TV: Comedy and Politics in a Post-Network Era* (New York University Press, 2009); *Television Entertainment* (Routledge, 2008); *Watching with The Simpsons: Television, Parody, and Intertextuality* (Routledge, 2006); *Fandom: Identities and Communities in a Mediated World* (New York University Press, 2007), edited with Cornel Sandvoss and C. Lee Harrington); and *Battleground: The Media* (Greenwood, 2008), an encyclopedia of media hot-button issues, edited with Robin Andersen. His research examines the interactions of entertainment media and audiences, with particular interest in parody and satire, transmedia storyworlds, and the changing nature of "television." He has degrees from the University of British Columbia (BA in English), University of Leeds (MA in Literature from Commonwealth Countries), and Goldsmiths College, University of London (MA and PhD in Media and Communication Studies).

David Gurney is currently a doctoral student in Northwestern University's Screen Cultures program. His MA thesis, *Exploring the Mockumentary*, analyzes the narrative strategies employed by comedic writer/director/actors who have been drawn to the mockumentary form in work across both film and television. Continuing his interest in the function of humor across media, his recent work has dealt with the evolution of sitcoms, comedic film shorts, and even comic product-placement practices in the age of the Internet, and the building, development, and maintenance of various taste cultures or media enclaves through video-hosting and social-networking sites.

James Hay is an Associate Professor in the College of Communication at the University of Illinois–Champaign-Urbana. He is a co-editor of *The Audience and its Landscape*.

Heather Hendershot is the editor of *Nickelodeon Nation: The History, Politics, and Economics of America's Only TV Channel for Kids* and author of: *Saturday Morning Censors: Television Regulation before the V-Chip*; *Shaking the World for Jesus: Media and Conservative Evangelical Culture*; and a forthcoming book on cold war right-wing broadcasting. Hendershot is also the editor of *Cinema Journal*, the official publication of the Society for Cinema and Media Studies.

Michael Kackman is an Assistant Professor of Media Studies in the Department of Radio-TV-Film at the University of Texas at Austin, and is the author of *Citizen Spy: Television, Espionage, and Cold War Culture* (University of Minnesota Press), a cultural and industrial history of US television espionage programs of the 1950s and 1960s. His work has also been published in *Cinema Journal*, *The Velvet Light Trap*, and the *Encyclopedia of Television*. He is currently researching the development of international syndication practices for children's Westerns in the 1950s. Kackman has also served as the primary faculty supervisor for FlowTV from its launch in 2004.

Misha Kavka teaches film, television, and media studies at the University of Auckland. She has one book on reality television in press with Palgrave Macmillan, and a second book on the history and concepts of reality TV under contract with the TV Genre Series at Edinburgh University Press. In addition to teaching reality television, feminist theory, gothic film, and New Zealand cinema, she has published numerous articles on these subjects, as well as two co-edited anthologies: *Feminist Consequences: Theory for the New Century* (Columbia University Press, 2001) and *Gothic NZ: The Darker Side of Kiwi Culture* (Otago University Press, 2006).

L.S. Kim is an Assistant Professor of Film and Digital Media at the University of California, Santa Cruz. Her work focuses on racial discourse, postfeminism, and intertextuality. Her current book, *Maid in Color: Racial Discourse and Representational Economy in American Television*, examines the intersection of race and class relations embodied in a long history of television maids as integral (rather than marginal) to the idealized US family. She is also developing writing on "New Orientalism" (theory and criticism about cross-cultural media forms – for example, the action genre, and anime).

Derek Kompare is an Assistant Professor in the Division of Cinema-Television in the Meadows School of the Arts at Southern Methodist University, where he teaches courses on media history, media theory, film and television genres, and media globalization. He has written about television history and form in *Media History*, *Television and New Media*, *Flow*, and in anthologies. His 2005 book *Rerun Nation: How Repeats Invented American Television* was runner-up for the Society for Cinema and Media Studies Katherine Singer Kovacs Book Award.

Jason Mittell is Associate Professor of American Studies and Film & Media Culture at Middlebury College. He is the author of *Genre and Television: From Cop Shows to Cartoons in American Culture* (Routledge, 2004), *Television and American Culture* (Oxford, 2009), numerous essays in a number of journals and anthologies, and

the blog Just TV. He is currently writing a book on narrative complexity in contemporary American television.

Matthew Thomas Payne is a Media Studies doctoral student in the Department of Radio-TV-Film at the University of Texas at Austin. His research focuses on communication technologies, video games, and media literacy. He was a coordinating editor for FlowTV volumes V and VI, and is a co-editor (with Nina B. Huntemann) of *Joystick Soldiers: The Politics of Play in Military Video Games* (Routledge, 2009).

Allison Perlman is an Assistant Professor in the Federated Department of History at the New Jersey Institute of Technology and Rutgers University-Newark. Her current research examines the intersection of media reform activism and twentieth-century social movements in the United States. She earned her PhD in American Studies at the University of Texas at Austin, where she was the senior columns editor for FlowTV volume I and co-coordinated the first Flow conference.

Bryan Sebok is an Assistant Professor of Media Studies at Lewis and Clark College. His research interests focus on convergence in Hollywood, digital innovation and diffusion, and digital regulation. He is also an independent film producer, and earned his PhD in Media Studies at the University of Texas at Austin, where he served as a coordinating editor of FlowTV, volumes III and IV.

Louisa Ellen Stein is an Assistant Professor of Television, Film, and New Media at San Diego State University. She has written previously on contemporary media culture, including film, television, the Internet, and videogames. She lives in La Mesa, California.

Chuck Tryon is an Assistant Professor at Fayetteville State University where his teaching interests include film history, documentary studies, and digital media. He has published essays in *Film Criticism*, *Rhizomes*, and *Post-Identity* and in the anthologies, *The Essential Science Fiction Television Reader* and *Violating Time: History, Memory and Nostalgia in Cinema*. He is currently completing work on a book focusing on cultural debates about Hollywood's shift from film to digital media.

Index